EAKINS AND THE PHOTOGRAPH

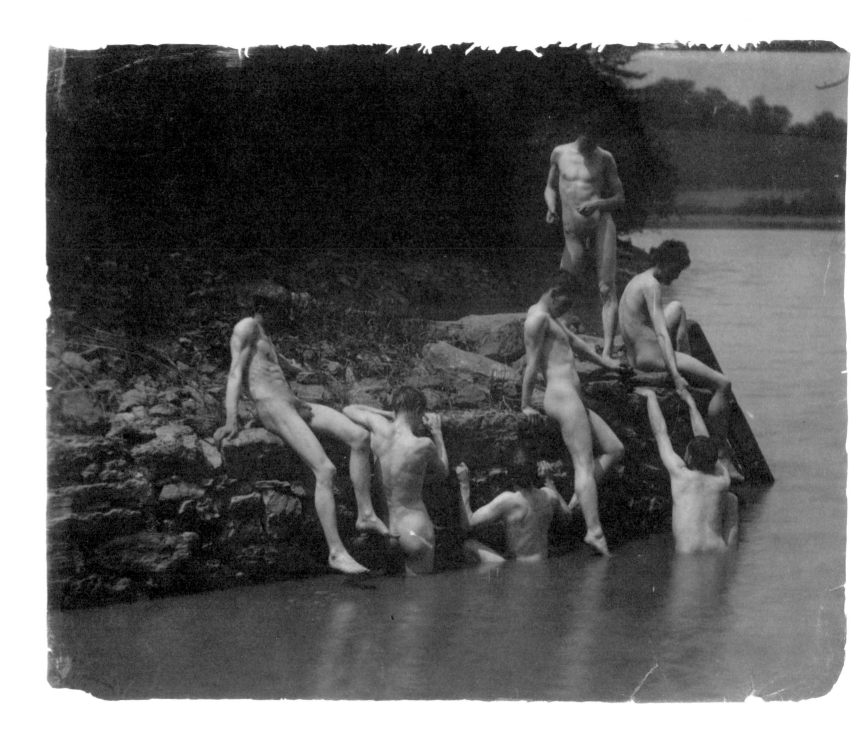

EAKINS AND THE PHOTOGRAPH

WORKS BY THOMAS EAKINS
AND HIS CIRCLE
IN THE COLLECTION
OF THE PENNSYLVANIA ACADEMY
OF THE FINE ARTS

SUSAN DANLY AND CHERYL LEIBOLD

WITH ESSAYS BY
ELIZABETH JOHNS, ANNE McCAULEY, AND MARY PANZER

PUBLISHED FOR THE PENNSYLVANIA ACADEMY OF THE FINE ARTS
BY THE SMITHSONIAN INSTITUTION PRESS
Washington and London

Published by the Smithsonian Institution Press for the Pennsylvania Academy of the Fine Arts
118 North Broad Street
Philadelphia, Pennsylvania 19102

DESIGNER: Janice Wheeler
SUPERVISORY EDITOR: Duke Johns
COPY EDITORS: Jacolyn A. Mott and Judy Spear
COPY PHOTOGRAPHERS: Rick Echelmeyer and Thomas Palmer
PRODUCTION MANAGER: Ken Sabol

Frontispiece: *Thomas Eakins and students, swimming nude,* by circle of Eakins, ca. 1883, platinum print (cat. no. 393 [.480])

Library of Congress Cataloging-in-Publication Data
Pennsylvania Academy of the Fine Arts.
Eakins and the photograph : works by Thomas Eakins and his circle in the collection of the Pennsylvania Academy of the Fine Arts / Susan Danly and Cheryl Leibold ; with essays by Elizabeth Johns, Anne McCauley, Mary Panzer.
p. cm.
Includes bibliographic references (p.) and index.
ISBN 1-56098-352-3 (alk. paper). —
ISBN 1-56098-353-1 (pbk. : alk. paper)
1. Eakins, Thomas, 1844–1916—Catalogues raisonnés.
2. Bregler, Charles—Photograph collections—Catalogs.
3. Photographs—Private collections—Pennsylvania—Philadelphia—Catalogs.
4. Pennsylvania Academy of the Fine Arts—Photograph collections—Catalogs.
I. Danly, Susan. II. Leibold, Cheryl. III. Title.
TR652.P46 1994 779'.092—dc20 93-32940

British Library Cataloguing-in-Publication Data is available

Manufactured in the United States of America
01 00 99 98 97 96 95 94 5 4 3 2 1

♾ The paper used in this publication meets the minimum requirements of the American National Standard for Permanence of Paper for Printed Library Materials Z39.48-1984.

For permission to reproduce illustrations appearing in this book, please correspond directly with the Pennsylvania Academy of the Fine Arts. The Smithsonian Institution Press does not retain reproduction rights for these illustrations individually.

CONTENTS

FOREWORD

Although Thomas Eakins is recognized as one of America's greatest painters, he has received considerably less attention as a photographer. The scope of his photography remained obscure until Charles Bregler's Thomas Eakins collection was acquired in 1985 by the Pennsylvania Academy of the Fine Arts. Bregler studied with Eakins and enjoyed a close friendship with him and his wife. After she died in 1938, Bregler preserved the major portion of Eakins's photographs and glass-plate negatives. Although he distributed some prints during his lifetime, most of the images now in the Pennsylvania Academy's collection have remained out of public view.

This publication constitutes the first attempt to catalogue systematically a significant number of Thomas Eakins's photographs and to provide an overview of his photographic career. The essays suggest new ways of looking at the photographs in terms not only of Eakins's own art but also of the history of the medium. This is the second book dealing with the Thomas Eakins material in the collection of the Pennsylvania Academy of the Fine Arts. The first, *Writing about Eakins: The Manuscripts in Charles Bregler's Thomas Eakins Collection,* by Kathleen A. Foster and Cheryl Leibold, was published in 1989 and already has contributed greatly to Eakins scholarship. The Academy is now preparing a publication on the drawings and oil sketches acquired with the Bregler collection.

Eakins and the Photograph: Works by Thomas Eakins and His Circle in the Collection of the Pennsylvania Academy of the Fine Arts received generous financial support from several sources. The National Endowment for the Humanities funded in 1988 the conservation of the photographs and more recently the writing of the text. Additional funds for conservation came from the National Endowment for the Arts. The John Medveckis Foundation supported cataloguing and copy photography. Funds for printing and production were provided by the Getty Grant Program. The Pennsylvania Academy is grateful to all these donors and to the Smithsonian Institution Press for taking on the production of the book.

Linda Bantel
The Edna S. Tuttleman Director, Pennsylvania Academy of the Fine Arts

This book was published with the assistance of the Getty Grant Program. Additional support to underwrite the conservation, cataloguing, and copy photography of the Bregler collection, and the preparation of the text, was provided by the John Medveckis Foundation and by the National Endowment for the Humanities and the National Endowment for the Arts, independent federal agencies.

ACKNOWLEDGMENTS

Cataloguing the many photographs that were acquired with the Bregler collection has presented a special challenge. There are no publications that come close to offering a model for comprehensive examination of Thomas Eakins's work as a photographer. Seeking to present these photographs in a way that would reflect Eakins's use of the camera and its impact on his work as a whole, the authors benefited greatly from conversations with fellow Academy staff members, consultants, and colleagues. We acknowledge especially the research on Eakins conducted by Kathleen A. Foster (now at the Indiana University Art Museum), who was the first curator to have access to the Bregler collection and who continues to share her expertise and insights on Eakins's work. In addition, staff members and volunteers at the Pennyslvania Academy helped to coordinate and research this extensive collection: Catherine Kimmock, Helen Mangelsdorf, Anne Monahan, Marie Naples, Dorothy Belknap, and Cynthia Haveson Veloric.

The contributing essayists are Elizabeth Johns, Silfen Term Chair in American Art, University of Pennsylvania, Philadelphia; Anne McCauley, associate professor of art history, University of Massachusetts, Boston; and Mary Panzer, curator of photography, National Portrait Gallery, Washington, D.C. They served, along with Kenneth Finkel of the Library Company of Philadelphia and William I. Homer of the University of Delaware, as consultants on the project. The photograph conservator Debbie Hess Norris provided invaluable information on the technical processes used by Eakins and performed treatments on the entire collection; Mary Schobert and Claudia Deschu carried out other conservation procedures. Douglas Munson of the Chicago Albumen Works helped to identify the medium of many prints in collodion and on printing-out paper. Curators of major photographic collections that include the work of Thomas Eakins provided valuable assistance: Martha Chahroudi, Ann B. Percy, and Darrel L. Sewell at the Philadelphia Museum of Art; Weston Naef, Judith Keller, and Gordon Baldwin at the J. Paul Getty Museum, Malibu; Phyllis Rosenzweig at the Hirshhorn Museum and Sculpture Garden, Washington, D.C.; Mary Leahy at Bryn Mawr College, and Maria Morris Hambourg and Jeff L. Rosenheim at the Metropolitan Museum of Art, New York. Daniel W. Dietrich II of Philadelphia and the Macdowell family of Roanoke, who have long

maintained an interest in both Eakins's paintings and his photographs, were most generous with their time and knowledge about Eakins.

Making copy photographs and printing from Eakins's original negatives was a major component of this cataloguing project. Rick Echelmeyer provided his sensitive skills as a photographer in reproducing the individual character of the various media represented in the collection, which includes cyanotypes, albumen and platinum prints, and glass-plate negatives and positives. Steven Puglia of the National Archives in Washington made enlargements directly from Eakins's negatives. For advice about the quality and effectiveness of modern reproductive processes, we consulted with Richard Benson and Thomas Palmer of Newport, Rhode Island, whose involvement was crucial in producing the portfolio section of this book.

Jacolyn A. Mott, editor in chief for the Pennsylvania Academy, gave the entire manuscript her scrupulous attention, and her suggestions about cataloguing procedures were invaluable. Amy Pastan and Duke Johns, editors at the Smithsonian Institution Press, guided us through the complex phases of book production. In addition, Elizabeth Milroy, Jeanette Toohey, and James F. O'Gorman read portions of the manuscript, and their suggestions were of great help. Finally, like their subject, Thomas Eakins, the authors owe much to the support of their families.

Susan Danly
Curator of American Art, Mead Art Museum, Amherst College

Cheryl Leibold
Archivist, Pennsylvania Academy of the Fine Arts

EAKINS AND THE PHOTOGRAPH

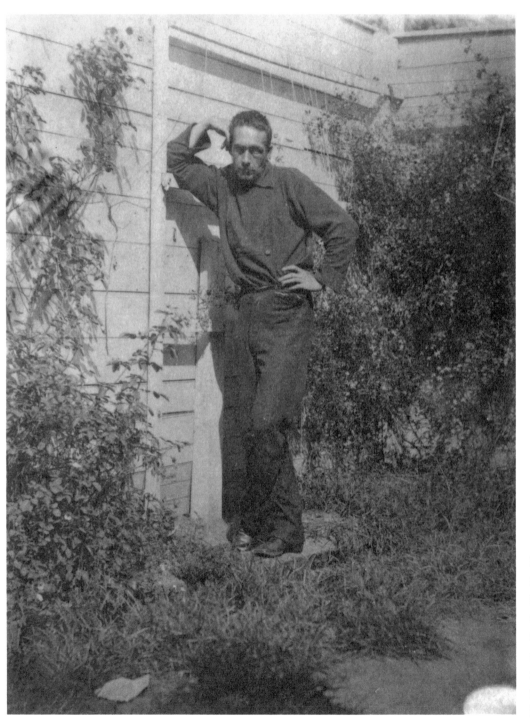

Figure 1. *Thomas Eakins at about age thirty-five leaning against fence,* attributed to Susan Macdowell Eakins, 1880, gelatin silver print (cat. no. 107 [.34])

EAKINS AND THE PHOTOGRAPH: AN INTRODUCTION

SUSAN DANLY and CHERYL LEIBOLD

From about 1880 to 1900, Thomas Eakins was an avid and innovative photographer. He made photographs for personal and at times very private reasons but not for public exhibition. In addition to taking photographic portraits of family and friends, Eakins used photographs as documents of scientific inquiry, as teaching tools in his art classes, and as studies related to his own work in painting and sculpture. While creating images that fulfilled this wide variety of practical functions, he also produced photographs that stand as independent works of art. Scholars have discussed them as documents of Eakins's personal life[1] and as studies for finished works of art in other media.[2] Only recently, however, has his work been seen as part of the history of photography.[3] The aim of this publication, therefore, is to place Eakins's photographs within the context of what was then a relatively new artistic medium and to suggest ways in which photography both enhanced and hindered his career as a whole. The following essays explore Eakins's photographs within the larger cultural contexts of Paris and Philadelphia. Anne McCauley discusses the artist's preoccupation with photographic studies of the nude as the outgrowth of his student days in France and as a means of expressing his own aesthetic ideology. Although formally conservative, Eakins's artistic practice ultimately brought him into conflict with the moral arbiters of his day. As Elizabeth Johns argues, however, he did not use overt nudity and latent sexuality in his photographs merely to shock, but to evoke the kind of realistic classicism that he could not achieve in his paintings. Photography, as opposed to any other visual medium, allowed Eakins to balance his interest in modern science with the more traditional aspect of academic art. Mary Panzer's essay further ties Eakins's working methods in photography to a circle of contemporary scientists and physicians active in late nineteenth-century Philadelphia. Along with the introduction and the catalogue of photographs in the collection of the Pennsylvania Academy of the Fine Arts, these essays provide examples of various ways in which to explore Eakins's work as a photographer.

Until 1985, when the Pennsylvania Academy acquired the cache of photographs included in Charles Bregler's Thomas Eakins collection,[4] no extensive assessment of Eakins's contribution to the medium could have been undertaken. Before then only a small portion of his photographic output was accessible, scattered among several collections.[5] Many of the

images were known solely through copy prints made by Charles Bregler, and there was little documentation about Eakins's photographic practice. For reasons that relate to the manner in which Eakins made and used photographs, the extent of his involvement in the medium has never been fully discussed. Although some works were displayed in his studio and classrooms at the Pennsylvania Academy of the Fine Arts and the Philadelphia Art Students' League, there are only two recorded instances of the public exhibition of his photographs during his lifetime. Many of the images that he took were made as studies and, as such, were never intended for public display. Furthermore, the photographs of male and female nudes would have been misunderstood by viewers outside the small circle of Eakins's most loyal students and immediate family. Even within the limited confines of the Pennsylvania Academy's studios, the display of such photographs eventually contributed to his dismissal as director of instruction in 1886.[6]

After Thomas Eakins died in 1916, his wife, Susan Macdowell Eakins, showed the photographs to only a few of the artist's devoted admirers. Among them were his student Charles Bregler and the Philadelphia bibliophile and art collector Seymour Adelman.[7] With Susan's death in 1938, these photographs, along with numerous letters, diaries, drawings, and other Eakins memorabilia, were rescued by Bregler and Adelman. Most of the photographs remained in the hands of Bregler and his heirs until they were acquired by the Pennsylvania Academy in 1985. (Appendix B charts the dispersal of materials to other collections.)[8]

In addition to Bregler's holdings, the Pennsylvania Academy has acquired other Eakins-related photographs over the past thirty years. Three photographs of Eakins came from the estate of Harriet Sartain in 1959. More recently a photograph by Eakins of one of her forebears, the artist William Sartain, was given to the museum. After organizing the first exhibition devoted to Eakins photography at the Academy in 1969,[9] Gordon Hendricks gave the institution two photographs that he had acquired from Fanny Crowell, Eakins's niece. Another group of sixty-one photographs was purchased from the Hendricks estate in 1988. About twenty of these have been attributed to Eakins; the rest are Crowell family portraits and images by unidentified photographers.

The Pennsylvania Academy's Eakins collection contains almost 1,200 photographic objects, including prints, dry-plate negatives, and glass positives. Of these there are almost 650 separate images produced by Eakins and his circle. While most of the prints were unmounted, some were glued to album pages, probably by Charles Bregler. The only album remaining intact[10] contains 192 photographs grouped mainly by subject: family portraits, figure studies, and animal photographs.[11] Such subject groupings are typical of the work produced at the time by amateur photographers, who were increasing in number because of advances in photographic techniques and a decline in production costs.

Of the approximately 550 photographic prints attributed to Eakins and his circle in the Pennsylvania Academy's collection, there are 182 portraits (33 percent), 71 clothed figure studies (13 percent), 61 animal subjects (11 percent), and 8 landscapes (2 percent). The largest single group of images—218 prints (39 percent) and an additional 86 negatives—is devoted to the study of the nude, a problematic subject that sets Eakins's work apart from other amateur photographers of the 1880s.[12] Among the 270 glass negatives, a similar variety of subject categories is found, although not in the same proportion: 55

Figure 2. *Margaret Eakins and other figures on beach at Manasquan, New Jersey (?), ca. 1880, modern print from dry-plate negative (cat. no. 178)*

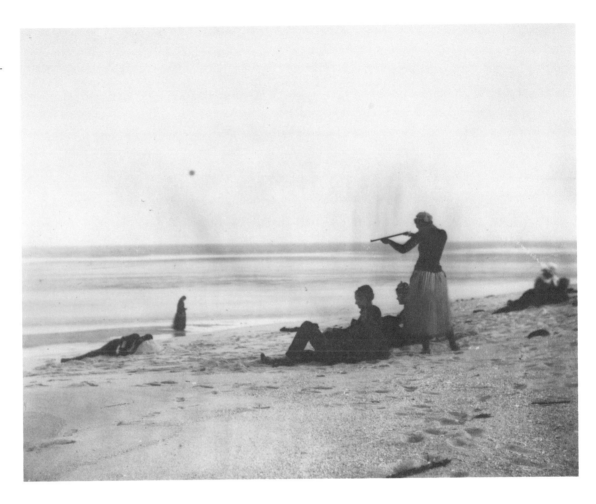

portraits (20 percent), 29 animal studies (11 percent), 13 landscapes (4 percent), and 6 clothed figure studies (2 percent). There are also two series of negatives: 45 scenes of shad fishing along the Delaware River (13 percent) and 36 images that record Eakins's trip to the Dakota Territory (16 percent). The glass positives are primarily portraits.

Eakins must have gained a general knowledge of photography by 1880 through his academic studies in Paris and his contacts with Philadelphia's artistic and scientific communities. Like many amateur photographers of the period, he first used the medium informally to record the casual occurrences of family outings and to document the picturesque activities of local fishermen.[13] With the introduction of smaller dry-plate negatives that were easier to carry and develop, Eakins would have found it relatively simple to use a view camera. His wife, Susan, who began photographing at about the same time, may have given him assistance; or he could have followed the basic instructions published by the photographic journals of his day. *Philadelphia Photographer,* in particular, offered amateurs a ready means of instruction in its monthly

articles on aesthetics, camera and darkroom equipment, and photographic chemistry. The German photographer Hermann Vogel described the new dry-plate method in various issues in 1879 and 1880 and emphasized just how simple it was:

The gelatin plates have imparted a new impulse, not alone to the portrait photography, but also to amateur photography. Since excellent, all ready prepared plates can be bought, which can be kept for months, and are easily developed and finished, photographing is within reach of anybody who has the means to spend some money for the necessary apparatus.[14]

Because so few of Eakins's photographs were exhibited or published during his lifetime, it is difficult to know when he began to photograph or to date his work precisely. Susan Eakins remembered taking a photograph of "Tom leaning against a fence" at their home at 1729 Mount Vernon Street in 1880.[15] The figure in this informal portrait (fig. 1) is posed in a casual manner and suggests the attitude that Eakins himself adopted in his earliest works. Starting about 1880, he recorded the outdoor activities of friends and family on the beach at Manasquan, New Jersey (see fig. 2).[16]

Eakins quickly saw the potential of the medium as a source of studies for paintings. The series of photographs of shad fishing, for example, taken in 1881 and 1882, was incorporated into several of his Gloucester paintings and watercolors. Because so few vintage prints of this series survive and because Eakins used so many parts of individual photographs in the final composition of paintings and watercolors, it appears that he then thought of photographs as documentary studies rather than artfully constructed images.[17] Also in 1881 he made several photographic figure studies of Margaret Harrison in his studio (cat. nos. 183–93) in preparation for the portrait titled *The Pathetic Song* (1881, Corcoran Gallery of Art, Washington, D.C.).

By 1883 Eakins had produced two more series of photographs related to paintings—photographs demonstrating that he had begun to view them as both preliminary studies and works of art. In comparison with his Gloucester series, the photographs of students posing nude for the Arcadia and Swimming Hole subjects (see plates 3, 4)[18] are more thoughtfully composed and lighted; and their proportions are more in keeping with the paintings to which they relate. These nude studies are, significantly, among the works that exist as large platinum prints. Whereas Eakins's earliest photographs had been relatively simple albumen contact prints—that is, the same size as the four-by-five-inch negatives—the Arcadia and Swimming Hole prints cover a wider range of sizes and media. With these images he truly began to experiment with the aesthetic potential of photography.

Among the subjects that Eakins first explored photographically were figure studies of women in historical costume.[19] In the 1880s he photographed two female students in classical garb (plate 11; cat. no. 194).[20] These studio views are related to, but not specifically studies for, his Arcadia paintings. Later, in the 1890s, he posed the Cook sisters in classical dress (cat. nos. 200–204). There are also photographs of women in colonial and Empire-style dresses (plate 14; cat. nos. 207–35). Within this group some of the images attributed to the circle of Eakins have a composition cluttered with domestic accoutrements, such as a tea table and background tapestries (see cat. nos. 224–25 and 233–35). The startling mood of historical re-creation

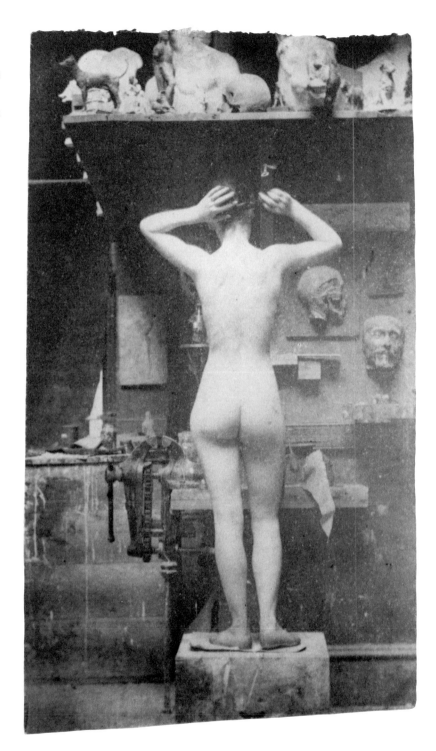

Figure 3. *Female nude standing on wooden block, arms raised, from rear,* ca. 1898, platinum print (cat. no. 290 [.523])

in these images is not unlike the more polished versions of colonial-revival subjects in the photographs of Wallace Nutting, which became popular just after the turn of the century.[21]

During the mid-1880s, Eakins began analytic studies of the human form as well. At the Pennsylvania Academy in about 1883, he photographed his students, professional models, and himself posing nude—a group of images that he called the "naked series" (see figs. 17, 50; cat. nos. 419–35).[22] Experiments with motion studies carried out in 1884 and 1885 at the University of Pennsylvania (see figs. 45, 49; cat. nos. 436–62) represent Eakins's work at its most documentary. They were followed by a series of rather prosaic landscape and figure studies made during a recuperative trip to the Dakota Territory in 1887 (see cat. nos. 612–48).[23] There was little in the way of picturesque scenery to photograph, but Eakins took dozens of images of the landscape, ranch buildings, and cowboys at the BT Ranch. The Pennsylvania Academy has thirty-six glass-plate negatives and one platinum print of these images. The three other surviving prints from the series are albumen contact prints, the medium preferred by professional documentary photographers of the period.[24] As he did in the Gloucester shad-fishing series, Eakins later reused portions of the Dakota photographs in a painting, *Cowboys in the Badlands* (1888, private collection).

Only two other paintings by Eakins from the 1880s are related to photographic studies, and both are portraits: *The Artist's Wife and His Setter Dog* (ca. 1886, Metropolitan Museum of Art, New York) and *Walt Whitman* (1888, Pennsylvania Academy of the Fine Arts). The photographs associated with the portrait of Eakins's wife are preparatory studies of composition and costume (plate 14; cat. no. 213), taken with an unidentified model posing in her place. The photographs of Walt Whitman, on the other hand, were probably made in the spring of 1891, long after the portrait had been completed.[25] At that time two of Eakins's friends, the sculptors William O'Donovan and Samuel Murray, were working on busts of Whitman; and a photograph of the three artists in Eakins's Chestnut Street studio (cat. no. 128) clearly shows several photographs of Whitman tacked to the wall. The authorship of the Whitman photographs remains open to question; while some have been attributed to Eakins, others are thought to be the work of Murray.[26]

In the 1890s Eakins continued to produce photographs that were directly related to projects in other media. Equine studies made at Avondale and West Point (see cat. nos. 492–505 and 515, respectively) were used for the sculpture on the Brooklyn Memorial Arch (1895) and were published in an article on the project.[27] The artist also made two series of portrait studies for paintings of Frank Cushing (1895, Gilcrease Institute, Tulsa) and Addie Williams (ca. 1900, Philadelphia Museum of Art).[28] Two series of figure studies, probably made in the early 1890s, were used likewise in later paintings. Four are photographs (cat. nos. 403–6) related to his painting *Wrestlers* (1899, Columbus Museum of Art); and the nude model in figure 3, which was taken at the Chestnut Street studio that Eakins relinquished after 1899, may have been the source for the model in his late version of *William Rush Carving His Allegorical Figure of the Schuylkill River* (1908, Brooklyn Museum). By the mid-1890s Eakins's interest in photography appears to have been on the wane, as he concentrated his efforts on portrait painting.

Apart from the dated projects just described, a large number of photographs produced by Eakins seem to be independent

of his work in painting and sculpture and are more difficult to date. In some of them identification of the studio background places them in the period of Eakins's teaching at either the Pennsylvania Academy (1876–86) or the Art Students' League (1886–93). Many of the images relate to the pictorialist aesthetic that was just beginning to coalesce as a coherent stylistic force among American photographers.[29]

Philadelphia's photographers and critics had long promoted the artistic side of the medium. For example, in 1865 the landscape photographer John Moran, who came from a family that included the painters Thomas and Edward Moran and the printmaker Mary Nimmo Moran, strongly defended the position that photography was a fine art: "This refusal to rank photography among the fine arts, I consider, is in a measure unfounded, its aim and end being in common with art. It speaks the same language, and addresses itself to the same sentiments."[30] Although he himself was a commercial photographer, Moran's ideas served a growing field of amateur photographers, who turned to landscape and genre for their subjects.

Like Moran, John C. Browne photographed Pennsylvania's historic buildings in the 1870s. He also dressed up members of his family to re-create historic scenes, such as Moravian pilgrims at a harvest table.[31] Dressing for the camera had been

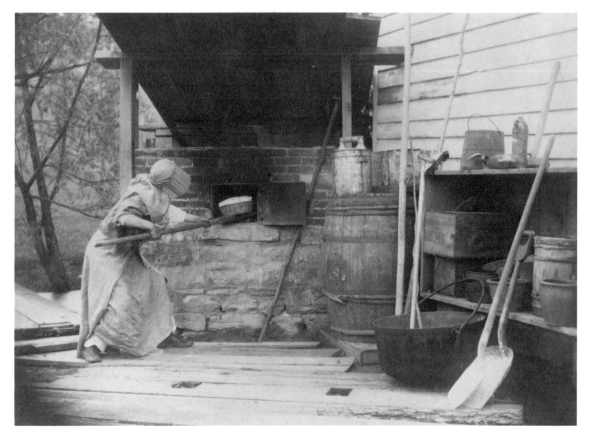

Figure 4. *The Oven Is Hot,* by S. Fisher Corlies, ca. 1892, albumen print (Library Company of Philadelphia)

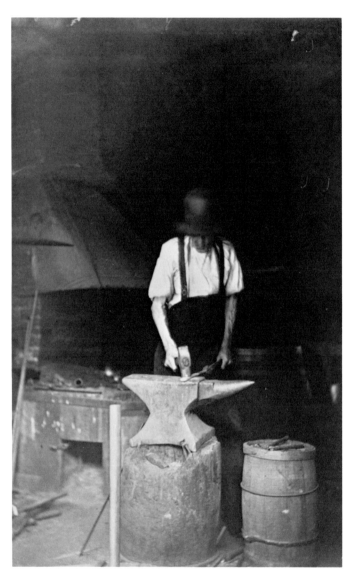

Figure 5. *Blacksmith*, by circle of Eakins, ca. 1886, albumen print (cat. no. 259)

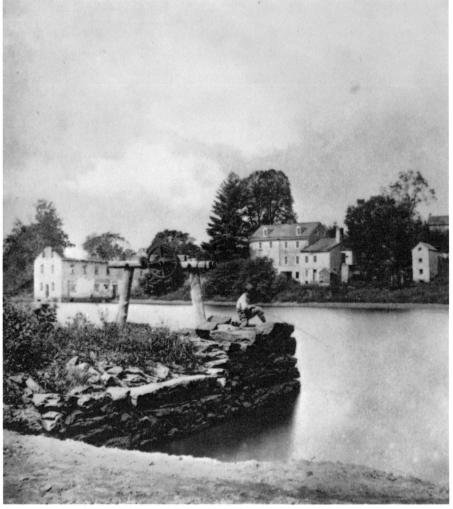

Figure 6. *Mill Creek*, by John C. Browne, 1878, albumen print (Library Company of Philadelphia)

a studio practice since the Daguerrean days, and this activity was enhanced by the popular production of tableaux vivants in the 1870s and 1880s. In 1882 S. Fisher Corlies, the first treasurer of the Photographic Society of Philadelphia,[32] dressed an actor as a woman and posed him, back to camera, with an old-fashioned, outdoor brick oven (fig. 4) as part of a series of sentimental genre scenes. For the 1888 Photographers' Association of America competition, George Bacon Wood, a painter recently turned photographer, posed his children in animal skins to reenact the Death of Minnehaha.[33]

Genre photographers depicted the everyday life around them. In Wood's case this included narrative scenes of his family and neighborhood activities: a herd of sheep being driven down Germantown Avenue, men and women in gardens and shops, girls swinging on gates, and boys playing marbles and showing off their puppy dogs. Occasionally Wood also returned to the past and photographed a child with a spinning wheel or an old Pennsylvania farmhouse with an artist friend posed in front. Eakins shared this interest in genre subjects. Both he and members of his circle photographed spinning wheels, farmhouses, and ladies in historical costume (see plate 14; cat. nos. 207–35). Among the photographs acquired with the Bregler collection is an example of one of the most popular genre subjects of the day—a village blacksmith (fig. 5). Although the photograph does not appear to have been taken by Eakins, its presence in his collection illustrates his interest in such subjects.

Many amateur photographers of the period went on excursions by canal or rail in search of picturesque sites to record with their cameras. John C. Browne was one of the most enthusiastic participants in such outings. He scoured the countryside for old churches, early taverns, and dilapidated mills; and he carefully noted the historical subjects on the sleeves of the negatives. In 1878 Browne discovered a rocky promontory at Mill Creek (fig. 6), the same site that Eakins later photographed (see plate 3; cat. nos. 394–95) and painted in *The Swimming Hole* (fig. 44).

An important impetus behind the sense of history that emerged among Philadelphia's photographers was the Centennial Exhibition of 1876, which served also to promote photography to the general public. Here for the first time, viewers had an opportunity to enjoy the wide array of work produced by both professional and amateur photographers. An entire hall dedicated to photography contained 2,882 prints by 322 photographers from around the world. Although the emphasis was clearly on the work of commercial photographers, certain of them, including Marcus Aurelius Root and John Moran, were concerned about artistic merit. Root suggested that a committee "carefully examine all of the specimens of photography presented for exhibition . . . and reject all such as are found not credible as specimens of art."[34] Some of the most artistic photographs exhibited at the Centennial were sent in by Julia Margaret Cameron, a noted English amateur. One of them, a scene from Arthurian legend engraved for the cover of *Harper's Weekly* (fig. 7), is typical of the romantic sensibility that infused many Victorian photographs. Even Edward L. Wilson, the rather conservative editor of *Philadelphia Photographer,* grudgingly admitted that he found in her works "an amount of art feeling so suggestive that it claimed attention and admiration in spite of the faults."[35]

Figure 7. Cover of *Harper's Weekly* 21 (September 1, 1877), wood engraving after Julia Margaret Cameron's photograph *Lancelot and Guinevere* (Library Company of Philadelphia)

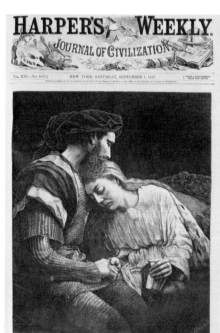

It caused little surprise, therefore, a few years later, when the Pennsylvania Academy of the Fine Arts began to host exhibitions and lectures devoted to amateur photography. In 1882, at about the same time that Eakins himself took up the new art form, he was appointed head of the school. Thus, although he never became a member of the Photographic Society of Philadelphia, he would have had ready access to their exhibitions at the Academy (see Appendix C). This group of photographers included the well-known professionals John C. Browne, William H. Rau, William Bell, and Edward L. Wilson, as well as amateurs such as Robert S. Redfield, one of the first American photographers to adopt a pictorialist style. In April 1883, members of the society showed a selection of their most recent work in lantern slides at the Pennsylvania Academy.[36] An even larger exhibition, of over 1,800 photographs, was held at the Academy in January 1886.[37] It included figure studies, landscapes, and portraits—the types of photographs that Eakins himself produced.

To date, scholars have uncovered only two references to the exhibition of Eakins's photographs during his lifetime. It is significant, however, that both of these exhibitions occurred within the context of the growing pictorialist movement of the 1880s and 1890s. A motion study titled *History of a Jump* (see fig. 45) was shown by the Philadelphia Photographic Society in 1886. In late December of 1899, the Camera Club of New York opened an exhibition of pictorialist photography from private collections. Among the works on view were photographs by Eakins[38] probably lent by Eva Watson, herself a pictorialist and a former student at the Pennsylvania Academy. It seems unlikely that Eakins would have sought an affiliation with such a clubby group, but his photographs were seen by the pictorialists as examples of their artistic approach. Although Eakins's intentions may never have been stated clearly, his use of platinum prints, his emphasis on chiaroscuro, and his choice of subject matter were elements of style that he shared with the pictorialists.

That Eakins used photography for his own ends and not for public gratification seems clear. Most of his photographs were taken for personal reasons relating to his private life, his teaching activities, and his art. The evidence for Eakins's use of these images comes not only from written documents[39] but also from incidental details gleaned from period photographs. Portraits of Walt Whitman informally tacked to the walls of the Chestnut Street Studio, their edges curling and gathering dust (see cat. no. 128), were used as compositional aids. An even more revealing interior view (figs. 8, 9), shows more than a dozen of Eakins's mounted photographs arranged on the wall of a studio at the Philadelphia Art Students' League. Most of these prints are enlargements: two of the swimming-hole subjects, several photographs of Eakins posing nude outdoors at the beach at Manasquan, and a daring photograph of Eakins posing nude with a female model at the Pennsylvania Academy. In addition, Eakins included two photographs of Susan posing nude[40] (for an expanded description of this image, see Johns essay). There appears to be no direct relationship between the poses in the foreground of figure 8 and the photographs mounted on the wall. All of the models are nude, however, and Eakins probably intended these images as illustrations of figural compositions. That most of them are mounted enlargements suggests that Eakins considered them, to some degree, independent works of art.

Figure 8, probably made between 1886 and 1893, is from a collection of just over a hundred glass-plate negatives acquired by the Philadelphia Museum of Art from the daughter of Edward Boulton. Boulton was one of Eakins's students and, like

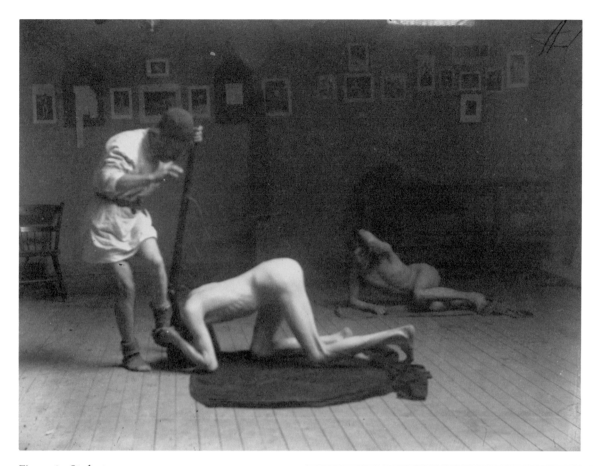

Figure 8. *Students posing at the Philadelphia Art Students' League,* attributed to Edward Boulton, ca. 1890, modern print from dry-plate negative (Philadelphia Museum of Art, purchased with funds given by Mr. Seymour Adelman)

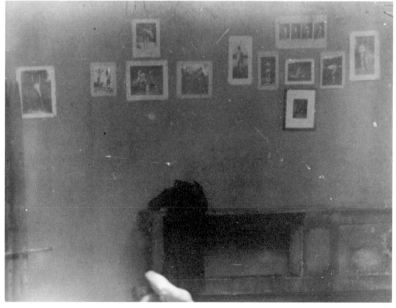

Figure 9. Detail of figure 8

his mentor, took a special interest in wrestling subjects. A print from one of these negatives—a wrestling scene usually attributed to Eakins—survives in the Bregler collection (cat. no. 404). The presence of its negative in Boulton's collection suggests the free manner in which Eakins seems to have shared his photographic experience with his students, perhaps even borrowing from their work.[41] Because his students often collaborated with him, taking turns in front of and behind the camera, and may have exchanged negatives and prints with him, the attribution of many of Eakins's photographs is problematic. Certain works traditionally assigned to the artist should thus be considered the products of group endeavor.[42]

With so little documentation of his actual practice, much of what can be said about the meaning and function of Eakins's photography must remain speculative. An entry in an 1883 account book provides a meager listing of his equipment but no mention of what he wished to photograph or why:

I have as photographic apparatus a camera 4 × 5, American Optical Co., a Ross portrait tube marked No. 2 C d V #23193, a view or landscape tube of long focus marked 8 × 5 S. A. doublet 17375, also by Ross of London, 14 double backs for dry plates, small trunk for carrying them, tripod & accessories. Also a solar camera and accessories, and chemicals. . . . Many photographs and photographic studies and many pictures and painted studies unsold, and many frames.[43]

In addition to the equipment listed above, Eakins acquired a Darlot lens, probably for detailed studies in dim light.[44] He used Ross lenses for portraits and general landscape views, and with the solar camera he created albumen enlargements from dry-plate negatives. This was a slow enlarging process, however, and was not practical for making platinum enlargements—prints that required the production of an interpositive and faster developing time. Although no interpositives for making such enlargements have as yet come to light,[45] a number of platinum enlargements of Eakins's photographs survive. Providing notes on several enlarged platinum prints now in the Metropolitan Museum of Art, Charles Bregler suggested that both Thomas and Susan made them.[46] Moreover, in a letter to J. Laurie Wallace, written in 1888, Eakins referred indirectly to the creation of platinum prints:

I had my negatives out the other day and was printing some. The sight of those old things brought back many a pleasant recollection and made me long to see you again. . . . I send you a print at Mrs. Eakins's suggestion because it is a favorite with us. I think though you have one in platinum.[47]

This casual reference to platinum prints points to several critical aspects of Eakins's photographic activities. It demonstrates that he reprinted from old negatives long after the original impulse in the picture's making had faded; it shows that Susan Eakins was involved in the selection process; and it suggests that platinum prints had a special status among his photographic works. Platinum prints became especially popular with amateur photographers in the United States after 1879 with the dissemination of William Willis's "platinotype process" in the photographic journals.[48] In addition to Susan's diary reference to buying commercially prepared platinum printing paper,[49] there is evidence that her husband may have experimented with hand-coated paper. Two platinum enlargements in the Bregler collection (plates 15, 16) exhibit the residual

marks of a cloth-covered rod used to hand-coat the paper with platinum and iron salts. It is also possible that Eakins sent some of his negatives to be printed commercially. Albert Moore, a Philadelphia photographer active in the 1880s, advertised his services for solar printing and copying and noted that "the negatives will be carefully preserved, under lock and key, or returned if desired."[50] This professional practice of retaining negatives may explain why so few remain for the photographs that Eakins chose to enlarge in platinum.

In her diary of 1899, Susan Eakins referred to the activities of another professional photographer: "Fred von Rapp here to print."[51] About 1902 Frederick Von Rapp produced a number of large platinum portraits of Thomas Eakins, four of which are in the Bregler collection. Susan's comment suggests that Von Rapp either printed Eakins's negatives or provided technical assistance in making the platinum prints. Other intriguing references to the photographic activities of both Thomas and Susan appear in Susan's 1899 diary, as well as in her retrospective diary.[52]

The earliest photographs mentioned are figure 1, taken by Susan in 1880, and two taken in 1881, which she records without specifying their makers. "Mother's photograph taken in Eakins yard" may be the image of Mrs. Macdowell (cat. no. 23); "That group of infant waist dressed Acad. girls taken in Trots yard, 1881" may refer to a series of images of young women in Empire dress (see cat. nos. 209, 210) posed at the home of Mary K. Trotter, a Pennsylvania Academy student and friend of the Macdowell sisters.[53]

Other important scraps of information regarding the photographic activities of Susan and her sister, Elizabeth Macdowell, can be gleaned from inscriptions on the backs of two photographs in the Pennsylvania Academy and from some photographs that remain with descendants of the Macdowell family. Two nude subjects, one a young woman and the other a child, (fig. 36; cat. no. 333), are signed by Elizabeth Macdowell. There are also several five-by-eight-inch glass negatives in the collection of Macdowell descendants in Roanoke, Virginia, that are believed to have been made by Elizabeth.[54] The Bregler collection includes a number of prints from these negatives and close variants, among them portraits of Mary Macdowell and figure studies of women (see cat. nos. 26 and 260). There is also a set of large negatives for a series of studies of Clara Mather (see cat. nos. 228–32). She was close to both Elizabeth and Susan Macdowell, and either of them could have been responsible for taking the images.[55] While clearly inspired by some of Eakins's figure studies (e.g., plate 14), the Mather compositions are set apart from his work by the varied props, the elaborate costuming, and the large size of the negatives.

Susan Eakins recalled that in 1882 her camera equipment, including the lens and developing materials, cost eighty dollars; but she did not specify what kind of photographs she took. Among several images firmly attributed to her in the Pennsylvania Academy's collection are two photographs of her husband (fig. 1 and cat. no. 122). The latter image is related to Susan's much-later painted portrait of Thomas (ca. 1920–25, Philadelphia Museum of Art). There is also a self-portrait (cat. no. 22)[56] and a photograph of Betty Reynolds holding a doll (cat. no. 68). The last is probably the image that Susan exhibited at the Photographic Salon of 1898, which was held at the Pennsylvania Academy.[57] Numerous photographs of Eakins in his studio (see cat. nos. 121, 125–27) may also be her work,[58] and it is possible that Susan was responsible for many informal portraits of her husband and their cats taken at home on Mount Vernon Street. Several of the photographs of cats are on gelatin

printing-out paper (cat. nos. 478, 480, 485–88), a technique unknown in Eakins's work until the Bregler collection came to light.

For the most part, the prints in the collection are equally divided between albumen (240) and platinum (243). There are also sixteen cyanotypes and twenty-two gelatin printing-out-process prints, probably made by Eakins or members of his circle between the years 1880 and 1900, as well as thirty-one gelatin silver prints that appear to have been made from earlier negatives by an unknown hand. Many of these are portraits of Eakins that were reprinted after his death, possibly authorized by his wife when she was attempting to interest museums and the public in his work. A number of commercially produced daguerreotypes and cartes de visite, many of which predate Eakins's involvement in photography, are included.

Eakins's photographic aesthetic seems to be most fully expressed in platinum prints. This is easiest to perceive when there are multiple prints of one image in a variety of media or in platinum enlargements. Eakins's platinum prints are characterized by soft focus and chiaroscuro, which produce indistinct shapes and suggest a romantic ambience, especially in photographs taken indoors. Many of the indoor studies of nudes are meant to be cropped or are printed so dark that distracting details are eliminated and the viewer's attention is concentrated on the human form (see plate 10 and compare the lower image there with fig. 27). In most cases in which the negative exists, the figure is centered in the image. Later cropping of the print usually served to enhance the centrality of the figure. In outdoor photographs Eakins often utilized natural vegetation as expressive form—for example, the cavernous canopy of leaves that surrounds the nude figure of Susan (fig. 35) or the picturesque willow that provides a lyrical backdrop in images of the Crowell children at play (plate 1).

By the mid-1880s such devices were rapidly becoming fashionable in the works of pictorialist photographers in the United States and Europe. Eakins would have known of them through exhibitions held at the Pennsylvania Academy and discussions in contemporary photography journals. As noted earlier, however, it seems unlikely that his aesthetic derived directly from the activities of pictorialist photographers. Among several factors more influential in shaping Eakins's approach to photography were his knowledge of French academic practice, his awareness of current trends in the Philadelphia art world, his love of scientific inquiry, and his fiercely held belief in the importance of the nude human form.

The most innovative aspect of Eakins's photographic work was his emphasis on the nude. While nudes had formed a part of the French repertoire of academic studies, or *académies,* they were unknown in the United States until Eakins. Because his images of the nude came into conflict with the prevailing social mores of the period, however, their impact was never fully realized outside a small circle of friends and family who understood the aesthetic and scientific purposes for which they were made.[59] Also unusual was the degree of Eakins's active participation in the photographic process both as model and as photographer. Advancing beyond the self-portraits made by others—ranging from Philadelphia's early daguerreotypist Robert Cornelius to Washington's most noted portrait photographer, Alexander Gardner—Eakins introduced a new and daring form by posing nude for the camera. Such nudity, which serves to increase the viewer's sense of voyeurism, indicates heightened self-awareness on Eakins's part. His willingness to display photographs of himself and his wife at the Art Students' League was unprecedented in the Victorian period.

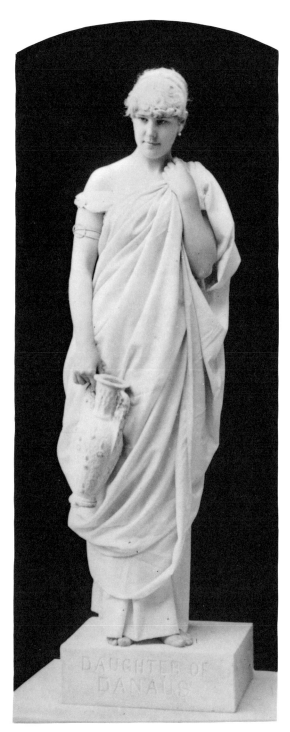

Figure 10. *Daughter of Danaus*, by C. W. Motes, albumen print, frontispiece to *Philadelphia Photographer* 21 (August 1884) (Library Company of Philadelphia)

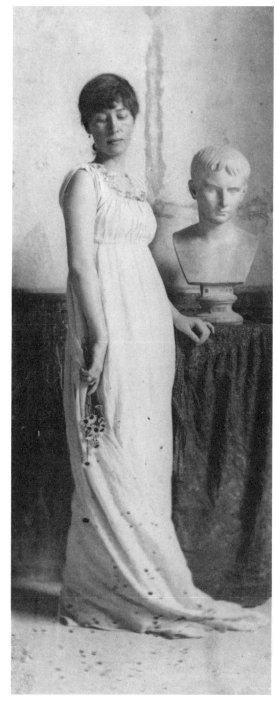

Figure 11. *Woman in classical costume, holding flowers, with bust of Caesar*, ca. 1885, platinum print (cat. no. 196)

The Eakins photographs that are related to paintings and sculpture subtly changed the function of the photographic study. Painters before him had used the photograph as an aide-mémoire,[60] but Eakins's photographic experience often seemed to inspire or reinvigorate a theme in his painting. The photographs of the Swimming Hole, William Rush, and Arcadia subjects are not simply visual aids. They altered the way in which the artist viewed the very meaning of those works. Nude studies related to the later versions of the William Rush theme, for example, helped to transform the subject from historical reenactment to autobiography. As Lloyd Goodrich and others have noted, the 1876–77 version of the painting is about William Rush, but the 1908 *William Rush and His Model* (Honolulu Academy of Arts) depicts an artist whose physique is more like that of Eakins.[61] Furthermore, the model, whose shape bears little resemblance to the svelte neoclassical proportions of the Rush sculpture, is much more akin to Eakins's photographic nudes (see fig. 3).

During the period in which Eakins was making photographic studies of classical figures, similar subjects began to appear in *Philadelphia Photographer*. In its issue of August 1884, the journal featured a photograph by C. W. Motes, a photographer in Atlanta, who depicted a model posed as a piece of sculpture (fig. 10).[62] The photograph was commended not only for its classical subject but also for its high degree of verisimilitude. Although apparent to nineteenth-century audiences, the "truthfulness" of the image is lost to modern eyes. An updated version of the Pygmalion story, Motes's photograph has a staged, tableau vivant character that contrasts markedly with Eakins's photographic conception of the classical figure (see fig. 11).

Thomas Eakins clearly worked in a transitional era in the history of photography. Between 1880 and 1900 American photography moved from the realm of commerce to that of art. It expanded its scope from a visual medium practiced principally by professionals to one in which the role of the amateur and the artist increased significantly. While professional photographers were usually knowledgeable about aesthetic principles and often argued for the merits of their art, they produced primarily albumen prints for a commercial market or for scientific or government use. Amateurs and artists, however, developed photographs for private viewing as a form of family amusement or for public display in exhibitions as aesthetic objects. Like a growing number of amateurs active during this period, Eakins took intensely personal photographs of his family and friends. Informal images of his wife, Susan, surrounded by their cats (cat. nos. 14, 15), of his father, Benjamin, pedaling a bicycle (cat. no. 87), and of his nieces and nephews in a creek at Avondale (plate 1; cat. no. 170) were made as keepsakes of favorite faces and special places in Eakins's life. An incipient snapshot aesthetic informs these works with a sense of spontaneity and intimacy.

The equal division between albumen and platinum prints among Eakins's photographs underscores the transitional nature of his work. His scientific studies of the human form and technical improvements in motion photography demonstrate the artist's keen interest in the most up-to-date innovations in the medium. But many of his images, especially the artfully posed nudes and picturesque landscapes, are more traditional in approach. Breaking new ground only in terms of their printing technique, his platinum prints, notably the enlargements, suggest a deep-seated romantic impulse. It seems ironic that photography, with its capacity to mirror reality to the greatest degree, was the very medium that Eakins used to move away from the realism that had marked his career as a painter.[63]

Eakins's continued involvement in photography, even after his dismissal from the Pennsylvania Academy, serves as evidence that he saw considerably more in the photographic image than did the detractors who criticized his artistic practices and his morals. For Eakins photography was a means of expression, distinct from painting, that made the latent romanticism of his art more real. In this respect, Eakins deliberately tapped the double nature of the photograph as a record of an actual event and an aesthetic work of the imagination. Notwithstanding the many allusions to a classical tradition in the staged poses of athletes and dreamy nude women, Eakins possessed a modern photographic sensibility—one that was filled with contradictions. The tension embodied in this dualism—expressed through the conflicting forces of reality and fantasy, representation and invention, science and art—is what gives rise to artistic integrity and vitality in his work.

NOTES

1. See Gordon Hendricks, *The Photographs of Thomas Eakins* (New York: Grossman Publishers, 1972). Primarily biographical, this book does not place Eakins's work within the context of the history of photography. Identification of sitters is unsubstantiated, and media of the vintage photographs are not specified.

2. See Lloyd Goodrich, *Thomas Eakins,* 2 vols. (Cambridge, Mass.: Harvard University Press for National Gallery of Art, 1982). This work remains the standard monographic treatment of Eakins's career as a whole.

3. William Innes Homer was one of the first scholars to deal with the historical importance of Eakins's photographic work; see, for example, "A Group of Photographs by Thomas Eakins," *J. Paul Getty Museum Journal* 13 (1985), pp. 151–56. See also Robert McCracken Peck, "Thomas Eakins and Photography: The Means to an End," *Arts Magazine* 53, no. 9 (May 1979), pp. 113–17; and Ellwood C. Parry III's introduction to *Photographer Thomas Eakins,* exhib. cat. (Philadelphia: Olympia Galleries, 1981), unpaged.

4. For a discussion of the history and contents of the Bregler collection, see Kathleen A. Foster, "An Important Eakins Collection," *Antiques* 130, no. 6 (December 1986), pp. 1228–37, and Kathleen A. Foster and Cheryl Leibold, *Writing about Eakins: The Manuscripts in Charles Bregler's Thomas Eakins Collection* (Philadelphia: University of Pennsylvania Press for the Pennsylvania Academy of the Fine Arts, 1989), pp. 1–27.

5. There are significant holdings of Eakins photographs in several other institutions: the J. Paul Getty Museum, Malibu; the Hirshhorn Museum and Sculpture Garden, Washington, D.C.; the Metropolitan Museum of Art, New York; and Bryn Mawr College. None of these Eakins collections represents the full range of his activities as a photographer. See also note 8.

6. See Kathleen A. Foster's essay "'Trouble' at the Pennsylvania Academy," in Foster and Leibold 1989, pp. 75–79.

7. Mary S. Leahy, "Susan Macdowell Eakins and the Adelman Family," in *Seymour Adelman, 1906–1985: A Keepsake* (Bryn Mawr, Pa.: Bryn Mawr College Library, 1985), pp. 17–41.

8. Bregler's collection has been dispersed to three institutions. A group of over seventy vintage prints (primarily in platinum), modern copy prints, and negatives was acquired by the Metropolitan Museum of Art from Bregler in the 1940s. The Hirshhorn Museum and Sculpture Garden is the repository of a large collection of Eakins material, much of it purchased by Joseph Hirshhorn in 1961 from Joseph Katz, a New York collector who had acquired his holdings from Bregler in 1944. The remainder of the Hirshhorn's Eakins collection came from the estate of Samuel Murray. See Phyllis D. Rosenzweig, *The Thomas Eakins Collection of the Hirshhorn Museum and Sculpture Garden* (Washington, D.C.: Smithsonian Institution Press, 1977). The rest of Bregler's collection, including the largest single group of Eakins's photographs, was purchased from his heirs by the Pennsylvania Academy in 1985. Seymour Adel-

man's much smaller collection was dispersed among the Daniel W. Dietrich II collection in Philadelphia, the J. Paul Getty Museum in Malibu, and Bryn Mawr College.

9. Gordon Hendricks, *Thomas Eakins: His Photographic Works,* exhib. cat. (Philadelphia: Pennsylvania Academy of the Fine Arts, 1969).

10. In addition to the bound album, there were fourteen loose pages from two albums that had not survived intact. For reasons of conservation, all but two of these loose album pages were dismantled after a photographic record of their original layout had been made.

11. Bregler annotated many of the images in the album. Almost 40 percent of the photographs do not relate directly to Eakins's work; and many are silver prints, a technique not used by Eakins. Among them are portraits of Bregler's relatives, unidentified street scenes, and travel photographs taken in France and Spain by one of Eakins's students, Edmond Quinn.

12. For a discussion of the kinds of subjects preferred by the pictorialist photographers, see John Szarkowski, *Photography until Now* (New York: Museum of Modern Art, 1989) p. 160.

13. Such subjects had drawn the attention of the earliest photographers, including William Fox Talbot and Hill and Adamson. Eakins, like his contemporary John G. Bullock, would have seen such work when it was exhibited at the Philadelphia Centennial Exhibition. For a discussion of photography at the Centennial, see Tom Beck, *An American Vision: John G. Bullock and the Photo-Secession* (New York: Aperture, 1989), pp. 18–19.

14. "German Correspondence," *Philadelphia Photographer* (17 April 1880), p. 127. The content of these articles reappeared in *The Progress of Photography since the Year 1879,* an edition of Vogel's writings issued in 1883 by Philadelphia's leading publisher of photography, Edward L. Wilson. Another of Wilson's books—a volume on photographic processes for amateurs, *Wilson's Photographics: A Series of Lessons* (Philadelphia, 1881)—contained instructions on the production of enlargements and lantern slides and on albumen and platinum printing. All of these techniques were employed by Eakins, whose studio was then located a few blocks north of Wilson's office on Chestnut Street.

15. Entry in retrospective diary that Susan Eakins began sometime after 1913 (see note 52). A print of the photograph in the collection of Bryn Mawr College is inscribed in an unknown hand: "Original print Eakins 1875 taken by Maggie Eakins in backyard of Mt Vernon St." There is no other evidence to show that Margaret Eakins was active as a photographer, and the date appears to be too early.

16. Eakins and his family visited Manasquan several times in the early 1880s (see fig. 2; cat. nos. 176–80, 548–54). A New Jersey beach scene at the J. Paul Getty Museum in Malibu (acc. no. 84.XM.155.35) is inscribed "Squan, 1880." Several others in the Dietrich collection were dated by Hendricks to 1880 (see Hendricks 1972, figs. 4–6).

17. For a discussion of the Gloucester photographs, see Kathleen A. Foster, "Realism or Impressionism? The Landscapes of Thomas Eakins," in *Studies in the History of Art,* vol. 37 (Washington, D.C.: National Gallery of Art, 1990), pp. 78–82.

18. There are several versions of Arcadia subjects in both painting and sculpture. For a complete list, see Goodrich 1982, vol. 1, pp. 230–37.

19. Most of the historical subjects are albumen prints; the classical subjects are primarily platinum prints. Very few negatives for these costumed figure studies survive (while many negatives survive for the nudes).

20. Photographs of male students in classical costume taken at the Pennsylvania Academy have been attributed to Eakins; see Olympia Galleries 1981, figs. 1–4. Contrived compositions, they may be the work of one of Eakins's students—possibly Thomas Anshutz or Charles Fromuth. Several such images are included in the Anshutz papers, Archives of American Art, Washington, D.C. None, however, appears in the collection of the Pennsylvania Academy.

21. One such photograph by Nutting survives among the materials in the Bregler collection: a colonial interior with a woman in period costume. As it was first copyrighted in 1917, it seems likely that this photograph was acquired by Susan Eakins after her husband's death.

22. Ellwood C. Parry III, "Thomas Eakins's 'Naked Series' Reconsidered: Another Look at the Standing Nude Photographs Made for the Use of Eakins's Students," *American Art Journal* 20, no. 2 (1988), pp. 53–77.

23. Cheryl Leibold, "Thomas Eakins in the Badlands," *Archives of American Art Journal* 28, no. 2 (1988), pp. 2–15.

24. Owned by the J. Paul Getty Museum in Malibu, Bryn Mawr College, and Daniel W. Dietrich II of Philadelphia. The scarcity of prints from the eighty-one surviving negatives for the Dakota and the Gloucester series suggests that the images—unlike his nude studies—were of only short-term interest to Eakins. He may never have printed from these negatives after using prints from them as studies for paintings.

25. Several negatives acquired from Samuel Murray are in the Hirshhorn Museum and Sculpture Garden in Washington, D.C., and several prints acquired from Seymour Adelman are in the Dietrich collection. There are no photographs of Whitman in the Bregler collection.

26. William Innes Homer, "Who Took Eakins' Photographs?" *Artnews* 82, no. 5 (May 1983), pp. 112–19. For other photographs of Whitman, see Carolyn Kinder Carr, "A Friendship and a Photograph: Sophia Williams, Talcott Williams, and Walt Whitman," *American Art Journal* 21, no. 1 (1989), pp. 2–12.

27. Cleveland Moffett, "Grant and Lincoln in Bronze," *McClure's Magazine* 5 (October 1895), pp. 419–32. This is the only known instance of the publication of Eakins's photographs during his lifetime. A wood engraving after an Eakins motion study (fig. 45) was reproduced as *History of a Jump* in University of Pennsylvania, *Animal Locomotion: The Muybridge Work at the University of Pennsylvania: The Method and the Result* (Philadelphia: J. B. Lippincott Company, 1888), p. 14.

28. Susan Eakins noted in her 1899 diary, on January 22: "Addie here and Tom takes more and better negatives of her" (Pennsylvania Academy Archives).

29. For a contemporary account of the emergence of the pictorialist movement, see Clarence B. Moore, "Leading Amateurs in Photography," *Cosmopolitan* 12 (February 1892), pp. 421–33. For recent discussions of the development of pictorialism, see Sarah Greenough, "The Economic Incentives, Social Inducements, and Aesthetic Issues of American Pictorial Photography, 1880–1902," in *Photography in Nineteenth-Century America,* exhib. cat. (Fort Worth: Amon Carter Museum, 1991), pp. 259–317; and Peter Bunnell et al., *The Art of Pictorial Photography, 1890–1925,* exhib. cat., published in *Record of The Art Museum, Princeton University* 51, no. 2 (1992).

30. John Moran, "The Relation of Photography to the Fine Arts," *Philadelphia Photographer* 2, no. 1 (March 1865), pp. 33–35. See also Bernard F. Reilly, Jr., "The Early Work of John Moran, Landscape Photographer," *American Art Journal* 11 (January 1979), pp. 65–75. The authors would like to thank Kenneth Finkel of the Library Company of Philadelphia for generously sharing his research on Philadelphia photographers.

31. Three albums containing approximately three hundred views made by Browne between 1874 and 1886 were given to the Library Company of Philadelphia in 1989; see *Annual Report of the Library Company of Philadelphia for the Year 1989,* pp. 33–34.

32. A portrait photograph inscribed "S. Fisher Corliss" [*sic*] is included in the Eakins material in the Macdowell family collection, Roanoke.

33. The largest group of Wood's photographs is in the collection of the Library Company of Philadelphia; see Frances S. Orlando, "George Bacon Wood, Photographer of the 1880s: An Introduction to the Wood Collection in the Library Company of Philadelphia," master's thesis, University of the Arts, Philadelphia, 1985. According to the register of auditorium bookings for 1884, Pennsyl-

vania Academy Archives, an exhibition of his photographs, sponsored by the Academy Art Club, was held on December 5, 1884, at the Pennsylvania Academy.

34. Marcus Aurelius Root, "The Photographic Art in the Great Exhibition. Addressed to All Photographers," *Philadelphia Photographer* 12 (December 1875), pp. 373–76. Root was a leading daguerreotype photographer and the author of one of the earliest books to discuss the aesthetics of photography, *The Pencil and the Camera, or, The Heliographic Art* (Philadelphia: J. B. Lippincott Company, 1864).

35. *Harper's Weekly* 21 (September 1, 1877), p. 682, discusses Cameron's photograph of Lancelot and Guinevere.

36. "The Annual Exhibition of the Photographic Society of Philadelphia," *Philadelphia Photographer* 20 (May 1883), p. 147. Among the exhibitors were John C. Browne and Robert S. Redfield, as well as Samuel Sartain and George B. Wood, close friends of Eakins's. Fairman Rogers, who helped found the society in 1862, served on the board of the Pennsylvania Academy and was one of Eakins's most ardent supporters.

37. For a discussion of the exhibition, see Mary Panzer, *Philadelphia Naturalistic Photography, 1865–1906,* exhib. cat. (New Haven, Conn.: Yale University Art Gallery, 1982), pp. 8–11; and William Innes Homer et al., *Pictorial Photography in Philadelphia: The Pennsylvania Academy's Salons, 1898–1901,* exhib. cat. (Philadelphia: Pennsylvania Academy of the Fine Arts, 1984), pp. 5–6.

38. *Camera Notes* 3 (April 1900), pp. 214–15. Lloyd Goodrich first mentioned this exhibition but did not publish the source of his information. The authors would like to thank Dorothy Belknap for locating the reference.

39. Kathleen A. Foster discusses the references to Eakins's use of the nude in photographs taken at the Pennsylvania Academy in "'Trouble' at the Pennsylvania Academy," in Foster and Leibold 1989, pp. 75–79.

40. A similar installation of mounted photographs appears in a photograph of Samuel Murray taken at the Art Students' League (Hirshhorn Museum and Sculpture Garden, Washington, D.C., reproduced in Hendricks 1972, fig. 170.)

41. Four prints of wrestlers in the Pennsylvania Academy were taken in an unidentified studio, possibly at 1330 Chestnut Street or at the Art Students' League. Four other Boulton photographs were taken at a gymnasium, and Eakins included the weight-lifting equipment visible in the background of these images in his final version of *Wrestlers* (1899, Columbus Museum of Art). The Boulton collection also contains the negative of the image of Franklin Schenck (cat. no. 102) on which Eakins based a painted portrait of Schenck (ca. 1890, Delaware Art Museum, Wilmington).

42. The collaborative nature of some of Eakins's photographic activity, especially the group outings that produced studies of nude men in wooded settings, is evident also in the images preserved in the papers of Thomas Anshutz (Archives of American Art). Careful examination of that collection suggests that Anshutz took part in this collaborative activity.

43. Entry dated January 1, 1883, from an account book in the collection of Mr. and Mrs. Daniel W. Dietrich II. In a manuscript dated July 1, 1911, in the Pennsylvania Academy Archives Eakins mentioned owning a "good camera and lenses."

44. His photographic equipment is now in the Hirshhorn Museum and Sculpture Garden; see Rosenzweig 1977, no. 131.

45. In a letter dated November 21, 1943, to A. Hyatt Mayor at the Metropolitan Museum in New York, Charles Bregler described the solar camera enlarger that Eakins used in the making of platinum prints. According to Bregler the equipment was destroyed by Susan Eakins. There are over forty platinum enlargements (mostly portraits and nudes) in the Pennsylvania Academy and another seventeen (primarily classical figure studies) in the Metropolitan Museum of Art.

46. When the works were acquired by the Metropolitan Museum of Art, Bregler's comments were recorded by A. Hyatt Mayor, then curator of the print collection. Some of these notes state explicitly that the photograph was made by Thomas Eakins but that the print was made by Susan Eakins and/or Thomas. See also A. Hyatt Mayor, "Photographs by Eakins and Degas," *Metropolitan Museum of Art Bulletin,* n.s. 3 (Summer 1944), pp. 1–7.

47. Eakins to Wallace, October 22, 1888, Pennsylvania Academy Archives; printed in Foster and Leibold 1989, p. 246.

48. See, for example, "Willis's Platinum Printing Process," *Philadelphia Photographer* 16 (October 1879), pp. 307–8; and 16 (November 1879), p. 328. Willis, an Englishman, visited Philadelphia in February 1881 to demonstrate the process before the Philadelphia Photographic Society (lecture printed in *Philadelphia Photographer* 18 [March 1881], pp. 85–87).

49. Entry dated January 3, 1900, Pennsylvania Academy Archives.

50. *Photographic Mosaics* (Philadelphia: Edward L. Wilson, 1881), p. 173. This publication, aimed at commercial and amateur photographers, was devoted solely to advertisements of photographic equipment and services, many of which were available to Eakins locally.

51. Entry dated April 20, 1899, Pennsylvania Academy Archives. Frederick Von Rapp is listed in the city directories between 1899 and 1910 in a variety of locations in Philadelphia. In 1899 his address was at 312 Fuller Building, where Eva Watson also had her studio.

52. The retrospective diary, recalling events in the 1880s and 1890s, must have been compiled at a later date; the printed pages are for the year 1913. Both diaries are in the Pennsylvania Academy Archives.

53. Charles Bregler misidentified the location for catalogue number 210 as 1729 Mount Vernon Street. The identification of Mary Trotter was suggested by Jeanette Toohey, co-curator of the exhibition *Thomas Eakins Rediscovered* held at the Pennsylvania Academy in 1991–92.

54. William Innes Homer has attributed the negatives to her, and the authors thank him for generously sharing his thoughts on these photographs and others in the Pennsylvania Academy. For further discussion of Elizabeth Macdowell, see David Sellin, *Thomas Eakins, Susan Macdowell Eakins, and Elizabeth Macdowell Kenton,* exhib. cat. (Roanoke, Va.: North Cross School, 1977), pp. 29–30 and nos. 4, 5, 18, and 26.

55. Information on Clara Mather and her relationship to Susan and Elizabeth Macdowell was provided by the Mather family.

56. Published erroneously as the work of Thomas Eakins in Hendricks 1969, fig. 28, p. 32. An inscription in Elizabeth Macdowell's hand on the verso of the print in the collection of Bryn Mawr College reads: "Taken on a hot summer day by herself. She had a fine little lens but slow." See also Sellin 1977, fig. 1, p. 53.

57. Homer 1984, p. 42.

58. The attribution to Susan Eakins was first suggested in Hendricks 1972, p. 12, figs. 262–64; it is reiterated in William Innes Homer et al., *"Eakins at Avondale" and "Thomas Eakins: A Personal Collection,"* exhib. cat. (Chadds Ford, Pa.: Brandywine River Museum, 1980), p. 64. See also Cheryl Leibold, "The Many Faces of Thomas Eakins," *Pennsylvania Heritage* 17, no. 2 (Spring 1991), pp. 4–9.

59. For a discussion of Eakins's dismissal in 1886 from the Pennsylvania Academy and his ensuing problems with the Philadelphia Sketch Club, see Foster and Leibold 1989, pp. 69–90.

60. In the 1860s, when Eakins was a student, the Pennsylvania Academy owned three framed daguerreotypes by the Langenheim Brothers depicting works of classical sculpture; see *Catalogue of the Paintings, Statuary in Marble Casts in Plaster, Books, Prints, etc.* (Philadelphia: Pennsylvania Academy of the Fine Arts, 1864), nos. 491–93. They were probably acquired as study tools.

61. Goodrich 1982, vol. 2, p. 247; Elizabeth Johns, *Thomas Eakins: The Heroism of Modern Life* (Princeton, N.J.: Princeton University Press, 1983), pp. 109–114.

62. Each month *Philadelphia Photographer* featured an original, tipped-in photograph as a frontispiece; Motes's photograph is discussed on pp. 239–40 of the journal.

63. Kathleen Foster (1990, pp. 69–91), argues that photography contributed to Eakins's turning from realism to impressionism, notably in his landscape painting.

Figure 12. Plate from *Etudes photographiques,* by Jacques-Antoine Moulin (Paris: Quinet, 1853), albumen print (Bibliothèque Nationale, Paris)

"THE MOST BEAUTIFUL OF NATURE'S WORKS": THOMAS EAKINS'S PHOTOGRAPHIC NUDES IN THEIR FRENCH AND AMERICAN CONTEXTS

ANNE McCAULEY

I see no impropriety in looking at the most beautiful of Nature's works, the naked figure. If there is impropriety, then just where does such impropriety begin? Is it wrong to look at a picture of a naked figure or at a statue? English ladies of the last generation thought so & avoided the statue galleries, but do so no longer. Or is it a question of sex? Should men make only the statues of men to be looked at by men, while the statues of women should be made by women to be looked at by women only? Should the he-painters draw the horses and bulls, and the she-painters like Rosa Bonheur the mares and the cows?

THOMAS EAKINS TO EDWARD H. COATES, SEPTEMBER 11, 1886[1]

The place for a woman's body to be denuded is in the privacy of her own apartments with the blinds drawn.

ANTHONY COMSTOCK TO A NEW YORK REPORTER, 1913[2]

The expression of the body of man or woman balks account, The Male is perfect and that of the female is perfect.

WALT WHITMAN, "I SING THE BODY ELECTRIC," FROM *LEAVES OF GRASS*, 1855[3]

Thomas Eakins spent most of his seventy-one years in and around Philadelphia with the exception of the period from October 1866 to June 1870, when he was an art student based in Paris. Although his European stay was short, it opened his eyes to a subculture that he was predisposed to appreciate: a bohemian world in which art and leisure were more important than industry and commerce, and bourgeois prudishness was undermined by free-wheeling sexuality and outrageous behavior. While he defended his American roots from the jibes of atelier colleagues in Paris, he identified himself increasingly with liberal European morality when faced with the upsurge of philistinism and self-righteousness that marked Philadelphia in the 1880s. Fearless, opinionated, with a strong commitment to personal freedom and a hatred of hypocrisy, Eakins thrived by defining himself as an outsider, an innovator, a man for whom truth was grounded in observed reality.

Nowhere do Eakins's French propensity to *épater la bourgeoisie* and his positivist fascination with exact knowledge better express themselves than in the hundreds of photographs that he took of nude men, women, and children between about 1880 and 1900. Rather than forming a consistent body of work, the photographs vary in style and function and can be divided into three major categories (with some overlapping): the "naked series," consisting of full-length shots of static, standing figures seen in profile, from the front, and from the back, usually in groups of seven; the *académies,* or studies of figures reclining, standing, or simulating action, taken both in studios and outdoors; and the motion studies in which a shutter behind a rotating disk with narrow slits (adapted from the techniques of the French physiologist Etienne-Jules Marey) captured successive movements on a single plate. In addition there are a few comic, late snapshots of a nude, aging Eakins frolicking in a river with his friends. For our purposes the naked series and *académies,* which represent the bulk of Eakins's production and seem to be concentrated in the 1880s, best reflect his attitudes toward the nude figure and allow us to explore his use of photography as a scientific, pedagogic, and aesthetic medium.

Eakins's extensive involvement with the nude in photography, which has inspired a great deal of speculation, remains problematic in many respects. Unfortunately, the artist himself left little discussion of his photographs and his goals in using the medium. Whereas only a few of his paintings deal directly with nude figures, and fewer drawings from the nude postdating his student years survive, the photographs represent a thorough repertoire of poses and models. That they were intended chiefly for use by his students is obvious, and the timing of their production supports this idea. What is more puzzling is the motivation behind Eakins's initial experiments with the camera. There was, of course, a tradition of photographic *académies* in Paris, but Eakins took no such pictures until ten years after his return to the United States, where such a practice was unknown. Furthermore, as we shall see, the relationship of photography to academic training at the Ecole des Beaux-Arts was in flux from the 1860s to the 1880s, and Eakins's ideas were often more radical than anything he would have been taught as a student. To begin, therefore, to position his nudes within the vastly different worlds of late nineteenth-century Paris and Philadelphia, we must reexamine Eakins's student days and the status of photography during the waning years of the Second Empire.

EAKINS IN PARIS, 1866–70

Even before his seminal European trip, Eakins as an urban American would have been familiar with photography in its accepted roles as a portrait, reproductive, and documentary medium. With the widespread dissemination of low-cost albumen prints in the form of cartes de visite and stereographic views in the late 1850s and 1860s, photography lost its novelty status. The Civil War, which flooded the market with portraits of Lincoln and his generals and views of major battle sites often still littered with decaying corpses, marked a new awareness of the unvarnished truthfulness of the camera's vision and its potential for recording history. Although the photograph was by no means accepted as art, it could improve the traditional fine arts, as well as increase the knowledge and happiness of the masses.[4]

The meticulous accounts of his life that Eakins sent from Paris to his family and friends reflect his acceptance of photogra-

phy as an accurate recording tool. He referred often to sending and receiving carte de visite portraits, which served to keep the memory of loved ones alive. In a letter to his sister Fanny in January 1867, he noted that he had received "one letter from Bill Sartain on Saturday last containing photographs and today one from Emily [Sartain] with still another family photograph and a good one it is. Emily's letter speaks of your looking at my photograph in Mommy's room. Do you sit now in her room instead of in the dining room, and why haven't I got her photograph?"[5] A few months later, he reported to his father that he had received Fanny's portrait, which he liked less than another one he had been sent.[6] Even with these commercial portraits, Eakins commented on their aesthetic merits and the fidelity of the likeness.

Similarly, Eakins sent portraits of himself and the people he admired to his family. On June 28, 1867, he complained to his mother that "no one has ever mentioned the photograph of A. Dumas I bought."[7] To give his family a better idea of his teachers, he sent them Charles Reutlinger's carte de visite portrait of Jean-Léon Gérôme a few weeks after his arrival,[8] and in September 1869 he dispatched a portrait of Léon Bonnat (probably the image by Ferdinand Mulnier in the collection of Mr. and Mrs. Daniel W. Dietrich II, Philadelphia). Both cartes were accompanied by physiognomic analyses to enhance his family's image of his teachers' personalities.[9] Eakins also acquired portraits of Thomas Couture and Rosa Bonheur by A. A. E. Disdéri (the latter in the Pennsylvania Academy of the Fine Arts).[10] And in January 1867 he had his own likeness taken by an unidentified Parisian studio.[11]

That Eakins had more than a secondhand acquaintance with portrait photography while in Paris is suggested by references in his letters to assisting a photographer and visiting the studio of the celebrated sculptor and portraitist Antoine-Samuel Adam-Salomon. According to a rather garbled account, when Eakins had his portrait taken in January 1867, "a young photographer got the students willing to help him," and Eakins spent the afternoon working with the students in the studio.[12] The photographer may have been the little-known A. Verneuil, who first appeared as a Parisian commercial operator in 1867 and purchased the former studio of Alexis Bertrand on the rue Dauphine near the Ecole des Beaux-Arts. Portraits by Verneuil of three of Eakins's classmates, Ernest Guille, Louis Cure, and Achille Guédé, are now in the Dietrich collection. Because it is unlikely that these artists would have patronized such an obscure establishment without knowing its owner, we can posit that Verneuil was the young person soliciting help in 1867.

More intriguing is a visit in December 1867 that Eakins and a rather unscrupulous American named Guthrie made to the elegant home and studio of Adam-Salomon on the rue de la Faisanderie. Adam-Salomon had built a reputation as a successful portrait sculptor before taking up photography in the late 1850s. He was renowned for the 100-franc, rich, full-length studio celebrity portraits that earned him a silver medal in the 1867 Paris International Exhibition. It was probably on account of this recent notoriety that Guthrie had ingratiated himself with the Adam-Salomon family. As Eakins recounted to his father, Guthrie stopped in a carriage and asked him if he wanted to see some "fine photographs" at a friend's house:

He took me to Salomon's the sculptor well known at Paris a friend of Couture of Gerome etc. He walked in to the parlor, accosted the wife, asked after the health of the daughter and then assured me she was an estimable young lady, told Madam what an excellent and amiable sister Fanny I had . . . hoped that when he was gone I would still continue my visits to the house, got shown through all

the studios of Mr. Salomon, got a taste of excellent Spanish wine sent him by Pereire the banker, asked Madam for a card that I might easily find the house again which she gave me. . . . After we got out he told me that this man was renowned for sculpture and photography, that he had the fault of everyone that had not received a classical education namely that he could not talk connectedly & was very foolish; that great men like Pereire etc. who wished him well for services rendered them but who could not of course invite him or his family into their houses on account of his awkwardness and very low extraction showed him attention by sending a present of a few dozen bottles of wine by a servant.[13]

Eakins learned later, to his embarrassment, that Guthrie had known the family only two or three days and "had come on the part of some relative in England or Scotland: a photographer to worm out of this kind old gentleman some secret of the photographic art." Guthrie then "took upon himself to advise Crepon to be a photographer as there was a great fortune to be made at it, without knowing Crepon's capabilities as a painter." As Eakins noted to his father (in the letter cited above), he planned to write Mme Adam-Salomon to apologize for his friend's presumptuousness. In a later letter to his sister, he cautioned her to have nothing more to do with Guthrie.[14]

Although Eakins's later photographic portrait style is vastly different from the prop-laden elegance of Adam-Salomon's work, his visit to the photographer's studio is telling in many respects. His willingness to accompany Guthrie shows an interest in the production side of the medium, and his familiarity with Adam-Salomon's reputation indicates that he was immersed in Parisian art gossip. Adam-Salomon's career as an established artist patronized by the court of Napoléon III and as a successful photographic portraitist could have demonstrated to Eakins that well-bred persons of taste were not above using a camera. At a time when the public generally stereotyped photographers as fly-by-night con men interested only in gain, the example of a talented artist openly selling photographs may have made an impression on the young student.

In addition to portraiture, Eakins was aware of the role that photography was increasingly playing as a guide for artists. His Paris account books show that he purchased a variety of "études académiques," stereoscopic views, and photos "d'après nature."[15] When he went to Spain, he also bought several views of a bullfight, gypsies, a picador, and a bull ring by the Seville photographer José Sierra Payba (collection of Mr. and Mrs. Daniel W. Dietrich II); it may have been there that he picked up the carte de visite of a boy acrobat by the Madrid-based J. Laurent (Pennsylvania Academy of the Fine Arts).

Nowhere did Eakins list the creators of these works, which represented familiar categories of imagery that were often targeted to artists. *Académies* were studies of nude or partially clothed models in poses ultimately inspired by life-drawing classes and previously available in lithographic translations. *Etudes d'après nature* could be any photographs taken from life, including figure and animal studies and even landscapes, whereas stereographs (paired images juxtaposed for viewing in a stereopticon) encompassed tourist and topographical shots, posed genre scenes, and occasionally current events.

In light of Eakins's later photographic production, the *académies* are naturally the most interesting of his Parisian purchases. When photographs were first registered for public sale with the Ministry of the Interior in 1851, *académies* and other studies for artists constituted by far the largest portion of the images that Parisian photographers thought they could market. By 1853, 40.5 percent of the 417 registered images were artists' studies.[16] Almost exclusively nude women with their

Figure 13. *Academic nude,* by Gaudenzio Marconi, ca. 1873, albumen print (Bibliothèque Nationale, Paris)

Figure 14. *Female nude standing on pedestal, arms raised,* by anonymous French artist, 1870s, or by circle of Eakins, ca. 1885, albumen print (cat. no. 297)

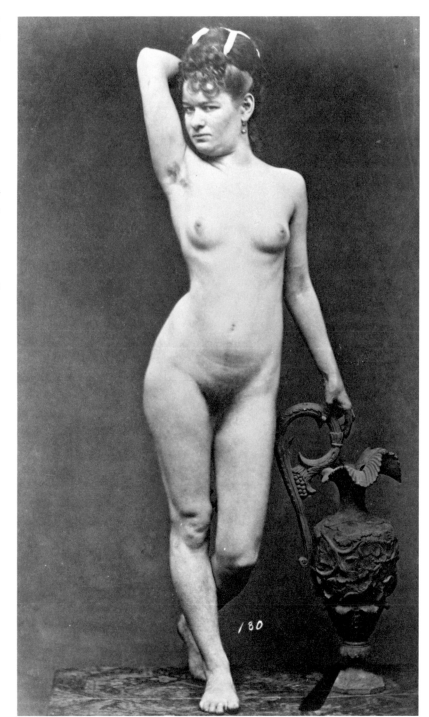

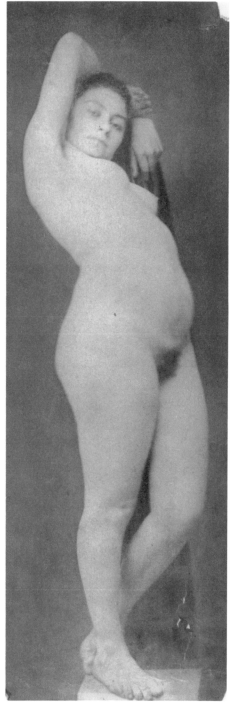

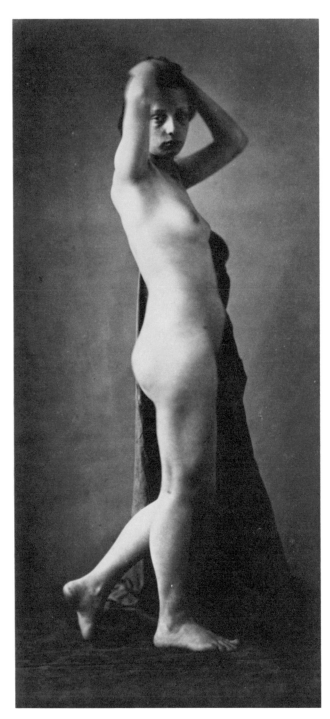

Figure 15. *Etude d'après nature,* by Henri Voland, ca. 1861, albumen print (Bibliothèque Nationale, Paris)

Figure 16. *Pornographic nude,* ca. 1861–63, albumen print (Archives de la Préfecture de Police, Paris)

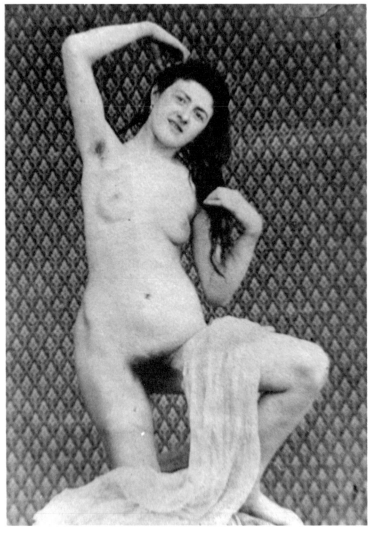

genitals discreetly hidden and surrounded by sensual drapery and exotic props (see fig. 12), such photographs were considered far more provocative than the lithographic studies by Bernard-Romain Julien and others that they replaced (see fig. 21).

Not surprisingly, state censorship of these photos and the conditions governing their sale tightened during the 1850s. By 1854 handwritten notations in the *dépôt légal* registers recorded that works deposited by a Mme Duetz and Louis d'Olivier could not be publicly sold or exhibited. Further annotations restricted their distribution to the confines of the Ecole des Beaux-Arts. There is no evidence, however, that "academic" photographs were actually marketed through the school or on its premises.

By the time Eakins arrived in Paris, few photographers bothered to register their photographs of nude figures with the state. The confusion between legal artistic *académies,* which showed nudes in "natural poses" with no visible pubic hair, and illegal pornography, ranging from explicit, hard-core scenes to frontal undraped figures, had forced the entire market underground. Significantly, no *académies* were registered in 1860. Nonetheless, the same studios that had emerged in the 1850s continued their production, in many cases both artistic and pornographic, into the 1860s but more often than not issued nudes anonymously to avoid arrest.

In the late 1860s, at the end of Eakins's European stay, a new above-ground specialist in artistic *académies* appeared in the person of Gaudenzio Marconi. Probably an Italian immigrant, Marconi first surfaced as the photographer of winning competition pieces at the Paris Ecole de Dessin in 1868.[17] The following year he listed himself in Parisian commercial directories at 11 rue de Buci, not far from the Ecole des Beaux-Arts. By 1872 he had moved to 45 boulevard Saint-Michel and promoted himself as the "photographe de l'Ecole des Beaux-Arts de Paris, portraits, peintures, clichés pour les photographes. Académies d'après nature." Marconi appears to be one of the first commercial operators to have produced true models for artists, complete with the ropes, poles, pulleys, and posing stands associated with the life model (see fig. 13). His works still included women staring at the viewer, but the seductive smiles and feigned coyness of 1850s artistic *académies* were less frequent.

Because few French "academic" photographs survive within collections of Eakins's works, it is impossible to pinpoint what he purchased in Paris. One anonymous example in the Charles Bregler collection at the Pennsylvania Academy of the Fine Arts (fig. 14), tentatively grouped with the products of Eakins's circle, could more plausibly be identified as a commercial print from the 1870s. Falling somewhere between the characteristic *académie* and the soft-core pornographic image, it conforms in pose to legally registered French works of the 1860s, such as Henri Voland's standing nude (fig. 15). Although Voland's print, with its form-defining, soft light from the left and subtle use of a reflective screen to set off the model's dark right side, is much richer than the faded Pennsylvania Academy image, it repeats the characteristic arms-over-head, breast-revealing posture that was a favorite with photographers and academic artists, including Jean-Léon Gérôme and J. A. D. Ingres. Both works also share a trait that caused French *académies* to irritate censors: the model's direct and provocative gaze at the camera and the viewer. The Pennsylvania Academy image, however, lacks the calm balance of Voland's print; in the model's strained, arched back and awkward, impassive stare down at the viewer, it is closer to the acrobatic provoca-

tions found in photographs seized as pornography (see fig. 16). Reviving the elaborate drapery and interiors of 1850s commercial *académies,* pornographic images reveal a more conspicuous angularity and a stiffness in pose that often reflect the lack of experience of young, amateur models and the untrained cameramen who generated the negatives.

While there were hundreds of photographs of nudes (almost exclusively of women) circulating in Paris during the Second Empire, there were very few legitimately present in classes at the Ecole des Beaux-Arts. The appropriateness of photographic models for art students had been a hotly debated subject since the invention of photography, and the consensus among academicians remained that they were generally dangerous.[18] Henri Delaborde, the art critic for the *Revue des Deux-Mondes* and, after 1855, assistant and then curator of the Bibliothèque Nationale Cabinet des Estampes, complained that "compared to art, photography for example seems insufficient to us, even vicious, because it knows how to produce the brute effigy of reality rather than an image of truth. In its principal and necessary condition, it is the negative of feeling, of the ideal, and one can consequently, while admiring the discovery itself, leave to science, which it directly interests, the task of appreciating its results."[19] Similarly, Charles Blanc, in his *Grammaire des arts du dessin* (1867), saw photography as contributing to the vulgarization of taste and the decline of the ideal: "Devoted more than ever to the worship of the real, [our world] carries the taste for it into the arts; hence the gross naturalism that, under the pretext of showing us the real truth, invites the passerby to look at flagrant crimes of vulgarity and indecency instead of the chaste nudities of art. Hence also the usurpations by photography, whose eye, so clairvoyant in the world of matter, is blind to the world of mind."[20]

The risk that photography would be seen by impressionable students as an end rather than a means increased after a much-publicized court decision in 1862 that proclaimed photography an art and therefore subject to copyright protection. Although this decision in the case of the well-known portrait firm of Mayer et Pierson versus Betbéder et Schwabbé was overturned in numerous subsequent rulings, it triggered a violent protest by artists. In a petition submitted to the court, the artists Ingres, Hippolyte Flandrin, Robert-Fleury, François Edouard Picot, Célestin François Nanteuil, Louis P. Henriquel-Dupont, and Achille Louis Martinet (all members of the Institut de France), as well as numerous less-established painters and printmakers, objected that "photography consists of a series of totally manual operations, which undoubtedly require some skill, but whose resulting prints can under no circumstances be assimilated to works born of intelligence and the study of art."[21] As the controllers of the Parisian artistic bureaucracy, these men would have frowned publicly on colleagues and pupils who drew from mechanically generated photographs rather than abstracting from the fuller realm of nature.

Eakins arrived in Paris three years after the historic reorganization of the Ecole des Beaux-Arts, which had in effect wrested its control from the Académie des Beaux-Arts and placed it with the state. It is open to question whether the 1863 reforms, which were intended to modernize the curriculum and allow French-designed goods to compete better in world markets, extended to the school's policy (official or implicit) on photographic models. Furthermore, we need to look more closely at Eakins's primary teacher, Gérôme, and his attitude toward photography, which could have influenced his students' use of life studies.

Until we have more information about the Ecole's acquisition of photographic *académies* after 1863, we are forced to rely on external debates concerning the appropriate models for art students. Numerous sources suggest that the school was slow to condone photographs *d'après nature*. In an article in *Le Constitutionnel* in December of 1865, the critic Ernest Chesneau complained about the poor level of draftsmanship in the 1865 exhibition of decorative arts and called for new drawing models. When Eugène Guillaume, a sculptor and director after 1864 of the Ecole des Beaux-Arts, gave a speech on the need for new models, the Ministry of Public Instruction formed a commission to study the issue. The commission's catalogue of appropriate models, published in 1867, included plaster casts of antique sculpture, animals, and ornaments from historical periods; prints of ornaments, body parts (taken mostly from the works of Raphael), and old-master oils; and a collection of photographic copies of plasters and drawings assembled by Félix Ravaisson, inspector of higher education.[22] Many artists, however, judged this new curriculum insipid, and thus a private initiative was launched. Charles Bargue, assisted by his teacher Gérôme, was charged with producing new lithographic models for figure drawing.[23] The resulting *Cours de dessin* by Bargue was sold through Albert Goupil (who was Gérôme's brother-in-law) for two francs a plate for the body parts and three francs for old-master copies. The success of the endeavor can be gauged by the fact that Goupil received a gold medal in the 1867 Paris International Exhibition. According to a Belgian historian of drawing instruction, the Bargue plates were *en vogue* in 1868 throughout Europe.[24]

Gérôme's involvement with this project at the very time that Eakins was in Paris suggests that, at least for young artists, Gérôme still advocated lithographic over photographic models for figure studies. Although his own use of photographs for his highly finished paintings has yet to be fully documented, it is known that he assembled photographic landscapes and cityscapes to serve as sources for the backgrounds of his oriental genre scenes. In 1857, on his first trip to Egypt, he was accompanied by the sculptor and calotypist Frédéric-Auguste Bartholdi, who photographed during the trip. Théophile Gautier, in an earlier review of Gérôme's works, had noted that photography "exempts artists from copying monuments and public buildings by its absolutely faithful prints" and claimed that Gérôme therefore did not "direct his efforts" to that aspect of a composition.[25] Traveling together on a trip to Egypt in 1867–68 (during the period when Eakins was enrolled in his studio), Gérôme and Goupil carried their own photographic equipment and presumably both exposed dry collodion plates.[26] The archaeologically accurate tile patterns, mosque interiors, and Cairo skylines that frame Gérôme's dancing girls and lounging Arabs were undoubtedly transcribed with imaginative color from the resulting sepia albumen prints.

In at least one case, Gérôme is known to have relied on photographs for figures. When he was commissioned to record the reception of the Siamese ambassadors in Paris, he hired the well-known commercial portraitist Nadar to take individual and group photographs of some of the busy Thai visitors. However, the resulting painting, *The Reception of the Siamese Ambassadors at Fontainebleau* (1864, Musée National de Versailles), shows profile views of the kneeling ambassadors rather than the frontal poses generally preferred by Nadar. The likenesses of the French participants in the ceremony also may derive from other commercial portraits.

Gérôme's attitude toward photography, like that of most contemporary artists, was to dismiss the medium's artistic

pretensions and to accept it as a form of neutral documentation. He actively used photographic reproductions of his works, distributed by Goupil, to further his reputation. Gérôme was present much later, in 1881, at the Paris reception for Eadweard Muybridge, sponsored by Jean-Louis-Ernest Meissonier, to see projections of Muybridge's early work on the horse in motion.[27] Despite the fact that none of the accounts of Gérôme's studio mentions the use of photographs in the student's training, the subtle tonal gradations, topographically accurate landscapes, and unidealized facial expressions in Gérôme's own works of the late 1860s strongly suggest photographic borrowings. The very difficulty today of locating albumen prints that served as sources suggests that he, like most painters regardless of stylistic persuasion, did not flaunt the practice.[28]

Eakins's letters reveal that he was personally involved with the crisis over artists' drawing models during the 1860s in Paris and with the potential role of photography in resolving that crisis. Rather than discussing the benefits to be gained by introducing photographic *académies* into the classroom, however, he was concerned with bringing photographs of sculpture and art works into Philadelphia drawing schools. In a letter to his father in October 1867, he described the series assembled by Ravaisson, which, as noted above, had been included in the list of new models issued by the Ministry of Public Instruction the same year:

I send you the list of the subjects already issued. They are photographs from the finest models, statuary of the Greeks, paintings and drawings of the Italians, a few French and Hollanders. They have been photographed with the greatest care by skilled men aided by eminent artists and everyone that exhibits the least defect is immediately destroyed. They are the finest specimens of photography I ever saw. It takes a long time to make them as the artists go all over Europe to select the objects to be photographed and only about 33 or 34 are already out. M. Ravaisson proposes to make it about 150 to complete the series, and promises that the last shall equal the first. The cost is 8 francs apiece. If Mr. Holmes should decide to buy any I would try to get them before the pasting down so as to lessen the cost of transportation or try to send them home by some friend like De Berg [De Bourg] Richards who I had placed under obligations to me. The list I send will hint very well the average selection. The statuary heads would be the most appropriate to buy for Mr. Holmes and maybe one or two whole statues. The Raphael and Michelangelo things are sketches not pretty drawings but strong rough unfinished very interesting to any artist but hardly to a beginner who does not yet know nature enough to appreciate shorthand notes of it.[29]

In November Eakins took his friend the Philadelphia printmaker John Sartain to see the photographs so that he could report directly to George W. Holmes, a local painter and teacher who was a friend of Eakins's father. Eakins's enthusiasm for the Ravaisson series was such that on January 30, 1868, he wrote again to his father and expanded his description:

I went to see the inspector general himself [Ravaisson]—they will make about 250 altogether. The list I sent was as far as they had gone. The idea of them was to replace in a measure Julien's lithographs among the very beginners who pay attention to how the thing is done rather than to the thing itself. The beautiful photograph shows nothing but the few broad simple tints. At the same time they are, I think, too expensive to be used in the everyday schools costing 8 francs a piece. They send their artists all over Europe for the subjects and destroy a dozen plates to every one they keep. In fact they are almost too nice to use.[30]

Unbeknownst to Eakins, the photographs that Ravaisson had begun issuing in 1867 represented the culmination of over a decade of debate about the use of even reproductive photography in art training. Back in 1853 the Ministry of Public Instruction had set up a commission to study drawing instruction in French primary and secondary schools.[31] Ravaisson, who was then inspector of higher education, authored the official report that resulted in a new curriculum established by a decree on December 29 of that year. Arguing that drawing instruction should aim to teach the eye to judge well, Ravaisson added photographs to the more traditional casts and prints: "Photography can also aid the pencil and burin, either in multiplying drawings of good artists or rare prints, in offering immediate reproductions of masterpieces of painting or sculpture, or representations of nature."[32] Only three years after the development of practical negative-positive photography, in the form of the collodion-on-glass negative and the albumen print, Ravaisson had the foresight to advocate its introduction into the teaching process. What was even more radical was his suggestion that studies from life be included.

According to the 1853 decree covering secondary-school drawing classes, students at the fourth level (roughly our seventh grade) would study, among other things, parts of the head or the entire head from prints or photographs. The following year they would copy the head and the extremities from prints, photographs, and casts. In the rhetoric and logic classes, students would draw torsos and nude figures after prints, photos, and casts. All the models were borrowed "from the great masters of art," however, and no mention was made of the "photographs from life" that Ravaisson recommended elsewhere in his report.[33]

Despite this decree, the substitution of photographs as drawing-class models was not enacted. According to an undated document (probably from 1864) in the archives of the Ministry of Public Instruction, the reorganization of drawing instruction had been argued for ten years and the question of models had not been resolved: "The question is complicated because people have tried to find another means of reproduction; they wanted to use photographs, and numerous attempts have been made to make them more permanent without losing any halftones. MM. Lemercier, Jolly Grangedor [sic] and Thomson are the artists primarily involved with this task."[34] Ravaisson, still enthusiastic, estimated that it would cost 150,000 francs to provide photographic models for all French lycées; but the Minister of Public Instruction, Gustave Rouland, was frightened by the outlay and abandoned the project. With a change of ministers in 1864, the idea was revived, and Parisian high schools were authorized to use the photographs of Joly-Grangedor as an experiment. Ravaisson was also given 400 francs to continue his research.[35] By 1867, having assembled part of his collection, he sold editions of six plates for 40 francs 80 centimes (or 6.80 a plate, rather than the eight francs quoted by Eakins).[36]

Thus, from his Paris experience, Eakins learned that photographs from nature, including the nudes that he would not have seen in Philadelphia, could be useful aides-mémoire for art students, although they could be dangerous for less experienced draftsmen. He also saw the pedagogical benefits to be gained from good reproductive photographs, which he tried to import into his hometown. And he learned a bit more about photographic production by visiting studios. Noting the quality of French prints, Eakins honed his critical skills and subjected the photographic image to the same scrutiny that he was developing for his own paintings. Nonetheless, the medium remained a convenient tool, a modern invention—like the

locomotives that fascinated him at the 1867 International Exhibition—that up-to-date painters interested in material reality should understand and exploit.

Eakins's stay in Paris also shaped his concept of the role of the nude in artistic practice and teaching, which later influenced his own photographic studies. Although most art historians have argued that exposure to the Beaux-Arts tradition solidified his belief that the nude was the basis of all art,[37] few have made the point that only certain kinds of nudes that he saw in Europe appealed to Eakins. The exacting life drawings that he did under Gérôme's direction apparently satisfied his desire for truthful representation. According to his friend and fellow Gérôme student Earl Shinn, the life-drawing sessions progressed as follows:

"On Monday he hits the pose, which is always vigorously pronounced and spirited, on the model's part, when first assumed; the dash that may be thrown into the attitude while the figure is perfectly fresh can never be caught again if missed at the beginning. By Tuesday the artist has become absorbed in the complications of light and shade. Wednesday—the master comes. The model, dropping upon his dais, may bear little resemblance to the elastic attitude of the drawing, and the student is accused of attempting to idealize. . . . The study is altered, in the spirit of realism, until all the stark and pitiful ugliness of the model's lassitude is exposed. One of the difficulties of a life 'academy' is that, although the example before you is a moving, changing object, now braced, now drooping, now turned to the right and now a little to the left, your copy of it is expected to show all the purism of the photograph."[38]

Truth to the model, from this account, was expected at the drawing stage.

Eakins's concept of the ideal human subject, envisioned in his letters but not yet put into practice in his paintings, echoed this taste for unadulterated reality. In comments lush with hearty sensuality, he praised Thomas Couture's works for their evocations of living flesh: "Who that has ever looked in a girl's eye or run his fingers through her soft hair or smoothed her cheek with his hand or kissed her lips or their corners that plexus of all that is beautiful in modelling but must love Couture for having shown us nature again and beauty on canvas."[39] Using the same tactile language in an often-quoted 1868 letter to his father, which is as close to an artistic manifesto as he ever produced, Eakins suggested that his ideal subjects were wholesome, Edenic people at one with nature: "I love sunlight and children and beautiful women and men their heads and hands and most everything I see and someday I expect to paint them as I see them and even paint some that I remember or imagine, made up from old memories of love and light and warmth."[40] This enthusiastic panegyric, expressed in lyrical rhythm, is a far cry from the goals of French naturalist writers and artists (such as Emile Zola and Edouard Manet), who tended to dwell on the sordid aspects of urban life. Reverberating with earthiness, Eakins's letter recalls that most American of poets, Walt Whitman. In *Leaves of Grass* (1855) Whitman celebrated sensuality in poem after poem: "If life and the soul are sacred the human body is sacred; / And the glory and sweet of a man is the token of manhood untainted, / And in man or woman a clean strong firmfibred body is beautiful as the most beautiful face."[41]

On the other hand, Eakins found disgusting the false, stylized nudes that populated most Paris Salon paintings. After visiting the 1868 show, he ridiculed the "naked women, standing sitting lying down flying dancing doing nothing which

they call Phrynes, Venuses, nymphs, hermaphrodites, houris & Greek proper names. The French court is become very decent since Eugenie had fig leaves put on all the statues in the Garden of the Tuileries & when a man paints a naked woman he gives her less than poor Nature herself did. I can conceive of few circumstances wherein I would have to make a woman naked but if I did I wouldn't mutilate her for double the money. She is the most beautiful thing there is [in] the world except a naked man but I never yet saw a study of one exhibited. It would be a godsend to see a fine man model painted in a studio with the bare walls, alongside of the smiling smirking goddesses of waxy complexion amidst the delicious arsenic green trees and gentle wax flowers & purling streams a running melodious up & down the hills especially up. I hate affectation."[42] From his student romps, Eakins had had a taste of the famous French libertinage in the form of brothel visits, ribald café concerts, and off-color jokes and songs.[43] Enjoying his new sexual freedom, he was outraged by the hypocrisy that marked both the Napoleonic court and official art.

If this condemnation of "false" nudes was an honest expression of his feelings (and his later actions and statements suggest that it was), then Eakins's adulation of Gérôme is puzzling. Gérôme was certainly one of the most guilty when it came to disguising naked models as classical figures or oriental types. His *Intérieur grec* (1850, unlocated), *Phryné before the Areopagus* (1861, Kunsthalle, Hamburg), *Cleopatra before Caesar* (1866, unlocated), and *The Slave Market* (1866, Sterling and Francine Clark Art Institute, Williamstown, Mass.) are just a few canvases spotlighting nude or partially nude women in erotic, twisted poses with boneless bodies and preadolescent pubes. The rigor of observation that Gérôme enforced in the atelier has yielded to extreme idealization in these slick, titillating scenarios. But in Eakins's eyes, Gérôme's nudes were somehow less false than those of other Salon artists. In a letter to his sister in 1869, he discussed *The Slave Market,* in which a slave seller examines the teeth of a girl:

See the coffee house Almé the fat dancing girl with a big belly low head. I heard two fools say Gerome painted that picture on the principle that Chaplin paints a girl with her clothes lifted up to interest only low people. It will interest very sensual people more sensual than those Turks who are yet hardly interested and they have nature while this is but a picture. . . . but the sensual people are better than the fools. Above those only sensual, comes a higher class, the thinking people and feeling ones who always want to see everything to know more. . . . Suppose he [Gérôme] had made dough-faced Virgins all his life. How much is Shakespeare not ahead of the poets of the Sunday School union.[44]

Eroticism, portrayed with talent, Eakins insisted, was better than insipid prudishness, and "thinking people" knew how to appreciate niceties of style and confront the physical signs of gender without embarrassment.

Eakins went to Paris a freethinker, a young man offended by official religious practice and hypocritical politeness. He was in many ways akin to Walt Whitman in his love of outdoor exercise, abolitionist sentiments, pantheistic enthusiasm for well-built men and women, tender desire to spawn healthy children, and confidence in American genius. His stay in Paris did not transform his basic values but in many ways reinforced them. The sight of hundreds of contemporary and old-master paintings of nudes, despite their affectations and false poses, highlighted the very absence of such works, and

condemnation of them, in his homeland. The freedom from parental and societal restraints available to Eakins as an expatriate art student allowed him to sow his wild oats and gain confidence in his judgments. He returned to Philadelphia in 1870 as an unshockable cosmopolitan who knew what the Old World had produced and who thought that with Yankee ingenuity he could do better.

TAKING UP THE CAMERA: THE "NAKED SERIES"

During the 1870s Eakins painted some of his most brilliant pictures: *Max Schmitt in a Single Scull* (1871, Metropolitan Museum of Art, New York); *The Gross Clinic* (1875, Medical College of Thomas Jefferson University, Philadelphia), *William Rush Carving His Allegorical Figure of the Schuylkill River* (1876–77, Philadelphia Museum of Art), and sensitive portraits of his family and friends. But he did not take up the camera. His paintings established new standards for scientific accuracy founded on exact perspectival studies and the careful, empirical examination of human anatomy and the interactions of color and value. Based on clearly readable tonal structures and characterized by an almost miniaturistic treatment of detail, these labor-intensive works rivaled the latest photographs in their often radical cropping of objects in the foreground and at the edges of the frame while dealing with situations of lighting—chiaroscuro interiors, back-lit figures on water—that could not be fully resolved in photography.[45] In many ways Eakins's paintings, like those of Edgar Degas, anticipated photographic effects rather than mimicking them.

 If Eakins could surpass the camera without resorting to it during his first decade as a painter, why did he bother to experiment with the medium around 1880? The popularization of dry gelatin plates, which were commercially available about 1878, has been posited as a contributing factor. Considering the extensive labor that Eakins went through for his own paintings, however, and his later mechanical improvements for motion photography, it is unlikely that a little chemical manipulation would have scared him away from the earlier collodion-on-glass negative processes. Admittedly dry plates were more light sensitive than dry or wet collodion negatives and would have allowed him to take more stop-action photographs. But with the exception of his Marey-wheel images, Eakins's photographs are of singularly static, posed figures.

 Although one scholar has suggested that Eakins's metamorphosis into a photographer came through a series of amateur snapshots taken at the Jersey shore,[46] it is more likely that his embrace of the medium resulted from the coincidence of two events in the late 1870s: his discovery, facilitated by his friendship with Fairman Rogers, of Eadweard Muybridge's work on the horse in motion and his appointment in the fall of 1879 as professor of drawing and painting at the Pennsylvania Academy of the Fine Arts, also aided by Rogers. Muybridge's California photographs for Leland Stanford had shown that the camera could see things that no amount of close looking could uncover. Eakins was intrigued by the prospect of going beyond the knowledge of bone structure and musculature that dissection could provide to actually viewing the figure in action. At the same time, his new and powerful position at the Pennsylvania Academy would allow him to improve the curriculum by enhancing life drawing with photographic studies from the nude.

Because Fairman Rogers is at the center of these events, it is important to understand who he was and what he represented. The only son of Evans Rogers, a wealthy iron merchant, and Caroline Augusta Fairman Rogers, the daughter of an inventor, Rogers represented a rare combination of established Philadelphia society and modern science. A University of Pennsylvania graduate trained in civil engineering, and a soldier in the Civil War (briefly in 1861), Rogers traveled in Europe, collected art, and defined himself as a gentleman scholar. He lectured on physics at the Franklin Institute and the University of Pennsylvania, and taught at Harvard University (in 1863). Active in learned societies, Rogers had been elected to the American Philosophical Society in 1857. He was one of the founders of the prestigious Union League Club and the National Academy of Sciences, and he served as treasurer of the National Academy from its inception in 1863 until April 1881. Not needing his post at the University of Pennsylvania for income, Rogers resigned in 1871 and was immediately elected to the board of trustees, on which he sat until 1881. Although his own scientific accomplishments were modest (he completed a study for the National Academy on the effects of magnetism on iron vessels, which he published in 1877), he was extremely well connected in the scientific and philanthropic worlds.

Rogers's two passions, outside his engineering work, were photography and horsemanship. None of his photographic prints has been located, but a 1903 biographer called him "one of the early photographers" whose images taken in about 1858 "show very careful manipulation, and will even stand a lenient comparison with those of the present day."[47] Active in the Photographic Society of Philadelphia as early as 1862, Rogers was cited as the designer of an instantaneous shutter in 1870 and was still attending the group's photographic excursions in 1883.[48] As a horseman, Rogers collected a vast library on the subject of horses and horsemanship that he gave to the University of Pennsylvania in 1878. He was the first person in the United States to test the technique of riding developed by the French master François Baucher, who defined the relationship of rider to horse scientifically in terms of weight and balance. In addition Rogers was the first person in Philadelphia to drive a four-in-hand, a coach drawn by four horses.

Eakins could have met Rogers at any point after 1876, when he began as a voluntary nighttime instructor of life drawing and demonstrator of anatomy at the Pennsylvania Academy of the Fine Arts. Rogers had been involved with the Academy since 1871 and had served on the building committee for the new structure designed by Frank Furness and George Hewitt. By 1876 Rogers had become chairman of the Committee on Instruction, which hired Eakins. Two years later Rogers was discussing equine anatomy and Muybridge's recently published plates with the painter.[49] Because Muybridge's photographs were small and showed no modeling within the outlines of the figures, Rogers hired Eakins to produce exact drawings based on the information they provided so that he could place them in a zoetrope to test their accuracy.[50] Taking Muybridge's measurements on the camera's distance from the subjects, the shutter speed, and the distance traveled between each shot, Eakins used the perspectival tools at his command to reconstruct the position of the horses. He discovered, however, that the distortion in the background vertical dividing lines caused by the camera angle greatly complicated his task and reduced the accuracy of the photographs. In 1879 he wrote Muybridge suggesting a technique to correct this flaw. Muybridge responded with a polite note in which he promised to change his measurement system.[51]

Rogers, and presumably Eakins himself, realized the potential significance for artists of these early Muybridge experiments. In an article published in *The Art Interchange* on July 9, 1879, Rogers concluded that "nearly all the attempts to represent the gaits of either animals or men, in painting, are extremely unsatisfactory, and it is only by thoroughly understanding the mechanism of the motion, that the artist will be able to portray it in any satisfactory manner. . . . There are many interesting speculations as to how this new information may be utilized by the painter, for which we have not space at present, but Mr. Muybridge deserves the thanks of all artists for the valuable addition that he has made to the general fund of knowledge."[52] Eakins himself immediately incorporated the new information on the horse's gait into the painting *Fairman Rogers's Four-in-Hand* (Philadelphia Museum of Art), which the engineer commissioned in 1879. Although Eakins's direct involvement with Muybridge in Philadelphia in 1883 and 1884 and his own motion studies from those years are beyond the scope of the present essay, we can posit that his interest in taking pictures of his own was piqued by this exposure in 1878 and 1879 to photography as a scientific tool for better understanding animal and human movement. Fairman Rogers's familiarity with the medium would have been another factor furthering Eakins's apprenticeship.

At the same time, assuming an influential position at the Pennsylvania Academy with Rogers's backing, Eakins had a chance to push an approach to figure drawing more scientific than that of his predecessor, Christian Schuessele.[53] With the reorganization of the Pennsylvania Academy in 1882 and Eakins's promotion to director of instruction, we begin to see in writing and in the classrooms the impact of his ideas. As Rogers had summarized in an 1881 pamphlet on the school, Eakins "has a strong feeling that a really able student should go early into the life class" and should paint rather than draw. When in front of the model, the student should attend to the great masses of the body rather than the contours and should not "conventionalize" or idealize what he sees.[54] In the circular issued by the Committee on Instruction for 1882–83, the introductory statement of the school's philosophy pointed out for the first time that "the course of study is believed to be more thorough than that of any other existing school. Its basis is the nude human figure."[55] This affirmation continued to appear in the annual circulars until 1886–87, the year of Eakins's dismissal.

To complement the students' understanding of the human body, dead and alive, from the inside to the outside, Eakins began shooting photographs, often with his students' assistance. As we have seen, this was not inspired by his official training in Paris, although commercial nude photographs were in circulation outside the Ecole des Beaux-Arts. The lack of any commercially available products in the United States made it all the more urgent that Eakins take the pictures himself. The photographing must have begun by 1882, because the 1883–84 Pennsylvania Academy circular noted that "a number of photographs of models used in the Life Classes were made in cases in which the model was unusually good or had any peculiarity of form or action which would be instructive, and a collection of these photographs will thus be gradually made for the use of the students."[56] The stated goal of the photographs, therefore, was to record "good" (presumably attractive, with well-developed muscles) or unusual models in terms of their form or action. Ellwood C. Parry III has argued that these works were in fact Eakins's "naked series," small images glued on cards in which the model assumed a sequence of standardized poses. Because the photographs cited in the 1883–84 circular were concerned with "action," however—not

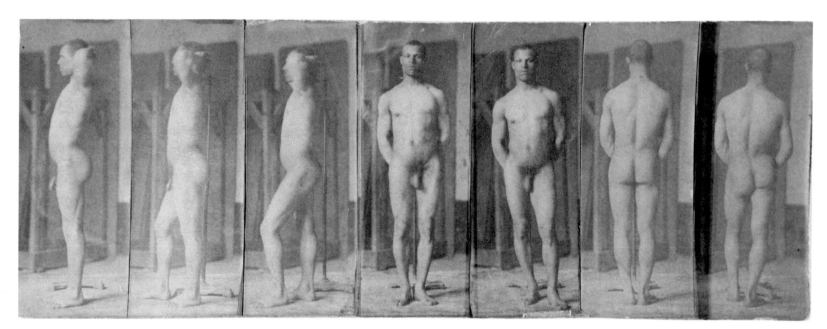

Figure 17. *Naked series: African-American male, poses 1–7*, by circle of Eakins, ca. 1883, seven mounted albumen prints (cat. no. 419)

with the distribution of weight within the figure that characterizes the naked series—they are probably best identified as precursors of the serial imagery seen in figure 17 (see also text preceding cat. no. 419).

The antecedents and the function of the naked series have been the subject of much discussion. As Parry has noted, the provenances of the photographs formerly in the Olympia Galleries in Philadelphia suggest that they were used primarily as teaching aids. What exactly they were demonstrating to students, however, has been misconstrued by Parry, who claimed that the works "make individual differences [in bodies] leap out at the viewer."[57] He compared the series with photographs of criminals; anthropological front, rear, and profile shots; Sir Francis Galton's composite views that attempt to construct human types; and, finally, William Rimmer's illustrations in *Art Anatomy* (1877), a book that the Pennsylvania Academy anatomy professor William W. Keen wanted to acquire for the school in 1878. Parry also cited the development of anthropometry, the amassing of measurements of parts of the figure for comparative purposes, but did not note that the writings of L. A. J. Quételet, the Belgian statistician credited with founding anthropometry, were concerned primarily with numerical lists of heights, weights, and so forth, across demographic or racial groups rather than with visual records.[58]

Although Parry correctly sensed that Eakins was borrowing the latest nineteenth-century language of exact science, consistent measurement, and comparison, he missed the tradition into which these images must be placed. Criminological photography, perfected in the 1870s by Alphonse Bertillon, showed frontal and profile views of the head accompanied by written data about the sizes of other body parts, hair color, and notable marks. Galton's photographs were composites of heads, a part of the figure that was notably of little interest to Eakins in the naked series.[59] Rimmer's plates, showing front and profile views of figures with different body builds and postures, bear a superficial resemblance to Eakins's poses but are examples of proportions, the relative size of one body part to the rest of the figure. Eakins was pointedly not interested in proportions in his series.

In annotations on a sheet of tracings (unlocated)[60] made from some of the photographs, Eakins stated clearly what he was after:

The centre lines in red represent the general axes of weight and of action and are deduced from a consideration of the centres of gravity of small horizontal sections of the figure, which centres joined form the continuous lines. In the thorax this line approaches the back outline rather than the front because first of the shape of a section of that region [drawing here] and second because of the position of the lungs of but little weight. These lines are maintained throughout their curves by increased action of the muscles on the convex parts of their curves by ligaments or by resistance of bones only. Such lines form the only simple basis for a synthetic construction of the figure.[61]

Parry connected this "line of action" with Eakins's Paris training, as described by Albert Boime. Boime stated that Paris art students centered figures on a sheet with vertical and horizontal axes and then defined the figure's main flow of movement through a lightly sketched "line of action."[62] Unfortunately, Boime did not indicate where he got the idea that this was the practice in the studios of Gérôme and Bonnat, and he did not distinguish a line approximating the external, visible disposition of the limbs and body angles from a line based on centers of gravity, which was what Eakins described (fig. 18).

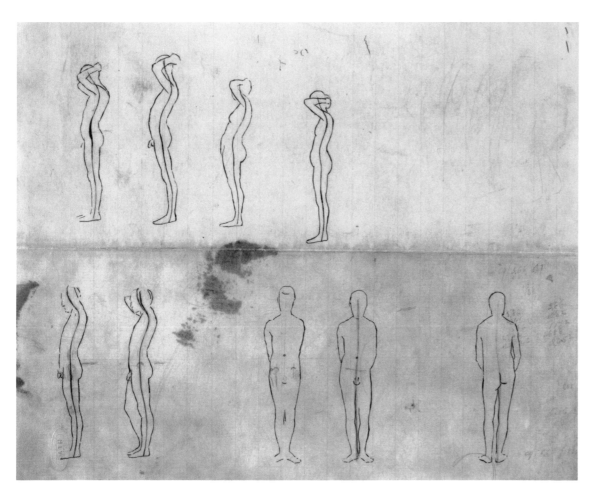

Figure 18. *Drawing derived from naked-series photographs,* ca. 1883, graphite and black ink on foolscap laid paper (1985.68.6.10)

Figure 19. Changing balance of the spinal column, from Félix Giraud-Teulon, *Principes de mécanique animale* (Paris, 1858), fig. 10 (Courtesy of the Trustees of the Boston Public Library)

Figure 20. Changing balance of the spinal column, from Félix Giraud-Teulon, *Principes de mécanique animale* (Paris, 1858), fig. 9 (Courtesy of the Trustees of the Boston Public Library)

The language that Eakins used in his annotations and the diagrammatic red lines connecting the centers of gravity originated not in the life-drawing class, or even the standard anatomy class, but in scientific investigations of animal mechanics and locomotion. The definition of the body's center of gravity as a point between the pubis and the sacrum was first put forth by Giovanni Alfonso Borelli in his *De motu animalium* (1685) and became a standard concept in both anatomical and physiological texts. For example, in his *Anatomie des formes extérieurs du corps humain, à l'usage des peintres et des sculpteurs* (1845), J. A. Fau stated in a section on *station* (or standing), in a chapter on animal mechanics, that "all parts of the body must be in equilibrium around the centre of gravity in order that it remain in repose."[63] In *La Machine animale,* which was concerned more with movement than stasis, Marey nonetheless cited the center of gravity as a possible point from which to measure the changes that occur in walking: "First of all, what point of the body will we choose to observe the displacements during walking? Almost all authors have wanted to choose the *center of gravity:* that point that Borelli placed *inter nates et pubim.*"[64] Marey rejected the center of gravity as an appropriate measuring point because the center changes as the body moves. It was better to choose a fixed point on the trunk, such as the pubis, he concluded.

Rather than positing a single center of gravity for the entire body, Eakins used lines to connect a variety of centers, each defined within a horizontal slice through the body. He then noted the relationship of those lines to the external contours and the role of the muscles and bones in supporting the points of gravity. Anatomists like Fau had emphasized the importance of the muscles in accommodating shifts of weight but were more concerned with the body in motion: "Observe the alternate shifting of the line of gravity from one foot to the other, the constant and careful balancing of the body, and the action of the long muscles of the back, occupying the vertebral grooves. As the foot quits the soil to be carried forward, the muscles in the corresponding vertebral groove swell and contract, whilst those of the opposite groove are not so distinctly in action."[65] Interestingly, in the next sentence, Fau referred the art student to physiological treatises on animal mechanics for more information.

In such treatises we do indeed find discussions of the static posture, as well as diagrams that seem related to Eakins's ideas. Félix Giraud-Teulon, a Paris professor who criticized Borelli for his lack of geometric rigor, represents the kind of writer whose analyses might have been known to Eakins. In his *Principes de mécanique animale* (1858), he devoted a chapter to standing in which he analyzed the effects of slight shifts in weight, the importance of the varying weights of the organs (as Eakins notes in his comment on the lungs), and the ways that the curves of the spinal column allow a human to stand vertically: "The inferior part of the vertebral column can be placed toward the front enough to meet, along some points of its curvature, the vertical passing through the center of gravity of the above segment. . . . As a result, the lever [*bras de levier*] corresponding to the weight of this segment is annulled, and from that, the effort needed for power reduces itself to zero. In other words, this disposition creates the possibility of balance independent of the voluntary contraction of the lever itself in the sense of its length."[66] Elsewhere Giraud-Teulon discussed what happened when the line of gravity fell behind the axis of the spinal column and described the effects of shifting weight on the legs: "Imagine the body temporarily carried on one of its supports, the other becomes a balance, as we have seen with the arms. . . . The projection of one of the abdominal

members forward, displacing the center of gravity, serves to restore equilibrium."[67] The diagrams accompanying his remarks show the changing balance of the legs and spinal column as the lower vertebrae shift in front of (fig. 19) and behind (fig. 20) a vertical dropped from the ear. Although these renderings include the leg and foot bones with only the back reduced to an abstract line, they come very close to Eakins's line drawings adapted from photographs (see fig. 18).

Giraud-Teulon also cited the work on human mechanics of the physiologists Wilhelm and Eduard Weber. Although most of their research was published only in German, one book appeared in a French edition in 1843 as *Traité de la mécanique* and could have been accessible to Eakins. According to Giraud-Teulon, the Weber brothers took measurements from a large number of subjects to determine the regular disposition in an erect, standing posture of the three curves of the vertebral column (cervical, thoracic, lumbar) and the tilt of the sacrum on the pelvis. Eakins seems to have substituted photographs for the hand-generated measurements of the Webers' works in order to get a sense of the range of lines of gravity for men and women of different builds.

How would Eakins have learned about the literature on human and animal mechanics? Certainly he was not exposed to it while an art student in Paris. The professor of anatomy at the Ecole des Beaux-Arts, Pierre Charles Huguier, was a competent but not particularly original physician in comparison to his illustrious followers, Charles Duval (at the Ecole from 1873 to 1883) and Paul Richer. Eakins's later colleague at the Pennsylvania Academy, Dr. William W. Keen, whom he assisted as chief demonstrator of anatomy from 1879 to 1881, did not lecture specifically on human mechanics, according to his reports to the administration. Nor were books by the Weber brothers and Giraud-Teulon among those that Keen reported acquiring after 1876, when he began teaching and complained that the school's library had "no books of value" on anatomy. In 1878 thirty volumes, mostly related to artistic anatomy, were acquired, but they did not include these texts.[68]

Because Eakins himself was reportedly against learning anatomy from books, he might have received secondhand accounts of these studies of standing postures from anatomist or scientist friends. A likely candidate was Fairman Rogers, who had already piqued Eakins's interest in locomotion. In his 1879 essay on Muybridge, Rogers stated that "a number of investigators have attempted to analyse the action of man and of animals in the various gaits. The Weber brothers, as to man, and Wachter, Raabe, Marey, and Lenoble de Teil, for horses."[69] That Rogers knew about the Weber brothers and studies of human locomotion shows that his interest in the subject was not merely an outgrowth of his equestrian passion. Between his friendship with Rogers and his connections with the medical profession, Eakins had ample opportunity to update the descriptive anatomy training that he had received in Paris and Philadelphia.

Eakins's naked series, then, should be seen as a complement to his chronophotographs of figures in motion. Whereas the chronophotographs expose the action of the muscles and the positions of the limbs during walking, running, and jumping, the naked series shows comparable muscular compensations as the weight shifts from leg to leg while the figure remains stationary. By hanging cards of mounted photographs on the walls of the Pennsylvania Academy's drawing and modeling classes, Eakins had a ready reference to living postures plus a reminder to his students that they had to master abstract principles and not just copy each model as a unique specimen. As Dr. Fau had written, the study of anatomy is a

Figure 21. *Etude
académique,* by B. R.
Julien, 1833, litho-
graph (Biblio-
thèque Nationale,
Paris)

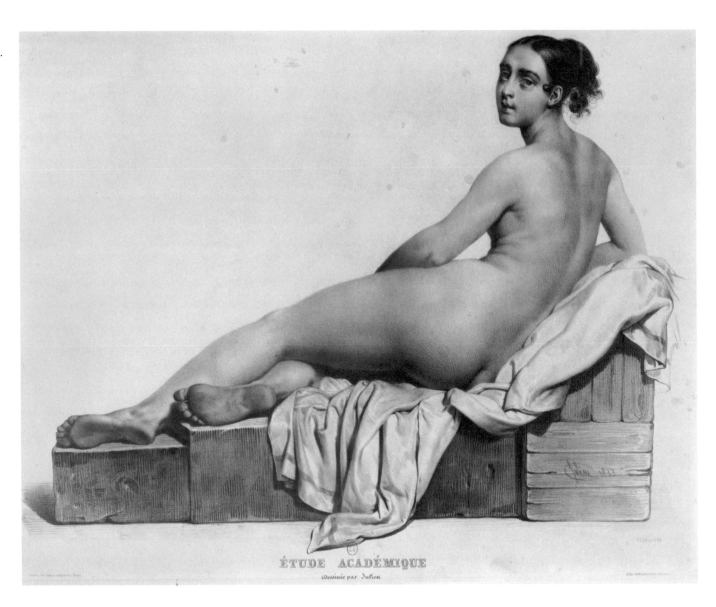

ÉTUDE ACADÉMIQUE

Dessinée par Julien

"search for causes," and Eakins's naked series was similarly a search for the underlying causes that account for slight differences in the external contours of the resting figure.

ACADÉMIES, TAME AND WILD

Produced concurrently with the photographs in the naked series, which were formulaic in pose and could have been taken by students, were Eakins's more ambitious artistic studies of the posed nude model assuming attitudes from past art that might appear in future narrative paintings. In addition to teaching the artist the external forms of the body, these académies played a role in later stages of the creative process, after the student understood the principles of human anatomy and motion and was ready to compose on the canvas. A photographic académie could be literally transcribed in those rare cases in which nudes appeared in mythological or historical scenes. More often, however, the figure was clothed in the final oil painting. In cases in which elaborate props surrounded the nude in a photograph, the image began to assume a life as an artistic (or erotic) object in its own right.

Indoor views of nude men, women, and children in the Pennsylvania Academy's collection range from rather static, graceless figures indifferently placed in front of distracting studio backgrounds to tableaux complete with palm fronds and drapery. Unlike many of the figures in the naked series pictures, the models typically do not wear masks, although their faces are often diverted from the camera.[70]

In comparison with French académies from the 1850s, Eakins's works are quite chaste and simple. The postures are conservative and restate a long tradition from old-master paintings through lithographs by Bernard-Romain Julien and others. For example, the back view of a reclining woman with her torso held off the floor and its frontal mirror image (plate 10) are variations on odalisque poses inspired by Ingres and often repeated in earlier prints and photographs (compare figs. 21 and 27). What is strikingly different about Eakins's female figures in comparison with French photographic work of the 1850s is the absence of the omnipresent, inviting glances at the camera and orientalizing paraphernalia. Within the Pennsylvania Academy's collection, only a nude on a Queen Anne chair (cat. no. 267) and a tantalizing view of an African-American girl (cat. no. 308) have the seductive gazes reminiscent of the French tradition. The series of a girl on a draped sofa (cat. nos. 293, 294), which may have been taken by Susan Eakins's sister, Elizabeth Macdowell, introduces baroque drapery and palm fronds but stops short of the lush tiger skins, plaster casts, and hookahs that clutter French images.

Eakins's many studies of nude men in interiors differ sharply from French 1850s académies. Male models, usually engaged in dynamic tasks such as pulling or pushing weights or mimicking statues of Greek athletes, were commonplace in lithographic académies but disappeared in the earliest photographic products.[71] They reappeared in the late 1860s and 1870s however, in images sold primarily by Marconi and Igout as legitimate studies for artists. Eakins posed reclining and standing men at rest in the studio as well as a wrestling pair (cat. nos. 403–6) with relatively little attention to his backgrounds. He

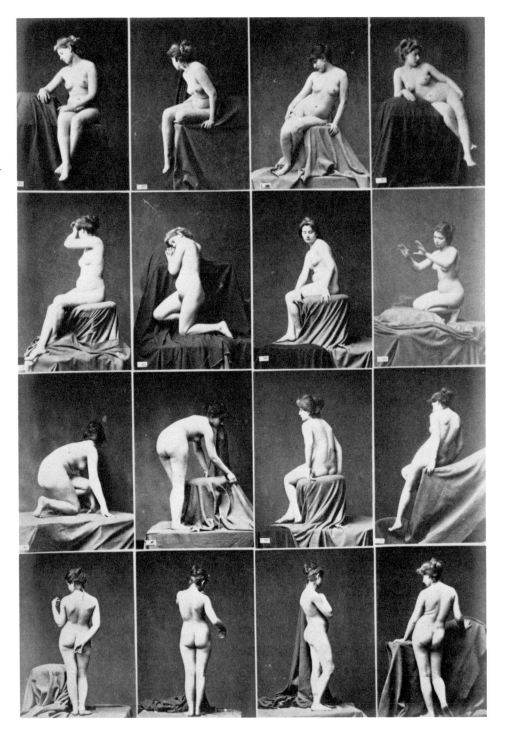

Figure 22. Academic nudes by Louis Igout, from *Album d'études—Poses,* ca. 1875–80, albumen print (anonymous loan to the International Museum of Photography at George Eastman House, Rochester, N.Y.)

often stretched a wrinkled drape behind the figures and usually allowed studio furniture to appear around the edges. His attention was clearly on posing and lighting the figures rather than constructing a harmonious, well-composed picture.

Commercially produced French *académies* from the 1870s and 1880s—less overtly erotic and with fewer props than the 1850s *tableaux*—were still pointedly different from Eakins's interior photos. Two bound books entitled *Etudes académiques* and *Album d'études* (International Museum of Photography at George Eastman House, Rochester, N.Y., loans L79.1850.000 and L79.1851.1–37) provide a good sampling of the standard repertoire of academic photographs from the Third Republic. Featuring the solid screens or painted backdrops used for studio portraits, these images, probably by Louis Igout, differ from Eakins's more amateurish efforts in their melodrama and the introduction of appropriately passionate facial expressions to correspond with the poses. Only rarely did Eakins suggest an affective attitude such as melancholy (e.g., cat. no. 264, which is comparable to fig. 22, top row, far left), and his poses were less stylized and tortured than those by Igout. Eakins's nudes, with few exceptions, do not smile, and they rarely use the arms-over-head pose that occurs repeatedly in Igout's work (see fig. 23).

Figure 23. Academic nudes by Louis Igout, from *Album d'études— Poses,* ca. 1875–80, albumen print, det. (anonymous loan to the International Museum of Photography at George Eastman House, Rochester, N.Y.)

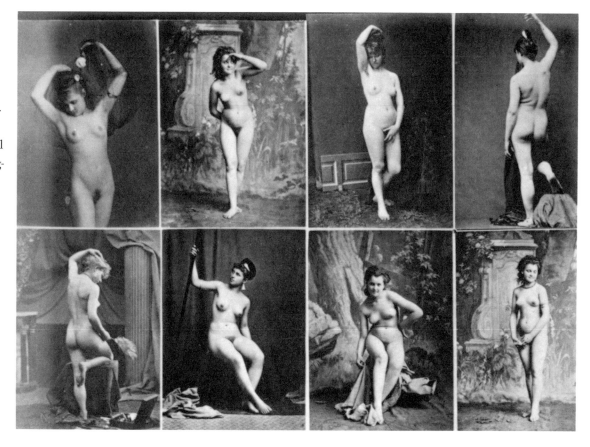

The comparisons are even more telling in male figures. A sheet of photographs of single men by Igout (fig. 24) shows them flexing muscles, throwing rocks, appearing despondent, fatigued, ecstatic, and so forth. An Eakins photograph (plate 2) that quotes from a classical statue—the Dying Gaul—has the face lost in shadow, adding nothing to the expression. A seated man photographed in profile by Eakins (fig. 39) seems casually resting, whereas the bearded figure with downcast head by Igout (fig. 24) suggests contemplation or remorse. Even Eakins's staged wrestling scenes (cat. nos. 403–6) contrast with Igout's exaggeratedly contorted wrestlers (see fig. 25), who recall a variety of late classical statues, such as Hercules and Antaeus, rather than actual combatants.

An important aspect of Eakins's nude studies that further distinguishes them from commercial French models is the prevalence of plein-air shots. Commercially produced *académies* dating between 1850 and 1890 are almost exclusively views of posed figures in interior studios. While the greater light available in plein-air photography would have facilitated more

Figure 24. Academic nudes by Louis Igout, from *Album d'études— Poses,* ca. 1875–80, albumen print, det. (anonymous loan to the International Museum of Photography at George Eastman House, Rochester, N.Y.)

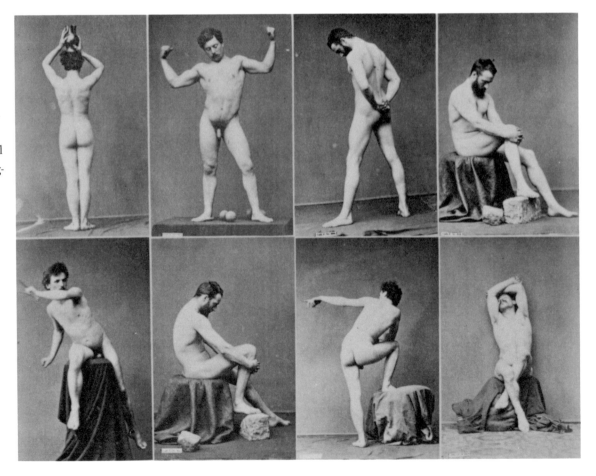

Figure 25. Academic nudes by Louis Igout, from *Album d'études— Poses,* ca. 1875–80, albumen print, det. (anonymous loan to the International Museum of Photography at George Eastman House, Rochester, N.Y.)

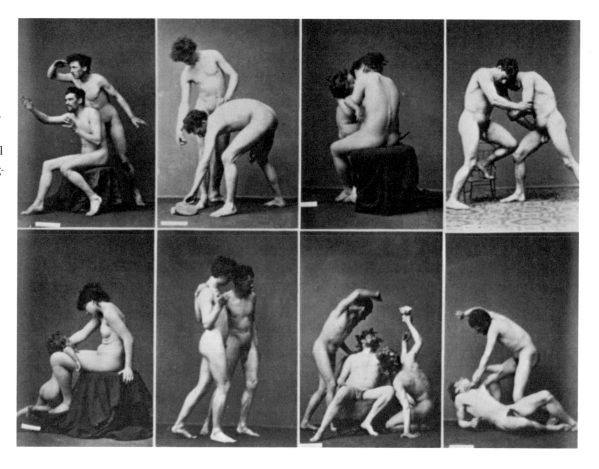

spontaneous poses, the logistical difficulties of finding an appropriately isolated locale and setting up a view camera, and, more important, the persistent linkage of photographic *académies* with studio life-drawing classes made such works unthinkable. Amateur snapshooters and artists with cameras, such as Pierre Bonnard and Wilhelm Von Gloeden, began to record the figure out-of-doors in the 1890s, but their photographs postdate Eakins's experiments.

Even the *drawing* of the nude model outdoors was rarely practiced. Horace Lecoq de Boisbaudran, a professor at the Ecole de Dessin when Eakins was in Paris, had challenged the academic norm in 1847 when he published his technique of memory drawing. In this treatise he advocated taking nude models outside and stopping them in midstep to get a spontaneous pose. "The immobility of the model, necessary for material study . . . soon froze movement, decomposed expression, deformed the muscles,"[72] he complained, and the use of a studio model "cannot be accepted as the study of entire nature. A model weakened by the fatigue of the pose, lit by the monotonous light of the studio, can give no idea of man acting spontaneously in the open air, in skylight and in the midst of the countryside."[73] According to Lecoq de Boisbaudran, higher

education in the fine arts should no longer concern itself with academic poses: "Its goal is to show man acting in his freedom and spontaneity. One would no longer say to a model, for example: 'Take the pose of a man carrying a rock.' One would say, 'Carry this rock from this place to that.'"[74]

Although Eakins never mentioned Lecoq de Boisbaudran in his letters from Paris or later as a teacher and artist in Philadelphia, he must have heard about his philosophy. Lecoq de Boisbaudran had been teaching at the Ecole de Dessin since 1841, had received the Légion d'Honneur in 1847, and in 1851 presented his memory-drawing technique to the Ecole des Beaux-Arts. In 1863 he opened a memory-drawing class at the newly formed Ecole des Arts Décoratifs and in 1866 was invited by Alfred-Emilien de Nieuwerkerke, the new Bonapartist superintendent of fine arts, to direct the school. His students included many young and innovative artists, such as Alphonse Legros, Jules Dalou, Léon-Augustin Lhermitte, Eugène Guillaume, Félix Régamey, Jean-Charles Cazin, Henri Fantin-Latour, James McNeill Whistler, and J. J. Tissot.[75] Notwithstanding support from state bureaucrats, Lecoq de Boisbaudran suffered attacks by his fellow professors, and by 1869 he had been ousted.

In two letters to his father, Eakins implied that he was using Lecoq de Boisbaudran's memory-drawing technique, which consisted of a series of increasingly complex reproductions of parts of a figure from memory, culminating in what Lecoq called "the retention of fugitive effects, rapid and spontaneous movements."[76] In November 1867 Eakins stated, "I see much more ahead of me than I used to, but I believe I am seeing a way to get at it and that is to do all I see from memory." Two months later he added, "I am working now from memory and composing. I make very bad things but am not so down-hearted as I have been at times when I was making a drawing from the model . . . when after painting a model I paint it from memory & then go back & do it again, I see things the second time, I would not have seen if I had staid at school painting on the same canvass all the week."[77] Whether he absorbed Lecoq de Boisbaudran's progressive enthusiasm for working *en plein air* along with his advocacy of memory training is not known.

Eakins's outdoor photographic studies, unlike the interior views, seem to be more for personal than pedagogic use. Many of those in the Pennsylvania Academy of the Fine Arts are related to his arcadian paintings of 1883 (*Arcadia*, Metropolitan Museum of Art, New York; and *An Arcadian*, Spanierman Gallery and Alexander Gallery, New York), or to *The Swimming Hole* (ca. 1883, Amon Carter Museum, Fort Worth). In *Arcadia*, an uncharacteristic experiment with a classicizing subject, Eakins literally transcribed onto a vague, idealized landscape photographs of a standing flute player (cat. no. 386), Susan Macdowell reclining on a white drape (cat. no. 306), and a reclining boy playing panpipes (Hirshhorn Museum and Sculpture Garden, Washington, D.C.). Similarly, the figure in *An Arcadian* (fig. 51) is Susan Macdowell as she appears in catalogue number 301, a white drapery added in the painting to cover the bony spinal column visible in the photograph.[78] Eakins was in effect using the photographs as the equivalent of experimental sketches and resolving the composition only when back in the studio.[79]

The Swimming Hole (fig. 44) has often been related to a series of photographs that Eakins took of his nude students on the same rocky promontory that is preserved in the oil. None of the poses in the extant plein-air group photographs or

single-figure studies corresponds exactly to those of the six figures in the painting, but the high-contrast lighting and the figures' failure to relate to one another in the painting suggest an additive composition from photographic models. With the exception of the diving figure, none of the boys is caught in mid-action, and they resemble a group of carefully arranged *académies*.[80] In the photograph that best approximates the oil (plate 3), Eakins directed his models to look away from the camera and the sun and to hold poses while the shutter was released. Just as in his outdoor boxing images (e.g., cat. no. 399), in which the boys spread their legs unnaturally far apart so that their muscles are stretched taut, the swimmers form a stylized rhythmic pattern: a seated figure yields to one climbing into the water, who is next to a half-immersed body, and so forth.

Unlike most artists, who used a model posed in the studio as the basis for a figure inserted into an outdoor scene, Eakins led his subjects for *The Swimming Hole* (fig. 44) to a local pond in order to avoid the "monotonous light of the studio" that Lecoq condemned. Ever sensitive to the importance of light in shaping forms, Eakins needed to see the ways that sunlight bleached out the flanks of pale, unclothed bodies and cast deep shadows. At about the same time, Eakins tried to resolve the problem of lighting for his motion studies by sewing bright balls on his figures in imitation of Marey's use of a black suit with white lines down the limbs. He even photographed a figure "swinging a bright ball in Prof. Barker's room in sunshine."[81] After his film had been fogged by reflections, he devised the technique of roofing over the running track, hanging black velvet behind the figure, and letting the sunlight fall only on the moving subject. Direct sunlight therefore allowed the muscles to stand out in relief in both the motion studies and the outdoor photographs used for paintings. In a pinch, a figure could be posed in full sun in an interior, as was done in catalogue number 335.

Eakins took many more photographs of outdoor male figures than he subsequently used in paintings and drawings. There are shots of himself (and Susan Macdowell, whom he married in 1884), astride a horse (cat. nos. 409, 410, 416–18); views of a tall, lanky model heaving a large rock (cat. nos. 363–65); and odd, affected images of himself and his student J. Laurie Wallace with their hands behind their heads, preening on a beach (cat. nos. 379, 380). While his male students had no qualms about stripping down in the wild, Susan was the only female who dared do so. There are no outdoor images of nude men and women together, and virtually no such groupings in indoor shots. In three interior photographs, however (cat. nos. 348–50), Eakins and a young female model appear in the nude. One (fig. 33) shows Eakins holding the listless girl in a classroom cluttered with easels and a posing stand. This baroque, erotically charged scene of rescue or abduction, centered under the brightest natural light, is at once beautifully composed and remarkably inconsistent with Eakins's other painted and photographic work. Another photograph, generated from one negative but today discreetly cut into two prints (figs. 31, 32), shows a naked Eakins from the rear next to a young female model standing in front of the black screen used for his chronophotographs. Probably the same model who assumed a mask in the studies of walking and running (cat. nos. 442, 443), the girl here seems caught in a moment of rest. That she and Eakins were both wandering around nude at the site of the motion studies would have naturally raised questions about the propriety of these "scientific" experiments, which could have resulted in the subsequent splitting of the print.

Although many of these indoor and outdoor nudes were collaborative efforts—someone else exposing the plate in the case of the portraits of Eakins, or students shooting one another—they were all inspired by the master. Eakins's repeated recording of stationary and mobile figures of both sexes in indoor and outdoor settings combines the style of French commercial *académie* wholesalers with the neutral scientism of Etienne-Jules Marey and the neo-Greek nude studies of early pictorialist photographers. No single French photographer approached the breadth of treatment that Eakins gave the human figure. By 1890 his brother-in-law William Crowell could charge that "you, it seems to me, have set up the worship of the nude as a kind of fetisch [*sic*]."[82] To understand Eakins's dogged pursuit of the nude, we must turn ultimately not to Paris but to Philadelphia, where in the 1880s Europe confronted America.

SINGING THE BODY ELECTRIC IN PHILADELPHIA

The story of Eakins's dismissal from the Pennsylvania Academy of the Fine Arts in February 1886, presumably for showing a completely nude male model to the women's life-drawing class, has become legendary in American art history. Scholars concede that many factors contributed to his forced resignation: the growing dissatisfaction of a group of students regarding his teaching philosophy; occasional complaints from mothers about the emphasis on nudity and about students modeling for one another in the nude; Eakins's demands for a higher salary and loss of support on the board of directors after Fairman Rogers's withdrawal in 1883.[83] In the best explanation to date, Kathleen Foster pinpoints the rumors spread by one student, Alice Barber, who recounted posing nude for Eakins in his own studio, as well as accounts of improper behavior within the Eakins household, as significant reasons for Eakins's downfall.[84]

Almost entirely absent from the story, however, are considerations of public opinion in Philadelphia at the time. In the Eakins literature the city has generally been cast as conservative and prudish, just as the United States as a whole has been painted as intolerant of nudes in art. Eakins's role as heroic iconoclast, a man before his time, has often been implicitly attributed to his assimilation of French values and sexual openness. There is some evidence that even at the time of his dismissal, the approach that he had introduced at the Pennsylvania Academy was considered European: a student letter to the press reported that "Gerome, Cabanel, Bouguereau—in fact any French professor—would scoff at the idea of any one attending a 'Life Model Class' if the 'points' so necessary in gaining the correct movement, proportion and swing of the figure, were covered."[85] Other defenders protested that Americans were provincials with false modesty and that art students could not be subject to the same strictures as other people with less disinterested approaches to the human body.

The 1880s, however, were marked by repeated attacks on all that Eakins increasingly seemed to stand for. As the attacks spread, he became more outspoken, more committed to freedom of expression. Although he was always scornful of public opinion, the directors of the Pennsylvania Academy were not. Their concern about the appropriateness of Eakins's position as director of instruction was shaped by fears of legal as well as social reprisals.

In the aftermath of the Civil War, abolitionist and temperance energies were in many cases directed to new causes—the

declining moral standards in the country and the perceived growth of prostitution and the notorious "white slave trade." The most famous layman to take it upon himself to eradicate evil in the form of vicious literature, entertainment, and art was Anthony Comstock, a former dry-goods clerk. Comstock's rise to national prominence as the enforcer of the Comstock Law of 1873, which prohibited any "obscene" materials from passing through the U.S. mails,[86] depended on the infusion of money and backing that he received from many of the new American industrial and commercial barons. Men such as William E. Dodge, Jr. (a copper magnate, founder of Phelps Dodge, and president of the New York Y.M.C.A.), and Morris Ketchum Jesup (a merchant, banker, railroad financier, founder of the New York Museum of Natural History, and future president of the New York Chamber of Commerce, who advanced Comstock $650 early in his campaign) used philanthropy to promote social stability and counter the lowered productivity bred by "vices." Many of the same men promoting Comstock were involved in the New England Society for the Suppression of Vice, founded in 1873: the first president was Samuel Colgate, who headed his family's soap business in New Jersey; the vice-presidents were Dodge and Alfred Barnes, a textbook publisher; and the treasurer was Kiliaen van Rensselaer, heir of the famous Hudson River patroon family.[87]

With such powerful friends, Comstock began a sweeping seizure of offensive books, photographs, contraceptive devices, and persons involved in their production and distribution. An 1874 Y.M.C.A. pamphlet claimed that 194,000 obscene pictures and photos had been seized.[88] Comstock himself published in 1880 a table itemizing 202,679 obscene images, 7,400 "microscopic pictures for charms, knives, etc.," and 1,700 obscene negatives among the mass of materials that he had confiscated during the course of some 140,000 miles traveled outside New York City.[89]

In his many published books and pamphlets, Comstock carefully explained the dangers of such pictures: "The effect of this cursed business on our youth and society, no pen can describe. It breeds lust. Lust defiles the body, debauches the imagination, corrupts the mind, deadens the will, destroys the memory, sears the conscience, hardens the heart, and damns the soul."[90] Expounding in *Traps for the Young* on "artistic and classical traps," Comstock revealed his criteria for acceptable public art and pointedly distinguished between paintings and photographs:

Is a photograph of an obscene figure or picture a work of art? My answer is emphatically, No. A work of art is made up of many elements that are wanting in a photograph of the same, precisely as there is a marked difference between a woman in her proper womanly apparel and modest appearance, and when shorn of all these and posed in a lewd posture. Because we are above savages, we clothe our nakedness. So with a work of art as compared to a copy. . . . The lines of beauty, the mingling colors, tintings, and shadings, all seem to clothe the figures by diverting attention from that which, if taken alone, is objectionable. . . . What is the difference, in point of morals or decency, between a photograph of a nude woman in a lewd posture, with a lascivious look on her face, and a photograph of the same form and the same expression, taken from a piece of canvas? It is the original picture which represents the skill and talent of the artist.[91]

Figure paintings were dangerous in their own right and should be shown only to cultivated audiences in museums. Photographs (even photographs of paintings), however, had no redeeming aesthetic virtues.[92]

Comstock's fanatical pursuit of cheap crime novels, obscene art and reproductions, and advocates of free love was not

an isolated, aberrant, right-wing assault but part of a national movement. Close to home in Eakins's Philadelphia, Comstock found a kindred soul in the person of Josiah W. Leeds, a Quaker and former grammar-school history teacher who had been active in the early 1870s in the peace movement and the Prohibition Party.[93] Like Comstock, Leeds directed his reformist energies to lewd entertainment, such as the can-can dancing in variety halls fed by the 1876 Philadelphia Centennial Exhibition, and to penny papers for boys that glamorized crime and the underworld. He shared Comstock's taste for pamphleteering and published "Concerning Household Games and Gambling" (1883), "The Theatre" (1884), "Concerning Printed Poison" (1885), and "Simplicity of Attire in Relation to Social Purity" (1886).

During the 1880s Leeds and his sympathizers extended their public-relations campaign against immoral behavior to actual criminal charges. In 1881 Leeds went after a Philadelphia firm, R. C. Brown and Company, that used enticing young women in advertisements. In his irate reply to Leeds, Brown charged that the images were not prurient: "We defy you or anyone else to point out to us any obscene point in our card and we deny that the mere exposure of limbs in our advertisement is sufficient to precipitate any sound minded person into dissipation. . . . We don't know who or what you are, but it is quite evident you have never seen certain masterpieces of paintings and sculpture which are to be seen even in this country."[94] By 1884 Leeds had begun petitioning the City Council to prohibit the sale of pernicious literature in public buildings and demanded that all newsdealers be required to have permits. In September 1884 he pointed out an objectionable poster on Sansom Street, and in December one of his followers publicly criticized "things to be seen in the window of a museum on Chestnut Street, above Seventh. No one surely wants the female members of our families nor anyone else to see those things."[95]

The founding in 1885 of a Citizen's Representative Committee of Philadelphia (popularly known as the Moral Committee of One Hundred), led by the Reverend J. Gray Bolton, paralleled stepped-up arrests of persons who threatened moral principles. In May 1885 Leeds had William Gilmore of the New Central Theatre arrested for posting indecent pictures of women in tights. Gilmore was convicted and sentenced in October. The following year Leeds went after photographs of female tobacco workers that were included in all boxes of five hundred cigarettes. Referring to Comstock's writings, he claimed: "I am not opposed to art or the nude in art, but the line is so fine that only those educated in art can appreciate where beauty ends and vulgarity begins."[96]

Another target of Leeds's indicting glance was sports, particularly competitive and intercollegiate games. In 1883 he wrote, "I have nought to object to such employment, within reasonable limits, whether it be in the way of running, leaping, ball-playing, rowing or similar bodily exercises. It is simply to that abuse of skilled athletic practice, which has led to those competitive inter-collegiate and other matches."[97] Two years later he asked Mayor William B. Smith of Philadelphia to stop the McCaffrey-Sullivan boxing match and succeeded in getting it canceled with the help of the district attorney, George Graham.[98]

Considering the difficulty of controlling access to art so that only the cultivated might see it, Leeds and his mentor, Comstock, were suspicious of all aesthetic products. After examining bound reproductions of the 1878 Paris art exhibition,

Leeds found the book so "filled with illustrations of the decidedly sensuous, that I felt sure it could only be rightly treated by burning."[99] In March 1887 he managed to get a law passed prohibiting lewd pictures, defined as representations of the "human form in nude or semi-nude condition" but "not to be confused with purely scientific works written on the subject of sexual physiology or works of art."[100] The problem was, of course, distinguishing "art" from lewd pictures. Leeds had the saloon owner Robert Steel arrested in 1888 for displaying *The Temptation of Saint Anthony* by Louis Garnier in his establishment at Broad and Chestnut streets. The painting was one of two life-sized depictions of nude women decorating the bar. After Steel argued that the work had been exhibited in the Paris Salon, Leeds observed that "Parisian art was no criterion for art in this city."[101] His words echoed those of Comstock, who had written him in 1887 to warn that the new issue was "whether the lewd and indecent [pictures] of the Salon of Paris may break from their bonds, cross the water and debauch the minds of children of this country."[102]

Thomas Eakins never mentioned either Comstock or Leeds, but, as a Philadelphian, he had to know and be outraged by their campaigns. His brother-in-law William Crowell, in a letter chiding Eakins for making his pupils pose in the nude, feared that his own children under Eakins's tutelage might pick up "that to me exceedingly offensive agglomeration of pettiness that is called 'Bohemianism,' less respectable even, I think, than Comstockery because harder in its subjects to get rid of."[103] Crowell's positioning of Comstockery as unrespectable is telling, in that it shows his unwillingness to ally himself with such an extreme camp. But his fear of bohemianism, which he identifies with Eakins, is equally crucial, placing the artist among the freewheeling opponents of Comstock and Leeds.

The major group that coalesced to stop Comstock and the moral-purity movement that he embodied was the National Liberal League, which held its founding convention in Philadelphia in 1876. The league's major goal was the separation of church and state, but it defended all attacks on the Constitution, including Comstock's attempts to limit free speech. Made up of freethinkers, the league was also in favor of women's suffrage and, in its more radical factions, included communists and promoters of free love. Robert G. Ingersoll, America's most respected atheist, was a member, as were the publisher D. M. Bennett and Ezra Heywood, a socialist leader of the New England Free Love League based in Princeton, Massachusetts. Other opponents (and targets) of Comstock in the 1870s included Victoria Claflin Woodhull and Tennessee Claflin, two outspoken advocates of equality for women, free love, and communism, who managed a New York brokerage firm and edited *Woodhull and Claflin's Weekly*.[104] In the pages of this radical journal they published the novels of George Sand, interviewed Karl Marx, championed women artists, and encouraged women to enter politics.

Although Eakins was not one to join social movements, he shared many traits with the anti-Comstock faction. Anticlerical, open to the latest in foreign ideas, he probably sympathized with the sexual frankness that marked many of Comstock's enemies. *The Human Body—The Temple of God; or, the Philosophy of Sociology* (1890), a compilation of lectures given by Woodhull and Claflin from 1869 to 1877, noted that "only those are ashamed of any parts of the body whose secret thoughts are impure" and "when there is purity in the heart, it cannot be obscene to consider the natural functions of any part of the body, whether male or female."[105] These words echo those of Eakins, as does the text of R. T. Trall's controversial *Sexual*

Physiology—a book for which the author was arrested repeatedly. Its clinical discussion of male and female sex organs and their functions was accompanied by an argument that sex should be pleasurable to both partners and that women had the right to accept or refuse sexual activity.[106] What Eakins thought about sexual practice is not known, but his behavior and advocacy of equal training for women artists suggests a rather advanced attitude.[107]

During a time when the medical establishment was split on many social-purity issues, a doctor who was one of Eakins's best-known friends was involved in an early debate that pitted science against the upholders of moral order. In the early 1870s controversy over the regulation of prostitution, in which several prominent physicians spoke out in favor of the adoption of the French system of legalization and control, Dr. Samuel Gross emerged as a leading Philadelphia regulationist. He was opposed by Dr. Harriet French and several Quaker members of the Moral Education Society of Philadelphia.[108] Given the fundamentalist nature of the debate, there is reason to speculate that many of Eakins's other scientific acquaintances shared his aversion to the promoters of moral purity.

By the newspaper clippings that he saved, we know that Eakins was aware of the outrage being provoked by nudity in art throughout English-speaking countries. A story in the *Philadelphia Evening Telegraph* on November 12, 1878, reported that Liverpool papers had attacked an exhibition including nudes in paintings, specifically Sir Lawrence Alma-Tadema's *Sculptor's Model* (1877). The painting, known today only through a photogravure, depicted a frontal, full-length nude woman with an all-too-contemporary facial type and hair-do, posing on a raised platform in the foreground for an intent, toga-clad sculptor. In response to the controversy, a paper defending "The Nude in Art" was read at the Social Science Congress at Cheltenham. Claiming that the human form was the standard of all beauty, the speaker remarked that "in French art there have been questionable nude figures exhibited; but the fault was not that they were nude, but that they were the portraits of ugly, immodest women."[109] Heartened by such overseas defeats of prudery and surrounded by friends who were well-known scientists and artists and who undoubtedly considered Comstock and his followers to be crackpot extremists, Eakins underestimated the political clout that the promoters of moral purity were able to muster in his hometown.

The Pennsylvania Academy of the Fine Arts apparently could not afford to ignore local public opinion. Leeds and his followers may or may not have exerted direct pressure on Edward H. Coates, chairman of the Committee on Instruction, in 1886, when Eakins was fired (no evidence survives in documents suggesting their complicity), but they certainly complained in 1891, when the Academy's annual exhibition included depictions of several provocative nude women. A group of "Christian women" protested in February "an offense to womanhood, an attack on the delicacy of our daughters and the morality of our sons."[110] Later that month Leeds himself wrote to Coates and claimed that the offensive paintings by William Dodge, Alexander Harrison, and others were as improper as the large canvas in Steel's saloon that had been removed after the establishment was threatened with the loss of its license. Citing his successful arrest of the manager of the Variety Theater for exhibiting "vile posters," Leeds insinuated that the display of nakedness at the Pennsylvania Academy could be used by such criminal entrepreneurs as a way to justify their own exhibits of nude bodies.[111] Several Philadelphia officers of the local Social Purity Alliance then wrote to the Academy's board of directors on March 7 and called for women on the

exhibition committee, removal of offensive works from the permanent collection, and resistance to the nefarious influence of foreign literary and artistic movements. Claiming that they were not objecting to all presentations of the human form, "a work of God" that is "essentially beautiful and pure," the writers protested "the so-called 'realism' which portrays figures suggestive, not of any ideal truth or sentiment, but only of the fact of nudity."[112] Far from being the fanatics that Eakins may have thought them to be, local followers of social purity included leading Quakers, the dean of Swarthmore College, and the president of the Pennsylvania Society for Prevention of Crime and Vice, as well as a host of philanthropic leaders who must have constituted a notable part of the Pennsylvania Academy's funding base. The only surprising thing about Coates's dismissal of Eakins was that it did not come earlier.

If any proof were needed that Eakins aligned himself with liberal factions in Philadelphia both before and after his tenure at the Pennsylvania Academy, it could be found in the subjects that he chose to make the focus of his art. As vociferously as Josiah Leeds and Anthony Comstock attacked nudity, prize fighting, theaters, ballet, Sunday bathing, French art, Walt Whitman, and honesty in regard to bodily functions, Eakins championed them in paint and photography. The human body, whether sedated under the scalpel of Dr. Gross, relaxing in Arcadia, lounging by a river, or stretching in a boxing ring, confronts the viewer with all its strengths and faults, its bulging biceps and bony elbows. Selecting a medium identified with unvarnished truth, Eakins used the camera to celebrate the variety of the "most beautiful of Nature's works," as he wrote in his defense in 1886. The body, which Woodhull and Claflin called the "garden of Eden,"[113] was similarly for Eakins the symbol of a purer life before the Fall—a world in which men and women had lived without the weight of sin and false modesty.

NOTES

1. Kathleen A. Foster and Cheryl Leibold, *Writing about Eakins: The Manuscripts in Charles Bregler's Thomas Eakins Collection* (Philadelphia: University of Pennsylvania Press for Pennsylvania Academy of the Fine Arts, 1989), p. 237.

2. Interview in *New York Evening World,* 1913; cited in Heywood Broun and Margaret Leech, *Anthony Comstock* (New York: A. and C. Boni, 1927), p. 17.

3. In Mark van Doren, ed., *The Portable Walt Whitman* (New York: Penguin Books, 1983), p. 133.

4. Marcus A. Root, *The Camera and the Pencil* (New York: D. Appleton and Company, 1864), p. 26.

5. Thomas Eakins to Fanny Eakins, January 8, 1867, Pennsylvania Academy Archives.

6. Thomas Eakins to Benjamin Eakins, May 24, 1867, collection of Mr. and Mrs. Daniel W. Dietrich II, photocopy in Thomas Eakins Research Collection, Philadelphia Museum of Art (hereafter referred to as PMA).

7. Thomas Eakins to Caroline Eakins, June 28, 1867, Pennsylvania Academy Archives.

8. According to Lloyd Goodrich (*Thomas Eakins* [Cambridge, Mass.: Harvard University Press for National Gallery of Art, Washington, D.C., 1982], vol. 1, p. 21), Eakins claimed that he bought Gérôme's photograph the night after the master first critiqued his work.

9. About Gérôme, Eakins wrote: "Gerome is a young man as you see by his photograph, that I have sent, not over 40. He has a beautiful eye and a splendid head. He dresses remarkably plain. I am delighted with Gerome." (Quoted in Goodrich 1982.) As for Bonnat, he explained: "He has a queer shaped head and looks as if he might be anything at all from a philanthropist to a murderer. His forehead is very low but it is very wide and behind his head is high." (Thomas Eakins to Caroline Eakins, September 8, 1869, photocopy in PMA.) In using the language of Johann Kaspar Lavater and the more recent phrenological system developed by Franz Josef Gall and Johann Gaspar Spurzheim, Eakins was a typical man of his time. In both Europe and the United States, the correspondence between exterior physical traits and moral temperament was not challenged at a popular level until the twentieth century.

10. The Couture portrait is listed in Eakins's account book, March 1868, PMA, acc. no. 49–84–1.

11. This may be the carte de visite formerly in the collection of Gordon Hendricks (now in the Pennsylvania Academy) and reproduced as plate 242 in Hendricks's *Photographs of Thomas Eakins* (New York: Grossman Publishers, 1972). Eakins records the name and address of Carjat et Cie., a well-known commercial firm, in the account book now in the PMA. The style of Hendricks's plate 242, however, is not that of Carjat, who typically took standing, three-quarter-length portraits.

12. Thomas Eakins to Benjamin Eakins, January 16, 1867, Lloyd Goodrich collection, photocopy in PMA.

13. Thomas Eakins to Benjamin Eakins, December 19, 1867, collection of Mr. and Mrs. Daniel W. Dietrich II, photocopy in PMA.

14. Thomas Eakins to Fanny Eakins, undated, private collection, photocopy in PMA.

15. These included, in 1866, a view of an elephant (2 francs), "photo études académiques" (8 francs), "Groupe d'atelier" (4 francs), "photo nature" (4 francs), "photo paysage" (1.20 francs), "photos académiques" (6 francs), "photo femmes turques" (10 francs); in 1867, 50 francs worth of photos; in March 1868, 7 francs for stereos and a 3-franc study of a camel; in 1869, four life studies (8 francs), photos from nature (4 francs), and a landscape (.80 francs). (Eakins's Paris account book, 1867–68, PMA.) See also Thomas Eakins to Benjamin Eakins, March 17, 1868; Thomas Eakins to Caroline Cowperthwait Eakins, August 30, 1869; and the Spanish notebook, undated pages but probably from the beginning of his Paris stay (Pennsylvania Academy Archives).

16. Archives Nationales (hereafter referred to as AN), Paris, F[18]* VI 53–54. I also wish to thank Bernard Marbot, curator of nineteenth-century photography at the Bibliothèque Nationale in Paris, and André Le Cudennec, curator, and Bernard Garnier, director, of the Archives de la Préfecture de Police in Paris, for assistance in procuring the French nude studies illustrated in this essay.

17. AN, F[21] 655.

18. On this point I disagree with Robert Peck ("Thomas Eakins and Photography," *Arts Magazine* 53 [May 1979], p. 113), who claims that "the French school was quite progressive in comparison to American art academies of the same period" in its use of photographs. His reference to Eugène Delacroix's interest in photography in fact weakens his argument. Delacroix was the consummate Ecole des Beaux-Arts and Académie outsider. His attitude toward photography was not altogether positive, despite his copies of Eugène Durieu's images. In 1855, for example, he cautioned against using the daguerreotype as an artistic dictionary because it was only a mirror that gave certain details more importance than they merited. See Anne McCauley, *A. A. E. Disdéri and the Carte de Visite Portrait Photograph* (New Haven, Conn.: Yale University Press, 1985), p. 179.

19. Henri Delaborde, "La photographie et la gravure," *Revue des Deux-Mondes* (April 1856), p. 617. Except where otherwise stated, translations are mine.

20. Charles Blanc, *Grammar of Painting and Engraving* (New York: Hurd and Houghton, 1874), p. 319.

21. Quoted in "Mayer et Pierson c. Betbéder et Schwabbé, Cour de cassation—28 novembre 1862," *Annales de la propriété industrielle,*

artistique et littéraire (1862), pp. 419–33. The other artists signing the petition were Philippe Auguste Jeanron, Luigi Calamatta, Henri Félix Emmanuel Philoppoteaux, Eugène Modeste Edmond Lepoittevin, Constant Troyon, Alexandre Bida, Joseph Louis Hippolyte Bellangé, Charles François Jalabert, Philippe Rousseau, Ernest Augustin Gendron, Eugène Louis Lequesne, Eugène Isabey, François Louis Français, Charles Emile Hippolyte Lecomte-Vernet, Pierre Puvis de Chavannes, Vincent Vidal, Louis Gabriel Emile Lassalle, J. Bourgeois, Jean Baptiste Adolphe Lafosse, Emile Jacques Lafon, and François Hippolyte Lalaisse.

22. "Rapport de M. Dufresne sur les modèles propres à l'enseignement du dessin," *Bulletin administratif du Ministère de l'Instruction Publique,* no. 133 (1867), pp. 179–90. These models were intended for children, lycées, and colleges and schools of ornament.

23. *Des modèles de dessin* (Paris: Goupil et Cie., 1868).

24. L. J. van Péteghem, *Histoire de l'enseignement du dessin depuis le commencement du monde jusqu'à nos jours* (Brussels: A. Mertens et fils, 1868), p. 145.

25. Théophile Gautier, "Gérôme, tableaux, études, et croquis de voyage," *L'Artiste* 3 (1856), p. 23; quoted in Gerald M. Ackerman, *The Life and Work of Jean-Léon Gérôme* (London: Sotheby's, 1986), p. 44.

26. A description of this trip, including numerous references to photographing with dry collodion plates and to the sophistication of Egyptian picturesque "types" in stopping photographers, is provided in Paul Lenoir, *The Fayoum or Artists in Egypt* (London: Henry S. Kine and Company, 1873).

27. *Eadweard Muybridge, The Stanford Years, 1872–1882* (Stanford, Calif.: Stanford University Museum of Art, 1972), p. 99.

28. For more about young artists' use of photographs during the Second Empire, see McCauley 1985, chap. 6.

29. Thomas Eakins to Benjamin Eakins, October 1867, Pennsylvania Academy Archives.

30. Thomas Eakins to Benjamin Eakins, January 30, 1868, Pennsylvania Academy Archive.

31. The commission consisted of the painters Delacroix, Ingres, Flandrin, Jean Louis Ernest Meissonier, and François Edouard Picot; the sculptors Pierre Charles Simart and François Jouffroy; Ravaisson; Jean Hilaire Belloc, the director of the Ecole de Dessin; the architect Joseph Louis Duc; Gustave Pilet; and a M. Brongniart. Ingres and Jouffroy did not participate, and Meissonier suffered "a cruel accident" that curtailed his involvement.

32. Félix Ravaisson, *De l'enseignement du dessin dans les lycées* (Paris: P. Dupont, 1854), p. 63.

33. Ravaisson 1854, p. 74.

34. AN, F^{12} 6902.

35. AN, F^{12} 6902.

36. For a more detailed discussion of the use of photographs in the teaching of industrial design, see Anne McCauley, "Photographs for Industry: The Career of Charles Aubry," *J. Paul Getty Museum Journal* 14 (1986), pp. 157–72.

37. For example, Goodrich 1982, vol. 1, p. 22.

38. Quoted in Barbara Weinberg, *The American Pupils of Jean-Léon Gérôme* (Fort Worth: Amon Carter Museum, 1984), p. 30.

39. Quoted in Gordon Hendricks, *The Life and Work of Thomas Eakins* (New York: Grossman Publishers, 1974), p. 54.

40. Quoted in Goodrich 1982, vol. 1, p. 31.

41. Walt Whitman, "I Sing the Body Electric," in Mark van Doren, ed., *The Portable Walt Whitman* (New York: Penguin Books, 1983), p. 133.

42. Thomas Eakins to Benjamin Eakins, May 1868, quoted in Goodrich 1982, vol. 1, pp. 28–29.

43. In the Spanish notebook now in the Pennsylvania Academy Archives, Eakins jotted down some of the racy couplets he heard:

"Si le mari doute/Que sa femme foute,/Qu'il prenne un crayon/Et qu'il marque au cou/La marque effacée/La femme est baisé/L'enfant est bâtard/Et le mari cornard." (If a husband questions/whether his wife is fucking/Let him take a pencil/And mark her ass/The mark is erased/The woman is laid/The child is a bastard/And the husband is a cuckold.)

44. Thomas Eakins to Fanny Eakins, April 1869, microfilm, roll 640, frames 1548–50, Archives of American Art. I am grateful to Robert Brown, of the Archives of American Art in Boston, for his assistance.

45. The problem of exposing for both shadows and lights is discussed by H. P. Robinson, who developed his technique of extensive composite photography using separate negatives for figures and landscape backgrounds to resolve it. See H. P. Robinson, *De l'effet artistique en photographie* (Paris: Gauthier-Villars, 1885). For more on this issue, see McCauley 1985, p. 135.

46. Hendricks 1972, p. 2.

47. H. H. Furness, *F. R., 1833–1900* (Philadelphia: private printing, 1903), unpaged.

48. John C. Browne, History of the Photographic Society of Philadelphia, microfilm, roll 3658, frames 915–55, Archives of American Art. This group included several of Eakins's friends, such as John and Samuel Sartain and James L. Claghorn, president of the Pennsylvania Academy from 1872 to 1884.

49. In 1878 Muybridge copyrighted and published six photographic cards of Leland Stanford's horses running in front of a white screen divided by vertical black lines into twenty-one-inch sections. Drawings (of the horse minus the rider) from this series also appeared on the cover of *Scientific American,* October 19, 1878. For a discussion of this series and the international reaction that it inspired, see Gordon Hendricks, *Eadweard Muybridge—The Father of the Motion Picture* (New York: Grossman Publishers, 1975), pp. 104ff.

50. The French anatomist Mathias Duval had already done this using E. J. Marey's data as a basis. See Etienne-Jules Marey, *La Machine animale* (Paris: G. Baillière, 1873), p. 143.

51. Goodrich (1982, vol. 1, p. 263) cited excerpts from these letters but implied that Eakins's note came after the Muybridge letter of May 1879. The contents suggest the reverse.

52. Reprinted in full in *Eadweard Muybridge,* 1972, pp. 117–19.

53. For a closer look at the contrast between Schuessele and Eakins, see Ronald Onorato, "The Context of the Pennsylvania Academy: Thomas Eakins's Assistantship to Christian Schuessele," *Arts Magazine* 53 (May 1979), pp. 121–29.

54. Rogers also defended the school against unspecified critics who charged it lacked variety in instruction, inasmuch as the nude was the main subject in the casts, dissecting room, and life classes. See his article "The Schools of the Pennsylvania Academy of the Fine Arts," *Penn Monthly* (June 1881), pp. 2, 3, 5.

55. Microfilm, roll P71, frame 878, Archives of American Art.

56. Microfilm, roll P71, frame 889, Archives of American Art.

57. Ellwood C. Parry III, "Thomas Eakins's 'Naked Series' Reconsidered: Another Look at the Standing Nude Photographs Made for the Use of Eakins's Students," *American Art Journal* 20, no. 2 (1988), p. 65.

58. Keen acquired Quételet's work in 1879 and had his assistant compile a large table of proportions from it. (Report to Committee on Instruction, May 10, 1879, microfilm, roll 4337, frames 327–29, Archives of American Art.)

59. Eakins as an anatomist consistently showed little interest either in the head or in a subject that appeared in almost all nineteenth-century anatomy texts and lectures—the representation of the passions and facial expressions. Keen himself included this topic in his lectures at the Pennsylvania Academy and knew about the use of photographs by Darwin and Duchenne de Boulogne to ex-

plore expressions and the facial muscles involved. Eakins's paintings, including his portraits, do not depict figures with anything other than calm, relaxed faces, which probably accounts for his indifference to this category of anatomy instruction.

60. Published in *Photographer Thomas Eakins,* exhib. cat. (Philadelphia: Olympia Galleries, 1981), fig. 45. A drawing by Eakins in the collection of the Pennsylvania Academy (see fig. 18) is similar to the aforementioned but has no annotations.

61. Quoted in Parry 1988, p. 72.

62. Albert Boime, "American Culture and the Revival of the French Academic Tradition," *Arts Magazine* 56 (May 1982), pp. 97–98.

63. J. A. Fau, *The Anatomy of the External Forms of Man* (London: H. Baillière, 1849), vol. 1, p. 69.

64. Marey 1873, p. 121.

65. Fau 1849, p. 72.

66. Félix Giraud-Teulon, *Principes de mécanique animale* (Paris: J. B. Baillière et fils, 1858), p. 76.

67. Giraud-Teulon 1858, p. 150.

68. Lists of books in the library collection, Pennsylvania Academy Archives. In his annual report of April 2, 1878, Keen listed "Gray's Anatomy, [Jean] Cruveilhier's Anatomy, [Charles] Darwin on Expression, [Guillaume-Benjamin] Duchenne de Boulogne, Harlin's Plastic Anatomy, [Benjamin Robert] Haydon's Lectures, [Pierre Nicolas] Gerdy's Anatomy of External Forms, and Salvage's cast of the Gladiator" as purchases. (Microfilm, roll 4337, frames 323–26, Archives of American Art.)

69. Quoted in *Eadweard Muybridge* 1972, p. 117.

70. Masks do not appear in European photographic *académies,* but the models in explicit pornographic images often cover their faces with skirts or arms.

71. In those rare *académies* taken by artists themselves, such as the Durieu plates copied by Delacroix, nude men appear.

72. H. Lecoq de Boisbaudran, *L'Education de la mémoire pittoresque et la formation de l'artiste* (Paris: H. Laurens, 1913), p. 47. The author also encouraged artists to study a horse in a field (p. 50).

73. Idem, *Coup d'oeil sur l'enseignement des beaux-arts* (Paris: Vve. A. Morel, 1872), p. 40.

74. Idem, *Lettres à un jeune professeur—Sommaire d'une méthode pour l'enseignement du dessin et de la peinture* (Paris: Vve. A. Morel et Cie., 1876), p. 74.

75. Félix Régamey, *Horace Lecoq de Boisbaudran et ses élèves* (Paris: H. Champion, 1903).

76. Lecoq de Boisbaudran 1876, p. 49.

77. Quoted in Goodrich 1982, vol. 1, pp. 25–26.

78. Plate 9 shows Susan in an identical pose but in a mostly shady setting. The mottled light and shadow in this photo made it unacceptable as a source for a painting.

79. Eakins probably used cat. no. 384 as the basis for the seated man on the right side of his 1883 relief sculpture *Arcadia*. Although the pose is not identical, the treatment of the figure's left pelvic region and left biceps seems inspired by the pattern of light and shadow in the photograph.

80. I disagree with Goodrich (1982, vol. 1, p. 241), who argued that the figures were "photographed in action" with unplanned attitudes.

81. Quoted in Goodrich 1982, vol. 1, p. 270.

82. William J. Crowell to Thomas Eakins, April 10, 1890, Pennsylvania Academy Archives.

83. Goodrich 1982, vol. 1, pp. 281–87.

84. Foster and Leibold 1989, pp. 69–90.

85. H. C. Cresson to *Philadelphia Evening Item,* quoted in Goodrich 1982, vol. 1, p. 289.

86. A federal law against mailing obscene books and pictures, passed in 1868, had been poorly enforced. See Anthony Comstock, *Frauds Exposed* (1880; reprint Montclair, N.J.: Patterson Smith, 1969), p. 389.

87. See Paul S. Boyer, *Purity in Print: The Vice-Society Movement and Book Censorship in America* (New York: Charles Scribner's, 1968), p. 5.

88. Quoted in Broun and Leech 1927, p. 153.

89. Comstock 1969, p. 435.

90. Comstock 1969, p. 416.

91. Anthony Comstock, *Traps for the Young* (1883; reprint Cambridge, Mass.: Harvard University Press, 1967) pp. 171–72.

92. In the pamphlet "Morals vs. Art" (1887), Comstock pursued this subject further and commented on the seizure in November 1887 of 117 photographs of works of living French artists from Knoedler's Gallery in New York. He claimed that he wanted not to suppress French art but to banish "cheap lewd French photographs." Reprinted in Comstock 1967, p. xxv.

93. Leeds papers, box 950, Haverford College Library, Pa. I thank the staff of the Rare Book Room at the Haverford College Library for research assistance.

94. R. C. Brown and Company to Leeds, dated April 12, 1881, in Leeds Scrapbook, vol. 1, Haverford College Library.

95. Clipping, dated December 10, 1884, ibid., vol. 2.

96. Clipping, dated June 21, 1886, ibid., vol. 3.

97. Comment, dated June 30, 1883, ibid., vol. 2.

98. Clipping, "Local Affairs," *Philadelphia Ledger,* April 1, 1885, ibid.

99. Clipping, "Dealing with Pernicious Prints," *Union Signal,* March 29, 1888, ibid., vol. 4.

100. "The Law against Lewd Pictures," *Daily Local News,* (Huntington, Pa.) June 22, 1887, ibid.

101. "Steel's St. Anthony," *Press,* January 17, 1888, ibid.

102. Anthony Comstock to Josiah W. Leeds, November 21, 1887, ibid.

103. William J. Crowell to Thomas Eakins, April 10, 1890, Pennsylvania Academy Archives.

104. Heywood, Claflin, Woodhull, and Bennett were all arrested by Comstock. Bennett was charged with selling and distributing Heywood's pamphlet *Cupid's Yoke* (1876). He circulated a petition opposing the Comstock Law and got 70,000 names. Heywood himself was arrested in 1877 for mailing R. T. Trall's *Sexual Physiology.* A meeting was held at Faneuil Hall in Boston on August 1, 1878, to protest his arrest, and he eventually received a presidential pardon. In 1882 Comstock arrested him again for *Cupid's Yoke* and a second tract, *The Word Extra,* which contained Whitman's poems "To a Common Prostitute" and "A Woman Waits for Me." Victoria Woodhull was arrested in 1872 for libelous exposure of the illicit love life of Henry Ward Beecher. See Broun and Leech 1927, pp. 82ff. and 177ff.; Sidney Warren, *American Freethought, 1860–1914* (New York: Gordian Press, 1966); and Comstock 1969, pp. 392–426.

105. Victoria C. Woodhull and Tennessee C. Claflin, *The Human Body—The Temple of God; or, the Philosophy of Sociology* (London, 1890), pp. 31, 33.

106. R. T. Trall, *Sexual Physiology,* 28th ed. (New York: M. L. Holbrook, 1881), pp. xi, 245.

107. His reported loose language and telling of off-color stories to his female students (to say nothing of the famous episode of dropping his trousers to make an anatomical point) could by modern standards be considered sexual harassment. But much of his

"scandalous" behavior is consistent with the open discussions of sexuality and the sex organs among both men and women that the progressive members of the National Liberal League advocated.

108. David J. Pivar, *Purity Crusade—Sexual Morality and Social Control, 1868–1900* (Westport, Conn.: Greenwood Press, 1973), p. 61.

109. "The Nude in Art," *Evening Telegraph,* November 12, 1878, Pennsylvania Academy Archives. Alma-Tadema's painting is reproduced in Vern G. Swanson, *Alma Tadema: The Painter of the Victorian Vision of the Ancient World* (London: Charles Scribner's, 1977), p. 22. Swanson says that the work was criticized by the Bishop of Carlisle as "mischievous" but does not cite the Liverpool controversy.

110. Letter to Committee of Selection, February 1891, Pennsylvania Academy Archives.

111. Josiah W. Leeds to Edward H. Coates, February 28, 1891, Pennsylvania Academy Archives.

112. William N. McVickar, president [rector of the Episcopal Holy Trinity Church in Philadelphia, 1843–1910]; Elizabeth B. Justice May, secretary; Joseph May [Unitarian minister], Mary Grew, and T. P. Stevenson, committee, for the Social Purity Alliance, to Edward H. Coates, William Baker, and other directors of the Pennsylvania Academy, March 7, 1891, Pennsylvania Academy Archives. McVickar and the Mays were members of the executive board of the American Purity Alliance in 1895. See Pivar 1973, Appendix A.

113. Woodhull and Claflin 1890, p. 34.

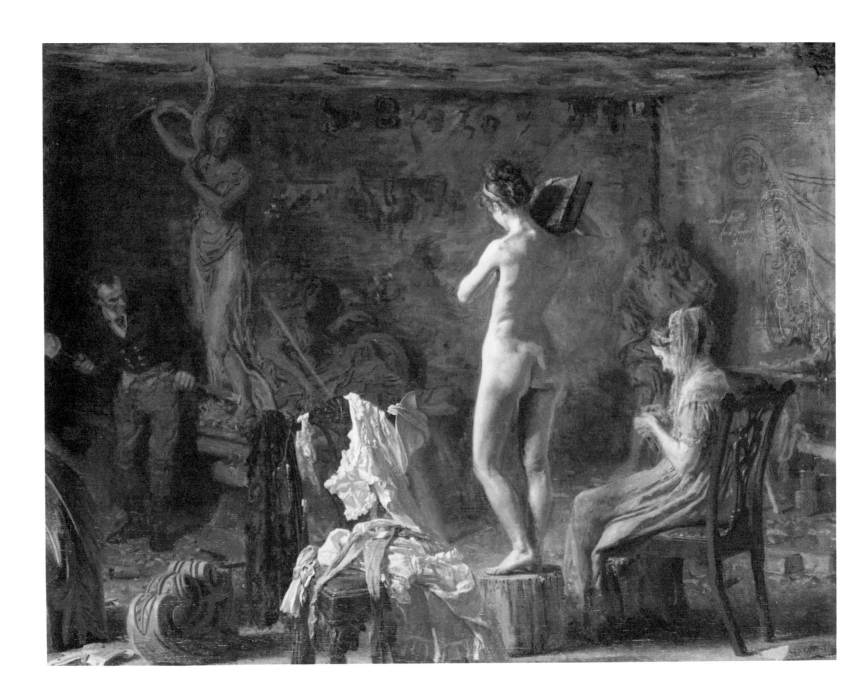

AN AVOWAL OF ARTISTIC COMMUNITY: NUDITY AND FANTASY IN THOMAS EAKINS'S PHOTOGRAPHS

ELIZABETH JOHNS

After interpreting certain photographs of his nude subjects, the common description of Thomas Eakins as a "scientific realist" no longer seems to apply. Like other artists of the period, especially in Europe, Eakins and his students took pictures in a climate of excitement about photography's relation to existing images, its technical means, and its uses for the study of the mechanics of the human body. Yet Eakins used photography also to explore the broader meanings of artistic community, bodily beauty, and fantasy—purposes that in only some instances can be subsumed under the category of study, as can the motion studies, the "naked series," and the *académies*.

About one-third of all photographs by Eakins in the Pennsylvania Academy of the Fine Arts, including negatives without prints, are of nudes.[1] Although this represents a substantial use of the camera by him and his friends to probe the implications of nudity, the nude subjects do not exist as a coherent body of work. Eakins did not catalogue his photographs, so we do not know how many he made. There are negatives (glass plates) for which no prints survive and, conversely, prints for which no negatives survive. More than a few of the images exist in several prints—albumen and platinum contact prints (some tattered by extensive handling, display on a wall, or mounting in an album), as well as enlargements in both media. The task of historians is complicated by the fact that after the death of Eakins's wife, Susan, many images were destroyed.[2] The issue of the nude in photography was delicate when Eakins took the pictures in the 1880s and 1890s, it continued to be so when his estate was inventoried after Susan died in 1938, and it persists as a controversy today.

That Eakins should have involved the nude in photography is no surprise, given his ambition as an artist. In the practice of painting, the nude human figure had been of central importance since the Renaissance, the sculpture of antiquity serving as its models. Artists were trained by first learning to draw from casts of antique sculpture and then by drawing or painting from models, who often posed in the repertory associated with classical sculpture. Nudity, through its major role in verbal texts both sacred and classical across the centuries, evoked complex and even overlapping associations from virtue and invincibility on the one hand to sensuality and shame on the other.

The human figure was a basic element in Eakins's training, first in Philadelphia and then in Paris. From the beginning

Figure 26. *William Rush Carving His Allegorical Figure of the Schuylkill River,* oil on canvas, 1876–77 (Philadelphia Museum of Art: Gift of Mrs. Thomas Eakins and Miss Mary Adeline Williams)

he aspired to understand the body completely, and he had clear ideas about how it ought to appear in art. During Eakins's student years in Paris, from 1866 to 1870, his teacher Jean-Léon Gérôme and such other popular Salon painters as Alexandre Cabanel and Adolphe-William Bouguereau frequently exhibited works involving women in the nude. Some of the paintings upheld the associations of nudity with virtue, and others exploited its carnal aspects. To pictures of this second type, Eakins had a violent reaction. A letter written home to his father expresses disgust at artists' disregard for the natural beauty of the human body, as portrayed by "naked women [in the Salon paintings], standing sitting lying down flying dancing doing nothing".[3] In his own career as a painter, he found it difficult to reconcile his respect for the body with his commitment to paint the realism of modern life, and thus he depicted the nude figure in only a few canvases. The first, in 1876—*William Rush Carving His Allegorical Figure of the Schuylkill River* (fig. 26)—involves the theme of the nude in the studio, a subject to which Eakins returned in 1908 (the version at the Honolulu Academy of Arts being especially close). Two later paintings with the nude, *Arcadia* (1883, Metropolitan Museum of Art, New York) and *The Swimming Hole* (ca. 1883, fig. 44), are related to his photographic projects and are discussed below.

When Eakins became a teacher himself, in the late 1870s, he placed the study of the human figure and deep respect for its materiality at the center of the curriculum of the Pennsylvania Academy of the Fine Arts. He encouraged his students to progress rapidly from the antique class to the life class, in which—at his insistence—they painted rather than drew from the live model. He discouraged drawing because "the outline is not the man; the grand construction is," and he wanted his students to be able to secure with the brush "the instant grasp" of it.[4] Once he had established himself as director of instruction at the Pennsylvania Academy, Eakins and the Committee on Instruction surveyed nine other art schools in the United States and two in Europe in order to characterize the Academy's curriculum. As a result, Eakins boasted in 1882 that the "course of study is believed to be more thorough than that of any other existing school. Its basis is the nude human figure."[5] Although at the time members of the committee supported Eakins's emphasis, his activities in achieving that emphasis aroused anxiety among other members of the Pennsylvania Academy community and eventually in the committee as well.

This alarm seemed to begin with discomfort at Eakins's practice of blurring the distinction between model and student. Frequently, instead of relying on hired models, Eakins had students pose nude for each other at the Pennsylvania Academy and for himself in his private studio.[6] Although this had a practical dimension, such a procedure—especially when it involved women—was likely to raise eyebrows. So potentially inflammatory was the subject that in 1883, when Eakins moved back into the household at 1729 Mount Vernon Street, he and his father made an explicit agreement that no one in the family had the right to question the artist's use of nudity in his studio.[7] In the Academy itself—a more public space—tensions were not so easily declared off limits. Some students raised such an outcry against their fellow students' serving as models that the Committee on Instruction intervened and forbade the practice.[8]

A more explosive source of the controversy about nudity and art study at the Pennsylvania Academy of the Fine Arts had its center in Eakins's use of the nude figure in photography. Soon after his appointment to the instructorship at the

Academy, he began to incorporate photography of the nude into the curriculum. He had been introduced to photography as an aid to the study of the figure while he was a student in Paris. The poses in European *académies,* or photographic prints of life studies, were typically those that models took in the life class, which were inspired in turn by the long tradition of images in painting and sculpting from the nude human figure. Eakins, however, saw photography of the nude as considerably more than the presentation of a static figure. For example, when the photographer Eadweard Muybridge conducted photographic experiments at the University of Pennsylvania in 1884 and 1885, Eakins joined him in creating a body of photographs that studied the human figure in motion. Even before his association with Muybridge, perhaps as early as 1880 but certainly by 1883, Eakins made photographic studies of nude figures in a series of seven poses that demonstrate the weight and construction of different body types. These images, now identified as the "naked series," helped students understand the figure as it moved through space.[9] (For examples of the naked studies and the motion series, see figs. 17, 45, 49, and 50.)

A major factor in Eakins's and his friends' pursuit of the nude in photography was that it created a sense of bohemian community and inspired fierce loyalty in his students. Nudity in anatomical study and in photography represented for Eakins his distinctiveness from the society in which he lived, a context in which he felt that pretentiousness and false modesty took the place of honesty. With nudity in the studio, especially in photography, he created an ambience that set himself and his followers apart not only from ordinary laymen but also from less thorough artists. He made students' acceptance of his attitude a carrying card for membership in his circle.

Eakins led his students in taking photographs that probe the expressive possibilities of the nude body. Many are studio photographs that convey—indeed create—a rich appreciation of collegiality in artistic practice. Unlike the naked series in that they reveal the entire process of posing and sketching, most of these photographs were made at the Philadelphia Art Students' League, formed after Eakins's dismissal from the Pennsylvania Academy of the Fine Arts. There, withdrawal from established authority—the shared purpose of a student-driven organization—fueled the enterprise. Plate 10 for instance, depicts a model front and back in a typical academic pose, the odalisque, but the photographs are not so much life studies as documentation of the serious work underway at the Art Students' League: a sketching male student (visible at the far left in figure 27) is an important part of the image.[10] That the model was photographed more than once (evident in the differences in the screen behind the model and the blanket on the platform) suggests that photographic studies had a recurring place in the artistic life of the group. Catalogue number 345 serves to make explicit the work taking place as the model poses: behind the male model, who stands on the bare floor, is a student at an easel (identifiable as George Reynolds); and the environment, including a cat stretched out on the floor near the easel, is clearly that of a working studio. Other photographs suggest that Eakins or some of the students made series to document thoroughly the poses of favorite models. Figures 28 and 29 capture different views of Tom Eagan, a sturdy, well-muscled figure, maintaining a contrapposto pose in front of a screen. The images study him from the left, the right, the back, and the front. Some of the humor that reputedly flourished in Eakins's working environments is evident here: in large letters on the screen behind this model is the word

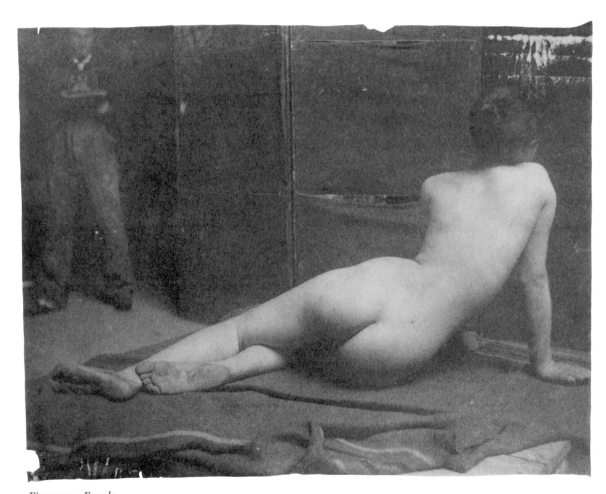

Figure 27. *Female nude semireclining, from rear,* ca. 1889, platinum print (cat. no. 273 [.501])

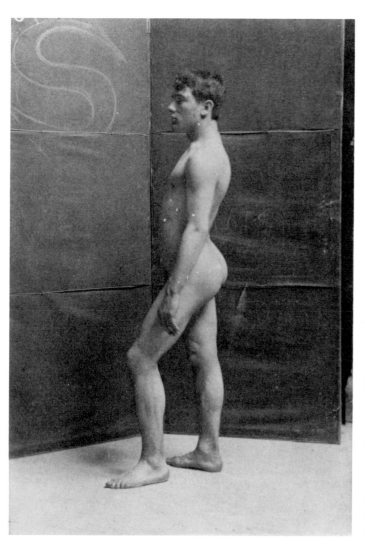

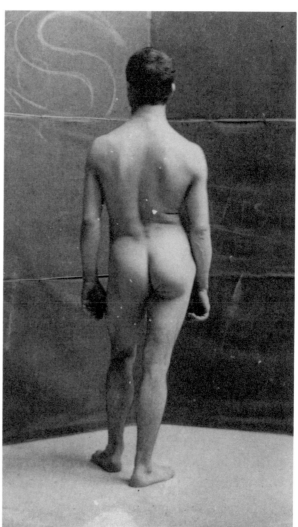

Figure 28. *Tom Eagan nude, facing left, in front of folding screen*, ca. 1889, platinum print (cat. no. 342)

Figure 29. *Tom Eagan nude, from rear, in front of folding screen*, ca. 1889, platinum print (cat. no. 344)

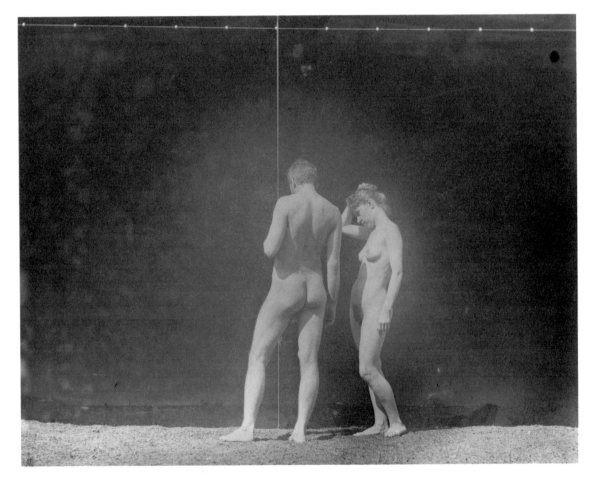

Figure 30. *Thomas Eakins nude and female nude, in University of Pennsylvania photography shed,* by circle of Eakins, 1885, modern print from dry-plate negative (cat. no. 390)

RATS. Elsewhere are conveyed the quiet moments of artistic community when no class was in session. One example is catalogue number 334, in which a male model sits on a hexagonal posing platform and toys with a small sculpture of a horse; another, catalogue number 335, shows perhaps the same model kneeling on the floor on one knee, caught in a brilliant rectangle of light that pours in from a window.

Collegiality in Eakins's studio meant that men and women posed nude together during photographic sessions and perhaps occasionally during regular modeling sessions—a practice that would certainly have scandalized the Pennsylvania Academy's directors as well as the Philadelphia public. Several images that have surfaced in the Pennsylvania Academy reveal a disregard for conventional propriety. Figure 30 depicts Eakins and a female model, both nude, in the shed that he built at the University of Pennsylvania in 1884 for his motion studies: the two figures stand against the black background as though consulting about the next pose. As we view Eakins with his back to the camera, the model standing beside him, turned slightly in his direction, the question occurs: Who took this picture? Did Eakins alternate with the other nude models in using the camera? Was he here demonstrating a pose that he would later assume himself? As a print, the image survives in two pieces rather than one, each half of the print showing only one of the two nude figures (figs. 31, 32). This alteration of the circumstances of the photograph confirms the socially charged nature of the nudity.[11]

Eakins's creation of an artistic community resistant to social authority is apparent also in photographs from the sculpture studio at the Pennsylvania Academy. Made at approximately the same period as his motion studies (before February 1886), these prints show a nude Eakins carrying a nude female model. In catalogue number 349 and in figure 33, Eakins carries the model in two distinct positions, revealing that he has lifted her twice, and then in catalogue number 350 he seems to lower her to the drop cloth on which he stands. Who was the photographer? Did he or she make the images in an atmosphere of high jinks? Or was Eakins improvising a kind of motion study? The placement marker on the floor between the artist's feet suggests that some kind of modeling had been going on. Yet the smile on his face reveals amusement that accompanied either the situation itself or the photographing of it. In light of the subsequent destruction of photographs, does this particular survival—of two plates and one print without a negative—suggest that men and women, posing in the nude, were simultaneously involved at the Pennsylvania Academy in devising and carrying out ideas for photographs? Whether they were, or whether this is an incident of conspiratorial horseplay among a limited few, it was perhaps rumors of such activity that contributed to the readiness with which the Academy dismissed Eakins when a student in a large life class lodged the verifiable charge that he had lifted the loincloth from a male model during a class session attended by women students and possibly men, as well.

That nudity was controversial in Eakins's photography seems confirmed by the fact that some students later interpreted their posing in the nude as having been carried out in an atmosphere of subtle coercion. Posing for the naked series, for instance, was problematic for some of the female models, who wore masks.[12] Students involved in less "scientific" modeling construed such posing in retrospect to have meant something quite different from study. One who reassessed her nudity was Alice Barber. Early in her career she had been so committed to study from the model that she painted *Female Life Class*

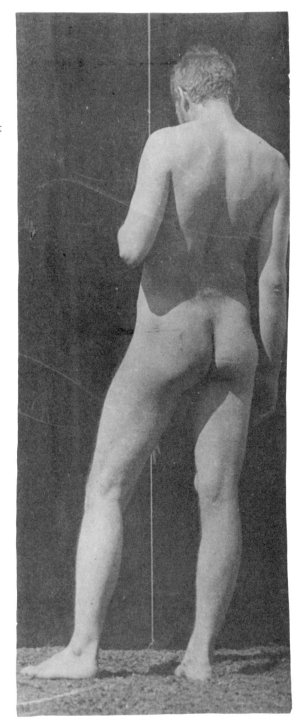

Figure 31. *Thomas Eakins nude, from rear, in University of Pennsylvania photography shed*, by circle of Eakins, 1885, platinum print (cat. no. 391)

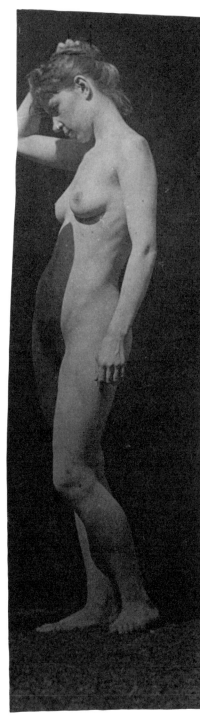

Figure 32. *Female nude, facing left, right arm raised, in University of Pennsylvania photography shed*, by circle of Eakins, 1885, platinum print (cat. no. 392)

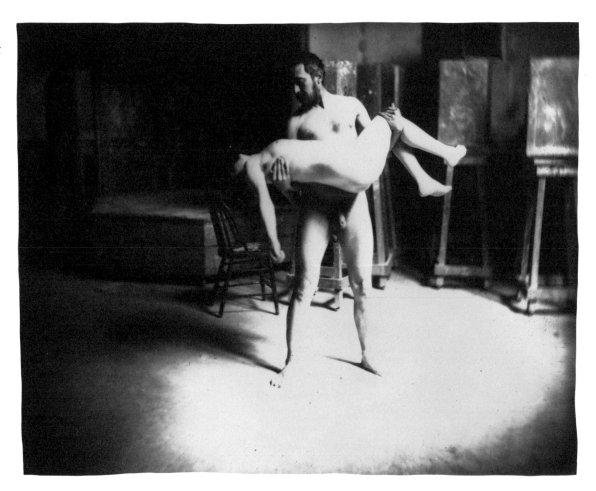

Figure 33. *Thomas Eakins nude, holding nude female in his arms, looking down,* by circle of Eakins, ca. 1885, modern print from dry-plate negative (cat. no. 348)

Figure 34. *Thomas Eakins nude, facing right, on his horse Billy,* by circle of Eakins, ca. 1890, platinum print (cat. no. 418 [.306])

(1879, Pennsylvania Academy of the Fine Arts) with Susan Macdowell in the foreground. Then, about 1883, Barber posed nude for Eakins in his studio. During the uproar of 1886, she, like a few other students, came to believe that her posing was of questionable appropriateness and spoke of it as evidence of Eakins's unsuitability as a teacher. Some of the young men had second thoughts, as well, or were encouraged to have them. Eakins noted that his student Jesse Godley, who "by his actions and words [over the] years admitted of no impropriety in the exposure of the living male form even to female eyes,"[13] was persuaded by an antagonistic group to complain that women should not have to dissect male cadavers without the genitals removed.

For his part, Eakins refused even to discuss the multiple implications of the nudity in his studio, whether for painting or for photography. At the outbreak of the accusations in 1886, he wrote to the chairman of the Pennsylvania Academy's

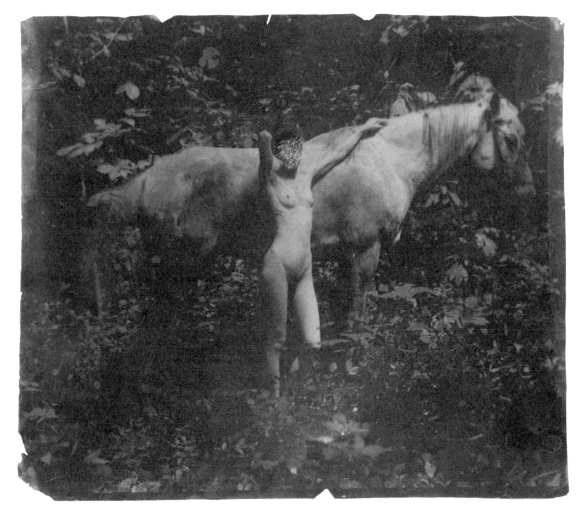

Figure 35. *Susan Macdowell Eakins nude, left arm resting on neck of Thomas Eakins's horse Billy,* ca. 1890, platinum print (cat. no. 407 [.547])

Committee on Instruction, Edward H. Coates, that the modeling at his own studio and at the Academy was conducted with "all the dignity which comes from serious thoughts." He also commented that at the time he taught her, Alice Barber had "motives as pure as my own."[14] Explaining his own willingness to be nude before his students, Eakins wrote to Coates: "If the exposure of the naked body for study purposes is improper, life classes should be shut up, but I maintain that art is refining rather, and I should have very little respect for any figure painter or sculptor man or woman who would be unwilling to undress himself if useful; yet by his presence in a life class would encourage a model to do it, holding it either a sin or degradation."[15]

Despite his matter-of-fact, even ingenuous front, Eakins seemed to relish the potential impropriety of such practices. Long after his dismissal from the Pennsylvania Academy, he shocked women sitters by suggesting that he would like them

to return after their portrait was completed and pose for him in the nude. Late in his life, during a visit to his studio by an elderly couple, Mr. and Mrs. James Mapes Dodge, Eakins showed them photographs of himself carrying a nude woman in his arms (possibly cat. nos. 348–50).[16] He seemed always to have been as he was in 1886, when a relative defended him as anything but "lewd, profligate, or depraved" but admitted that he was "a man whose notions of decorum are unpractical, impracticable and inexpedient."[17]

The bohemian community that Eakins created included his wife, Susan, who supported her husband's emphasis on nudity. She was a "capable photographer" even as a young woman, before she joined Eakins's circle, and for many years she assisted him in the making of photographs.[18] In the late 1880s the two of them may have taken a small group of highly unconventional photographs at Eakins's sister's farm in Avondale: images of each other nude with Eakins's horse Billy, which he had brought back from the Dakota Territory in 1887. The images of Eakins show him riding (fig. 34) while Susan is posed against the animal (fig. 35), as well as sitting sideways on it. What were they exploring in the imagery? In the pose of a very thin Susan with the horse, was the interest the poignant relationship between skeleton and muscle of two creatures no longer young? Or, more profoundly, were Eakins and Susan evoking the metaphorical implications of the horse as

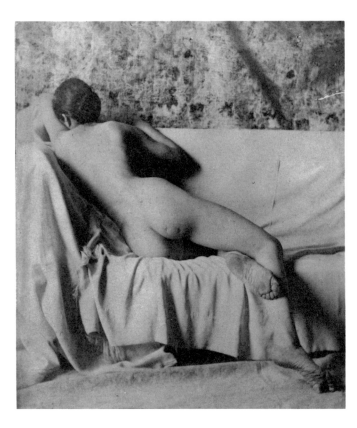

Figure 36. *Female nude semireclining, on draped couch, from rear,* by circle of Eakins, ca. 1885, albumen print (cat. no. 291)

nature, which, like women, was "ridden" and dominated by men? So potentially upsetting were the images that Susan's face was obscured in one of the negatives showing her posed against the horse (cat. no. 407).[19] Moreover, only one negative survives of these four images; the remaining prints were perhaps kept clandestinely.[20]

If one function of photographing in the nude was to vouch for—even to create—camaraderie, a variation on that theme was Eakins's and his students' exploration of a kind of androgynous beauty in both male and female figures. In the 1880s the slender, tall, and youthful body build was seen increasingly in women's fashions and the cultural revival of things Greek. This physique seems to have been extremely appealing to Eakins, though he himself was solid in build, even somewhat chunky by the time of the motion studies. He had chosen fiancées with slight figures, first Kathryn Crowell[21] and then Susan Macdowell; and his closest male students—John Wallace, Samuel Murray, and Charles Bregler—were all small in stature. That such slenderness was unusual in the period is suggested by photographs from other contexts. With only one or two exceptions, the models who posed for Muybridge had ample proportions; and to a certain extent, Eakins relied on similar models for his motion studies. Yet, while certain of the informal photographs made at the Art Students' League and the Pennsylvania Academy of the Fine Arts feature robust physiques (e.g., those of Tom Eagan, cat. nos. 341, 343, figs. 28,

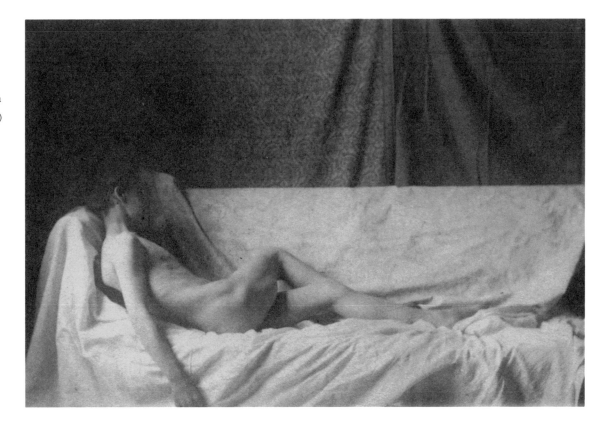

Figure 37. *Male nude reclining on draped couch,* by circle of Eakins, ca. 1885, albumen print (cat. no. 351)

29; and the female model in cat. nos. 295, 296), more of these photographs than not are of models who are slender. The portrayals of masculine and feminine are almost interchangeable: in figure 36 and catalogue number 292, a woman poses languidly on a covered couch that is placed against a drape[22]; the male model in a similar pose on the same couch (fig. 37) is surprising to modern viewers.[23]

In some instances the photographs explore the male aesthetic alone. In fact, there is a high proportion of nude men in the photographs by Eakins and his circle. As a student, Eakins had written his father, after visiting the 1868 Salon, that it would be refreshing to find a study of a male nude on exhibition.[24] Perhaps quite consciously, he used the camera (and to a limited extent the canvas, as discussed below) to make up this deficiency. With a number of photographs of Bill Duckett,[25] taken apparently at one photographic session, Eakins probed a delicate male beauty. In figure 38 and plate 2 he lounges on an oriental rug covered in part by a drop cloth and placed against drapery. The former shows him lying on his stomach, facing away from the camera and studying a vase of suggestive shape. The latter reveals full frontal nudity, with Duckett reclining on his side in a pose associated with Greek and Roman river gods. In figure 39 and catalogue number 339 he

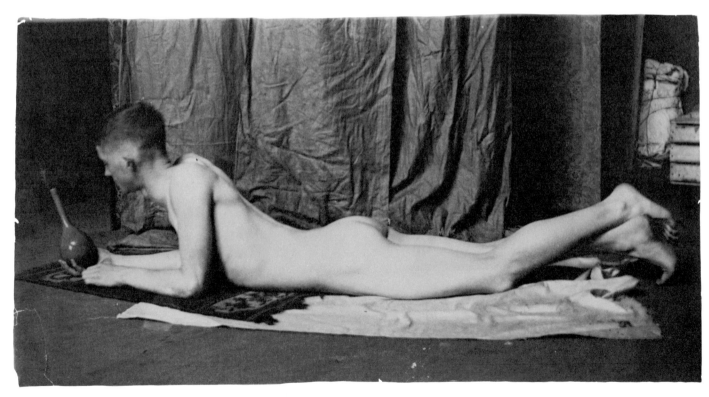

Figure 38. *Bill Duckett nude, lying on stomach, holding vase*, ca. 1889, platinum print (cat. no. 336 [.410])

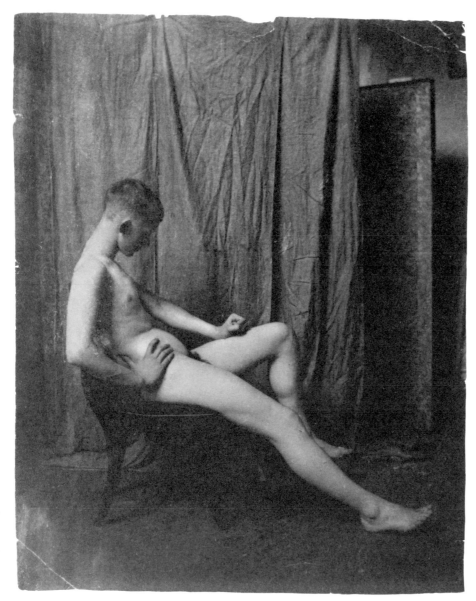

Figure 39. *Bill Duck-
ett nude, sitting on
chair,* ca. 1889, plati-
num print (cat. no.
338 [.418])

lounges on the edge of a chair in positions that flatter his boyish, long-limbed, soft sensuality. Duckett is photographed not so much from various study angles as in a variety of meditative poses. Although only two negatives survive in the Pennsylvania Academy of the Fine Arts, there are twelve prints of Duckett in various positions, testifying to the popularity of the images with Eakins's circle; some, such as catalogue number 337, were enlarged and printed in platinum.

Most provocative among Eakins's photographs of nude men is one of himself, made in his studio at 1729 Mount Vernon Street: plate 7 probes the possibilities of the photograph to interpret male attractiveness in the odalisque position, traditionally associated with women. Again, as with figure 30, we must wonder who took the photograph. Was it Susan (and, if so, before or after they had married)? A male student? Were there other photographs made during this session? In its formal and iconographic qualities, the photograph evokes meanings that the conventions of painting leave unexplored. Significantly, the negative that survives was squared off, as though for transformation into a lantern slide.

In addition to photographs that show the nude bodies of the inner circle at work and those that project androgynous and male beauty, a third group by Eakins and his students explores the very potential of photography to transcend reality with fantasy. At first this seems a contradiction in terms. The photograph appeared in the nineteenth century—indeed appears today—to present unmediated reality or at least the semblance of it. Thus the making of photographs—and the images produced—marks a substantial departure from image making with paint. Because the painted image of the nude is mediated by the perception of the artist and is in turn manipulated in pigment through brushwork, looking at paintings does not call for the acceptance of the image as something that actually took place. In the photographic print, however, the model seems removed from the viewer only by the accident of time.

This phenomenon offered—and still offers—great potential for the photograph as a vehicle of the expression of wishes or fantasies. With a camera present to inspire and record the activity, groups could invent scenarios in which the participants pretended to be someone else in some other time. The finished image records the bodies they inhabited—and thus in this sense, seems "direct" and "real"—but it also kindles memories of the fictive identity the group assumed at the moment the photograph was taken. Eakins's students practiced this in several contexts. At the Pennsylvania Academy of the Fine Arts and the Art Students' League, for instance, they dressed in classical costumes and posed in front of casts of antique sculpture, assuming identities of the past.[26] The personae they were encouraged to invent were brought to life again and again in the photographic print. Thus the photograph made possible a different genre of human meaning, one that existed only through the camera.[27]

Like many camera-club members, Eakins and his friends made at least two outdoor excursions with the purpose of generating such special images. As the term *excursion* implies, these events were meant to break the literal and psychological bonds of routine. Rather than photographing natural sites, as did most groups, the Eakins circle produced and recorded fantasies involving figures in the nude. The first known camera outing in which they made such reconstructions was in the summer of 1883, to Manasquan Inlet, at Point Pleasant, New Jersey, a popular tourist resort long familiar to Eakins.[28] Banded together for the special project was a small group consisting of Eakins, his student J. Laurie Wallace, and several of the

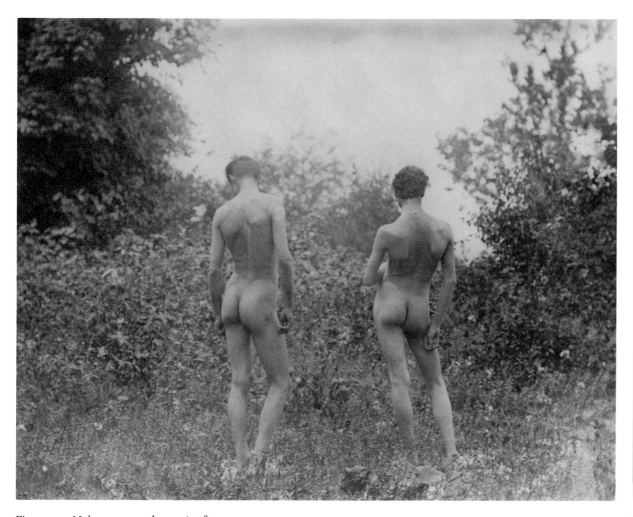

Figure 40. *Male nude and J. Laurie Wallace nude, from rear, in wooded landscape,* by circle of Eakins, ca. 1883, modern print from dry-plate negative (cat. no. 376)

Figure 41. The Belvedere Antinous, marble (Vatican Museum, Rome)

Figure 42. *Cast room at the Pennsylvania Academy,* by Charles Truscott, 1890s, platinum print, Pennsylvania Academy Archives

Macdowell brothers and nephews.[29] They withdrew to a spot on Manasquan Inlet that was momentarily isolated, perhaps by the time of day or the season, and there they made a series of photographs that re-create Greek poses and celebrate the male physique. Against backgrounds of a beach and a calm inlet and sea oats, sandy-growth shrubbery, and trees, the cast of five men (and an additional one who remained clothed) and at least one boy relived an era in which male friendship and beauty were celebrated throughout the Mediterranean. Eakins and his students made their photographs with the free spirit, and no doubt the express sanction, of his father-in-law, William H. Macdowell, an embosser, engraver, and photographer and an ardent admirer of the freethinker Thomas Paine.[30]

The photographs depict men and boys creating an idyllic present in terms of an idealized past. In some Eakins appears alone, as if he were an ancient Greek (cat. no. 367). In others two figures pose together, standing with their backs to the camera before a landscape of tall grass and bushes (see fig. 40). Figure 41 shows the contrapposto of classical statues long associated with male pulchritude, most prominently the Roman youth Antinous but also Apollo. Many of the photographs

taken outdoors, like the indoor ones, form sequences. Catalogue number 377 is a variation on 376, in which the figure on the right turns slightly, the person taking the picture having moved back. This suggests that a session was devoted to exploring a certain motif. Also quite similar is catalogue number 379, except that the two figures—one, Eakins himself and his student John Wallace—stand on a beach next to an empty boat. The photographs project the same mood: the figures do not look at each other; indeed, they turn slightly and look down as though in reverie. It is as if the tableau of two men, aware of each other's physical appeal at the same time that they self-consciously make a grouping for others to see, were meant to be variations on the female Three Graces. One of the photographs is of a young boy (cat. no. 356), and one (cat. no. 357) shows the boy with one of the older men, implying an aesthetic tradition into which boys are initiated.[31]

While most of the images are reflective, some capture physical action, as though the men were re-creating Greek athletic prowess. There are several scenes of a figure who seems to be about to throw a rock (e.g., cat. no. 363, photographed from the front; and cat. no. 364, photographed from the back). In a variation on this theme, a figure holds a flat rock above his head as though in triumph (cat. no. 365).[32] Other photographs show the figures enacting motion-implying motifs from antique sculpture. Catalogue number 366, for instance, shows a man seeming to extract a thorn from his foot, reminiscent of the Roman Spinario (1st century A.D., Capitoline Museum, Rome).

Most of the poses represent those of Antinous (see especially cat. nos. 374, 375, 379). The resemblance recapitulates the very conception of the body as beautiful, as an object for study, and as a form whose intellectual and emotional meaning is couched in its relationship to sculptures from antiquity. As William Vance has shown in his study of American travelers and artists in Rome, tourists throughout the nineteenth century admired sculptures that depicted the slender, androgynous ideal.[33] The cast and sculpture collection of the Pennsylvania Academy of the Fine Arts, with which Eakins and his students had daily contact, reflected this bias. Whereas the representations of women ranged from full-bodied Venus to lithe, virginal Diana, those of men emphasized slender, youthful grace.[34] In the collection were a number of variations on Adonis, Antinous, and Apollo, including the Apollo Belvedere. The sculpture collection (both plaster casts and marble) was brought to viewers' attention as a regular part of the annual exhibitions, and the text of the catalogues emphasized the images of Antinous. Of the one in the Vatican, for instance, the Pennsylvania Academy's catalogue informed viewers that "Nicolo Poussin drew from this figure, in preference to all others, his proportions of the human form." It gave even more detail about the Antinous of the Capitol: "Antinous was a beautiful youth for whom the Roman Emperor Hadrian entertained a strong affection, and many sculptors were employed to make statues of him, sometimes as Apollo, but more frequently simple portrait statues, like the one before us. The grace and modelling of this figure are such that it can only be praised in superlatives; it is not only beautiful, but beauty itself."[35] Other figures in the sculpture collection were the twins Castor and Pollux, who loved each other so fiercely that they could not bear to be separated in death (the catalogue did not remind viewers of the story, presuming their familiarity with it). The attractiveness of androgyny was highlighted by the prominence in the collection of the marble Sleeping Hermaphrodite (after the Roman Hermaphrodite of the second century B.C., in the Musée du Louvre, Paris), which was hailed by the catalogue as "so much esteemed by the ancients that many antique

repetitions of it have already been found."[36] A photograph of the cast room at the Pennsylvania Academy in the 1890s (fig. 42), made not long after Eakins left the instructional program, suggests the effect of these emphases. In a display that includes casts of the Belvedere Antinous, Diana of the Hunt, and the Apollo Belvedere, as well as the Faun in Rosso Antico, students are drawing from one of Pierre Puget's *Milo of Crotona.*

Eakins's and his friends' use of photography to allude to, even to create anew, classical ideals of male beauty and friendship put into practice the master's pedagogical principles. He spoke frequently of Greek sculpture to the larger body of his students at the Pennsylvania Academy. "I don't like a long study of casts," he said in an interview about his teaching philosophy, "even of the sculptors of the best Greek period. At best, they are only imitations, and an imitation of imitations cannot have so much life as an imitation of nature itself. The Greeks did not study the antique: the 'Theseus' and 'Illyssus,' and the draped figures in the Parthenon pediment were modeled from life, undoubtedly. And nature is just as varied and just as beautiful in our day as she was in the time of Phidias . . . our business is distinctly to do something for ourselves, not to copy Phidias."[37] The camera provided the very opportunity for Eakins and his circle to explore the variety and expressive potential of the male body; the two Antinouses would not have strolled along the Jersey shore (fig. 43) unless a third Antinous had been standing nearby with a camera.

Unusual as it may seem from today's perspective, this activity was part of a larger cultural tapestry. The tableau vivant, posed in a theatrical setting rather than in the open air, was common throughout most of the nineteenth century.[38] In the 1830–31 season the phenomenon came from England to the New York stage and before long Philadelphians took it up as well. Such theatrical enactments began in the United States as between-acts entertainment by horsemen and acrobats who depicted versions of popular paintings and sculptural groupings. Philadelphia theater bills show that presentations of actors and models as "living statuary" and in tableaux vivants continued until the turn of the century. In 1875, for instance, the offerings of Fox's American Theatre included Hiram Powers's *Greek Slave,* Antonio Canova's *Three Graces,* and Peter-Paul Rubens's *Nymphs Surprised by Satyrs.*[39] As director of instruction at the Pennsylvania Academy, Thomas Eakins hired acrobats as models, many of whom may have enacted these tableaux.[40] On less public stages, such entertainments flourished. Students at the Pennsylvania Museum School of Industrial Art presented "Classic Tableaux" at the Pennsylvania Academy of the Fine Arts on March 13, 1888, depicting such groups as Venus Victrix, Narcissus, Ceres and Proserpine, Bacchus and Ariadne, and Apollo.[41] Tableaux were a popular entertainment at parties, at least in the New York set, as we find in Edith Wharton's novel *The House of Mirth,* in which the guests' enactment of favorite pictures and sculptural groups is described as "giving magic glimpses of the boundary world between fact and imagination."[42] The attractiveness of the entertainment may have spurred the New York photographer Gabriel Harrison to produce his "descriptive daguerreotypes." Begun as early as 1851, these allegorical photographs include a picture of three young women called Past, Present, and Future.[43]

The nudity in the living allegories created by Eakins and his students was at least partially a declaration of their separateness from contemporary gentility. During the same period distressed city leaders complained that the living statuary to be seen in Philadelphia theaters bordered on obscenity. In 1888 the New Central Theatre welcomed the Night Owls, a novelty

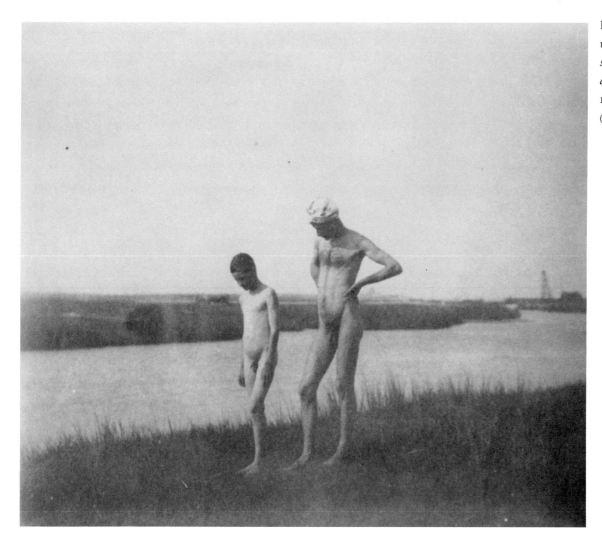

Figure 43. *Male nude, wearing head-scarf, and boy nude, at edge of river,* ca. 1882, albumen print (cat. no. 357)

and burlesque company that performed the play *Adonis, or the Sculptor's Studio,* "presenting twenty beautiful women, calcium light effects, handsome scenery, elaborate costuming and stage appointments, and the grandly perfect living statuary."[44] Such promises of grandeur on the playbill were interpreted by those unfriendly to the theater as evidence of vulgarity, as was William Gilmore's display of posters that depicted women in tights (see McCauley essay).

Perhaps bolstered by such public discomfort with nudity and near-nudity, Eakins and his friends treasured the photographs that kindled memories of their fantasy excursions. Eakins printed images for the participants soon after the photographs were made and also in later years. Those that were especially lively or meaningful were printed in platinum. These photographic studies were also used as studies for paintings, which may have served as a justification for excursions that otherwise would have seemed to cross the line into impropriety. From the Manasquan trip Eakins made a series of paintings that have come to be called Arcadia. In them the photographic studies occur in various configurations: within an idealized landscape, a nude man playing an *aulos,* or double flute; a young boy playing panpipes; and a woman, either nude or dressed in a chiton.[45] Whereas the photographs of all the male participants were made at Manasquan (including the boy playing the pipes),[46] Susan, the only woman to appear in the paintings, was photographed nude at Eakins's sister's farm in Avondale.[47] Eakins and his group seem to have treasured especially the nude images of Susan outdoors (plate 9, cat. nos. 300–307), for the Pennsylvania Academy of the Fine Arts has three negatives and a total of thirteen prints, two of which exist as enlargements (see cat. nos. 303, 307).

Another outing, to Mill Creek near Bryn Mawr in 1882 or 1883, would result in the Swimming Hole series. Whereas the camera activity at Manasquan was in a familiar place, the swimming and photography excursion to Bryn Mawr may well have been a unique trip and a different kind of photographic fantasy—one that re-creates the atmosphere of Plato's Academy. With Eakins buying special photographic plates and paying the carfare for some of the group, he and several students rode the train out to the creek.[48] An older man who was clothed vouched for the respectability of the activities, while Eakins posed his students swimming, boxing, playing tug-of-war, and in general enjoying the outdoors.[49] He clearly staged the photographs to represent youths—again, the associations are with the Greeks—in a variety of poses conveying beauty, fitness, and camaraderie. There were other emphases that Eakins and his students shared with Plato's Academy, which they may have expected the photographs to trigger: Eakins's devotion to the scientific exploration of reality, his interest in mathematics, his leadership of the group (indeed, his being "the Boss"), and the students' devotion to good health and fellowship. All recall the specialness, the elitism, of the old Greek way. Such a photograph as plate 3, with seven male figures variously posed on a rocky promontory, including one standing in an ideal pose, shows the self-consciousness with which the students assumed the positions. Rather than a random array of figures, the grouping displays a rhythm of limbs and torsos across the photograph that suggests the beauty of the classical body.[50] This image, which includes Eakins climbing out of the water, must have been the group's favorite; it exists in four known enlargements printed in platinum, two of which are in the Pennsylvania Academy. The Swimming Hole images, surviving in a variety of prints, would have been treasured by the participants and served as reminders of ideals and experiences held in common. The students' ideals were

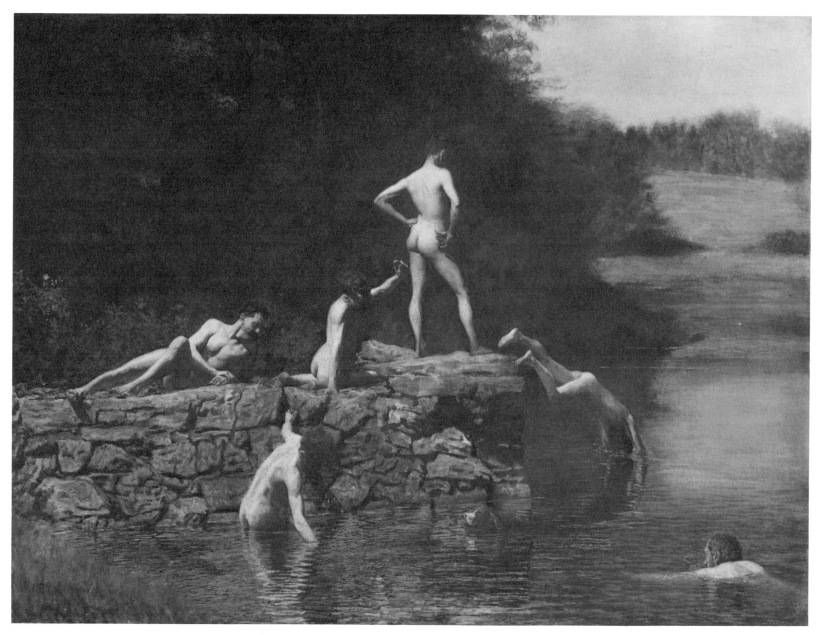

Figure 44. *The Swimming Hole,* oil on canvas (ca. 1883, Amon Carter Museum, Fort Worth)

not universally held, however, nor even widely understood. The extent of the general misperception became apparent after Eakins was commissioned by Edward H. Coates to paint *The Swimming Hole* (fig. 44)—a commission he may have had in mind when he undertook the excursion. No doubt because of Coates's position as chairman of the Pennsylvania Academy's Committee on Instruction, Eakins assumed he would have a sympathetic patron, knowledgeable about the implications of the work. In what must remain one of the great ironies of his career, Eakins found Coates to be taken aback when he was presented with the painting. Although he exhibited it as his property in the fifty-sixth annual exhibition at the Pennsylvania Academy in 1885, Coates exchanged the work soon afterward for another picture. Eakins noted tersely in his journal that the dour patron preferred *The Pathetic Song* (1881, Corcoran Gallery of Art, Washington, D.C.).[51]

There is no doubt that the photographs represented for Eakins much more than their survival would indicate. The most important evidence we have of the significance of nude bodies in his work is their communal display by Eakins and his friends during his lifetime. It was not unusual for artists to paper their walls with photographs of *académies,* of works of art, of artists and other figures they admired, and of friends. Several specific photographs and their arrangement on the wall of the Art Students' League, however (see figs. 8, 9)[52] seem to be anything but casual. Whether they were arranged by Eakins or by one of his students and whether the placement shifted or grew by increments and then stayed the same, we cannot know. However they came together, they appear to be at once a reference point for study, a statement about the philosophy of artmaking, and a creed about the meaning of the community of students.

The wall is covered with three groups of photographs. In the first, starting at the left, are two photographs flanking a long newspaper clipping. They show Eakins on the shore at Manasquan Inlet, photographed from the rear (the one on the left is similar but not identical to cat. no. 371; the image on the right is unidentifiable). Next are two photographs placed one above the other: on the top, a nude woman in a semireclining position seen from the front (plate 10); on the bottom one of the photographs of group nudity from the swimming excursion (plate 3). To the right of that pairing is a print of Eakins in a Pennsylvania Academy studio, holding a nude woman (fig. 33). Then comes a printed program and finally a print of a nude man holding a flat rock above his head (cat. no. 365), from the excursion to Manasquan.

The images in this first group highlight the meanings of nudity in the studio, as well as outdoors—nudity as a studio practice that sets artists apart from others and nudity as a re-creation of antique originality. The fantasy excursions extend the implications of the work in the studio. Do the newspaper clipping and the printed program reinforce this bohemian community? Does the program, for example, come from an annual dinner at the Art Students' League? Does the clipping report Eakins's forced resignation from the Pennsylvania Academy? Photographs and text might comprise both a narrative and a creed.

Images in the second group on the wall of the Art Students' League (fig. 9, left half) convey similar meanings. This group, separated only slightly in a continuum across the wall, is composed of four images. In the first (plate 6) Eakins and Wallace, both nude, pose in front of a boat at Manasquan Inlet. Next are two images placed one above the other. The print on the top is at present unidentifiable; the one on the bottom, from the swimming hole (cat. no. 394), is enlarged and

cropped to show only the figures. To the right of that pair is another outdoor photograph from the Manasquan excursion (cat. no. 376), showing two nude men from the back. In this sequence male camaraderie is the motif.

The final group, composed of seven images (fig. 9, right half), begins with a nude boy (cat. no. 356, made at Manasquan), cropped and enlarged. Next comes Susan Eakins as a standing nude outdoors, rear view (cat. no. 300). Then there is a group of three images one above the other: at the top, four mounted views of a nude man (possibly figs. 28, 29; cat. nos. 341, 343); in the center, Susan Eakins, seated nude on a white cloth in a pose taken outdoors at Avondale (cat. no. 303) and used for one of the Arcadia paintings; and at the bottom, an image that is indecipherable. To the right of this group and concluding the display are two nude men: Eakins at Manasquan with his hands poised above his knee (cat. no. 369) and a man in Eakins's photography shed at the University of Pennsylvania (cat. no. 388). In this group, as in the first, nudity of men and women in the studio and outdoors is employed as an avowal of artistic community.

Thus, photographs of nude subjects by Eakins and his students offer evidence of a richer, more complex artistic practice than we have previously understood. That Eakins was always a student of the body seems clear, but it is also the case that photography, in contrast to painting, made it possible for him to explore meanings about physical beauty—its history, its relation to gender, and the fantasy it inspires—that were unachievable in painting. For the camera, not for the brush, Eakins and his friends created and preserved connections between body, nature, and past ideals of beauty. The camera served this community by transcending time, bringing into being images of new relationships and giving them permanence. That our greatest realist would seem to have relished fantasy is implied by Mariana Griswold Van Rensselaer after a puzzling afternoon with Eakins in 1881: "He seemed to me much more like an inventor working out curious & interesting problems for himself than like an average artist."[53]

NOTES

1. I owe my confidence in this generalization to Cheryl Leibold, archivist at the Pennsylvania Academy of the Fine Arts, who in a letter to me of June 11, 1991, calculated the proportion of nudes in the collection by two methods—by the total number of photographs and negatives regardless of duplication and by the number of discrete images, eliminating duplication by prints.

2. According to Seymour Adelman, "Scores of [Eakins's photos of the female nude] were destroyed, soon after Mrs. Eakins' death in 1938, by a well-meaning but tragically misguided family friend." See introduction to *Thomas Eakins: 21 Photographs* (Philadelphia: Olympia Galleries, 1979), p. xiv; quoted in Lloyd Goodrich, *Thomas Eakins* (Cambridge, Mass.: Harvard University Press for National Gallery of Art, 1982), vol. 1, p. 246.

3. Thomas Eakins to Benjamin Eakins, May 1868; quoted in Goodrich 1982, vol. 1, p. 28. It is curious that Eakins apparently did not see the nudes of Gérôme as salacious.

4. William C. Brownell, "The Art Schools of Philadelphia," *Scribner's Monthly Illustrated Magazine* 18, no. 5 (September 1879), pp. 741; quoted in Goodrich 1982, vol. 1, p. 175.

5. Academy statement, quoted in Goodrich 1982, vol. 1, p. 187.

6. Eakins worked simultaneously and successively in several studios: from 1876 to 1884 his personal studio was on the third floor at the family home, 1729 Mount Vernon Street, but at the same time he photographed in the studios at the Pennsylvania Academy in his capacity as instructor of drawing and then director of instruction; from 1884 to 1900, his personal studio was at 1330 Chestnut Street, but after 1886, when he was fired from the Academy, he taught and photographed at the Philadelphia Art Students' League until about 1893. After 1900 his personal (and only) studio was a newly built space on the fourth floor of 1729 Mount Vernon Street. He may have made no photographs whatsoever after 1900.

7. Phyllis D. Rosenzweig, *The Thomas Eakins Collection of the Hirshhorn Museum and Sculpture Garden* (Washington, D.C.: Smithsonian Institution Press, 1977), p. 114.

8. For a detailed discussion, see Kathleen A. Foster and Cheryl Leibold, *Writing about Eakins: The Manuscripts in Charles Bregler's Thomas Eakins Collection* (Philadelphia: University of Pennsylvania Press for Pennsylvania Academy of the Fine Arts, 1989), pp. 74–79. An earlier sanction was recorded in the minutes of the committee on instruction for March 24, 1884.

9. Discussed in Ellwood C. Parry III, "Thomas Eakins's 'Naked Series' Reconsidered: Another Look at the Standing Nude Photographs Made for the Use of Eakins's Students," *American Art Journal* 20, no. 2 (1988), pp. 53–77. See also the McCauley essay in this volume.

10. A feminist reading would emphasize that a clothed student draws the model from the front, while the photographer, also clothed, makes an image from behind, thus trapping the woman in an objectifying male gaze. The photographer was not necessarily male, however.

11. The surfacing of the negative in the Pennsylvania Academy is welcome evidence of this aspect of Eakins's studio practice; it is undoubtedly only by accident that the negative survived.

12. The sculptor A. Stirling Calder, who was a student at the Pennsylvania Academy from 1886 to 1889, put the matter in perspective many years later: "At this time it was the custom for female models to wear black masks while posing nude. So odd to think of now, that while exposing the body that was usually covered, they covered the face that was invariably exposed." (Memoir of his student days, Pennsylvania Academy Archives.)

13. Thomas Eakins to Edward Hornor Coates, September 11, 1886, printed in Foster and Leibold 1989, p. 237.

14. Eakins to Coates, February 15, 1886, printed in Foster and Leibold 1989, pp. 214–15. In this letter Eakins alluded to a recent ruling in New York (in a case brought against John La Farge) that a figure painter's studies were his private property; the issue is discussed in *The Photographic Times and American Photographer* 15 (September 11, 1885), pp. 525–26, an article brought to my attention by Susan Danly. Kathleen Foster, whose analysis of Eakins's behavior has been invaluable in shaping my own, discusses the incidents and accusations related to Eakins's resignation in Foster and Leibold 1989, pp. 69–90.

15. Eakins to Coates, September 11, 1886, printed in Foster and Leibold 1989, p. 238. Eakins's participation in the naked-series studies proves his point: four series survive for which Eakins posed.

16. Goodrich 1982, vol. 2, p. 96.

17. William J. Crowell to John V. Sears, June 5, 1886; printed in Foster and Leibold 1989, pp. 230, 232. Crowell, Eakins's brother-in-law and fellow artist, identified the source of the gossip that surrounded the dismissal as another brother-in-law, the immature and vengeful Frank Stephens: "The knowledge of some harmless, or at worst, annoying breaches of conventional decorum has enabled a shallow, vindictive enemy, armed with a glib tongue, and ready cunning, to deal most damaging blows to reputation and happi-

ness" (p. 231). It was apparently Stephens who turned the Sketch Club against Eakins and humiliated him by insisting, when he was in fact not a member but only an instructor, that he "resign."

18. Seymour Adelman, "Recollections," in Susan P. Casteras, *Susan Macdowell Eakins, 1851–1938* (Philadelphia: Pennsylvania Academy of the Fine Arts, 1973), p. 12.

19. For discussion of publications by the gynecologist Augustus Kinsley Gardner that developed the implications of the metaphor of the horse, see G. J. Barker-Benfield, *The Horrors of the Half-Known Life: Male Attitudes toward Women and Sexuality in Nineteenth-Century America* (New York: Harper and Row, 1976), pp. 287–94.

20. In contrast, the motion studies exist primarily in negatives, proudly kept as records of study.

21. Eakins depicted her in *Kathryn* (1872, Yale University Art Gallery, New Haven).

22. The relation of these poses to an "art photograph" is suggested by the addition of a palm to the very similar pose of another slender female model in the same setting (see cat. nos. 293 and 294). Still another slim model is seated on a drop cloth in catalogue number 274.

23. The kneeling figures in catalogue numbers 261 and 354 provide another example of female and male models assuming similar poses; the latter figure bends forward over his knees in an unusual posture for a male model.

24. See McCauley's essay, note 39, for the source of the quotation.

25. The identification of this model was made possible by comparison with a photograph of Bill Duckett and Walt Whitman (Bayley Collection, Ohio Wesleyan University, Delaware, Ohio) generously provided by Edward Folsom, professor of art history at the University of Iowa. Duckett was close to the poet, who probably introduced the young man to Eakins; see Horace Traubel, *With Walt Whitman in Camden* (Boston: Small, Maynard, and Company, 1906), vol. 4, pp. 63ff.

26. Several examples of figures in classical costume are reproduced in *Photographer Thomas Eakins,* exhib. cat. (Philadelphia: Olympia Galleries, 1981).

27. For a valuable statement in this context, see David Green, "Veins of Resemblance: Photography and Eugenics," in *Photography/Politics Two,* ed. Patricia Holland, Jo Spence, and Simon Watney (London: Comedia Publishing Group, 1986), p. 10: "Photographic representations are not constructed first and then used, but as representations they are always constructed in use. Accordingly we cannot study photographs by methods which assign to them any meanings or values independent of their function within specific social contexts." In "The Politics and Sexual Politics of Photography," in the same volume, p. 1, the editors state insightfully: "[The photograph offered its practitioners] identities to inhabit, constructing and circulating a systematic regime of images through which [they could propose] the probabilities and possibilities of [their] lives."

28. From the late 1870s on, Eakins's family and his wife's, the Macdowells, had made vacation trips to this part of the shore via the ferry to Camden and the Jersey Central Railroad to Brielle. (See Gordon Hendricks, *The Photographs of Thomas Eakins* [New York: Grossman Publishers, 1972], p. 2.) The families took pictures of each other on the beach during the early years of these excursions and perhaps throughout their vacations together. (Catalogue number 180, for example, shows Eakins's sister Margaret on the beach. She died in 1882.) Years later, in reminiscence, Susan painted a landscape of Point Pleasant (*Landscape,* n.d., collection of Mr. and Mrs. Daniel W. Dietrich II, Philadelphia).

 The assignment of 1883 as the date of the excursion is my own, based on Eakins's use of poses and motifs in a series of 1883 paintings now referred to as the Arcadia images. I have identified Manasquan Inlet as the site for the photographs based on my own familiarity with it, as well as its proximity to the vacation areas that the Eakinses and the Macdowells frequented.

29. Unlike the identification of John Wallace, which is secure, the identity of the Macdowell brothers and nephews is based on speculation—namely, resemblance of the figures to family photographs and to Eakins's portraits. Susan's brothers—William, Frank, and Walter—would have been thirty-eight, thirty-four, and twenty-nine in 1883, ages that are consistent with the figures in the photographs. Eakins painted portraits of Frank and Walter in 1886 and 1904, respectively.

30. Goodrich 1982, vol. 1, p. 221, gives an assessment of the senior Macdowell.

31. In these, as in figure 52 taken outdoors at the Avondale farm, the photography of nude children, an idea that startles us even today, is consistent with Eakins's use of the camera both to study the body and to create images with metaphorical resonance. Particularly surprising are catalogue numbers 308 and 309 of an African-American child posed on a couch as Venus. Like the children in other photographs by Eakins, she has qualities that reinforce his often-expressed admiration for the sheer wonder of the body. Nearby piles of clothing, as in catalogue numbers 322 and 323 (and evident also in some photographs of nude adults), indicate the spontaneity with which the images were made.

32. According to Phyllis Rosenzweig (1977, p. 105), these works suggest motifs from Antonio Pollaiuolo's engraving *Battle of Ten Naked Men,* an impression of which had been in the Pennsylvania Academy since about 1876.

33. William L. Vance, *America's Rome,* vol. 1: *Classical Rome* (New Haven, Conn.: Yale University Press, 1989), pp. 182–362.

34. Although the casts (many still in the collection) included figures associated with certain athletic activities, such as the Discobolus, the Fighting Gladiator, and the Wrestlers, there were apparently no representations of the muscular Hercules (with the exception of a torso) or of other powerful male figures from antiquity. Among recent images, however, Pierre Puget's *Milo of Crotona* (1671–83) was given an important place.

35. *Catalogue of the Paintings, Statuary in Marble, Casts in Plaster, Books, Prints, Etc., The Property of the Pennsylvania Academy of the Fine Arts* (Philadelphia: Collins, 1864), p. 25.

36. *Catalogue* 1864, p. 20. Holdings in the Pennsylvania Academy library in 1864, listed at the end of this catalogue, included *Engravings of Antique Statues* by R. W. Billings and *Statues Antiques* (Paris, 1804) by G. B. Piranesi.

37. Brownell 1879, p. 742; quoted in Goodrich 1982, vol. 1, pp. 173–74.

38. Apparently the creation of tableaux vivants was begun in some places as early as the sixteenth century. For a survey with historical background, see Jack McCullough, *Living Pictures on the New York Stage* (Ann Arbor, Mich.: UMI Research Press, 1983).

39. Playbills, Rare Book Collection, Van Pelt Library, University of Pennsylvania, Philadelphia.

40. Goodrich 1982, vol. 1, pp. 181–82. Photography of actors and acrobats in their work as living statuary was apparently not unusual: two photographs in the Pennsylvania Academy (cat. nos. 298, 299) depict an unknown nude actress on a small podium on a theater stage, her back to the audience. In their reportorial nature, such photographs are distinct from those by Eakins and his students.

41. Cheryl Leibold kindly brought to my attention the program, preserved in the Pennsylvania Academy Archives.

42. Edith Wharton, *The House of Mirth* (1905; reprint New York: Bantam Books, 1986), p. 128.

43. Alan Trachtenberg, *Reading American Photographs: Images as History, Mathew Brady to Walker Evans* (New York: Hill and Wang, Noonday Press, 1989), p. 66.

44. Playbill, Rare Book Collection, Van Pelt Library, University of Pennsylvania, Philadelphia.

45. The best-known painting is *Arcadia* (1883, Metropolitan Museum of Art, New York).

46. Thus I am relocating to Manasquan the photograph tentatively identified by Hendricks (1972, fig. 48) as Ben Crowell at Avondale. I think that the figure is instead a Macdowell child or friend.

47. The images bear close resemblance to photographs and painted studies identified unequivocally as having been made at Avondale Farm, such as figure 52.

48. An entry for July 31, 1884, in Eakins's journal under the heading "Swimming Pictures," lists expenses for "photographic equipment" and "carfare to Bryne Mawr & boat houses with 'Godley and brother'"; quoted in Rosenzweig 1977, p. 101 (inaccurately dated 1883; correctly given as 1884 in Goodrich 1982, vol. 1, p. 332, note 239:3). The location is the same as that in photographs of Mill Creek by John C. Browne in 1878 (Library Company of Philadelphia); see figure 6.

49. The present environment of Dove Lake, created when Mill Creek was dammed, includes a large grassy area with plenty of room for boxing and tug-of-war. Goodrich (1982 vol. 1, p. 239–41) suggested that the cast of characters in the photographs indicates that the images were made the same day as the swimming.

50. Here I disagree with those (e.g., Goodrich 1982, vol. 1, p. 241) who suggest that Eakins took the swimming pictures as "unintentionally posed candids" and *then* used them as studies for the painting *The Swimming Hole.* Two other enlargements of catalogue number 393 exist, one in the Hirshhorn Museum and Sculpture Garden, Washington, D.C. and the other in the J. Paul Getty Museum, Malibu.

51. Goodrich 1982, vol. 1, p. 332, n. 239:3. Coates was so unnerved by the photographs of nudes that Eakins had made at the Academy that he put eighty-five (presumably all he could find) in his safe-deposit box after the artist was fired.

52. I thank Cheryl Leibold for bringing this crucial piece of evidence to my attention. Here, as elsewhere, her expertise was invaluable.

53. Quoted in Lois Dinnerstein, "Thomas Eakins' 'Crucifixion' as Perceived by Mariana Griswold Van Rensselaer," *Arts Magazine* 53 (May 1979), p. 144; quoted in turn in Goodrich 1982, vol. 1, p. 198.

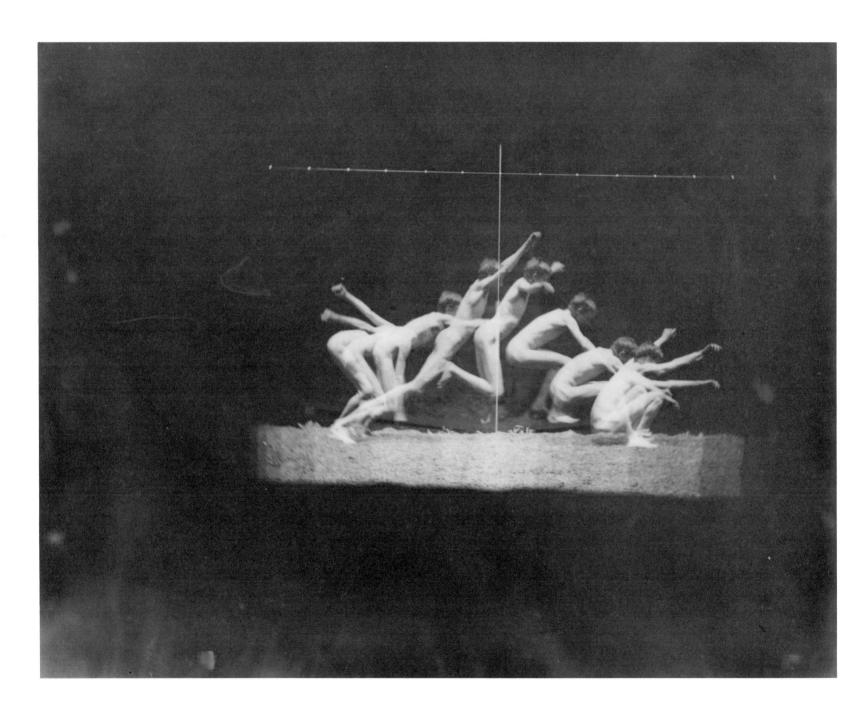

PHOTOGRAPHY, SCIENCE, AND THE TRADITIONAL ART OF THOMAS EAKINS

MARY PANZER

Art historians have long cited Thomas Eakins's photographic practice as proof of his taste for innovation. On closer scrutiny, however, his photographs reveal an unswerving (if idiosyncratic) commitment to a continuous tradition in the history of art. Eakins sought to forge a modern method built on the foundations of classicism. He used photographs to represent the world with the spontaneity and naturalness that he found in classical sculpture and so establish historical continuity with the artistic masters he most admired.

Eakins joined many conservative painters of his generation in employing photographic images to enhance vivid illusionistic canvases. These painters included P. A. J. Dagnan-Bouveret, Alfred Roll, and Jules-Alexis Meunier, who, like Eakins, studied with Jean-Léon Gérôme. They all learned to separate the formal strength of Gérôme's technique from the orientalist subjects for which he was best known.[1] Comparison of photographs with finished paintings suggests that Eakins turned to photography in order to render more convincing illusions. He used photographs to mimic spontaneous effects that had no equivalent in traditional figure study, such as the bleached shadows of bright fabric in sunlight or the apparently awkward position of muscles and limbs that resulted when familiar gestures were caught by the rapid shutter of a camera.

Despite his modern methods, Eakins's art remained highly conservative. He shared his contemporaries' belief in the power of art to evoke moral values, but he did not try to personify abstract virtues as toga-clad deities or noble peasants. Instead he followed the standards of physicians and scientists who sought to describe the existing world with ever-greater completeness. Eakins located the moral foundation of art in the unflinching representation of reality as it appeared to the naked eye. The world of science provided a method and a philosophy that enabled him to use photographic images to link the classical art that he admired with the art of the present. Eakins relied directly on the essays of the British intellectual Herbert Spencer and indirectly on the work of the French physician Claude Bernard, two prominent scientist-philosophers of the mid-nineteenth century.[2] In place of the rote study of antiquated philosophical texts, they proposed practical, laboratory-based investigation and direct observation of the natural world. Through their teaching they helped to establish a new standard of objectivity that valued observation and record without regard for moral precepts or social conventions.

Figure 45. *Motion study: male nude, standing jump to right,* 1885, modern print from dry-plate negative (cat. no. 449)

95

Today Spencer is usually linked to the popularization of Charles Darwin's theory of evolution; Bernard occupies a central place in the history of modern medicine. In their own time, however, these scientists reached a wide audience, and they addressed issues of broad concern, notably the contemporary demand for art that could represent such abstract principles as Truth and Beauty. Both men acknowledged that their methods were in direct conflict with prevailing standards of morality and taste. They argued that their innovations brought civilization closer to understanding the natural world and closer therefore to the Truth that their contemporaries sought. Spencer further believed that a modern understanding of Truth and Beauty would have practical economic applications that would improve industry, increase general prosperity, and propel Western civilization into a golden age.

By placing Eakins's words and pictures against this intellectual background, we can reconstruct the battle lines as Eakins and his contemporaries saw them in regard to such issues as the perception of beauty, the function of art, moral principles, and social good. Through Eakins's photographs historians can better appreciate the paradox of his career: that America's exemplary modern artist failed to produce modern art.

Figure 46. *Results at Excision of the Elbow Joint* from *Medical and Surgical History of the War of Rebellion*, pt. 2, vol. 2, by William Bell (Washington, D.C.: U.S. Government Printing Office, 1887; Otis Historical Archives, National Museum of Health and Medicine)

THE PHOTOGRAPHIC MILIEU OF PHILADELPHIA

Thomas Eakins's interest in photography clearly derived from his deep sensitivity to the visual world. All around him—in the schools, streets, and salons of Philadelphia—prevailing taste and fashion strengthened and challenged his innate curiosity. The curriculum at Central High School placed great emphasis on drawing skills. Following the work of Rembrandt Peale, Eakins's teachers equated the ability to draw with the ability to reason.[3] Philadelphia was an international center of commerce, its shops, theaters, magazines, hotels, and banks supporting an American incarnation of what has been called the "society of the spectacle."[4] As local museums exhibited art from across the nation and Europe, the city's industrial fairs displayed new machinery and prize-winning inventions. Merchants imported prints, books, and consumer goods from London and Paris and sold a wide array of local manufactures.[5] The banks issued paper money known for reliability and artful design. Philadelphia's intellectuals achieved national prominence for their empirical study in fields such as botany, microscopy, geology, and paleontology.

This community, with its taste for scientific endeavor, appreciation of art, and talent for making the most of new technology, embraced photography wholeheartedly. Local manufacturers produced fine cameras, lenses, chemicals, plates, and paper for the national trade; local publishers issued the nation's leading photographic journals; and local photographers formed one of the first amateur photographic societies in the country. Together they made Eakins's Philadelphia the photographic capital of America from mid-century through the Centennial Exhibition.[6]

Eakins and his contemporaries used photography in many ways. Photographs reproduced works of art, and stereo views

and lantern-slide shows entertained audiences at home and in public halls. Photographs also assisted illustrators of technical and popular journals and books, including those devoted to natural history, medicine, and other scientific topics. During the Civil War and after, innovative local physicians and surgeons developed new ways to apply photographic evidence to support research and education. For example, William Bell photographed injured Civil War veterans who had survived the surgeon's knife so that the army could weigh the merits of corrective surgery over amputation (fig. 46). In the early 1870s Francis F. Maury and Louis A. Duhring published *Photographic Review of Medicine and Surgery*—a journal devoted primarily to documenting the symptoms of syphilis, known as the Great Pretender for its ability to mimic other illnesses (fig. 47). The Philadelphia medical community welcomed these studies, which combined research in anatomy and physiology with experimental use of photographic documentation.

Figure 47. *Inherited Syphilis* from Francis F. Maury and Louis A. Duhring, *Photographic Review of Medicine and Surgery* 1 (1870–71), albumen print (Historical Collections of the Library of the College of Physicians of Philadelphia)

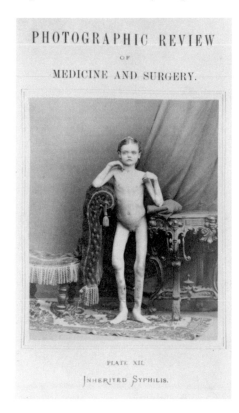

The most explicit demonstration of Eakins's interest in anatomy and scientific investigation can be found in three studies—all illustrating ways in which he used photography to assist his own work as an artist and teacher. The first, the "naked series," was undertaken privately in 1883 at the Pennsylvania Academy of the Fine Arts to provide for Eakins's students an anatomical record of the structure and variation in the human body. In 1884 and 1885 he worked alongside Eadweard Muybridge in the study of animal locomotion sponsored by the University of Pennsylvania. In 1894 Eakins investigated the function of the large muscles in the leg of a horse. This last study, especially, illuminates a great deal about Eakins's philosophy by discussing, if only briefly, the relationship between his work and that of the prevailing intellectual and cultural institutions.

In the spring of 1894, an address by Eakins to the Academy of Natural Sciences of Philadelphia—"The Differential Action of Certain Muscles Passing More than One Joint"[7]—concerned physiological experiments that he had designed (see fig. 48 and cat. nos. 464–68). Eakins undertook this investigation when he found himself dissatisfied with the conventional descriptions of the way in which muscles functioned. Through a dense, technical analysis, he reworked a favorite theme, showing how common assumptions impeded accurate investigation. Traditionally physiologists had described the function of muscles working in pairs, in opposition to one another—that is, flexors working while extensors rest. Eakins proposed that these muscles be studied "with relation to the whole movement of the animal. Then it will be seen that many muscles rated in the books as antagonistic, are no more so than are two parts of the same muscle."[8] Through his experiments and the photographic documents that record them, Eakins showed that careful firsthand examination could successfully challenge accepted theory. He showed also how art could establish strong ties between the present and the past, and revealed the test he used to evaluate his results. "On the lines of the mighty and simple strains dominating the movement, and felt intuitively and studied out by him," Eakins explained, "the master artist groups, with full intention, his muscular forms. No detail contradicts. His men and animals live. Such is the work of three or four modern artists. Such was the work of many an old Greek sculptor."[9] This conclu-

sion reveals goals that Eakins pursued throughout his career: to marshal detail in the service of an effective, convincing illusion of life; to ally himself with an elite group of modern artists; and to make art belonging to a tradition that could trace its origins to the sculpture of ancient Greece.

ANATOMICAL STUDIES

In Philadelphia opportunities for artists to study anatomy had existed since 1820, when an entrepreneurial physician opened the Philadelphia School of Anatomy. This unusual institution trained and employed several generations of Philadelphia physicians who attained national prominence, especially the surgeon, anatomist, and textbook author William W. Keen,[10] who later taught anatomy at the Pennsylvania Academy of the Fine Arts, and the surgeon and educator Samuel D. Gross, who was the subject of Eakins's most famous portrait. Eakins eventually painted portraits of many of these men.[11]

The Philadelphia School of Anatomy closed in 1875. Because anatomical study had become fully incorporated into the modern medical curriculum, a specialized institution was no longer required. At the same time, the importance of anatomy as a discipline increased as the vast growth in knowledge of infection and disease discredited much traditional medical training. Dr. Gross called anatomy "the cornerstone of the grand edifice of medicine" wherein students could "learn not from books, but from nature."[12] He also taught that anatomical study provided an essential bridge between past wisdom and present knowledge. He conceded that the power of modern discoveries made it easy to celebrate the present "as if all true science had been reserved as a kind of special gift to the present generation," but he cautioned against severing all connections with what had come before. Gross believed that a world without a past would be something monstrous, dark, and barbaric. He insisted that "the Past and the Present are one and indivisible."[13] Eakins carried this conviction with him as he applied his own experiments in modern scientific practice—including the practice of photography—to the making of art.

Through his friends and through libraries such as those of the College of Physicians and Jefferson Medical College, Eakins would have been able to see photography applied to advanced medical research. Most notable were the works produced by a group of French physicians, including the psychologist Guillaume-Benjamin Duchenne de Boulogne, the neurologist Jean-Martin Charcôt, and the physiologist Etienne-Jules Marey.[14] Duchenne de Boulogne hired Adrien Tourna-chon, an art photographer, to make records of his insane patients. Charcôt used the camera to measure the effect of electricity on the nervous system, and he also produced a three-volume photographic study of hysteria.[15] Marey put pathology aside and developed new photographic techniques to study the mechanics of a horse's gait and of birds in flight, as well as human locomotion.

In *The Birth of the Clinic,* the historian Michel Foucault organized a history of modern medicine around changes in methods of investigation, especially those used to observe patients. His study points out that detached observation of superficial symptoms was gradually replaced by intimate examination of the patient's body, in which all the doctor's

senses—hearing, taste, and especially touch—were used. The tactile qualities of the physician's examination came to be closely linked to the healing process.[16] Such tactile investigations colored Eakins's working style and his teaching methods, as seen in the use of sculpture and physical demonstrations in his own work and in the classroom. The new, close, and more physical relationship between doctor and patient was accompanied by a revised understanding of the relationship between all scientific practitioners and their subjects. Just as modern healers ceased to separate themselves from their patients, modern scientists included themselves in their research, observing their own reactions as part of the evidence.[17]

Both the public and the scientific community found it difficult to accept the wealth of information that this style of scientific investigation produced, in part because no single "correct" interpretation could justify the resulting mass of facts. More often, several possible explanations arose at once, and investigators competed for authority. "A cowardly assassin, a hero and a warrior each plunges a dagger into the breast of his fellow," wrote the physiologist Claude Bernard. "What differentiates them, unless it be the ideas which guide their hands? A surgeon, a physiologist and Nero give themselves up alike to mutilation of living beings. What differentiates them also, if not ideas?"[18] In his treatise on the philosophical education of a scientist, Bernard himself argued eloquently for the triumph of science despite its challenge to accepted standards of morality and decorum. His rhetoric makes poignant use of metaphor to explore problems that Eakins eventually faced in concrete form.

A physiologist is not a man of fashion, he is a man of science, absorbed by the scientific idea which he pursues: he no longer hears the cry of animals, he no longer sees the blood that flows, he sees only his idea and perceives only organisms concealing problems which he intends to solve. Similarly, no surgeon is stopped by the most moving cries and sobs, because he sees only his idea and the purpose of his operation. Similarly again, no anatomist feels himself in a horrible slaughter house; under the influence of a scientific idea, he delightedly follows a nervous filament through stinking livid flesh, which to any other man would be an object of disgust and horror. After what has gone before we shall deem all discussion of vivisection futile or absurd. It is impossible for men, judging facts by such different ideas, ever to agree; and as it is impossible to satisfy everybody, a man of science should attend only to the opinion of men of science who understand him, and should derive rules of conduct only from his own conscience.[19]

New styles of investigation endowed Thomas Eakins with methods and standards that differed from those his American audience had come to expect from its artists. More important, these scientific models inspired a profound confidence in the merit of his own beliefs.

MOTION STUDIES AND THE "NAKED SERIES"

Eakins's motion studies grew out of the project in which he assisted the photographer Eadweard Muybridge at the University of Pennsylvania.[20] Muybridge was well known for having devised a photographic method to resolve speculation over

whether all four hooves of a trotting horse ever leave the ground at once. They do. Following the publication of Muybridge's photographs in 1879, the public enthusiastically accepted his new evidence, and artists quickly changed their way of depicting horses in motion.

Early in the 1880s Muybridge sought to extend his project to all species of animals, including humans. Believing that such research furthered the university's "great function as a discoverer and teacher of truth," President George Wharton Pepper arranged to fund Muybridge's project.[21] In 1884 and 1885, under the general title Animal Locomotion, Muybridge recorded birds, mammals, and reptiles, as well as men and women of all ages. He observed his human subjects in various activities, mostly mundane—running, walking, climbing, dancing. The project's sponsors included the physiologist F. X. Dercum, who hoped to record the specific motion of various pathological conditions, such as polio and epilepsy, and the psychologist S. Weir Mitchell, who treasured memories of his early career in the Philadelphia School of Anatomy.

Eakins assisted Muybridge in finding models and in assembling the complex apparatus needed to photograph them. They arranged batteries of cameras along a track. After calculating the time needed for models to traverse the distance, they set an electric motor to trip the camera shutters at appropriate intervals. In the case of activities that were performed in one place—such as swinging a bat or kicking a ball—they timed the duration of the action. The procedure took many months to develop; and Eakins's student Thomas Anshutz, who also assisted in the early stages, despaired of ever gaining any results.

Muybridge's battery of cameras produced a series of individual negatives that were then assembled in sequence and printed together on a single collotype plate to create a complete visual record of one motion. Actions were frequently photographed from several points of view, and many plates represented a single gesture as it appeared simultaneously from side, front, and rear.

In describing the Muybridge project for Century Magazine, Talcott Williams conjectured that his readers would express outrage upon seeing familiar figures (such as the horse, dog, and men that illustrated his article) portrayed in rigid, often unflattering positions, like machines straining to "maintain balance in an awkward, illogical gait." He anticipated, however, that when the plates of Animal Locomotion revealed just what moving bodies actually looked like, the public would discard erroneous images in favor of ones that were anatomically and technically correct.[22]

Eakins constructed a separate shed on the university campus for taking his own still and moving pictures.[23] But he did not follow Muybridge in making individual pictures and assembling them in sequence. Instead Eakins experimented with various cameras and techniques to record motion on a single negative, according to methods first described by Etienne-Jules Marey.[24] Through a disk spun before the open lens of a camera, admitting light at a single point, a photographer could make successive exposures at rapid intervals. The device produced a new kind of visual record in which it was possible to observe changes that took place in the body throughout the execution of a single action, such as jumping, running, and walking (fig. 45; see also cat. nos. 436–63).[25]

Figure 48. *Differential-action study: Man on ladder, leaning on horse's stripped hind leg, while second man at left looks on*, 1885, modern print from dry-plate negative (cat. no. 465)

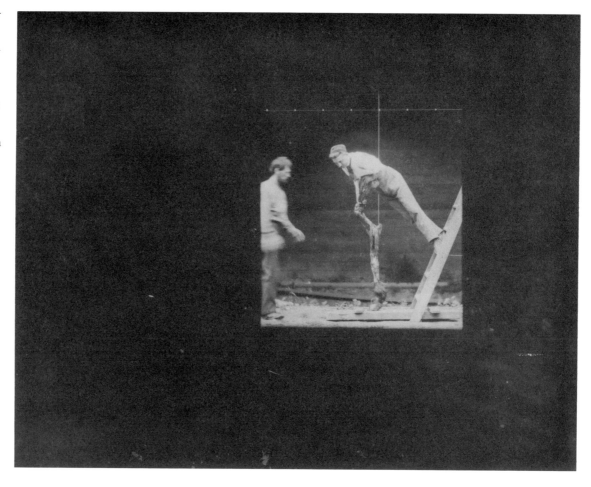

Motion studies by both Marey and Muybridge preserved a crucial distinction in presenting themselves as tools for artists, not art itself.[26] No one could have doubted that *Animal Locomotion* belongs to the realm of the useful, the educational, the scientific; its sponsoring committee of credentialed doctors, the encyclopedic subject matter, and the methodical representation of the human body indicates its scientific rigor notwithstanding the fact that many of its figures are nude or nearly so. Edward H. Coates referred to this delicate issue in the fall of 1886, when, in his role as chairman of the committee supervising Muybridge, he wrote somewhat cryptically to the provost of the University of Pennsylvania: "If the work is to be published at all the usual question as to the study of the nude in Art and Science must be answered Yes."[27] The committee's advertisement addressed Coates's concerns by describing the 781 plates as "nude, semi-nude, or draped," so that patrons could order accordingly.[28]

Coates's allusion to the "usual question" recalled the events surrounding Eakins's dismissal from the faculty at the Pennsylvania Academy of the Fine Arts, where Coates was also a director. Historians have come to believe that Eakins's "naked series" may have been one of the factors that contributed to the scandal. Why, if the committee for the University of Pennsylvania accepted Muybridge's photographs of nude models, did the directors of the Pennsylvania Academy reject Eakins's similar work? What ensured the propriety of Muybridge's figures in their scanty drapery, if the photographs of Eakins's nude models inspired alarm? Part of the answer is that Muybridge preserved the old-fashioned separation between the observer and the objects under investigation. *Animal Locomotion* assumed an audience of impartial investigators who would use the studies of naked men, women, and children to assist in their work.[29] These photographs provided tools with which artists could create more convincing illusions, and they sustained the dichotomy between science and art.

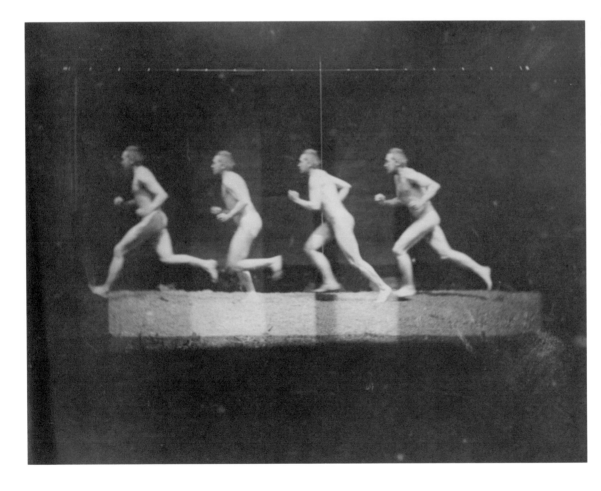

Figure 49. *Motion study: Thomas Eakins nude, running to left,* by circle of Eakins, 1885, modern print from dry-plate negative (cat. no. 446)

Eakins, on the other hand, followed the lead of investigators like Claude Bernard, who believed that the fictional barriers separating observer from observed stood in the way of progress for science as well as art.[30] Eakins declined to detach himself from the object of his investigations. He included careful observations of his own body and his own reactions in the course of his experiments in image making. He posed for pictures in the shed built for his motion studies (fig. 49) and for the naked series (fig. 50; cat. nos. 419–35). He turned his own body into evidence for a larger investigative study, and he encouraged his students to pose nude as well. Eakins explained to Coates that he could hardly respect a teacher who asked models to perform activities that he himself would find "a sin or degradation."[31] As Talcott Williams observed, however, in his discussion of Muybridge's motion studies, some objected that this investigative gaze transformed human beings, including the investigators themselves, into heartless, inhuman objects. Others identified a more profound problem: when investigators became part of the world they sought to explore, they could no longer fulfill what many of Eakins's contemporaries defined as the observer's most important function—to identify a world apart from, and better than, everyday life. They expected artists to reveal an ideal world that otherwise would remain invisible. Eakins found a different role for the artist, one articulated most clearly by the popular philosopher Herbert Spencer, who called for a more rigorous representation of the world as it actually appeared.

EAKINS AND SPENCER

Herbert Spencer's essays on art echoed the principles that Eakins had learned in Paris. They formed part of a global philosophy that united education, economics, science, and industry in a vision of advancing civilization.[32] Most important for Eakins, Spencer consistently emphasized the close relationship between science and art. He believed that nature was the source of all inspiration and judged all art according to its accuracy in representing the world as he perceived it. Using his own visual perception as the standard, Spencer faulted Chinese landscapes for erroneous perspective and criticized the pre-Raphaelites for rendering detail with unnatural quantity and precision. Spencer maintained that "the highest Art of every kind is based on Science—that without Science there can be neither perfect production nor full appreciation."[33] The following passage states a principle that became central to Eakins's art and to his teaching:

Youths preparing for the practice of sculpture have to acquaint themselves with the bones and muscles of the human frame in their distribution, attachments, and movements. . . . For the stability of a figure it is needful that the perpendicular from the centre of gravity—"the line of direction," as it is called—should fall within the base of support; and hence it happens, that when a man assumes the attitude known as "standing at ease," in which one leg is straightened and the other relaxed, the line of direction falls within the foot of the straightened leg. But sculptors unfamiliar with the theory of equilibrium, not uncommonly so represent this attitude, that the line of direction falls midway between the feet. Ignorance of the law of momentum leads to analogous blunder: as witness the admired Discobolus, which, as it is posed, must inevitably fall forward the moment the quoit is delivered.[34]

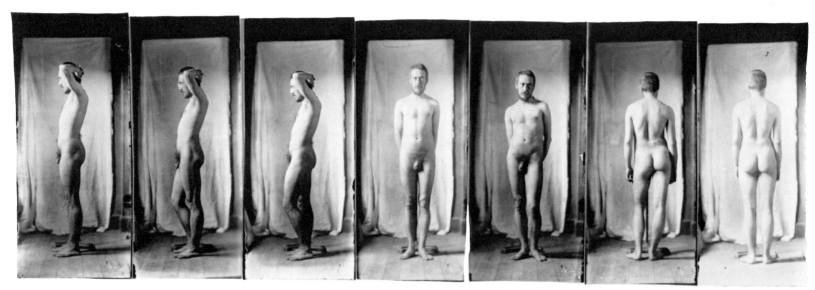

Figure 50. *Naked series: Thomas Eakins in front of cloth backdrop, poses 1–7*, by circle of Eakins, ca. 1883, modern prints from seven dry-plate negatives (cat. no. 428)

Eakins used photographs from the naked series to identify the precise "line of direction" as it occurred in models posed as Spencer described (figs. 17, 18). In addition, this series of photographs demonstrates Eakins's strong commitment to the new standards of scientific observation discussed earlier.

Spencer dealt also with the relationship between new scientific methods and the traditional content to which these methods were applied. Thus, in education, students who learned practical information—science, mathematics, modern history, geography—could not be taught in the old rote style that suited the study of classics, philosophy, and religious texts. Similarly, the artist who ceased to copy inaccurate and stylized models produced figures that no longer resembled those found in much traditional art. Spencer called attention to the fact that in each case the ultimate product remained constant—artists made images, and students received an education. But they shed the faulty methods of the past.

Eakins took Spencer's philosophy very much to heart and sought ever more effective ways to render the natural world so that his paintings would re-create in viewers the sensation that he had felt upon seeing the scenes himself. Writing from Paris in 1869, he explained to his father:

In a big picture you can see what o'clock it is afternoon or morning if its hot or cold winter of summer & what kind of people are there & what they are doing & why they are doing it. The sentiments run beyond words. If a man makes a hot day he makes it like a hot day he once saw or is seeing if a sweet face a face he once saw or which he imagines from old memories or parts of memories & his knowledge & he combines & combines never creates but at the very first combination no man & less of all himself could ever disentangle the feeling that animated him just then & refer each one to its right place.[35]

In the same letter, Eakins, invoking Spencer as a guide, said:

I think Herbert Spencer will set them right on painting. The big artist does not sit down monkey like & copy a coal scuttle or an ugly old woman like some Dutch painters have done nor a dungpile, but he keeps a sharp eye on Nature & steals her tools He learns what she does with light the big tool & then color then form and appropriates them to his own use. Then he's got a canoe of his own smaller than nature's but big enough.[36]

This navigation by the artist, "parallel to Nature's sailing," was one of Eakins's favorite metaphors. He contrasted it to the work of "the lummix [sic]" (a category that included most artists and art teachers), who could not perceive the natural world apart from the worn-out formulas used to represent it.

Because Eakins believed that the methods of the great antique artists were "easier to see & measure than to understand," he saw a danger in teaching students to copy casts of Greek sculpture and revere modern interpretations of the antique. In his eyes this led them to substitute classical forms (and neoclassical interpretations) for the original sources in the natural world. "If I went to Greece to live there twenty years I could not paint a Greek subject for my head would be full of

classics," he complained, "the nasty besmeared wooden hard gloomy tragic figures of the great French school of the last few centuries & Ingres & the Greek letters I learned at the High School."[37] For Eakins the significance of Greek art was that it placed the "greatest confidence in Nature."

Drawing from memory and imagination to elicit an emotional response, Eakins also used a vivid and convincing rendering of nature to establish a bond with the viewer. He believed that in order to achieve his goal, he had to cleanse the "besmeared" vision he had inherited from his teachers. Inspired by classical sculpture and influenced by Herbert Spencer, he turned to nature for fresh imagery and to photography as the means to capture the spirit of the ancient art that he admired.

THE CLASSICAL TRADITION

In a large group of photographic images, Eakins explored classical themes, using draped and nude models in the studio and in the open air. Eakins, his wife, his students, and professional models all posed for these tableaux. Some photographs depicting costumed female models in elaborate settings (plates 11–13 and fig. 11; see also cat. nos. 194–205) recall the "picture-making" studies that Eakins discouraged in his students. Others correspond closely to the Arcadia series—both in oil paintings and in a bas-relief (plate 9; see also cat. nos. 300–307). These photographs were made more than ten years after Eakins commented that he would not be able to paint a Greek subject because his head would be full of classics, the "nasty besmeared wooden hard gloomy tragic figures." The evidence of such photographs suggests that he had become able to consider classical subjects anew, free of unwanted academic formulas. As Eakins explained to the critic William C. Brownell, "The Greeks did not study the antique . . . the draped figures in the Parthenon pediment were modeled from life. . . ." Similarly, modern artists could study circus tumblers, acrobats, sailors, ball players. "Our business is distinctly to do something for ourselves, not to copy Phidias."[38]

Eakins used the formal properties of photographic studies to serve his purposes in another way: to achieve effects of spontaneity in paintings. The casual posture of the model in *An Arcadian* (fig. 51), which lends the work a contemporary air, was achieved by painting his wife's body and drapery in highly contrasting values of light and shadow, so that her right torso nearly disappears into darkness, while the bright folds of her chiton are almost without detail.[39] By incorporating such aspects of photographic form in his paintings, Eakins avoided the static atmosphere common to figure studies constructed in the constant north light of the studio. Photography enabled him to claim antique subjects on his own terms.

Photographic sources underlay nearly all of Eakins's major works after 1875 (at lease one predating his own use of a camera, around 1880): *The Gross Clinic* (1875, Medical College of Thomas Jefferson University, Philadelphia), *The Crucifixion* (1880, Philadelphia Museum of Art),[40] *Mending the Net* (1881, Philadelphia Museum of Art), *Shad Fishing at Gloucester* (1881, Philadelphia Museum of Art), *The Pathetic Song* (1881, Corcoran Gallery of Art, Washington, D.C.), *Arcadia* (1883, Metropolitan Museum of Art, New York), and *The Swimming Hole* (ca. 1883, fig. 44). One exception was his painting *William Rush*

Figure 51. *An Arcadian,* oil on canvas, ca. 1883, (Spanierman Gallery, New York and Alexander Gallery, New York)

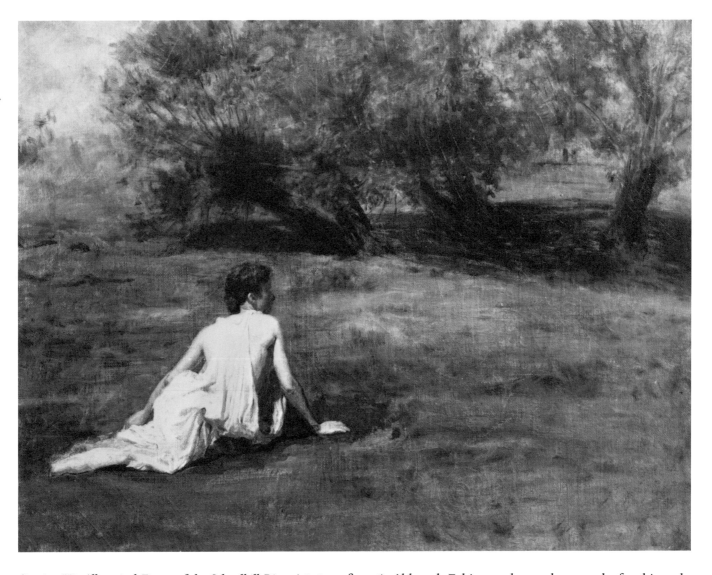

Carving His Allegorical Figure of the Schuylkill River (1876–77, fig. 26). Although Eakins made no photographs for this early version of the subject, there were photographic precedents related to it;[41] and he later produced photographs based on the painting (see fig. 3).

By comparing selected photographic studies with finished works, it is possible to locate the origins of some of Eakins's most distinctive stylistic traits in his appropriation of photographic effects. Not surprisingly, perhaps, contemporary critics consistently praise Eakins's technical skill while complaining of his clinical execution, monochromatic palette, and relentless

accumulation of detail. William Clark, for example, observed that *The Crucifixion* failed to please its audience because Eakins depicted the death of Christ as "an event which actually occurred under certain understood conditions."[42] Another reviewer commented that it "is of course a strong painting from the scientific side, but it is difficult to praise it from any other point of view . . . the mere presentation of a human body suspended from a cross and dying a slow death under an Eastern sun cannot do anybody any good, nor awaken thoughts that elevate the mind. . . . Nobody, so far as we can learn, is moved by it to do more than comment on the artist's technical skill, or to criticise some of his details."[43] In short, the painting resembles a photographic record of an actual event. Several formal aspects of this composition suggest its photographic origins: the monochromatic palette, the harsh natural illumination that recalls a scientific report, the relentless inclusion of minute physical detail, and the absence of any softening embellishment—such as costumed figures or other narrative motifs—that could not have been observed firsthand.

Similar complaints arose about *The Gross Clinic*. The *New York Times* observed that Eakins's portrait had "no conception of where to stop, or how to hint a horrible thing if it must be said, or what the limits are between the beauty of the nude and indecency of the naked. Power it has, but very little art."[44] The critic for the *New York Daily Tribune* could not imagine why the portrait had ever been painted: "The scene is so real that [viewers] might as well go to a dissecting room and have done with it." For that reviewer, Eakins's apparent refusal to differentiate between the real world and the world of art meant that he failed to meet his professional responsibilities. He believed that a work of art "ought to . . . do somebody some good to look at and study, or give someone pleasure. The time ought to be gone for these bloody, savage scenes; scenes of human despair and agony, scenes in cold blood to make us weep when weeping does no good."[45]

Eakins's clinical gaze aroused moral anxiety when he depicted female subjects, as in the relatively early genre scene *William Rush Carving His Allegorical Figure of the Schuylkill River*. This work obeyed many popular conventions. It represented a traditional subject, the artist in his studio, and joined it with a well-known local legend in which the early nineteenth-century sculptor used a burgher's daughter as the model for a public fountain. Eakins's painting shows Rush bent over his sculpture in deep shadow in the background; at the center his young model faces him, her back to the chaperone and the viewer, while the chaperone sews. A chair heaped with the model's clothing claims the bright foreground. Many reviews found the model unattractive. The critic for the *New York Times* also objected to the emphasis placed on her discarded attire. The sight of the model's linen "cast carelessly over a chair . . . gives a shock which makes one think about the nudity—and at once the picture becomes improper!"[46] By the 1880s the naked woman, the heap of clothes, and the sculptor as observer recalled the visual conventions of pornography, which generally appeared in photographic form. Moreover, Eakins exploited the belief, common to all photographs and especially useful to pornography, that no artist or agent intervened between viewer and subject. Abigail Solomon-Godeau has argued that this sense of transparency is the single most distinctive feature of the photographic medium, enabling photography to produce "a wholly different visual paradigm from that of older graphic arts." She observes that the photograph situates the spectator "in a certain—however ambiguous—relation to the real" that differs from all other forms of image making. From the frescoes of Pompeii to nineteenth-century litho-

graphs, the handmade image "offers evidence of its own mediation, [whereas] photographic representation normally effaces such evidence."[47] Eakins's audiences watched carefully for evidence of this new photographic paradigm at work. And when they found it, they used it to distinguish good art from bad.

When, in 1879, the journalist William C. Brownell visited the newly reorganized school of the Pennsylvania Academy of the Fine Arts, he produced a vivid account of Eakins's didactic methods—which revealed the incompatibility of Eakins's ideals and those of his contemporaries.[48] Brownell admired the facilities, which included an extensive collection of photographic reproductions of art and a large number of plaster casts of antique sculpture. In a break from tradition, the curriculum no longer emphasized a long apprenticeship spent drawing from casts; students began to paint early on, using simple exercises to master the use of materials. For example, they painted still-life compositions of eggs and oranges; they also modeled in clay to understand their subjects in three dimensions. And they studied the nude.[49]

As he moved through the classrooms and inspected the students' work, Brownell plaintively described his vain search for what he called beauty. In its place he saw students meticulously copy the "distortions of nature" and heard Eakins discourage "conventionalizing" or improving the models. Eakins called this picture making—a practice students could learn outside the studio from private teachers, from other works of art, or from exhibitions.[50] The dissecting room, with its frightening "arsenal" of implements and its grim cadaver, filled Brownell with "physical revulsion." He did not see how Eakins's rigorous dissections could serve aesthetic ends. Traditionally, students of "artistic" anatomy attended lectures illustrated with skeletons and diagrams. Following the lead of French physicians, however, Eakins enhanced his course with live models and actual dissections, and he encouraged the active participation of his advanced students. Brownell perceived a school given over to scientific practice. He failed to understand the benefits of such training; moreover, he feared its consequences for art. Sensing "danger arising from constant association with what is ugly and unpoetic, however useful, instead of even occasional association with what is poetic and beautiful, however useless," Brownell complained most bitterly about Eakins's neglect of "the invisible forces that lie about us, and now and then, as when in the spring the buds burst into blossoms, give tokens of their existence."[51]

Brownell was inspired by the English critic John Ruskin, who enjoyed a strong American following. Eakins, however, called Ruskin "a writer who knows nothing about painting."[52] Ruskin believed that artists could effect social change through their ability to create images of an ideal world. Art's power also conferred responsibility, and those who chose to represent a world without perfection shirked their duty. Thus, he advised his students: "What you do not wish to see in reality, you should not try to draw."[53] The poetic, beautiful, and ideal world created by Ruskin's American followers was filled with figures in vaguely classical dress who, through their affable smiles and passive postures, presented themselves as willing subjects to the viewer's gaze. These conventions guaranteed the popularity of a large group of artists, such as Elihu Vedder and Kenyon Cox, whose work appeared in murals and book illustrations as well as conventional paintings. Early in the twentieth century, Cox praised the inherently American character of this school and noted its "conservatism, its discipline and moderation, its consonance with all great and hallowed traditions—in short its classicism."[54]

Figure 52. *Three Crowell boys nude, outdoors at Avondale, Pennsylvania*, ca. 1885, platinum print (cat. no. 328)

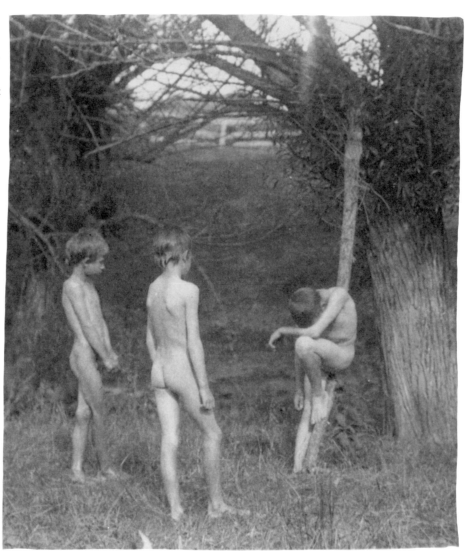

Ironically, Eakins also aspired to join the classical tradition. Like Cox, he concentrated on the representation of the human figure and chose traditional subjects. He invited viewers to suspend disbelief long enough to join his illusionistic world. Although he would not teach "picture-making," he composed paintings that tell stories; but, in every instance, he also confounded the expectations of his audience. Eakins refused to suppress particular details simply to represent an ideal world. He would not make aesthetic improvements. He worked hard to convince his audience that when they viewed his art they saw the world. Insofar as his painted images successfully conveyed this illusion, they resembled photographs. This is the effect that Eakins sought and the one his viewers condemned.

The most articulate description of the acute pain that Eakins's aesthetic philosophy aroused in his audience comes from a letter written by his brother-in-law, William J. Crowell, in April 1890. Crowell wrote to rescind his wife's permission for Eakins to give art lessons to their children. Frances Crowell approved as long as they did not pose nude, but her husband did not want them to study art with Eakins at all: "The thought of their naked living bodies being used as instruments either to illustrate scientific truth, or to gratify an artistic . . . lust of the eye, is unspeakably revolting to me." Citing Eakins's "contempt for convention and society's usages," Crowell continued:

If ever our children . . . should come to believe that . . . religion is a device of canting hypocrites for ruling imbeciles, that chastity of mind or body is a matter merely of taste or whim, that purity is chiefly shown by an alacrity in displaying their naked forms for the bishop of "art," that your favorite Rabelais motto "Fay ce que voudras [Faites ce que vous voudriez]," contains the true philosophy of life, they will be to Fanny a living constant torture, to me a bitter memory.[55]

Despite Crowell's wishes, Eakins did photograph the naked bodies of his nieces and nephews, as well as those of other children.[56] These photographs, whether in the studio or in a pastoral setting, recall his persistent quest to represent a classical world (see fig. 52).

William Crowell was right. Eakins had an uncontrollable passion for observation, especially for observation of the human form. He subscribed to an aesthetic that demanded an absolutely faithful transcription of everything that the eye could see. He did not discriminate between moral and immoral zones of the body. Eakins did not believe that human beings required the improving hand of an artist to make them beautiful, and he welcomed any image that offered this uncensored view of the human form. Through the many such images that he captured in photographs Eakins learned to cleanse his work of the academic conventions he had learned from teachers and fellow artists. By doing so, he strived to remain true to the traditions of art that he cherished.

Continuing to make paintings that embody moral ideals, Eakins was challenged, unlike his contemporaries, to find those ideals in the scrupulous depiction of everyday life. And although he discouraged the activity in his students, Eakins maintained the old-fashioned tradition of using images to tell stories, even when his audience found his stories repellent. To contemporaries his work appeared harsh and unartistic. To modern eyes his paintings adhere closely to standards of representation that would soon be overturned. Eakins differed from the most innovative of his contemporaries, such as the French artists Gustave Caillebotte, Edgar Degas, and Edouard Manet, who used photographs to help them sever their art from the traditions of the past. While they began to use art to refer to the world of art alone, Eakins used photographs to strengthen his commitment to the very conventions that they sought to undermine: Eakins continued to paint images that conveyed an illusion of three-dimensional space on a two-dimensional canvas; he continued to infuse his work with narrative tension; above all, he continued to emphasize the representation of a world beyond the canvas. True to his talent for paradox, Eakins remained stubbornly on the threshold of modern art.

NOTES

1. We know very little about Gérôme's teaching practice, but the wealth of photographs in the archives of his students suggests that their use was commonplace within this group. The work of these artists appears in Gabriel P. Weisberg, *Beyond Impressionism: The Naturalist Impulse* (New York: Harry N. Abrams, 1992). See also Gerald M. Ackerman, *The Life and Work of Jean-Léon Gérôme* (London: Sotheby's, 1986).

2. Elizabeth Milroy discusses Herbert Spencer's influence on Eakins in "Thomas Eakins's Artistic Training, 1860–1879" (Ph.D. diss., University of Pennsylvania, 1986), pp. 229–39.

3. Elizabeth Johns, "Drawing Instruction at Central High School and Its Impact on Thomas Eakins," *Winterthur Portfolio* 15 (Summer 1980), pp. 139–49.

4. Guy Debord, *Society of the Spectacle* (Detroit: Black and Red, 1977).

5. For a contemporary account of this commercial world, see Edwin T. Freedly, *Philadelphia and Its Manufactures: A Hand Book Exhibiting the Development, Variety and Statistics of the Manufacturing Industry of Philadelphia in 1857* (Philadelphia: Edward Young, 1859).

6. For background on the history of photography in Philadelphia, see Julius F. Sachse, "Philadelphia's Share in the Development of Photography," *Journal of the Franklin Institute* 135 (April 1893), pp. 271–87; Kenneth Finkel, *Nineteenth Century Photography in Philadelphia* (New York: Dover Publications, 1980); William F. Stapp, M. Susan Barger, and Marian S. Carson, *Robert Cornelius: Portraits from the Dawn of Photography* (Washington, D.C.: National Portrait Gallery, 1983); Mary Panzer, "Romantic Origins of American Realism: Photography, Arts, and Letters in Philadelphia, 1850–1875" (Ph.D. diss., Boston University, 1990); and Kenneth Finkel, ed., *Legacy in Light: Photographic Treasures from Philadelphia Area Collections* (Philadelphia: Philadelphia Museum of Art, 1990).

7. Published in *Proceedings of the Academy of Natural Sciences of Philadelphia* (1894), pp. 172–80.

8. *Proceedings* 1894, p. 176.

9. *Proceedings* 1894, p. 180.

10. See William W. Keen, *The History of the Philadelphia School of Anatomy, A Lecture Delivered 1 March 1875* (Philadelphia: J. B. Lippincott Company, 1875), p. 24. For more than five decades, the school was one of the few places in the United States where students could dissect or autopsy human subjects and experiment on animals. Over the years, dissections were carried out on dogs, cats, pigeons, goats, guinea pigs, turtles, rabbits, ducks, geese, mice, rats, snakes, and (in 1839) a lion. John H. Brinton learned to preserve organic specimens, a skill he used as head of the U.S. Army Medical Museum during the Civil War; and S. Weir Mitchell studied the effects of snake venom before his wartime care of neurologically impaired patients launched his career in psychology.

11. Lloyd Goodrich, *Thomas Eakins* (Cambridge, Mass.: Harvard University Press for National Gallery of Art, 1982), vol. 2, p. 53.

12. Employing a common metaphor, Gross went on to advise students to "photograph" the revealed image in their imaginations "so that with your eyes shut you may see it as clearly as if it were reflected from the surface of a broad mirror." See S. D. Gross, *Then and Now: A Discourse Introductory to the 42d Course of Lectures in the Jefferson Medical College* (Philadelphia: Collins, 1867), p. 42.

13. Gross 1867, pp. 4–5.

14. All three physicians are listed in *Dictionary of Scientific Biography*, ed. Charles C. Gillispie, 12 vols. (New York: Scribner's, 1971); see also Georges Guillain, *J-M Charcôt, 1825–1893: His Life—His Work*, trans. Pearce Bailey (New York: Paul B. Hoeber/Harper and Brothers, 1959), p. 103. (For Marey's photographic work, see *E. J. Marey, 1830–1904, La Photographie du Mouvement* [Paris: Centre Georges Pompidou, Musée National d'Art Moderne, 1977]). Their writings and those of other European and American scientists were avail-

able to Eakins and his contemporaries at the College of Physicians in Philadelphia. I am grateful to Gretchen Worden, director of the Mutter Museum there, and the research librarians at the College of Physicians.

15. See Joan Coapjec, "Flavit et Dissipati Sunt," *October* 18 (Fall 1981), pp. 21–40; and Georges Didi-Huberman, *Invention de l'hystérie: Charcôt et l'iconographie photographique de la salpêtrière* (Paris: Editions Macula, 1982).

16. Michel Foucault, *The Birth of the Clinic: An Archaeology of Medical Perception,* trans. A. M. Sheridan Smith (New York: Vintage, 1975), especially pp. 165ff.

17. William Coleman, *Biology in the Nineteenth Century: Problems of Form, Function, and Transformation* (New York: Cambridge University Press, 1977), pp. 118–59.

18. Claude Bernard, *An Introduction to the Study of Experimental Medicine,* trans. Henry Copley Green, with introduction by Lawrence J. Henderson and new foreword by I. Bernard Cohen (New York: Dover Publications, 1957), p. 103.

19. Bernard 1957, p. 103.

20. The best single source on Muybridge remains Robert B. Haas, *Muybridge, Man in Motion* (Berkeley: University of California Press, 1977).

21. University of Pennsylvania, *Animal Locomotion: The Muybridge Work at the University of Pennsylvania, The Method and the Result* (Philadelphia: J. B. Lippincott Company, 1888), p. 5.

22. Talcott Williams, "Animal Locomotion in the Muybridge Photographs," *Century Magazine* 34 (May 1886), p. 357.

23. Some contemporary French painters, such as P. A. J. Dagnan-Bouveret, Jules-Alexis Meunier, and Alfred Roll, also worked in specifically constructed sheds, as did the expatriate painter Alexander Harrison, a fellow Philadelphian. Other Americans, notably Daniel Ridgway Knight and Charles Sprague Pearce, built glass-walled studios in order to achieve in their paintings an effect that hovered between the changeless north light of the studio and the bright illumination of a photograph made in the open air. Knight and Eakins both lived in Philadelphia in the 1870s, and both participated in activities at the Pennsylvania Academy, but nothing is known about their relationship. For more about the French naturalist painters and their American colleagues, see Weisberg 1992, pp. 148–69.

24. Marey's work was widely published, but Eakins probably learned of it through Muybridge, who visited Marey in Paris in 1881.

25. Eakins also produced a single "Marey wheel" in which images of a figure in motion made by Muybridge's battery of cameras were assembled around the circumference of a disk. When the disk spun, the figure appeared to move. Two of these disks are preserved in the collection of the Franklin Institute in Philadelphia.

26. As they hoped, Muybridge's publishers captured the attention of the art world by providing plentiful examples appropriate for popular narrative illustrations and tableaux. Subscribers to the series included John La Farge, Thomas Moran, Gaston Tissandier, Louis Comfort Tiffany, John G. Brown, Sanford Gifford, Eastman Johnson, Augustus Saint-Gaudens, James McNeill Whistler, Daniel Ridgway Knight, Jean-Louis-Ernest Meissonier, Louis Bonnat, Adolphe Bouguereau, Charles-Emile Carolus-Duran, Jean-Léon Gérôme, Pierre Puvis de Chavannes, Auguste Rodin, August Menzel, Franz Lenbach, Lawrence Alma-Tadema, William Powell Frith, Holman Hunt, Frederick Leighton, John Everett Millais, George Frederic Watts, Edgar Degas, and Frederic Remington. This list appears in Eadweard Muybridge, *Descriptive Zoopraxography or, the Science of Animal Locomotion Made Popular, Memento to a Series of Lectures given . . . at the World's Columbian Exposition in Zoopraxographical Hall* (Philadelphia: University of Pennsylvania, 1893), Appendix B, pp. 12–13.

27. Edward Hornor Coates to George W. Pepper, September 27, 1886; quoted in Haas 1977, p. 153.

28. Haas 1977, p. 154.

29. For another interpretation, see Linda Williams, "Film Body: An Implantation of Perversions," in *Explorations in Film Theory: Selected Essays from Cine-Tracts,* ed. Ron Burnett (Bloomington: Indiana University Press, 1991), pp. 46–71.

30. See Bernard 1957, pp. 102–3.

31. Thomas Eakins to Edward Hornor Coates, September 11, 1886; printed in Kathleen A. Foster and Cheryl Leibold, *Writing about Eakins: The Manuscripts in Charles Bregler's Thomas Eakins Collection* (Philadelphia: University of Pennsylvania Press for Pennsylvania Academy of the Fine Arts, 1989), p. 238.

32. Lawrence A. Cremin, *The Transformation of the School: Progressivism in American Education, 1876–1957* (New York: Alfred A. Knopf, 1964), p. 91; see also Henry F. May, *The End of American Innocence: The First Years of Our Own Time, 1912–1917* (New York: Alfred A. Knopf, 1959; reprint Oxford University Press, 1979), p. 12. Spencer's work became the foundation for Charles Eliot's reconstruction of the liberal arts curriculum at Harvard; see Henry James, *Charles W. Eliot, President of Harvard University, 1869–1909* (Boston: Houghton Mifflin Company, 1930), vol. 1, pp. 349ff.; see also introduction by Charles W. Eliot in Herbert Spencer, *Essays on Education and Kindred Spirits* (New York: E. P. Dutton, 1911).

33. Spencer 1911, p. 32.

34. Spencer 1911, p. 33.

35. Thomas Eakins to Benjamin Eakins, March 6, 1868, printed in Foster and Leibold 1989, p. 207.

36. Foster and Leibold 1989, p. 206.

37. Foster and Leibold 1989, p. 207.

38. See William C. Brownell, "The Art Schools of Philadelphia," *Scribner's Monthly Illustrated Magazine* 18 (September 1879), p. 742; quoted in Goodrich 1982, vol. 1, pp. 173–74. See also Thomas Eakins to Earl Shinn, January 30, 1866[?]: "Ball players are very fine in their build. They are the same stuff as bull fighters only bull fighters are older and a trifle stronger perhaps." (Earl Shinn Papers, microfilm, roll 3580, frame 1351, Archives of American Art).

39. For a contemporary account of the way in which photographic images recorded values of light and dark without regard to form, see Earl Shinn (Edward Strahan), "Fine Art," in *The Masterpieces of the Centennial Exhibition of 1876* (Philadelphia: Gebbie and Barrie, 1876–78) vol. 1, pp. 19–22.

40. In *Thoughts of A. Stirling Calder on Art and Life* (New York: privately printed, 1947), p. 6, the author reported having borrowed photographs and negatives (sources for *The Gross Clinic* that have not survived) from Eakins to create his posthumous sculpture of the famous surgeon. Goodrich (1982, vol. 1, pp. 190–91) stated that, in 1939, he learned from interviews with J. Laurie Wallace that Eakins had made photographs of Wallace on a cross, which they first set up in a secluded spot near the Delaware River and later erected in Eakins's studio. Photographic sources for other works can be found in the Pennsylvania Academy Archives.

41. See for example, Uwe Scheid, *Das erotische Imago* (Dortmund: Bibliophilen Taschenbucher, 1984); Paul Hammond, *French Undressing* (London: Jupiter Books, 1976); and Gerald Needham, "Manet, *Olympia,* and Pornographic Photography," in *Woman as Sex Object: Studies in Erotic Art, 1730–1970* (New York: Newsweek, 1972), pp. 81–89.

42. *Evening Telegraph,* November 1, 1882. For an excellent discussion of this painting, see Elizabeth Milroy, "'Consummatum est . . . ': A Reassessment of Thomas Eakins's *Crucifixion* of 1880," *Art Bulletin* 71 (June 1989), pp. 269–84.

43. "The American Artists Supplementary Exhibition," *Art Amateur* 7 (June 1882), p. 2.

44. *New York Times,* March 8, 1879.

45. "Society of American Artists, Second Annual Exhibition," *New York Daily Tribune,* March 22, 1879.

46. *New York Times,* March 13, 1878.

47. Abigail Solomon-Godeau, *Photography at the Dock: Essays on Photographic History, Institutions, and Practices* (Minneapolis: University of Minnesota Press, 1991), pp. 232, 303. The author's reference to these conventions as paradigms recalls the work of the philosopher and historian Thomas Kuhn, who first used the term *paradigm* to describe the complex set of assumptions and associations that govern the progress of scientific inquiry. Kuhn also observed that during moments of transition, the challenge to a prevailing paradigm can cause extreme physical and emotional discomfort, as an individual discovers something once thought fixed and stable to be in fact mutable. Kuhn's intellectual paradigm is useful in analyzing the extreme unease that Eakins's work aroused.

48. Brownell 1879, pp. 737–50.

49. Like medical students, Eakins's art students examined animals, including horses, cows, and sheep.

50. Fairman Rogers, "The Schools of the Pennsylvania Academy of the Fine Arts," *Penn Monthly* 12 (June 1881), pp. 457–60.

51. Brownell 1879, pp. 749, 750.

52. Thomas Eakins to Benjamin Eakins, October 29, 1868; printed in Foster and Leibold 1989, p. 209. For discussion of Ruskin's influence in America, see the classic study by Roger B. Stein, *John Ruskin and Aesthetic Thought in America, 1840–1900* (Cambridge, Mass.: Harvard University Press, 1967).

53. John Ruskin, *The Eagle's Nest: Ten Lectures in the Relation of Natural Science to Art* (New York: John Wiley and Sons, 1886), p. 140. To enforce his social and aesthetic vision, Ruskin (p. 33), marshaled the twin authorities of convention and denial, telling his students, "You do not . . . need . . . chemistry, botany, geology, or anatomy, to enable you to understand art, or produce it. But there is one science which you *must* be acquainted with. You must very intensely and thoroughly know—how to behave."

54. Kenyon Cox, *Concerning Painting, Considerations Theoretical and Historical* (New York: Charles Scribner's Sons, 1917), p. 258.

55. William J. Crowell to Thomas Eakins, April 10, 1890, Pennsylvania Academy Archives.

56. Weisberg (1992, pp. 167–69), compares these images to photographs made in France by Jules-Alexis Meunier.

PORTFOLIO SECTION

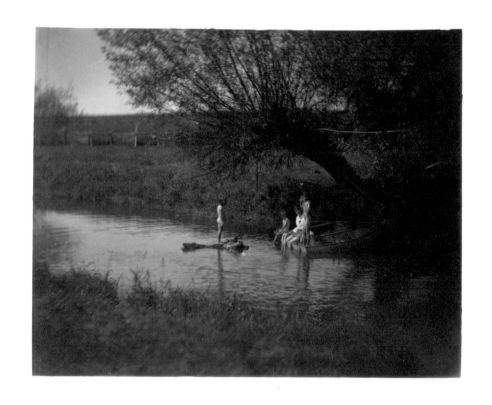

PLATE 1

Susan Macdowell Eakins and Crowell children in rowboat at Avondale, Pennsylvania, 1883, gelatin printing-out-paper print (cat. no. 169)

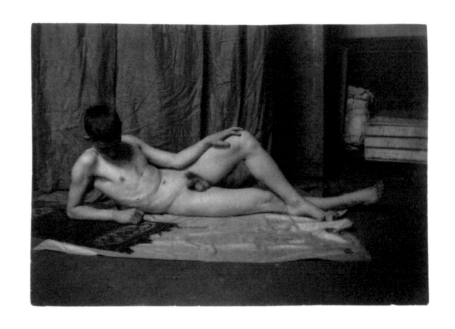

PLATE 2

Bill Duckett nude, reclining on side, hand on knee, ca. 1889, platinum print (cat. no. 337 [.416])

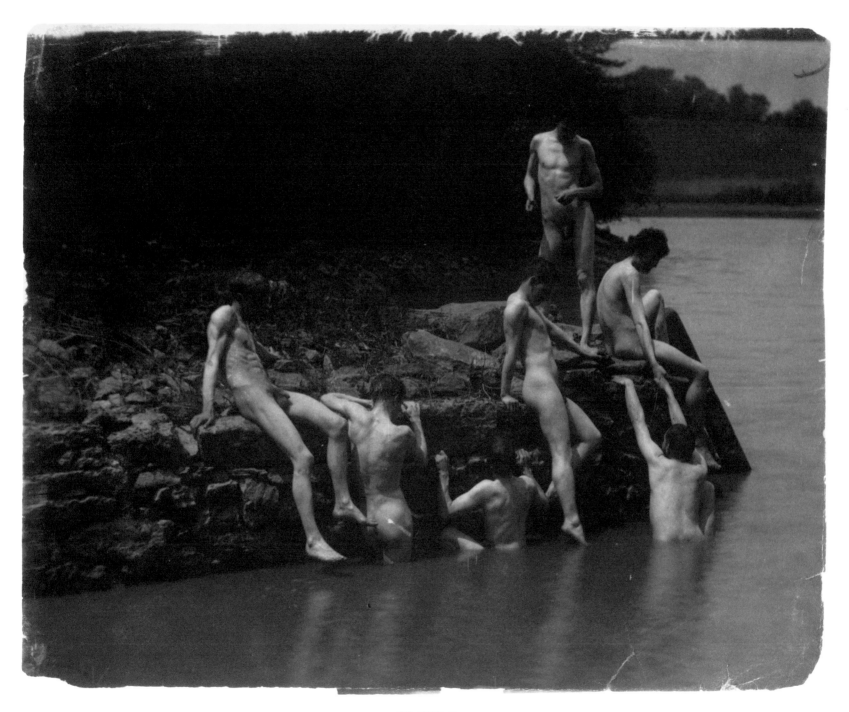

PLATE 3

Thomas Eakins and students, swimming nude, by circle of Eakins, ca. 1883, platinum print (cat. no. 393 [.480])

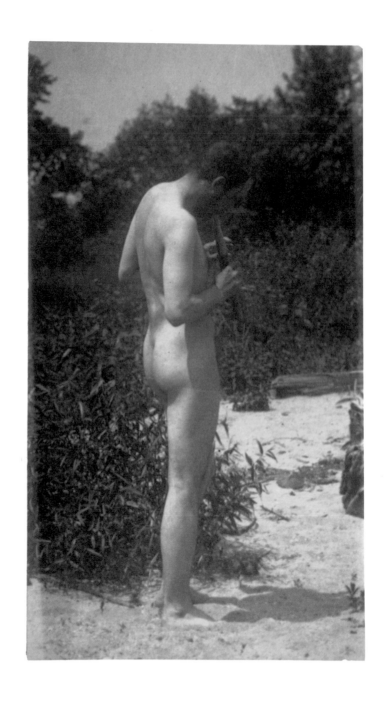

PLATE 4

Thomas Eakins nude, playing pipes, facing right, by circle of Eakins, ca. 1883, platinum print (cat. no. 382 [.487])

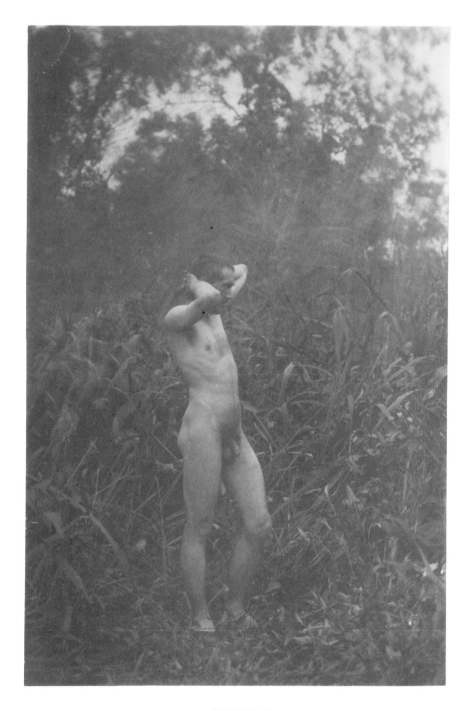

PLATE 5

Thomas Eakins nude, facing right, hands clasped behind head, in tall grass, by circle of Eakins, ca. 1883, albumen print (cat. no. 367)

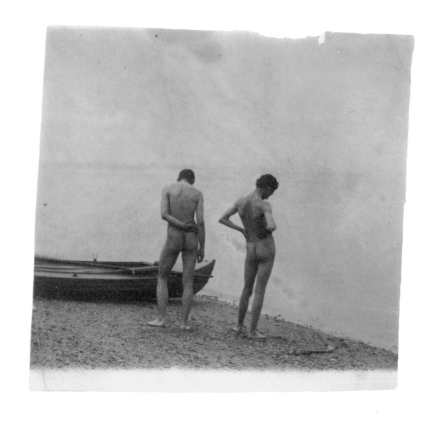

PLATE 6

Thomas Eakins nude, and J. Laurie Wallace nude, from rear, in front of boat at shoreline, by circle of Eakins, ca. 1883, albumen print

(cat. no. 380)

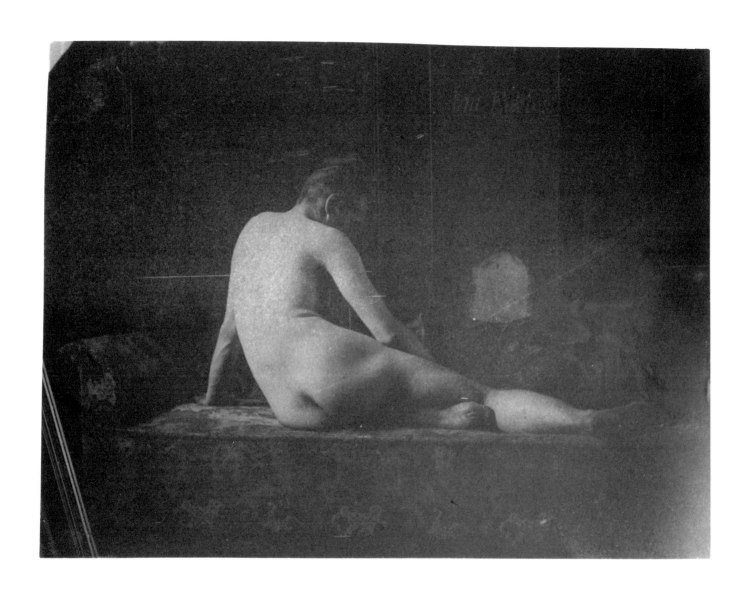

PLATE 7

Thomas Eakins nude, semireclining on couch, from rear, by circle of Eakins, ca. 1883, platinum print (cat. no. 347)

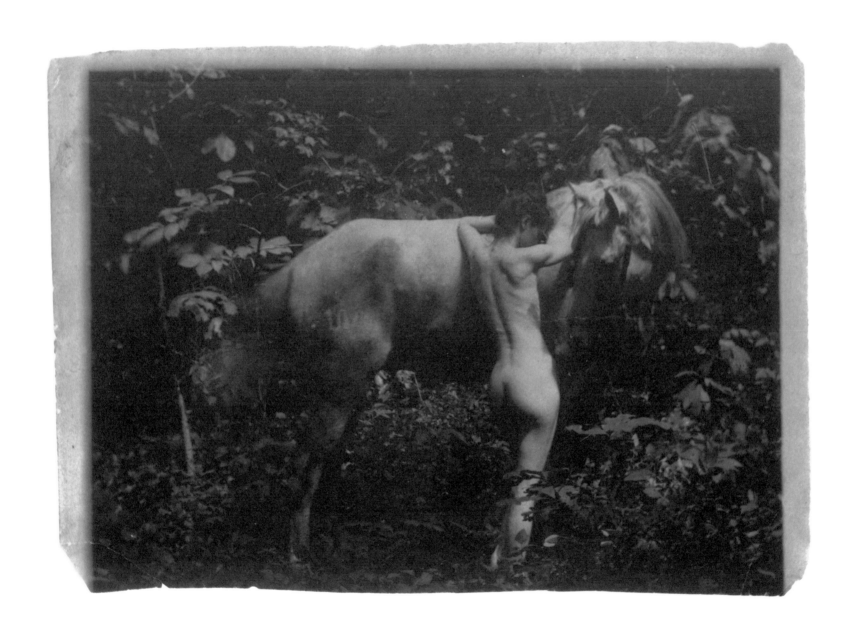

PLATE 8

Susan Macdowell Eakins nude, from rear, leaning against Thomas Eakins's horse Billy, ca. 1890, platinum print (cat. no. 408 [.550])

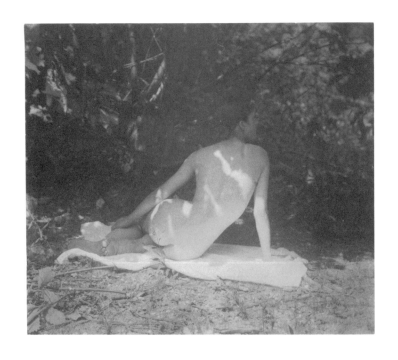

PLATE 9

Susan Macdowell Eakins nude, sitting on blanket, looking over right shoulder, outdoors, ca. 1883, albumen print (cat. no. 302)

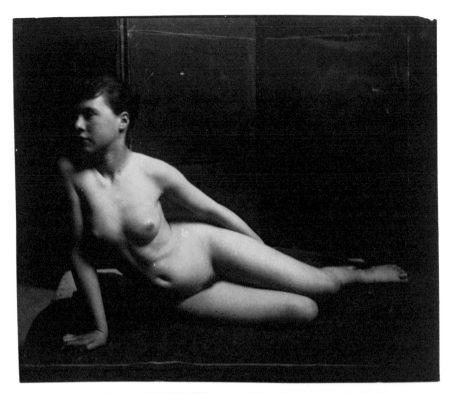

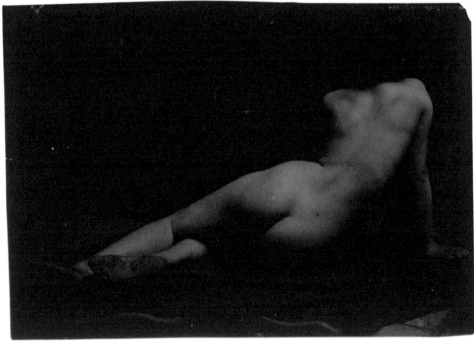

PLATE 10

Female nude, semireclining (above) and *Female nude, semireclining, from rear* (below), ca. 1889, platinum prints
(cat. nos. 272 [.511] and 273 [.506])

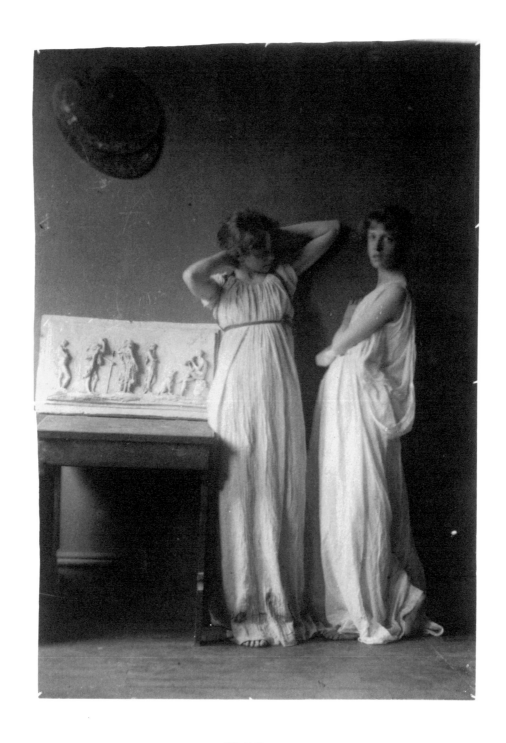

PLATE 11

Two women in classical costume, with Thomas Eakins's Arcadia relief at left, ca. 1883, platinum print (cat. no. 195)

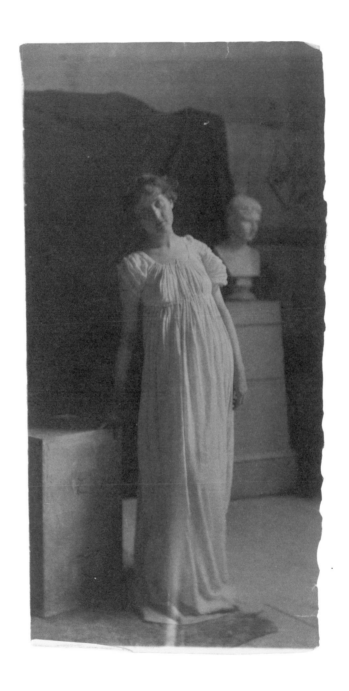

PLATE 12

Woman in classical costume, with bust of Caesar, ca. 1885, albumen print (cat. no. 197)

PLATE 13
Blanche Gilroy in classical costume, reclining, with banjo, ca. 1885, albumen print (cat. no. 199)

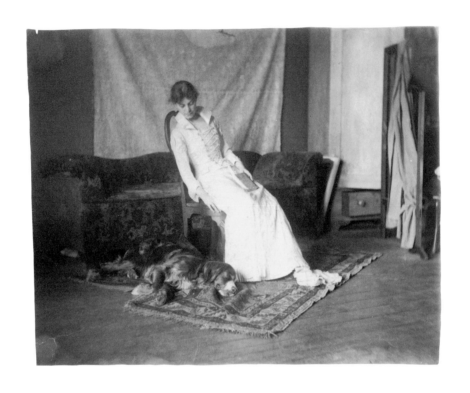

PLATE 14

Woman in laced-bodice dress, seated with setter at her feet, ca. 1883, albumen print (cat. no. 212)

PLATE 15

William H. Macdowell, in coat and hat, sitting, ca. 1884, platinum print (cat. no. 76 [1988.10.22])

PLATE 16

Mrs. William H. Macdowell, by circle of Eakins, ca. 1890, platinum print (cat. no. 34)

READER'S GUIDE TO THE CATALOGUE

The collection is organized into the following categories to facilitate access and study:

PORTRAITS AND CANDID
PHOTOGRAPHS
 Individual Portraits of Women
 Individual Portraits of Children
 Individual Portraits of Men
 Informal Portraits of Thomas Eakins
 Informal Groups

FIGURE STUDIES

NUDES
 Nude Women Indoors
 Nude Women Outdoors
 Nude Children Indoors
 Nude Children Outdoors
 Nude Men Indoors
 Nude Men Outdoors
 Nude Men in Sports
 Nudes with Horses

SCIENTIFIC PHOTOGRAPHS
 The "Naked Series"
 Motion Studies
 Differential-Action Studies

ANIMALS

LANDSCAPES AND MARINE VIEWS

GLOUCESTER (NEW JERSEY) STUDIES

DAKOTA TERRITORY STUDIES

Within each section are subdivisions for complex subjects, such as nudes. Photographs attributed to Thomas Eakins precede those attributed to the circle of Eakins. A small number of photographs are attributed directly to Susan Macdowell Eakins or Elizabeth Macdowell; these are not segregated but are interspersed with similar subjects within the circle of Eakins attributions.

CATALOGUE NUMBERS: Because there are multiple examples of some images, all prints and glass positives produced from the same negative are grouped together under one catalogue number. This number heads each entry.

ATTRIBUTIONS: In many cases definitive attributions have been difficult to make be-

cause of the absence of signed works, the frequency of shared photographic activities, and the later reprinting of many images. All photographs are attributed to Thomas Eakins except those under the heading "Circle of Eakins" (each preceded by a dagger [†]), by which the authors suggest a wider range of possible photographers without excluding Eakins himself. Photographs produced as part of a group activity and those that by date, style, or medium appear to be the work of another hand are included in this group. In a few cases a specific attribution to Susan Macdowell Eakins or Elizabeth Macdowell is made based on evidence such as inscriptions or known interests.

TITLES AND DATES: As far as can be discerned, Eakins never titled his photographs. Assigning separate titles for each photographic image proves impossible because there are so many close variants in the collection. Titles have been assigned using the following assumptions:
—If a person's identity is known, his or

her name appears in the title; the word *unidentified* has been avoided except in the case of portrait photographs where *Unidentified Woman* seems preferable to *Woman*.

—The persons in the photographs can be assumed to be clothed; if they are not, the word *nude* appears in the title.

—A position facing the camera is assumed; otherwise, the position of the body is specified.

—Groups are identified from left to right. In a few instances the exact date of a photographic series is known—for example, the Dakota photographs of 1887. In general, however, dates are approximate to a five-year range.

MEASUREMENTS: For all prints height precedes width. Dimensions are for the image only, regardless of sheet size or mount. Measurements were taken at the widest point of the image, since many prints are trimmed irregularly. The dryplate negatives are commercially manufactured plates with a standard size of 4 × 5 inches, regardless of the orientation of the image. Most of the images are registered irregularly on the plates, leaving a margin of from ⅟₁₆ to ⅛ of an inch along one or two edges. This margin has not been indicated in the catalogue entries. In two series, the motion studies and the differential-action studies, the image is significantly smaller than the plate, so an image size has been given. In the case of the "naked series," Eakins created smaller negatives by cutting the plates.

PRINTING: All catalogue illustrations in this volume were reproduced using modern copy negatives by Rick Echelmeyer. In those cases where a negative or a glass positive was the only version of an image, the reproduction here is from a direct-reversal copy negative. The duotone figures in the introductory essays and front matter and the tritone plates in the portfolio section were shot with a camera by Thomas Palmer. The plates and frontispiece were shot from the original prints.

ACCESSION NUMBERS: The majority of the photographs catalogued in this volume are from the Charles Bregler collection, purchased by the Pennsylvania Academy of the Fine Arts in 1985. Each photograph in the Bregler collection bears the same prefix number: 1985.68.2, followed by its individual accession number (e.g., 1985.68.2.884). For the sake of brevity, only the last portion of the number (e.g., .884) is included in this book. All other accession numbers are given in full. Accession numbers beginning 1988.10. indicate photographs purchased from the estate of Gordon Hendricks in 1988. A small number of other accession numbers represent photographs acquired in various years.

REFERENCES: For previously published images, Gordon Hendricks, *The Photographs of Thomas Eakins* (New York: Grossman Publishers, 1972), and *Photographer Thomas Eakins* (Philadelphia: Olympia Galleries, 1981) are cited as sources.

FORMAT OF CATALOGUE ENTRIES: Information includes catalogue number (for negative and all prints of same image); title; date; medium, dimensions, individual accession number; reference to previous publication; cross-reference to plate or figure; and remarks.

APPENDIXES: Among the photographs from the Bregler and Hendricks collections not catalogued in this volume are numerous portraits of Eakins, his family, and his friends taken by professional studio photographers, as well as a few miscellaneous subjects by other photographers outside the circle of Eakins. This group is described briefly in Appendix A to this volume, which lists also the names of the professional portrait photographers represented. Appendix B charts the dispersal of photographs by Eakins and his circle from their original owners to various collections. Appendix C lists the photographic exhibitions and lectures held at the Pennsylvania Academy between 1883 and 1906.

FOR FURTHER INFORMATION

MASTER LIST: The Pennsylvania Academy of the Fine Arts maintains an annotated master list of every photograph in the collection. The list, which is available to researchers, contains additional information such as inscriptions, condition, related images, and extended remarks on individual objects.

PHOTOGRAPHS OF PAINTINGS: In addition to the catalogued photographs, the Charles Bregler Collection contains a variety of other photographic materials. The most interesting is a group of glass negatives (forty 4 × 5 inches, and eight 8 × 10 inches—none formally catalogued) depicting works of art by Thomas Eakins. Several of the photographs appear to have been taken in his studio. Many show the painting still on the easel; some have paraphernalia in the background. Curiously, no vintage prints survive for any of these negatives, from which Bregler made modern prints. Contact prints are available to researchers.

COPY PRINTS: Bregler's collection contains about one hundred of his copy prints of Thomas Eakins's photographs, each existing in either a vintage print or an original negative. A large body of Bregler's own photographs have survived as well. All of this material is uncatalogued.

CATALOGUE OF THE COLLECTION

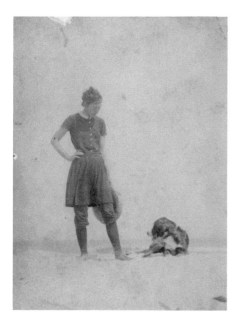

1

2 (.72)

6 (.75)

PORTRAITS AND CANDID PHOTOGRAPHS

INDIVIDUAL PORTRAITS OF WOMEN

Among these images are formal and informal portraits of Thomas Eakins's sisters; his wife, Susan Macdowell Eakins; and various members of her family. In addition, there are many images of students and friends and a number of unidentified women. Most are attributed to Eakins because of such stylistic features as the direct gaze of the sitter, the seriousness of expression, and straightforward composition. Most are known images, either already published or close variants of images published in Hendricks 1972.

THOMAS EAKINS'S FEMALE RELATIVES

1

Margaret Eakins with Thomas Eakins's setter Harry at beach, ca. 1880
Albumen print, 10.5 × 7.9 cm [4⅛ × 3⅛″]
(1988.10.12)
Hendricks 1972, fig. 4.

2

Margaret Eakins, ca. 1881
Albumen print, 10.2 × 10.0 cm [4 × 3¹⁵⁄₁₆″]
(.72)
Albumen print, 13.0 × 10.8 cm [5⅛ × 4¼″]
(.826)
Hendricks 1972, fig. 26.
The variant images in cat. nos. 2–5 are differentiated by pose and position of ribbon tie.

3

Margaret Eakins, ca. 1881
Albumen print, 8.6 × 7.3 cm [3⅜ × 2⅞″]
(.73)

4

Margaret Eakins, ca. 1881
Albumen print, 8.9 × 7.6 cm [3½ × 3½″]
(.74)
Glass positive, 11.3 × 8.9 cm [4⁷⁄₁₆ × 3½″]
(.591)

5

Margaret Eakins (vignetted), ca. 1881
Glass positive, 8.3 × 5.4 cm [3¼ × 2⅛″]
(1988.10.14)
Glass positive, 10.6 × 8.3 cm [4³⁄₁₆ × 3¼″]
(.590)
Hendricks 1972, figs. 23, 25.

7 (.13) 8 9

6

Margaret Eakins and Thomas Eakins's set-
ter Harry on doorstep of the family home
at 1729 Mount Vernon Street, Philadelphia,
ca. 1881
Albumen print, 7.1 × 8.3 cm [2¹³/₁₆ × 3¼″]
(.75)
Glass positive, 7 irr. × 10.3 cm [3 irr. ×
4¹/₁₆″] (.592)

7

Margaret Eakins sitting on ground with
Thomas Eakins's setter Harry, ca. 1881
Albumen print, 11.7 × 13.5 cm [4⅝ × 5⁵/₁₆″]
(1988.10.13)
Glass positive, 8.3 × 10.16 cm [3¼ × 4″]
(.593)
Hendricks 1972, fig. 15.

8

Eliza Cowperthwait seated in carved arm-
chair, ca. 1885
Albumen print, 10.5 × 8.9 cm [4⅛ × 3½″]
(1988.10.21)
Hendricks 1972, fig. 203.

See remark after cat. no. 228.

Circle of Eakins

9

†Ella Crowell, ca. 1897
Gelatin silver print, 9.8 × 6.0 cm [3⅞ ×
2⅜″] (1988.10.31)

10

†Frances Eakins Crowell, ca. 1910
Gelatin silver print, 11.4 × 6.2 cm [4½ ×
2⁷/₁₆″] (1988.10.10)

SUSAN MACDOWELL EAKINS

(MRS. THOMAS EAKINS)

11

Susan Macdowell sitting with setter in
yard, ca. 1880
Albumen print, 8.9 × 10.6 cm [3½ × 4³/₁₆″]
(.86)
Glass positive, 9.0 × 11.3 cm [3⁹/₁₆ × 4⁷/₁₆″]
(.598)
Glass positive, 9.0 × 11.3 cm [3⁹/₁₆ × 4⁷/₁₆″]
(.599)
Hendricks 1972, fig. 21.

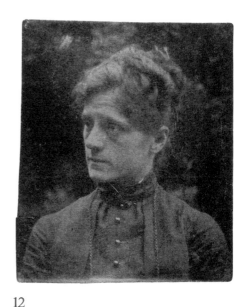

10

11 (.86)

12

12
Susan Macdowell Eakins, ca. 1885
Cyanotype, 6.5 × 5.6 cm [2⁹⁄₁₆ × 2³⁄₁₆″]
(.87)

13
Susan Macdowell Eakins, facing left, wearing hat, ca. 1890
Platinum print, 12.2 × 11.1 cm [4¹³⁄₁₆ × 4⅜″] (.791)

14
Susan Macdowell Eakins with monkey and two cats in yard of the family home at 1729 Mount Vernon Street, Philadelphia, ca. 1895
Platinum print, 9.5 × 11.9 cm [3¾ × 4¹¹⁄₁₆″] (.282)

15
Susan Macdowell Eakins sitting with cats in yard of the family home at 1729 Mount Vernon Street, Philadelphia, ca. 1895
Platinum print, 12.7 × 10.2 cm [5 × 4″] (.781)

16
Susan Macdowell Eakins sitting with monkey in yard of the family home at 1729 Mount Vernon Street, Philadelphia, ca. 1895
Platinum print, 9.7 × 12.4 cm [3¹³⁄₁₆ × 4⅞″] (.786)

17
Susan Macdowell Eakins holding bird and cat in yard of the family home at 1729 Mount Vernon Street, Philadelphia, ca. 1895
Platinum print, 11.3 × 9.7 cm [4⁷⁄₁₆ × 3¹³⁄₁₆″] (.787)

18
Susan Macdowell Eakins crouching with cats in yard of the family home at 1729 Mount Vernon Street, Philadelphia, ca. 1895
Gelatin silver print, 7.3 × 6.4 cm [2⅞ × 2½″] (.783)

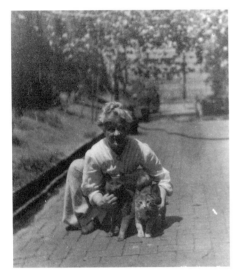

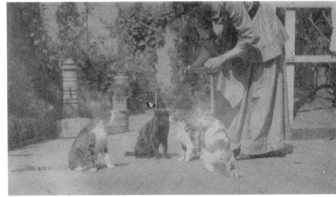

18

20 (.645)

21

19

Susan Macdowell Eakins crouching with cat and setter in yard of the family home at 1729 Mount Vernon Street, Philadelphia, ca. 1895
Albumen print, 6.4 × 8.3 cm [2½ × 3¼″] (.789)

20

Susan Macdowell Eakins and cats in yard of the family home at 1729 Mount Vernon Street, Philadelphia, ca. 1895
Platinum print, 5.4 × 9.4 cm [2⅛ × 3¹¹⁄₁₆″] (.645)
Gelatin printing-out-paper print, 8.3 irr. × 19.0 cm [3¼ irr. × 7½″] (.280)

21

Susan Macdowell Eakins sitting in yard of the family home at 1729 Mount Vernon Street, Philadelphia, ca. 1895
Platinum print, 10.3 × 7.3 cm [4¹⁄₁₆ × 2⅞″] (.640)

Circle of Eakins

22

Attributed to Susan Macdowell Eakins
†Self-portrait in gingham dress, ca. 1884
Albumen print, 7.8 × 6.7 cm [3¹⁄₁₆ × 2⅝″] (.642)
Albumen print, 9.4 × 6.8 irr. cm [3¹¹⁄₁₆ × 2¹¹⁄₁₆″ irr.] (.79)
Albumen print, 9.8 irr. × 7.3 cm [3⅞ irr. × 2⅞″] (1988.10.23)
Hendricks 1972, fig. 76.

Copies in collections of Bryn Mawr College (Pennsylvania) and the Macdowell family (Roanoke, Virginia) carry inscriptions in Elizabeth Macdowell's hand attributing this photograph to Susan Macdowell Eakins.

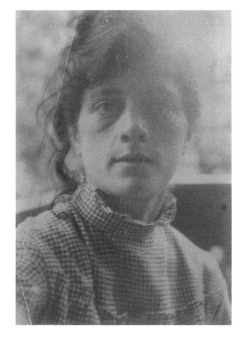

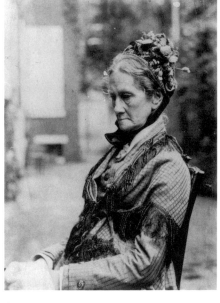

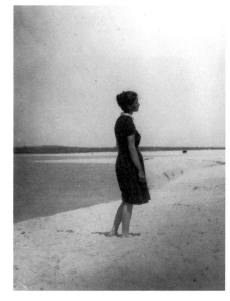

22 (.79)

23

24

WOMEN OF SUSAN MACDOWELL EAKINS'S
FAMILY

23

Mrs. William H. Macdowell wearing
shawl and bonnet, sitting, facing left,
ca. 1880
Albumen print, 11.1 × 8.3 cm [4⅜ × 3¼″]
(.638)

24

Mary Macdowell standing in profile at
shoreline, ca. 1881
Dry-plate negative, 10.2 × 12.7 cm [4 × 5″]
(.865)

25

Mary Macdowell in light dress, sitting, fac-
ing right, ca. 1885
Albumen print, 7.3 × 6.0 cm [2⅞ × 2⅜″]
(.101)
Albumen print, 10.8 × 9.2 cm [4¼ × 3⅝″]
(.100)
Platinum print, 11.7 × 9.8 cm [4⅝ × 3⅞″]
(.824)

26

Mary Macdowell in light dress, sitting,
looking down, ca. 1885
Albumen print, 8.3 × 7.1 cm [3¼ × 2¹³⁄₁₆″]
(.649)
Glass positive, 9.2 × 5.9 cm [3⅝ × 2⁵⁄₁₆″]
(.589)
Olympia Galleries 1981, fig. 49.

A glass negative, 12.7 × 20.3 cm [5 × 8″],
survives in the Macdowell family collec-
tion, Roanoke, Virginia.

27

Mary Macdowell with puppy, ca. 1885
Cyanotype, 6.8 × 7.5 cm [2¹¹⁄₁₆ × 2¹⁵⁄₁₆″
irr.] (.104)

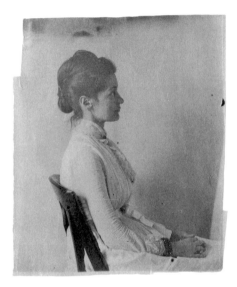

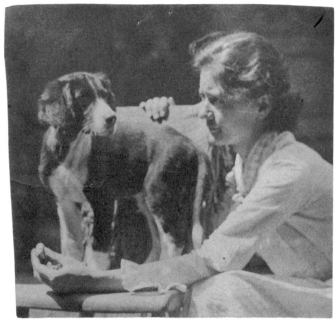

25 (.100)

27

28

28
Elizabeth Macdowell, facing right, ca. 1885
Albumen print, 6.7 × 6.0 cm [2⅝ × 2⅜″]
(.102)

29
Elizabeth Macdowell, ca. 1885
Albumen print, 6.2 × 5 irr. cm [2⁷⁄₁₆ × 2″
irr.] (.103)

30
Elizabeth Macdowell in print dress, sitting,
hands behind head, ca. 1889
Collodion printing-out-paper print, 10.8 ×
8.1 cm [4¼ × 3³⁄₁₆″] (.798)

Several glass negatives, 12.7 × 20.3 cm
[5 × 8″], close variants of cat. nos. 30 and
31, survive in the Macdowell family collec-
tion, Roanoke, Virginia.

31
Elizabeth Macdowell in print dress, sitting,
looking down, ca. 1889
Collodion printing-out-paper print, 10.3 ×
9.4 cm [4¹⁄₁₆ × 3¹¹⁄₁₆″] (.799)

32
Mary Trimble, 1880s
Albumen print, 8.1 × 6.4 cm [3³⁄₁₆ × 2½″]
(.126)

Identification is based on an inscription on
a print of this photograph in the Macdow-
ell family collection, Roanoke, Virginia.

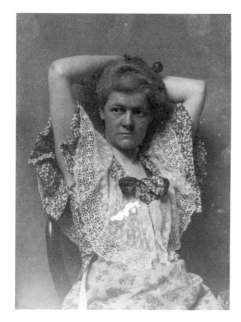

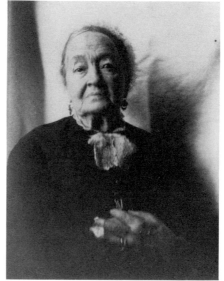

30

32

33

Circle of Eakins

33

†Mrs. William H. Macdowell, looking
right, ca. 1890
Dry-plate negative, 10.2 × 12.7 cm [4 × 5″]
(.877)
Hendricks 1972, fig. 20.

A print in the Metropolitan Museum of
Art, New York, is inscribed in Charles
Bregler's hand: *negative by Thomas and Su-*
san Eakins, platinum print by Mrs. Eakins;
and in A. Hyatt-Mayor's hand: *Mrs. Kenton*
says she took this picture.

34

†Mrs. William H. Macdowell, ca. 1890
Platinum print, 23.5 × 19.7 cm [9¼ × 7¾″]
(.800)

See plate 16.

OTHER IDENTIFIED WOMEN

35

Blanche Hurlbut sitting, ca. 1882
Platinum print, 14.6 irr. × 12.1 cm [5¾ irr.
× 4¾″] (.115)

36

Blanche Hurlbut (?) sitting, ca. 1882
Albumen print, 12.7 × 6.4 irr. cm [5 × 2½″
irr.] (.120)

37

Elizabeth Baldwin sitting, facing left,
ca. 1885
Albumen print, 10.5 × 6.2 cm [4⅛ × 2⁷⁄₁₆″]
oval (.117)

38

Elizabeth Baldwin, left profile, ca. 1885
Dry-plate negative, 10.2 × 12.7 cm [4 × 5″]
(.879)
Hendricks 1972, fig. 215.

35

36

37

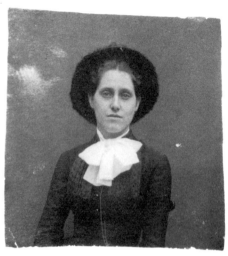

39

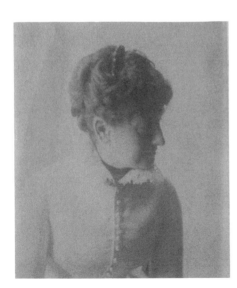

40

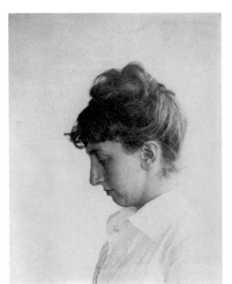

41

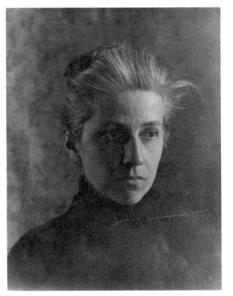

42

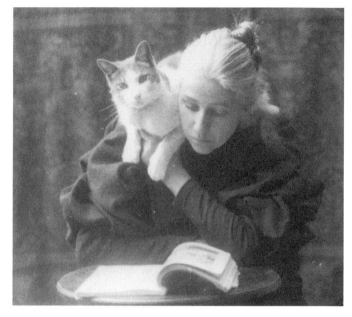

43

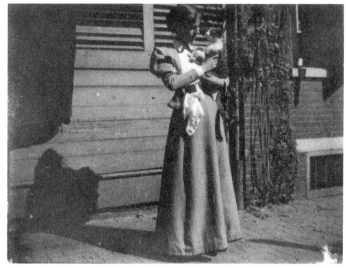

44

39

Margaret Alexina Harrison (?), ca. 1885
Platinum print, 7.8 × 7.5 cm [3¹⁄₁₆ × 2¹⁵⁄₁₆″]
(.114)

Tentative identification is based on resemblance to the sitter in cat. nos. 183–93.

40

Catherine Flanagan Towne, looking right, ca. 1888
Albumen print, 7.3 × 6.4 cm [2⅞ × 2½″]
(.116)
Hendricks 1972, fig. 71.

A print in the Metropolitan Museum of Art, New York, is inscribed in Charles Bregler's hand: *Pupil of Eakins/ do not recall name/ photo by Eakins;* in A. Hyatt-Mayor's hand: *Catherine Flanagan/ married Charles Towne of Phila./ She was a cousin of Mrs. Eakins.*

41

Catherine Flanagan Towne (?), left profile, 1880s
Albumen print, 11.1 × 9.2 cm [4⅜ × 3⅝″]
(.658)

Tentative identification is based on resemblance to the sitter in cat. no. 40.

42

Amelia Van Buren, ca. 1891
Platinum print, 16.4 × 12.7 cm [6⁷⁄₁₆ × 5″]
(.702)

43

Amelia Van Buren sitting with cat on shoulder, ca. 1891
Platinum print, 8.9 × 10.2 cm [3½ × 4″]
(.712)
Hendricks 1972, fig. 176.

44

Eva Watson (?) holding tiger-striped cat in front of house, ca. 1891
Platinum print, 3.8 × 5.1 cm [1½ × 2″]
(.283)

45

46

47

45

Lucy Lewis (?), ca. 1896
Platinum print, 8.9 × 7.6 cm [3½ × 3″]
(.118)
Hendricks 1972, fig. 216.

Tentative identification is based on resemblance to the sitter in Thomas Eakins's portrait *Miss Lucy Lewis* (ca. 1896, private collection; ill. Goodrich 1982, vol. 2, p. 66, fig. 173).

46

Jennie Dean Kershaw (later Mrs. Samuel Murray), right hand behind head, ca. 1897
Dry-plate negative, 10.2 × 12.7 cm [4 × 5″]
(.878)
Hendricks 1972, fig. 224.

47

Addie Williams, ca. 1899
Albumen print, 11.7 × 8.3 cm [4⅝ × 3¼″]
(.107)

48

Addie Williams, facing right, ca. 1899
Albumen print, 10.2 × 7.9 cm [4 × 3⅛″]
(.108)

Circle of Eakins

49

Attributed to Susan Macdowell Eakins
†Roseanna Williams, ca. 1880
Albumen print, 11.3 × 9.0 cm [4⁷⁄₁₆ × 3⁹⁄₁₆″]
(.112)

Platinum print, 9.4 × 8.1 cm [3¹¹⁄₁₆ × 3³⁄₁₆″]
(.113)

Identification is based on resemblance to the sitter in an oil study by Susan Macdowell Eakins (ca. 1879, Pennsylvania Academy).

50

†Amelia Van Buren in light dress, leaning against column, ca. 1891
Collodion printing-out-paper print, 10.3 × 17.9 cm [4¹⁄₁₆ × 7¹⁄₁₆″] (.1107)

48 49 (.113) 50

51

†Signora Gomez d'Arza (?), facing right, ca. 1902
Platinum print, 15.6 × 11.6 cm [6⅛ × 4⁹⁄₁₆″]
(.821)

Tentative identification is based on resemblance to the sitter in Thomas Eakins's oil painting *Signora Gomez d'Arza* (ca. 1902, Metropolitan Museum of Art, New York).

UNIDENTIFIED WOMEN

52

Two African-American women standing outdoors, 1880s
Dry-plate negative, 10.2 × 12.7 cm [4 × 5″]
(.880)

53

Unidentified woman sitting, 1880s
Albumen print, 10.5 × 8.1 cm [4⅛ × 3³⁄₁₆″]
(1988.10.39)
Hendricks 1972, fig. 81.

54

Unidentified woman, looking left, 1880s
Platinum print, 8.4 × 7.1 cm [3⁵⁄₁₆ × 2¹³⁄₁₆″]
(.125)
Glass positive, 9.2 × 7.9 cm [3⅝ × 3⅛″]
(.595)

55

Unidentified woman sitting, 1880s
Albumen print, 9.8 × 8.3 cm [3⅞ × 3¼″]
(.119)
Hendricks 1972, fig. 83.

56

Unidentified woman sitting, facing left, in chair with painted crest, 1880s
Glass positive, 10.5 × 8.4 cm [4⅛ × 3⁵⁄₁₆″]
(.596)
Glass positive, 11.3 × 8.9 cm [4⁷⁄₁₆ × 3½″]
(.597)
Hendricks 1972, fig. 80.

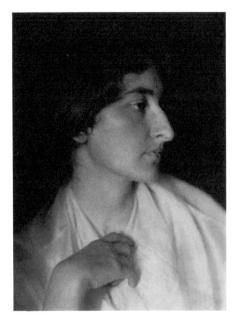 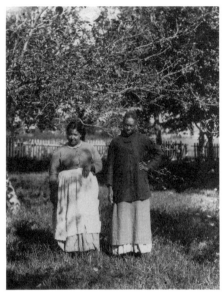 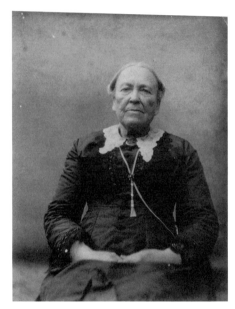

51 52 53

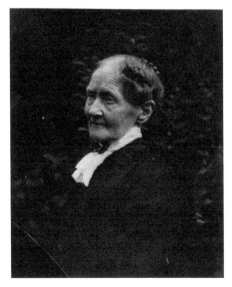 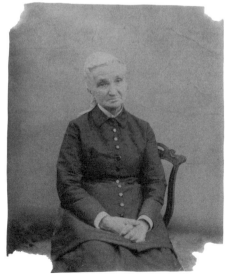 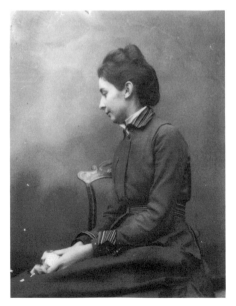

54 (.125) 55 56 (.596)

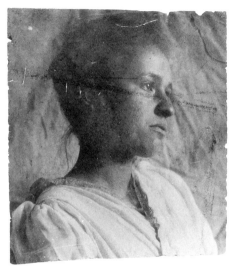

57

60

63

57

Unidentified woman sitting, looking right, 1880s

Albumen print, 6.0 × 5.2 cm [2⅜ × 2¹⁄₁₆″] (1988.10.41)

Hendricks 1972, fig. 186.

Circle of Eakins

58

†Unidentified woman sitting, facing right, arms folded, 1880s

Platinum print, 6.4 × 5.7 cm [2½ × 2¼″] (.124)

59

†Unidentified woman, facing left, ca. 1890

Albumen print, 9.2 × 8.6 cm [3⅝ × 3⅜″] (.128)

60

†Unidentified woman, ca. 1890

Platinum print, 8.4 × 6.2 cm [3⁵⁄₁₆ × 2⁷⁄₁₆″] (.134)

61

†Unidentified young woman in light dress, facing right, ca. 1890

Gelatin printing-out-paper print, 10.6 × 8.7 cm [4³⁄₁₆ × 3⁷⁄₁₆″] (.656)

The same model appears in cat. nos. 62 and 63.

62

†Unidentified young woman in light dress, looking left, ca. 1890

Gelatin printing-out-paper print, 11.6 × 9.2 cm [4⁹⁄₁₆ × 3⅝″] (.703)

63

†Unidentified young woman in light dress, ca. 1890

Gelatin printing-out-paper print, 11.7 × 8.1 cm [4⅝ × 3³⁄₁₆″] (.694)

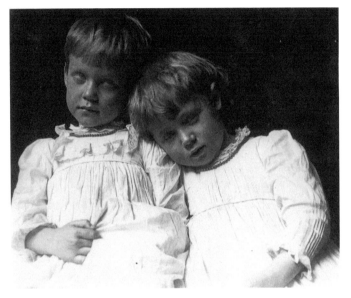

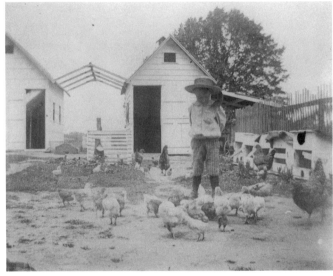

65 67

INDIVIDUAL PORTRAITS OF CHILDREN

This group of informal photographs consists of images of a few Crowell and Macdowell children and many more unidentified youngsters. (Note: There is a separate category for nude children.) The majority of these photographs are adhered to the pages of a photograph album that has survived in the Bregler collection.

Circle of Eakins

64
†Maggie Crowell(?), ca. 1878
Albumen print, 6.5 × 4.6 cm [2⁹⁄₁₆ × 1¹³⁄₁₆″] (1988.10.32)

65
†Two children in light dresses, ca. 1882
Platinum print, 10.0 × 12.2 cm [3¹⁵⁄₁₆ × 4¹³⁄₁₆″] (.148)

 The same models appear in cat. no. 66.

66
†Two children in light dresses, one holding box, ca. 1882
Platinum print, 15.4 × 11.6 cm [6¹⁄₁₆ × 4⁹⁄₁₆″] (.657)

67
†Boy with chickens in farmyard, ca. 1883
Gelatin printing-out-paper print, 9.5 × 11.6 cm [3¾ × 4⁹⁄₁₆″] (.777)

68
Attributed to Susan Macdowell Eakins
†Betty Reynolds with doll on lap, ca. 1885
Platinum print, 15.4 × 12.5 cm [6¹⁄₁₆ × 4¹⁵⁄₁₆″] (.652)
Gelatin printing-out-paper print, 6.8 × 6.5 cm [2¹¹⁄₁₆ × 2⁹⁄₁₆″] (.654)
Hendricks 1972, fig. 142.

A print in the collection of the Macdowell family (Roanoke, Virginia) identifies the sitter. Susan Macdowell Eakins exhibited a photograph called *Child with Doll* in the Philadelphia Photographic Salon of 1898.

69
Attributed to Susan Macdowell Eakins
†Betty Reynolds with puppy, ca. 1885

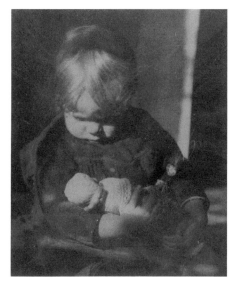

68 (.652)

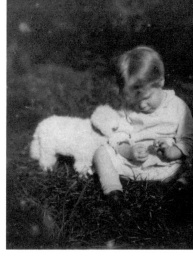

69

72

Albumen print, 5.2 × 5.7 cm [2¹⁵⁄₁₆ × 2¼″] (.651)

Betty Reynolds appears also in cat. no. 175.

70
Attributed to Susan Macdowell Eakins
†Betty Reynolds with Grandmother Reynolds partially visible, ca. 1885
Albumen print, 9.2 × 7.1 cm [3⅝ × 2¹³⁄₁₆″] (.655)

71
†Unidentified girl, ca. 1890
Platinum print, 6.8 × 5.9 cm [2¹¹⁄₁₆ × 2⁵⁄₁₆″] (.646)

The same model appears in cat. no. 72.

72
†Unidentified girl, looking left, ca. 1890
Platinum print, 7.2 × 6.4 cm [2¹³⁄₁₆ × 2½″] (.648)

73
†Unidentified girl in striped dress, ca. 1890
Platinum print, 18.9 × 14.8 cm [7⁷⁄₁₆ × 5¹³⁄₁₆″] (.647)
Platinum print, 7.6 × 7.1 cm [3 × 2¹³⁄₁₆″] (.659)

74
†Unidentified infant (Crowell child?), ca. 1900
Gelatin silver print, 11.3 × 6.4 cm [4⁷⁄₁₆ × 2½″] (1988.10.33)

73 (.647)

75

77

83

INDIVIDUAL PORTRAITS OF MEN

All but three of the photographs in this group of informal portraits are attributed directly to Thomas Eakins. Most reflect his usual style, characterized by simple composition and the sitter's direct gaze. Among these relatives, friends, and students only two remain unidentified. About half are published (in Hendricks 1972).

75

William H. Macdowell in coat and hat, standing in yard of the Eakins family home at 1729 Mount Vernon Street, Philadelphia, ca. 1884
Platinum print, 18.4 × 16.0 cm [7¼ × 6⁵⁄₁₆″] (.822)

76

William H. Macdowell in coat and hat, sitting, ca. 1884
Albumen print, 4.3 × 3.5 cm [1¹¹⁄₁₆ × 1⅜″] (.168)
Platinum print, 21.9 × 17.1 cm [8⅝ × 6¾″] (.820)

Platinum print, 29.1 × 22.4 cm [11⁷⁄₁₆ × 8¹³⁄₁₆″] (1988.10.22)
Hendricks 1972, figs. 77, 78.

See plate 15.

77

William H. Macdowell looking right, ca. 1884
Albumen print, 6.8 × 5.6 cm [2¹¹⁄₁₆ × 2³⁄₁₆″] (.169)

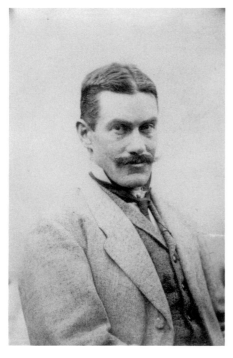

84 (.177)

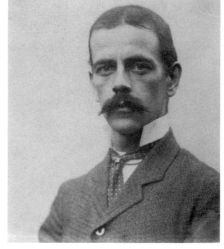

85

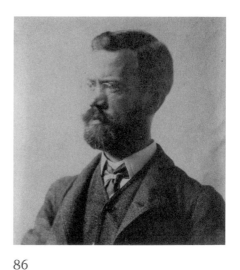

86

78
William H. Macdowell, ca. 1884
Cyanotype, 6.7 × 4.6 cm [2⅝ × 1¹³⁄₁₆″]
(.823)
Albumen print, 8.1 × 7.5 cm [3³⁄₁₆ × 2¹⁵⁄₁₆″]
(.170)
Hendricks 1972, fig. 79.

79
William H. Macdowell sitting on porch of
his home at 2016 Race Street, Philadelphia,
ca. 1884
Platinum print, 14.1 × 15.9 cm [5⁹⁄₁₆ × 6¼″]
(.792)
Hendricks 1972, figs. 74, 75.

80
Benjamin Eakins, ca. 1885
Photogravure, 14.0 × 9.0 cm [5½ × 3⁹⁄₁₆″]
(1988.10.6)
Photogravure, 14.0 × 9.0 cm [5½ × 3⁹⁄₁₆″]
(.151)

81
Benjamin Eakins in dark suit, sitting,
ca. 1885
Platinum print, 7.3 × 5.9 cm [2⅞ × 2⁵⁄₁₆″]
(.796)

Variant photographs from this session
were used to produce photogravures (see
cat. no. 80).

82
Benjamin Eakins in dark suit, sitting in
yard of the family home at 1729 Mount
Vernon Street, Philadelphia, ca. 1885
Albumen print, 7.9 × 6.7 cm [3⅛ × 2⅝″]
(.794)

83
Benjamin Eakins, sitting in yard of the
family home at 1729 Mount Vernon Street,
Philadelphia, ca. 1885
Platinum print, 16.0 × 13.2 cm [6⁵⁄₁₆ ×
5³⁄₁₆″] (.797)
Hendricks 1972, fig. 199.

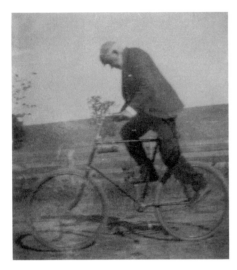

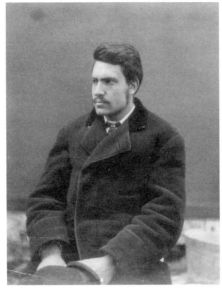

87

89

91 (.203)

84

Frank Macdowell, ca. 1885

Albumen print, 8.7 × 5.9 cm [3⁷⁄₁₆ × 2⁵⁄₁₆″]
(.177)

Platinum print, 2.1 × 1.3 cm [¹³⁄₁₆ × ½″]
(.176)

Glass positive, 10.2 × 8.1 cm [4 × 3³⁄₁₆″]
(.600)

Glass positive, 10.2 × 8.3 cm [4 × 3¼″]
(.601)

Glass positive, 10.8 × 8.3 cm [4¼ × 3¼″]
(.602)

Glass positive, 10.6 × 8.4 cm [4³⁄₁₆ × 3⁵⁄₁₆″]
(.603)

Hendricks 1972, fig. 72.

85

Walter Macdowell, ca. 1885

Albumen print, 6.5 × 5.6 cm [2⁹⁄₁₆ × 2³⁄₁₆″]
(.175)

86

William G. Macdowell, facing left, ca. 1885

Albumen print, 7.1 × 6.5 cm [2¹³⁄₁₆ × 2⁹⁄₁₆″]
(.180)

87

Benjamin Eakins riding bicycle, facing left,
ca. 1890

Platinum print, 10.2 × 9.0 cm [4 × 3⁹⁄₁₆″]
(.236)

Circle of Eakins

88

†William J. Crowell, ca. 1900

Gelatin silver print, 10.8 × 6.4 cm [4¼ ×
2½″] (1988.10.26)

THOMAS EAKINS'S MALE FRIENDS
AND STUDENTS

89

Unidentified man sitting, facing left,
ca. 1884

Albumen print, 10.6 × 8.6 irr. cm [4³⁄₁₆ ×
3⅜″ irr.] (.187)

93

94

96

90

Charles Bregler, ca. 1885
Gelatin silver print, 7.5 × 5.9 cm [2¹⁵⁄₁₆ ×
2⁵⁄₁₆″] (.202)

Inscribed in Charles Bregler's hand: *Photo
of Bregler / Taken by Eakins.* Print in Metro-
politan Museum of Art, New York, in-
scribed: *Charles Bregler at age 20.*

91

Charles Bregler, ca. 1885
Cyanotype, 10.2 × 7.1 cm [4 × 2¹³⁄₁₆″]
(.709)
Albumen print, 9.0 × 6.7 cm [3⁹⁄₁₆ × 2⁵⁄₈″]
(.203)
Gelatin printing-out-paper print, 9.0 × 7.1
cm [3⁹⁄₁₆ × 2¹³⁄₁₆″] (.205)
Gelatin silver print, 9.8 × 7.9 cm [3⅞ ×
3⅛″] (.204)
Dry-plate negative, 8.3 × 10.8 cm [3¼ ×
4¼″] (.881)

92

George W. Holmes, facing left, arms
folded, ca. 1885
Platinum print, 24.9 × 20.2 cm [9¹³⁄₁₆ ×
7¹⁵⁄₁₆″] (.185)
Hendricks 1972, fig. 197.

93

George W. Holmes, facing right, sitting,
arms folded, in carved armchair, ca. 1885
Platinum print, 21.9 × 17.5 cm [8⅝ × 6⅞″]
(.186)

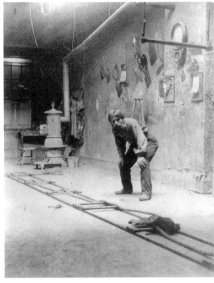

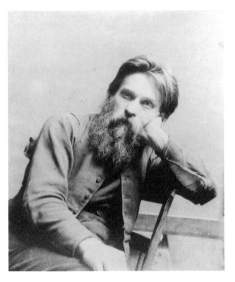

100 (.883)

101

102

94
Frank B. A. Linton(?) with setter, ca. 1885
Albumen print, 9.0 × 7.8 cm [3⁹⁄₁₆ × 3¹⁄₁₆″]
(.194)

Inscribed on verso: *Litton* (possibly a mis-
spelling of *Linton*). Frank Linton was a stu-
dent and friend of Thomas Eakins's.

95
Frank B. A. Linton(?), ca. 1885
Cyanotype, 8.3 × 5.1 cm [3¼ × 2″] (.195)

96
William Sartain sitting, ca. 1885
Albumen print, 10.8 × 8.9 cm [4¼ × 3½″]
(1988.10.24)

97
William Sartain sitting, ca. 1885
Albumen print, 9.4 × 7.1 cm [3¹¹⁄₁₆ ×
2¹³⁄₁₆″] (1991.14)

98
Henry Whipple, ca. 1885
Albumen print, 11.3 × 9.4 cm [4⁷⁄₁₆ ×
3¹¹⁄₁₆″] (.802)

99
Samuel Murray sitting, looking left,
ca. 1890
Platinum print, 8.4 × 7.1 cm [3⁵⁄₁₆ × 2¹³⁄₁₆″]
(.708)
Dry-plate negative, 10.2 × 12.7 cm [4 × 5″]
(.882)
Hendricks 1972, fig. 169.

100
Samuel Murray sitting, looking right,
ca. 1890
Platinum print, 11.4 × 8.7 cm [4½ × 3½″]
(.190)
Platinum print, 11.7 × 8.7 cm [4⁵⁄₈ × 3½″]
(.688)
Dry-plate negative, 10.2 × 12.7 cm [4 × 5″]
(.883)

101
Franklin Schenck at Philadelphia Art Stu-
dents' League, crouching, hands on knees,
ca. 1891
Albumen print, 11.9 × 9.8 cm [4¹¹⁄₁₆ × 3⁷⁄₈″]
(.196)
Hendricks 1972, fig. 175.

103

104 (.199)

102

Franklin Schenck sitting, resting head on hand, ca. 1891
Albumen print, 11.4 × 9.7 cm [4½ × 3¹³⁄₁₆″] (.710)
Hendricks 1972, fig. 173.

The negative for this image is in the Boulton collection (Philadelphia Museum of Art). The image is related to Eakins's portrait of Schenck (ca. 1890, Delaware Art Museum, Wilmington).

103

William R. O'Donovan on horse, ca. 1893
Platinum print, 7.8 × 8.6 cm [3¹⁄₁₆ × 3⅜″] (.192)

Circle of Eakins

104

Attributed to Susan Macdowell Eakins
†John Reynolds, ca. 1890
Albumen print, 8.6 × 7.1 cm [3⅜ × 2¹³⁄₁₆″] (.673)
Platinum print, 8.7 × 6.7 cm [3⁷⁄₁₆ × 2⅝″] (.199)
Hendricks 1972, fig. 221.

Identification of the sitter and photographer is based on an inscription on a print of this image in the Macdowell family collection, Roanoke, Virginia.

105

†Unidentified man reading, ca. 1890
Albumen print, 5.6 × 3.8 cm [2³⁄₁₆ × 1½″] (.711)

INFORMAL PORTRAITS OF THOMAS EAKINS

Clearly taken by more than a single photographer, these photographs are certainly by persons close to Thomas Eakins. They capture his image from about the age of thirty-five to just a few years before his death. Several are new to Eakins scholarship. The most likely photographers are Susan Eakins, Samuel Murray, Charles Bregler, and Elizabeth Macdowell. Note that many other photographs of Eakins are in the collection; see Nude Men, "Naked Series," Motion Studies, and Appendix A.

Circle of Eakins

106

†Thomas Eakins leaning against building, 1870–76
Albumen print, 26.8 × 15.1 cm [10⁹⁄₁₆ × 5¹⁵⁄₁₆″] (.33)
Wet-plate collodion negative, 10.2 × 12.7 cm [4 × 5″] (.832)
Wet-plate collodion negative, 10.2 × 8.3 cm [4 × 3¼″] (.833)
Wet-plate collodion negative, 12.7 × 20.3 cm [5 × 8″] (.834, double image)

107

Attributed to Susan Macdowell Eakins
†Thomas Eakins at about age thirty-five, leaning against fence, 1880
Platinum print, 12.4 × 9.4 cm [4⅞ × 3¹¹⁄₁₆″] (.687)
Gelatin silver print, 17.0 × 11.4 cm [6⁷⁄₁₆ × 4½″] (.34)
Hendricks 1972, fig. 247.

See fig. 1.

The date comes from a reference in Susan Eakins's retrospective diary: *Photographed Tom leaning against fence.*

108

†Thomas Eakins at Manasquan, New Jersey, 1880
Albumen print, 8.7 irr. × 5.6 cm [3½ irr. × 2³⁄₁₆″] (.35)

109

†Thomas Eakins nude, hand on hip, ca. 1880
Albumen print, 8.7 × 7.1 cm [3⁷⁄₁₆ × 2¹³⁄₁₆″] (.36)

110

†Thomas Eakins at age thirty-five to forty in a heavy wool jacket, ca. 1882
Dry-plate negative, 10.2 × 12.7 cm [4 × 5″] (.845)

111

†Thomas Eakins at age thirty-five to forty in a heavy wool jacket, ca. 1882
Platinum print, 10.9 × 9.2 cm [4⁵⁄₁₆ × 3⅝″] (.28)
Dry-plate negative, 10.2 × 12.7 cm [4 × 5″] (.846)
Hendricks 1972, fig. 250.

112

†Thomas Eakins at age thirty-five to forty in a heavy wool jacket, ca. 1882
Albumen print, 8.7 × 7.6 cm [3⁷⁄₁₆ × 3″] (.29)

113

†Thomas Eakins at age thirty-five to forty in a heavy wool jacket, ca. 1882
Albumen print, 10.8 × 8.4 cm [4¼ × 3⁵⁄₁₆″] (.30)

114

†Thomas Eakins at age thirty-five to forty, ca. 1882
Albumen print, 8.6 × 5.7 cm [3⅜ × 2¼″] (.31)
Dry-plate negative, 10.2 × 12.7 cm [4 × 5″] (.841)

115

†Thomas Eakins at age thirty-five to forty, ca. 1882
Albumen print, 9.4 × 7.1 cm [3¹¹⁄₁₆ × 2³⁄₁₆″] (.32)
Dry-plate negative, 10.2 × 12.7 cm [4 × 5″] (.843)

116
†Thomas Eakins at age thirty-five to forty, ca. 1882
Dry-plate negative, 10.2 × 12.7 cm [4 × 5″] (.838)

117
†Thomas Eakins at age thirty-five to forty, ca. 1882
Dry-plate negative, 10.2 × 12.7 cm [4 × 5″] (.839)

118
†Thomas Eakins at age thirty-five to forty, ca. 1882
Dry-plate negative, 10.2 × 12.7 cm [4 × 5″] (.840)

119
†Thomas Eakins at age thirty-five to forty, ca. 1882
Dry-plate negative, 10.2 × 12.7 cm [4 × 5″] (.842)

120
†Thomas Eakins at age thirty-five to forty, ca. 1882
Dry-plate negative, 10.2 × 12.7 cm [4 × 5″] (.844)
Hendricks 1972, fig. 255.

121
Attributed to Susan Macdowell Eakins
†Thomas Eakins with Dr. Frederick Milliken, in Chestnut Street studio, 1889
Dry-plate negative, 10.2 × 12.7 cm [4 × 5″] (.853)

122
Attributed to Susan Macdowell Eakins
†Thomas Eakins sitting, hand to forehead, ca. 1889
Platinum print, 17.0 × 13.0 cm [6¹¹⁄₁₆ × 5⅛″] (.38)
Platinum print, 20.5 × 15.2 cm [8¹⁄₁₆ × 6″] (.37)

The image is a probable source for Susan Eakins's portrait of her husband of ca. 1920–25 in the Philadelphia Museum of Art.

123
†Thomas Eakins sitting, hat in hand, 1890–93
Platinum print, 11.1 × 8.4 cm [4⅜ × 3⁵⁄₁₆″] (.39)
Hendricks 1972, fig. 274.

124
†Thomas Eakins sitting, hat in hand, 1890–93
Platinum print, 10.3 × 8.9 cm [4¹⁄₁₆ × 3½″] (.782)

125
Attributed to Susan Macdowell Eakins
†Thomas Eakins in profile, in Chestnut Street studio, 1891–92
Albumen print, 9.8 × 5.9 cm [3⅞ × 2⁵⁄₁₆″] (.40)
Gelatin silver print, 16.2 × 11.4 cm [6⅜ × 4½″] (.41)
Gelatin silver print, 16.2 × 11.3 cm [6⅜ × 4⁷⁄₁₆″] (.689)

Dry-plate negative, 10.2 × 12.7 cm [4 × 5″] (.850)
Hendricks 1972, fig. 263.

126
Attributed to Susan Macdowell Eakins
†Thomas Eakins in frontal view, in Chestnut Street studio, 1891–92
Gelatin silver print, 16.2 × 11.4 cm [6⅜ × 4½″] (.42)
Dry-plate negative, 10.2 × 12.7 cm [4 × 5″] (.852)
Hendricks 1972, fig. 262.

127
Attributed to Susan Macdowell Eakins
†Thomas Eakins in three-quarter view, in Chestnut Street studio, 1891–92
Platinum print on paper, 8.3 × 4.1 cm [3¼ × 1⅝″] (.793)
Dry-plate negative, 10.2 × 12.7 cm [4 × 5″] (.851)
Hendricks 1972, fig. 264.

128
Attributed to Susan Macdowell Eakins
†Samuel Murray, Thomas Eakins, and William R. O'Donovan, in Chestnut Street studio, 1891–92
Dry-plate negative, 10.2 × 12.7 cm [4 × 5″] (.854)
Hendricks 1972, fig. 272.

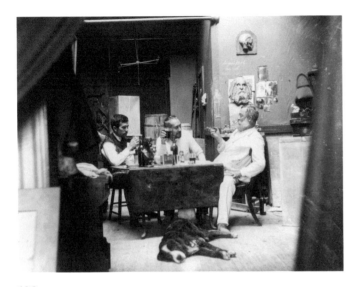

128

129
†Thomas Eakins, unidentified woman, and William R. O'Donovan, 1891–92
Platinum print, 5.7 × 9.5 cm [2¼ × 3¾"] (1959.19.1)
Platinum print, 6.0 × 9.2 cm [2⅜ × 3⅝"] (.44)
Hendricks 1972, fig. 261.

130
†Thomas Eakins at right, modeling the horse Billy at Avondale, Pennsylvania, 1891–92
Albumen print, 9.2 × 12.7 cm [3⅝ × 5"] (.50)
Albumen print, 5.4 irr. × 8.6 cm [2⅛ irr. × 3⅜"] (1988.10.57)
Hendricks 1972, fig. 265.

131
†Thomas Eakins at right, modeling the horse Billy at Avondale, Pennsylvania, 1891–92
Dry-plate negative, 10.2 × 12.7 cm [4 × 5"] (.855)

132
†Thomas Eakins at left, modeling the horse Billy at Avondale, Pennsylvania, 1891–92
Albumen print, 8.1 × 10.6 cm [3³⁄₁₆ × 4³⁄₁₆"] (1988.10.58)
Hendricks 1972, fig. 266.

133
†Thomas Eakins at about age fifty, ca. 1894
Platinum print, 7.3 × 5.6 cm [2⅞ × 2³⁄₁₆"] (.52)

134
†Thomas Eakins at about age fifty, ca. 1894
Platinum print, 4.6 × 3.7 cm [1¹³⁄₁₆ × 1⁷⁄₁₆"] (.53)

135
†Thomas Eakins at age fifty to fifty-five, 1894–99
Gelatin silver print, 9.8 × 5.2 cm [2⅞ × 2¹⁄₁₆"] (.51)
Gelatin silver print, 8.3 × 7.0 cm [3¼ × 2¾"] (.785)
Hendricks 1972, fig. 273.

Both prints are copies of an unlocated original.

136
†Thomas Eakins in vest and shirt sleeves, in Chestnut Street studio, ca. 1895
Platinum print, 4.4 × 1.9 cm [1¾ × ¾"] (.43)
Hendricks 1972, fig. 259.

137
†Thomas Eakins in light shirt, sitting, ca. 1895
Gelatin silver print, 7.6 × 6.0 cm [3 × 2⅜"] (.45a)
Gelatin silver print, 7.8 × 6.0 cm [3¹⁄₁₆ × 2⅜"] (.45b)

The two almost identical images are mounted side by side as if for a stereo-scope.

138

†Thomas Eakins in striped shirt, sitting in profile, ca. 1895
Gelatin silver print, 12.7 × 8.4 cm [5 × 3⁵⁄₁₆″] (.828)
Dry-plate negative, 10.2 × 12.7 cm [4 × 5″] (.849)
Hendricks 1972, fig. 276.

139

†Crowell farmhand and Thomas Eakins on horses from Dakota Territory, ca. 1895
Albumen print, 5.2 irr. × 7.6 cm [2¹⁄₁₆ irr. × 3″ (.311)

140

†Crowell farmhand and Thomas Eakins on horses from Dakota Territory, ca. 1895
Albumen print, 5.6 × 8.9 cm [2³⁄₁₆ × 3½″] (.690)
Albumen print, 7.0 × 9.0 irr. cm [2¾ × 3⁹⁄₁₆″ irr.] (.312)

141

†Thomas Eakins nude, head and shoulders only (fragment), ca. 1895
Platinum print, 4.9 × 3.8 cm [1¹⁵⁄₁₆ × 1½″] (.827)

142

†Thomas Eakins fondling a cat, ca. 1895
Platinum print, 8.7 × 8.6 cm [3⁷⁄₁₆ × 3³⁄₈″] (.790)

143

†Thomas Eakins sitting, smiling, wearing hat, 1890s
Gelatin silver print, 11.6 × 9.2 cm [4⁹⁄₁₆ × 3⅝″] (.54)
Glass positive, 8.3 × 10.2 cm [3¼ × 4″] (.588)
Hendricks 1972, fig. 275.

144

†Unidentified man and Thomas Eakins in sailboat at Fairton, New Jersey, ca. 1910
Gelatin silver print, 12.4 × 17.1 cm [4⅞ × 6¾″] (.327)

The same subjects appear in cat. nos. 145 and 146.

145

†Unidentified man and Thomas Eakins in sailboat at Fairton, New Jersey, ca. 1910
Gelatin silver print, 12.4 × 17.1 cm [4⅞ × 6¾″] (.328)

A print of this image in the Macdowell family collection (Roanoke, Virginia) is inscribed: *Dick Macdowell at the tiller/ Thomas Eakins in the bow/ picture taken by Louis Kenton.*

146

†Unidentified man and Thomas Eakins in sailboat at Fairton, New Jersey, ca. 1910
Gelatin silver print, 12.7 × 17.3 irr. cm [5 × 6¹³⁄₁₆″ irr.] (.329)

147

†Thomas Eakins playing with his dog in yard of the family home at 1729 Mount Vernon Street, Philadelphia, ca. 1914
Gelatin silver print, 11.6 × 8.7 cm [4⁹⁄₁₆ × 3⁷⁄₁₆″] (.66)

148

†Thomas Eakins tweaking his dog's ear in doorway of the family home at 1729 Mount Vernon Street, Philadelphia, ca. 1914
Gelatin silver print, 11.7 × 8.7 cm [4⅜ × 3⁷⁄₁₆″] (.67)
Hendricks 1972, fig. 291.

149

†Thomas Eakins and Addie Williams in doorway of the family home at 1729 Mount Vernon Street, Philadelphia, ca. 1914
Gelatin silver print, 11.0 × 12.4 cm [4⁵⁄₁₆ × 4⅞″] (.68)

150

†Thomas Eakins and Addie Williams in doorway of the family home at 1729 Mount Vernon Street, Philadelphia, ca. 1914
Gelatin silver print, 13.0 × 8.9 cm [5⅛ × 3½″] (.69)

151

†Thomas Eakins with his dog in doorway of the family home at 1729 Mount Vernon Street, Philadelphia, ca. 1914
Gelatin silver print, 10.8 × 7.8 cm [4¼ × 3¹⁄₁₆″] (.70)

152

†Thomas Eakins playing with his dog in yard of the family home at 1729 Mount Vernon Street, Philadelphia, ca. 1914
Gelatin silver print, 11.6 × 8.7 cm [4⁹⁄₁₆ × 3⁷⁄₁₆″] (.71)

INFORMAL GROUPS

This section contains a variety of informal photographs of people at leisure. (Another category, Figure Studies, has more purposefully posed groups.) The series showing Benjamin Eakins and his friends George Holmes and Bertrand Gardel is new to Eakins scholarship. That of Benjamin Eakins and Samuel Murray on a bicycle outing is well known. Both series appear to be platinum copy prints of lost originals. Another series shows various members of the Crowell family; almost all the images are known. The final series in this section consists of seven images that seem to have been taken on an Eakins family outing to the New Jersey shore. Several are new images but are closely related to published photographs (see Hendricks 1972).

153

Benjamin Eakins, George W. Holmes, and Bertrand Gardel, ca. 1882
Platinum print, 5.2 × 6.2 irr. cm [2¹⁄₁₆ × 2⁷⁄₁₆″ irr.] (.162)

154

Benjamin Eakins, George W. Holmes, and Bertrand Gardel, ca. 1882
Platinum print, 7.1 × 14.0 cm [2¹³⁄₁₆ × 5½″] (.161)

155

Benjamin Eakins, Bertrand Gardel, and George W. Holmes, ca. 1882
Platinum print, 8.3 × 11.0 cm [3¼ × 4⁵⁄₁₆″] (.156)

156

Benjamin Eakins, George W. Holmes, and Bertrand Gardel, ca. 1882
Platinum print, 7.3 × 16.2 cm [2⅞ × 6⅜″] (.160)

157

Benjamin Eakins and Bertrand Gardel, ca. 1882
Platinum print, 4.6 × 5.7 cm [1¹³⁄₁₆ × 2¼″] (.163)
Platinum print, 7.8 × 10.0 cm [3¹⁄₁₆ × 3¹⁵⁄₁₆″] (.155)

155

158

Bertrand Gardel and George W. Holmes, ca. 1882
Platinum print, 7.6 × 11.0 irr. cm [3 × 4⁵⁄₁₆″ irr.] (.157)

159

Bertrand Gardel, ca. 1882
Platinum print, 4.1 × 3.3 cm [1⅝ × 1⁵⁄₁₆″] (.158)

160

George W. Holmes, ca. 1882
Platinum print, 4.9 × 4.8 cm [1¹⁵⁄₁₆ × 1⅞″] (.159)

161

Benjamin Eakins and Bertrand Gardel in field, ca. 1882
Platinum print, 7.8 × 8.6 cm [3¹⁄₁₆ × 3⅜″] (.152)

156

163 (.233)

162

Benjamin Eakins and Samuel Murray with bicycles, ca. 1895
Platinum print, 3.5 × 5.2 cm [1⅜ × 2¹⁄₁₆″] (.153)
Platinum print, 4.8 × 5.6 cm [1⅞ × 2³⁄₁₆″] (.154)
Platinum print, 11.7 × 15.1 cm [4⅝ × 5¹⁵⁄₁₆″] (.235)
Hendricks 1972, fig. 223.

163

Benjamin Eakins and Samuel Murray with bicycles on stone bridge, ca. 1895
Platinum print, 7.1 × 9.8 cm [2¹³⁄₁₆ × 3⅞″] (.234)
Platinum print, 14.3 irr. × 22.0 irr. cm [5⅝ irr. × 8½″ irr.] (.233)

THE CROWELL FAMILY

164

Two Crowell children, Margaret Eakins, and Frances Crowell, standing on roof, ca. 1881
Dry-plate negative, 10.2 × 12.7 cm [4 × 5″] (.863)

Poses of the children in cat. nos. 164 and 165 were used in *Mending the Net* (1881, Philadelphia Museum of Art).

165

Two Crowell children, Frances Crowell, and Margaret Eakins (partially visible) standing on roof, ca. 1881
Dry-plate negative, 10.2 × 12.7 cm [4 × 5″] (.864)

166

Margaret Eakins, Artie Crowell, and Susan Macdowell at Avondale, Pennsylvania, ca. 1882
Albumen print, 7.8 × 9.8 cm [3¹⁄₁₆ × 3⅞″] (.641)
Dry-plate negative, 10.2 × 12.7 cm [4 × 5″] (.861)
Hendricks 1972, fig. 33.

167

Margaret Eakins, Artie Crowell, and Susan Macdowell at Avondale, Pennsylvania, ca. 1882
Albumen print, 8.3 × 10.2 cm [3¼ × 4″] (.637)
Dry-plate negative, 10.2 × 12.7 cm [4 × 5″] (.862)

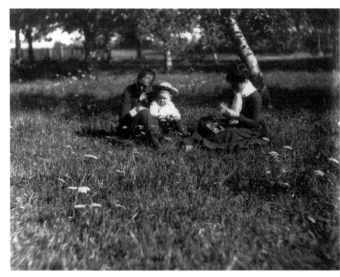

164

167 (.862)

168

Frances Crowell, Artie Crowell, Tom
Crowell, and Susan Macdowell, 1883
Albumen print, 8.9 × 11.4 cm [3½ × 4½″]
(1988.10.28)
Hendricks 1972, fig. 52.

169

Susan Macdowell and Crowell children in
rowboat at Avondale, Pennsylvania, 1883
Gelatin printing-out-paper print, 9.4 × 11.7
cm [3¹¹⁄₁₆ × 4⅝″] (.325)
Gelatin silver print, 27.9 × 35.6 cm [11 ×
14″] (.326)
Glass positive, 8.7 × 11.3 cm [3⁷⁄₁₆ × 4⁷⁄₁₆″]
(.610)

See plate 1.

170

Susan Macdowell and Crowell children
with rowboat in creek at Avondale, Penn-
sylvania, 1883
Glass positive, 8.7 × 11.3 cm [3⁷⁄₁₆ × 4⁷⁄₁₆″]
(.611)

171

Susan Macdowell and Crowell children in
creek at Avondale, Pennsylvania, 1883
Glass positive, 9.0 × 11.4 cm [3⁹⁄₁₆ × 4½″]
(.612)
Hendricks 1972, fig. 51.

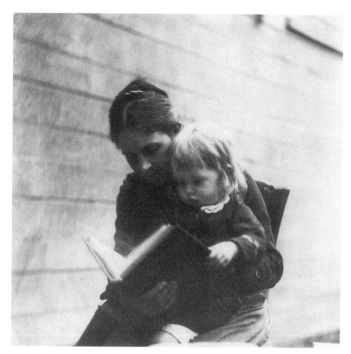

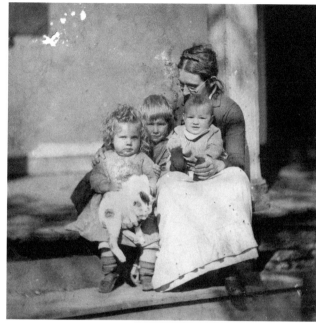

172

174

172
Frances Crowell and Katie(?) Crowell,
ca. 1888
Albumen print, 7.9 × 7.9 cm [3⅛ × 3⅛″]
(.78)

173
Katie Crowell, the dog Piero, and William
J. Crowell, ca. 1888
Albumen print, 8.9 × 11.1 cm [3½ × 4⅜″]
(1988.10.27)
Hendricks 1972, fig. 139.

174
Frances Crowell with Katie, James, and
Frances Crowell, ca. 1890
Platinum print, 20.0 × 19.7 cm [7⅞ × 7¾″]
(1988.10.9)
Hendricks 1972, fig. 163.

Circle of Eakins

175
Attributed to Susan Macdowell Eakins
†John Gardner and his granddaughter,
Betty Reynolds, ca. 1883
Gelatin printing-out-paper print, 7.6 × 7.6
cm [3 × 3″] (.653)
Glass positive, 10.2 × 7.1 cm [4 × 2¹³⁄₁₆″]
(.604)

The sitters have been identified by inscrip-
tions on photographs in the Macdowell
family collection, Roanoke, Virginia.

177

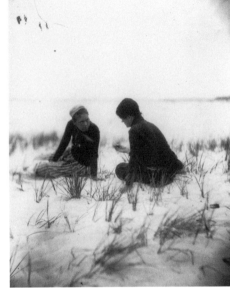

179

GROUPS AT LEISURE

176

Elizabeth Macdowell and Margaret Eakins
in woods at Manasquan, New Jersey (?),
ca. 1880
Dry-plate negative, 10.2 × 12.7 cm [4 × 5″]
(.860)
Hendricks 1972, fig. 27.

177

Margaret Eakins and Elizabeth Macdowell
in woods at Manasquan, New Jersey (?),
ca. 1880
Dry-plate negative, 10.2 × 12.7 cm [4 × 5″]
(.857)
Hendricks 1972, fig. 28.

178

Margaret Eakins and other figures on
beach at Manasquan, New Jersey (?),
ca. 1880
Dry-plate negative, 10.2 × 12.7 cm [4 × 5″]
(.859)

See fig. 2.

179

Margaret Eakins and Elizabeth Macdowell
sitting in beach grass at Manasquan, New
Jersey (?), ca. 1880
Dry-plate negative, 10.2 × 12.7 cm [4 × 5″]
(.856)

180

Margaret Eakins on beach at Manasquan,
New Jersey (?), ca. 1880
Dry-plate negative, 10.2 × 12.7 cm [4 × 5″]
(.858)

181

Beach scene with several groups of reclin-
ing figures, ca. 1880
Dry-plate negative, 10.2 × 12.7 cm [4 × 5″]
(.975)

Circle of Eakins

182

†Unidentified figures on beach, ca. 1880
Gelatin printing-out-paper print, 7.8 × 10.0
cm [3¹⁄₁₆ × 3¹⁵⁄₁₆″] (.776)

FIGURE STUDIES

In the figure studies, which are photographed both indoors and outdoors, the models are carefully posed so that costuming, props, lighting, and setting work together to create a specific mood. The majority of images are indoor studies of women, some of whom have been identified. They are posed in classical and other historical costumes.

The photographs are arranged according to subject. Two groups related to specific projects are listed first: negatives of photographic studies for the painting *The Pathetic Song* (1881, Corcoran Gallery, Washington, D.C.) and prints of studies of women in classical garb that are probably related to the Arcadia series of paintings. Within the next series—images of women in a variety of period costumes—are photographs related to the painting *The Artist's Wife and His Setter Dog* (ca. 1886, Metropolitan Museum of Art, New York). Other costume studies have less direct associations with specific projects and are therefore attributed to the circle of Eakins. More contrived in character, these include a series of images of women in colonial dress that may be by Susan Macdowell Eakins, Elizabeth Macdowell, or Amelia Van Buren. In addition, there is a group of images of Pennsylvania Academy students that were formerly attributed to Thomas Eakins but now seem to have a less direct connection to him in terms of style.

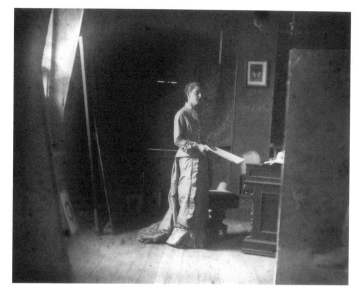

184

MARGARET HARRISON POSING FOR THE
PAINTING *THE PATHETIC SONG*

183

Margaret Harrison posing for *The Pathetic Song,* painting visible at right, 1881
Dry-plate negative, 10.2 × 12.7 cm [4 × 5″]
(.866)

184

Margaret Harrison posing for *The Pathetic Song,* painting visible at right, 1881
Dry-plate negative, 10.2 × 12.7 cm [4 × 5″]
(.867)

185

Margaret Harrison posing for *The Pathetic Song,* 1881
Dry-plate negative, 10.2 × 12.7 cm [4 × 5″]
(.868)

186

Margaret Harrison posing for *The Pathetic Song,* painting visible at right, 1881
Dry-plate negative, 10.2 × 12.7 cm [4 × 5″]
(.869)

187

Margaret Harrison posing for *The Pathetic Song,* 1881
Dry-plate negative, 10.2 × 12.7 cm [4 × 5″]
(.870)

188

Margaret Harrison posing for *The Pathetic Song,* detail of dress, 1881
Dry-plate negative, 10.2 × 12.7 cm [4 × 5″]
(.871)

190

189

Margaret Harrison posing for *The Pathetic Song,* half-length view, 1881
Dry-plate negative, 10.2 × 12.7 cm [4 × 5″] (.872)

190

Margaret Harrison posing for *The Pathetic Song,* head-and-shoulders view, 1881
Dry-plate negative, 10.2 × 12.7 cm [4 × 5″] (.873)

191

Margaret Harrison posing for *The Pathetic Song,* half-length view, 1881
Dry-plate negative, 10.2 × 12.7 cm [4 × 5″] (.874)

192

Margaret Harrison in profile, sitting in carved armchair, 1881
Dry-plate negative, 10.2 × 12.7 cm [4 × 5″] (.875)

193

Margaret Harrison in profile, sitting in carved armchair, 1881
Dry-plate negative, 10.2 × 12.7 cm [4 × 5″] (.876)

WOMEN IN CLASSICAL COSTUME

194

Two women in classical costume, sitting on couch, ca. 1883
Platinum print, 16.2 × 22.4 cm [6⅜ × 8¹³⁄₁₆″] (.663)
Hendricks 1972, fig. 64.

The same models appear in cat. no. 195.

195

Two women in classical costume, with Thomas Eakins's *Arcadia* relief at left, ca. 1883
Platinum print, 21.1 × 14.6 cm [8⁵⁄₁₆ × 5¾″] (.670)
Hendricks 1972, figs. 62, 63.

See plate 11.

196

Woman in classical costume, holding flowers, with bust of Caesar, ca. 1885
Albumen print, 9.2 × 4.1 cm [3⅝ × 1⅛″] (.244)
Platinum print, 23.3 × 9.2 cm [9³⁄₁₆ × 3⅝″] (.581)

See fig. 11.

197

Woman in classical costume, with bust of Caesar, ca. 1885
Albumen print, 16.0 × 8.4 cm [6⁵⁄₁₆ × 3⁵⁄₁₆″] (.249)

See plate 12.

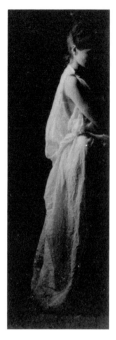

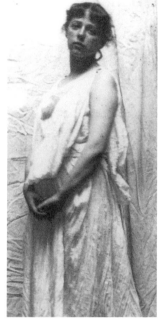

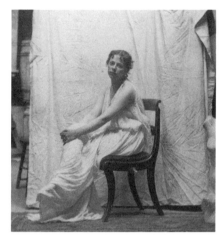

198

201 (.245)

203

198

Susan Hannah Macdowell (?) in classical costume, ca. 1885
Platinum print, 7.0 × 2.5 cm [2¾ × 1″]
(.248)

199

Blanche Gilroy in classical costume, reclining, with banjo, ca. 1885
Albumen print, 6.2 × 11.6 cm [2⁷⁄₁₆ × 4⁹⁄₁₆″]
(.250)
Platinum print, 5.9 × 11.4 cm [2⁵⁄₁₆ × 4½″]
(.679)

See plate 13.

The subject is identified through an inscription on an image of the same model in the J. Paul Getty Museum, Malibu.

200

Katherine Cook (?) in classical costume, sitting next to Venus torso, ca. 1892
Albumen print, 7.5 × 5.6 cm [2¹⁵⁄₁₆ × 2³⁄₁₆″]
(.668)
Hendricks 1972, fig. 182.

201

Weda Cook in classical costume, ca. 1892
Albumen print, 6.2 × 2.9 cm [2⁷⁄₁₆ × 1⅛″]
(.1108)
Platinum print, 5.9 × 2.4 cm [2⁵⁄₁₆ × ¹⁵⁄₁₆″]
(.662)
Platinum print, 15.9 × 7.9 cm [6¼ × 3⅛″]
(.245)

202

Weda Cook in classical costume, facing left, ca. 1892
Albumen print, 5.9 × 3.3 cm [2⁵⁄₁₆ × 1⁵⁄₁₆″]
(.1109)
Platinum print, 4.9 × 2.1 cm [1¹⁵⁄₁₆ × ¹³⁄₁₆″]
(.664)
Platinum print, 20.6 × 8.9 cm [8⅛ × 3½″]
(.676)
Hendricks 1972, fig. 184.

203

Weda Cook in classical costume, sitting in Empire chair, ca. 1892
Platinum print, 9.8 × 9.2 cm [3⅞ × 3⅝″]
(.674)

204

Weda Cook in classical costume with Venus torso, ca. 1892
Albumen print, 6.0 × 4.0 cm [2⅜ × 1⁹⁄₁₆″]
(.247)
Albumen print, 6.0 × 4.1 cm [2⅜ × 1⅝″]
(.246)
Hendricks 1972, fig. 183.

205

Two women in Empire and classical costume, sitting, ca. 1892
Platinum print, 11.4 × 8.4 cm [4½ × 3⁵⁄₁₆″]
(.677)

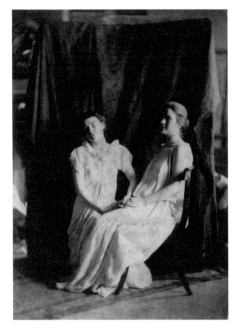

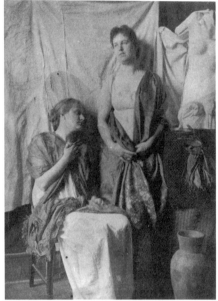

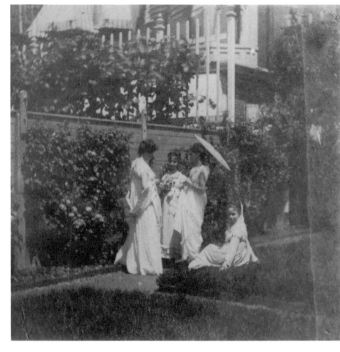

205

206

210

Circle of Eakins

206
†Two women in classical costume, wearing shawls, with Venus torso, ca. 1892
Cyanotype, 9.4 × 6.8 irr. cm [3¹¹⁄₁₆ × 2¹¹⁄₁₆″ irr.] (.255)

WOMEN IN PERIOD COSTUMES

207
Caroline Eakins, 1882
Albumen print, 11.0 × 5.4 cm [4⁵⁄₁₆ × 2⅛″] (.77)
Hendricks 1972, fig. 38.

208
Caroline Eakins, 1882
Gelatin silver print, 11.4 × 7.9 cm [4½ × 3⅛″] (1988.10.18)
Hendricks 1972, fig. 34.

209
Elizabeth Macdowell in Empire dress in yard, ca. 1881
Albumen print, 8.3 × 10.8 cm [3¼ × 4¼″] (.695)
Hendricks 1972, fig. 13.

210
Four women in Empire dresses in yard, ca. 1881
Albumen print, 9.2 × 9.5 cm [3⅝ × 3¾″] (.639)

Inscribed on album page in Charles Bregler's hand: *yard at 1729 Mt. Vernon St.* (misidentification; see Introduction, note 53).

211
Mary Macdowell in sleeveless dress, leaning back, hands behind head, ca. 1883
Albumen print, 5.2 × 6.4 cm [2¹⁄₁₆ × 2½″] (.667)

214 (.697)

217

212

Woman in laced-bodice dress, sitting with setter at her feet, ca. 1883

Albumen print, 9.0 × 11.4 cm [3⁹⁄₁₆ × 4½″] (.265)

See plate 14.

The same model appears in cat. no. 213. Both images are related to *The Artist's Wife and His Setter Dog* (ca. 1886, Metropolitan Museum of Art, New York).

213

Woman in laced-bodice dress, ca. 1883

Albumen print, 11.4 × 9.2 cm [4½ × 3⅝″] (.264)

Hendricks 1972, fig. 69.

214

Woman in sleeveless dress, arms crossed over back of chair, ca. 1885

Albumen print, 5.4 × 6.2 cm [2⅛ × 2⁷⁄₁₆″] (.1106)

Platinum print, 4.9 × 6.7 cm [1¹⁵⁄₁₆ × 2⅝″] (.660)

Platinum print, 12.4 × 15.1 cm [4⅞ × 5¹⁵⁄₁₆″] (.697)

215

Woman in Empire dress, sitting in front of printed-fabric backdrop, ca. 1885

Cyanotype, 9.5 × 5.6 cm [3¾ × 2³⁄₁₆″] (.253)

Albumen print, 7.8 × 5.1 cm [3¹⁄₁₆ × 2″] (.251)

Albumen copy print, 10.8 × 8.1 cm [4¼ × 3³⁄₁₆″] (.252)

Hendricks 1972, fig. 66.

216

Woman sitting, head against studio door in Pennsylvania Academy, ca. 1885

Albumen print, 11.43 × 9.0 cm [4½ × 3⁹⁄₁₆″] (.256)

217

Girl sitting in Chippendale chair, ca. 1885

Platinum print, 8.9 × 10.9 cm [3½ × 4⁵⁄₁₆″] (.261)

The same model appears in cat. no. 218.

218

Girl sitting in Chippendale chair, hands clasped, ca. 1885

Albumen print, 7.6 × 8.3 cm [3 × 3¼″] (.671)

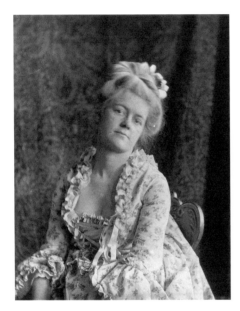

219

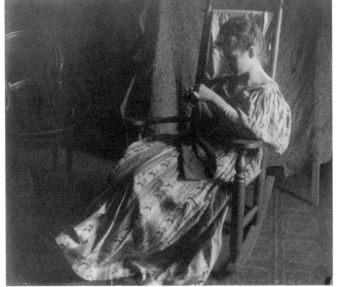

220

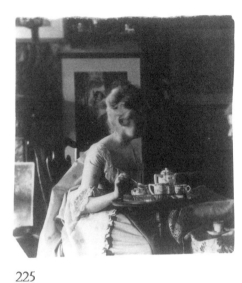

225

Circle of Eakins

219
†Elizabeth Macdowell in eighteenth-century dress, ca. 1885
Dry-plate negative, 10.2 × 12.7 cm [4 × 5″]
(.930)

220
†Woman sewing in rocking chair, ca. 1885
Albumen print, 9.2 × 10.8 cm [3⅝ × 4¼″]
(.257)

221
†Woman reading in bentwood chair, ca. 1885
Albumen print, 8.9 × 8.3 cm [3½ × 3¼″]
(.258)

222
†Woman sitting in bentwood chair, holding fan, ca. 1885
Albumen print, 9.2 × 9.4 cm [3⅝ × 3¹¹⁄₁₆″]
(.259)

223
†Woman sitting at open window, arm raised, ca. 1885
Platinum print, 6.2 × 5.4 cm [2⁷⁄₁₆ × 2⅛″]
(.260)

224
†Woman in eighteenth-century costume, holding teacup, ca. 1885
Albumen print, 9.0 × 8.1 irr. cm [3⁹⁄₁₆ × 3³⁄₁₆″ irr.] (.262)

The same model appears in cat. no. 225.

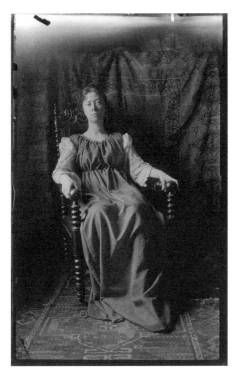

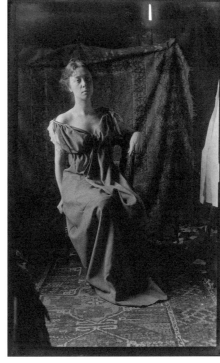

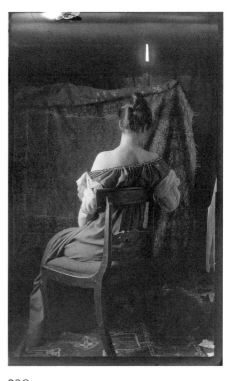

228

229

230

225

†Woman in eighteenth-century costume, sitting at tea table, ca. 1885
Albumen print, 8.6 × 8.1 cm [3⅜ × 3³⁄₁₆″] (.263)

226

†Woman in dress with slashed sleeves, ca. 1885
Albumen print, 14.9 × 9.5 cm [5⅞ × 3¾″] (1988.10.43)
Hendricks 1972, fig. 68.

227

†Clara Mather sitting in carved armchair, holding cello bow, ca. 1891
Platinum print, 9.0 × 5.2 cm [3⁹⁄₁₆ × 2¹⁄₁₆″] (.121)

228

†Clara Mather sitting in carved armchair, ca. 1891
Dry-plate negative, 12.7 × 20.3 cm [5 × 8″] (.935)

Cat. nos. 228–32 are the same size, 12.7 × 20.3 cm [5 × 8″], as several negatives attributed to Elizabeth Macdowell in the Mac-

dowell family collection, Roanoke, Virginia. The carved armchair visible in cat. no. 228 was acquired with the Bregler collection but is not the chair seen in Eakins's painted portraits.

229

†Clara Mather sitting in lyre-back chair, ca. 1891
Dry-plate negative, 12.7 × 20.3 cm [5 × 8″] (.931)

230

†Clara Mather sitting in Empire chair, rear view, ca. 1891

Dry-plate negative, 12.7 × 20.3 cm [5 × 8″] (.933)

231

†Clara Mather, bust-length portrait, ca. 1891

Dry-plate negative, 12.7 × 20.3 cm [5 × 8″] (.934)

232

†Clara Mather wearing head scarf and dress with feathered neckline, ca. 1891

Dry-plate negative, 12.7 × 20.3 cm [5 × 8″] (.932)

233

†Eva Watson, reading at small round table, ca. 1895

Platinum print, 14.6 × 11.6 cm [5¾ × 4⁹⁄₁₆″] (.109)

Cat. nos. 233–35 may be prints from 12.7 × 20.3 cm [5 × 8″] negatives. Different in style from Thomas Eakins's other costume studies, they may have been taken by Amelia Van Buren, who worked with Eva Watson.

234

†Eva Watson reading in high-backed chair, ca. 1895

Platinum print, 16.8 × 11.6 irr. cm [6⅝ × 4⁹⁄₁₆″ irr.] (.110)

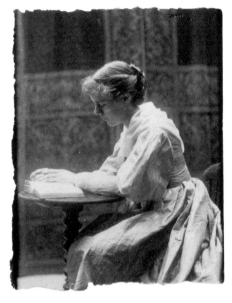

233

235

†Eva Watson reading at small round table in front of floral backdrop, ca. 1895

Platinum print, 11.0 × 15.1 cm [4⁵⁄₁₆ × 5¹⁵⁄₁₆″] (.111)

STUDENTS AT THE PENNSYLVANIA ACADEMY

Circle of Eakins

236

†Women's modeling class with cow in Pennsylvania Academy studio, ca. 1882

Albumen copy print, 9.4 × 12.5 cm [3¹¹⁄₁₆ × 4¹⁵⁄₁₆″] (.801)

Hendricks 1972, fig. 40.

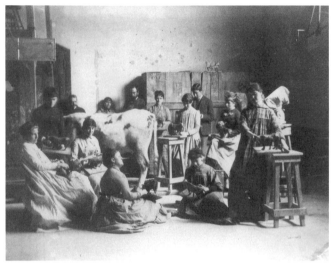

236

237

†Twenty-eight male students in Pennsylvania Academy studio, ca. 1882

Albumen copy print, 9.4 × 12.1 cm [3¹¹⁄₁₆ × 4¾″] (.803)

Olympia Galleries 1981, fig. 12.

238

†Seven male students in Pennsylvania Academy studio, ca. 1882

Albumen copy print, 12.1 × 9.4 cm [4¾ × 3¹¹⁄₁₆″] (.804)

Olympia Galleries 1981, fig. 21.

238

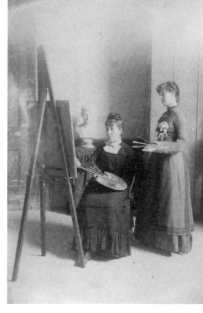

245

239

†Ten students in Pennsylvania Academy
studio, ca. 1882
Albumen copy print, 9.5 × 12.5 cm [3¾ ×
4¹⁵⁄₁₆″ (irr.)] (.1103)
Olympia Galleries 1981, fig. 17.

240

†Female student in Pennsylvania Academy
studio (fragment), ca. 1882
Albumen print, 4.3 × 1.3 cm [1¹¹⁄₁₆ × ½″]
(.1104)
Olympia Galleries 1981, fig. 17.

Cat. nos. 240 and 241 are small fragments
cut from cat. no. 239.

241

†Female student in Pennsylvania Academy
studio (fragment), ca. 1882
Albumen print, 4.1 × 1.3 cm [1⅝ × ½″]
(.1105)
Olympia Galleries 1981, fig. 17.

242

†Four students in Pennsylvania Academy
studio (fragment), ca. 1882
Albumen copy print, 9.7 × 7.1 cm [3¹³⁄₁₆ ×
2¹³⁄₁₆″] (.805)

Cat. no. 242 is the right half of a photo-
graph recorded in the Thomas Anshutz pa-
pers (Archives of American Art, microfilm
reel 795, frame 217).

243

†Three female students in Pennsylvania
Academy studio (fragment), ca. 1882
Albumen copy print, 8.4 × 4.0 cm [3⁵⁄₁₆ ×
1⁹⁄₁₆″] (.242)

Cat. nos. 243 and 244 are left and right
halves of an image reproduced in full in
Gordon Hendricks, *The Life and Work of
Thomas Eakins* (New York: Grossman
Publishers, 1974), p. 133.

244

†Seven students in Pennsylvania Academy
studio with écorché relief of horse (frag-
ment), ca. 1882
Albumen copy print, 8.9 × 7.9 cm [3½ ×
3⅛″] (.808)

245

†Two female students in Pennsylvania
Academy studio with palettes and easel,
ca. 1882
Albumen print, 12.7 × 8.7 cm [5 × 3⁷⁄₁₆″]
(.240)

246

†Female student in Pennsylvania Academy
studio (fragment), ca. 1882
Albumen print, 3.2 × 2.2 cm [1¼ × ⅞″]
(.1100)

Cat. nos. 246–48 are fragments cut from
an image seen in Olympia Galleries 1981,
fig. 8.

247

†Female student in Pennsylvania Academy studio (fragment), ca. 1882
Albumen print, 2.2 × 1.7 cm [7/8 ×¹¹⁄₁₆″] (.1101)

248

†Two female students in Pennsylvania Academy studio (fragment), ca. 1882
Albumen print, 1.4 × 1.6 cm [9/16 ×⁵⁄₈″] (.1102)

249

†Two male students in Pennsylvania Academy studio (fragment), ca. 1882
Albumen print, 2.5 × 3.8 cm [1 × 1½″] (.243)

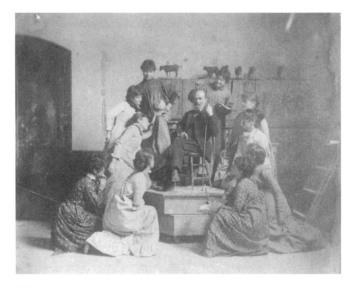

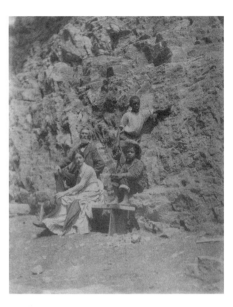

250

251

250

†Henry Whipple with ten female students in Pennsylvania Academy studio, ca. 1882
Albumen copy print, 9.5 × 12.4 cm [3¾ × 4⅞″] (.241)
Hendricks 1972, fig. 41.

OTHER FIGURE STUDIES

Circle of Eakins

251

†William H. Macdowell, Mary Macdowell, and two African-American boys at Clinch Mountain, Virginia, ca. 1881
Platinum print, 25.9 × 19.4 cm [10³⁄₁₆ × 7⅝″] (.231)

252

†Female model spinning while man watches, ca. 1882
Albumen print, 12.1 × 9.8 cm [4¾ × 3⅞″] (.713)

253

†Young woman standing in water near rowboat, ca. 1885
Cyanotype, 9.0 × 11.4 cm [3⁹⁄₁₆ × 4½″] (.239)

254

†Samuel Murray (?) sitting in woods, ca. 1885
Albumen print, 9.7 × 7.1 irr. cm [3¹³⁄₁₆ × 2¹³⁄₁₆″ irr.] (.237)

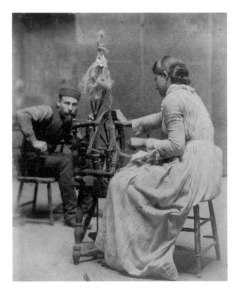

252

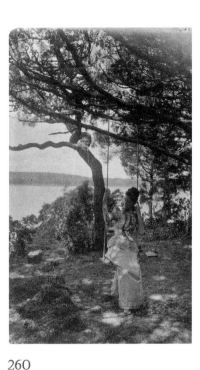

253

256

260

255

†Man and two dogs at edge of river,
ca. 1885
Albumen print, 8.9 × 11.6 cm [3½ × 4⁹⁄₁₆″]
(.238)

256

†Seven men in theatrical costume in
woods, ca. 1885
Albumen print, 15.6 × 19.1 cm [6⅛ × 7½″]
(.266)

Three photographs from the same session
as cat. nos. 256 and 257 are in the scrap-
books of the Philadelphia Sketch Club. All
are inscribed: *photo by Eakins.*

257

†Six men in theatrical costume in woods,
ca. 1885
Albumen print, 15.6 × 20.3 cm [6⅛ × 8″]
(.267)

258

†Landscape with man pitching hay into
wagon, ca. 1885
Glass positive, 9.8 × 12.4 cm [3⅞ × 4⅞″]
(.613)

259

†Blacksmith, ca. 1886
Albumen print, 19.4 × 12.4 cm [7⅝ × 4⅞″]
(.268)

See fig. 5.

260

†Mary Macdowell in swing, ca. 1890
Platinum print, 19.2 × 11.9 cm [7⁹⁄₁₆ ×
4¹¹⁄₁₆″] (.232)

The sitter has been identified through an
inscription in Elizabeth Macdowell's hand
on a print of this image in the Macdowell
family collection, (Roanoke, Virginia),
which also contains a 12.7 × 20.3 cm [5 ×
8″] glass negative of the image.

NUDES

NUDE WOMEN INDOORS

This group is made up of nude models photographed in various studio settings. Most are artfully posed on draped couches or in front of draped backdrops. There is also a small number of more prosaically posed women wearing masks (cat. nos. 269–71, taken at the Pennsylvania Academy, and cat. nos. 280–84, probably photographed at the Philadelphia Art Students' League). Their poses appear to be variations of the seven used by Thomas Eakins in his 1883 "naked series." While some of the nude women were no doubt taken by Eakins (particularly those for which the dry-plate negatives survive), many were probably photographed by his students. As a whole, they significantly increase our knowledge of Eakins's photographic activity in the area of nude studies. Lloyd Goodrich (1982) suggested that such prints were destroyed by a "misguided friend" concerned about Eakins's reputation. This group, however, provides a large number and wide variety of examples from which a new assessment of his interest in the nude can be made. Like all of Eakins's nude studies, they are difficult to date.

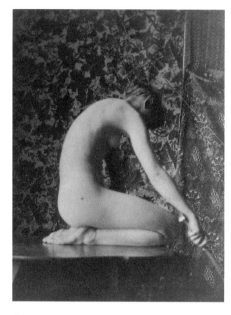

261 (.675)

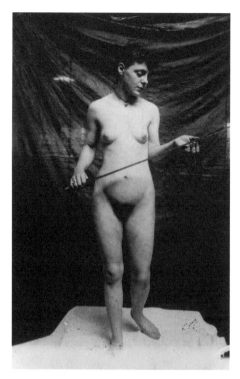

263

261
Female nude kneeling on table, ca. 1884
Albumen print, 9.7 × 7.8 cm [3¹³⁄₁₆ × 3¹⁄₁₆″] (.675)
Platinum print, 11.0 × 8.4 cm [4⁵⁄₁₆ × 3⁵⁄₁₆″] (.499)
Gelatin silver print, 19.7 × 16.3 cm [7¾ × 6⁷⁄₁₆″] (.500)

262
Female nude standing on cloth, hands on hips, from rear, ca. 1885
Platinum print, 9.4 × 5.4 cm [3¹¹⁄₁₆ × 2⅛″] (.528)
The same model appears in cat. nos. 263–65.

263
Female nude standing on cloth, with sword, ca. 1885
Platinum print, 9.7 × 6.5 cm [3¹³⁄₁₆ × 2⁹⁄₁₆″] (.527)

264
Female nude sitting on cloth-draped chair, facing left, ca. 1885
Platinum print, 8.6 × 6.0 cm [3⅜ × 2⅜″] (.530)
Platinum print, 9.5 irr. × 6.3 cm [3¾ irr. × 2½″] (.529)

264 (.529)

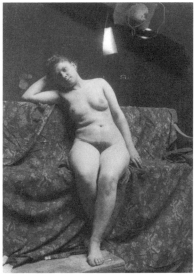

266

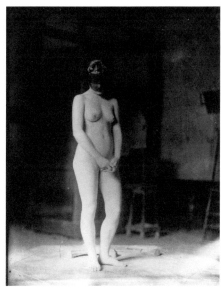

270

265
Female nude semireclining on cloth-draped platform, facing right, ca. 1885
Platinum print, 7.6 × 10.3 cm [3 × 4¹⁄₁₆″] (.531)

266
Female nude sitting on draped couch, foot on stool, ca. 1885
Platinum print, 9.8 × 7.1 cm [3⅞ × 2¹³⁄₁₆″] (.521)

267
Female nude sitting on Queen Anne chair, ca. 1885
Platinum print, 10.6 × 7.6 cm [4³⁄₁₆ × 3″] (.522)

268
Female with bare shoulders, in profile, ca. 1885
Cyanotype, 5.2 × 4.9 cm [2¹⁄₁₆ × 1¹⁵⁄₁₆″] (.254)

269
Female nude with black mask, ca. 1885
Platinum print, 11.3 × 4.8 cm [4⁷⁄₁₆ × 1⅞″] (.393)

The same model appears in cat. nos. 270 and 271. The poses are related to the "naked series." All three photographs were taken at the Pennsylvania Academy.

270
Female nude with black mask, left leg bent, ca. 1885
Gelatin silver print, 10.6 × 9.8 cm [4³⁄₁₆ × 3⅞″] (.394)

271

Female nude with black mask, facing left,
hands clasped behind head, ca. 1885
Platinum print, 12.1 × 5.7 cm [4¾ × 2¼"]
(.392)

272

Female nude semireclining, ca. 1889
Platinum print, 9.7 × 11.6 cm [3¹³⁄₁₆ ×
4⁹⁄₁₆"] (.511)
Platinum print, 10.0 × 13.0 cm [3¹⁵⁄₁₆ ×
5⅛"] (.507)
Platinum print, 10.2 × 12.9 cm [4 × 5¹⁄₁₆"]
(.512)
Platinum print, 9.8 × 12.9 cm [3⅞ × 5¹⁄₁₆"]
(.513)
Dry-plate negative, 10.2 × 12.7 cm [4 × 5"]
(.1054)

See plate 10.

The same model appears in cat. no. 273.

273

Female nude semireclining, from rear,
ca. 1889
Platinum print, 8.89 × 12.9 cm [3½ ×
5¹⁄₁₆"] (.506)
Platinum print, 9.5 × 13.0 irr. cm [3¾ ×
5⅛" irr.] (.502)
Platinum print, 9.8 × 13.5 irr. cm [3⅞ ×
5⁵⁄₁₆" irr.] (.503)
Platinum print, 10.0 × 13.2 cm [3¹⁵⁄₁₆ ×
5³⁄₁₆"] (.510)
Platinum print, 10.3 × 12.7 cm [4¹⁄₁₆ × 5"]
(.505)
Platinum print, 10.5 × 11.9 cm [4⅛ ×
4¹¹⁄₁₆"] (.504)

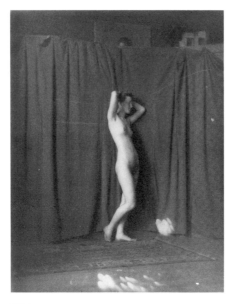

274

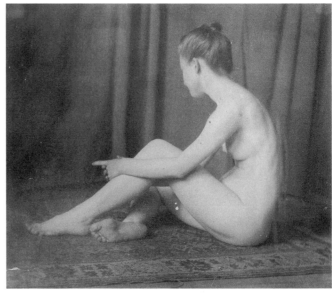

275 (.514)

Platinum print, 9.8 × 12.9 cm [3⅞ × 5¹⁄₁₆"]
(.501)
Dry-plate negative, 10.2 × 12.7 cm [4 × 5"]
(.1053)
Hendricks 1972, fig. 191.

See plate 10 and fig. 27.

274

Female nude, facing right, hands clasped
behind head, ca. 1889
Dry-plate negative, 10.2 × 12.7 cm [4 × 5"]
(.1056)

The same model appears in cat. nos.
275–77.

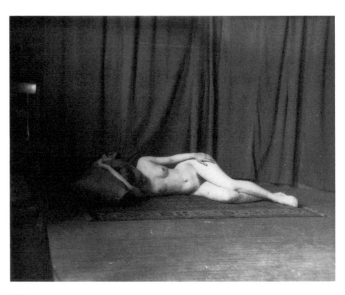

277

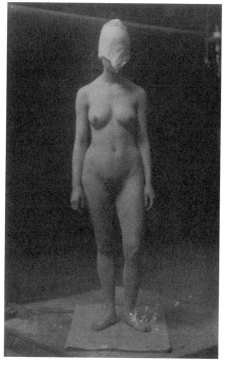 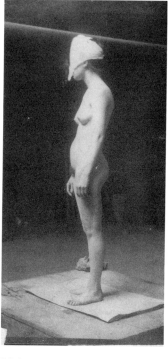 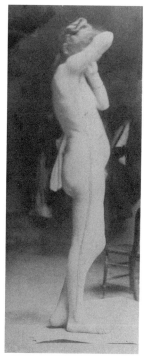 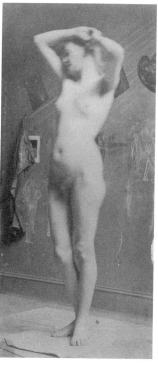

280 (.382) 284 (.380) 287 289

275
Female nude sitting on floor, grasping left leg, index finger pointed, ca. 1889
Albumen print, 8.6 × 11.3 cm [3⅜ × 4⁷⁄₁₆″] (.515)
Albumen print, 17.3 × 20.3 cm [6¹³⁄₁₆ × 8″] (.514)
Dry-plate negative, 10.2 × 12.7 cm [4 × 5″] (.1051)

276
Female nude sitting on floor, hands clasped below knee, ca. 1889
Dry-plate negative, 10.2 × 12.7 cm [4 × 5″] (.1052)
Hendricks 1972, fig. 190.

277
Female nude reclining on floor, head on pillow, ca. 1889
Dry-plate negative, 10.2 × 12.7 cm [4 × 5″] (.1055)

278
Female nude lying on stomach, head on hand, ca. 1889
Platinum print, 4.4 × 10.3 cm [1¾ × 4¹⁄₁₆″] (.508)

279
Female nude reclining on left side on bench, ca. 1889
Cyanotype, 5.4 × 11.4 cm [2⅛ × 4½″] (.509)

280
Female nude with mask, left leg bent, ca. 1889
Platinum print, 9.8 × 6.2 cm [3⅞ × 2⁷⁄₁₆″] (.383)
Platinum print, 10.8 × 5.7 cm [4¼ × 2¼″] (.382)

The same model appears in cat. nos. 281–85. The poses may be related to the "naked series."

281
Female nude with mask, legs straight,
ca. 1889
Albumen print, 9.7 × 4.1 cm [3¹³⁄₁₆ × 1⅝″]
(.385)
Platinum print, 9.8 × 5.4 cm [3⅞ × 2⅛″]
(.384)

282
Female nude with mask, facing right, left
leg bent, ca. 1889
Albumen print, 7.9 × 2.4 cm [3⅛ × ¹⁵⁄₁₆″]
(.377)

283
Female nude with mask, hands behind
head, left leg bent, ca. 1889
Albumen print, 8.9 × 4.6 cm [3½ × 1¹³⁄₁₆″]
(.378)

284
Female nude with mask, facing left,
ca. 1889
Albumen print, 9.7 × 4.1 cm [3¹³⁄₁₆ × 1⅝″]
(.381)
Platinum print, 9.7 × 4.8 cm [3¹³⁄₁₆ × 1⅞″]
(.379)
Platinum print, 10.8 × 5.4 cm [4¼ × 2⅛″]
(.380)

285
Female nude with mask, from rear,
ca. 1889
Albumen print, 9.7 × 4.0 cm [3¹³⁄₁₆ × 1⁹⁄₁₆″]
(.388)

Platinum print, 9.7 × 4.8 cm [3¹³⁄₁₆ × 1⅞″]
(.386)
Platinum print, 10.6 × 6.5 cm [4³⁄₁₆ ×
2⁹⁄₁₆″] (.387)

286
Female nude, facing right, right hand on
hip, left leg bent, ca. 1889
Albumen print, 11.6 × 6.5 cm [4⁹⁄₁₆ × 2⁹⁄₁₆″]
(.389)

The same model appears in cat. nos. 287–
89. Cat. nos. 286–89 share the same loca-
tion: the Arts Students' League. Note the
various items of art paraphernalia on the
rear wall. Cat. no. 101 shows more detail
of this wall.

287
Female nude, facing right, right arm
raised, left leg bent, ca. 1889
Albumen print, 11.6 × 4.8 cm [4⁹⁄₁₆ × 1⅞″]
(.390)

A pencil line was drawn along the model's
side from shoulder to ankle.

288
Female nude, from rear, ca. 1889
Albumen print, 11.6 × 5.5 cm [4⁹⁄₁₆ × 2¹⁄₁₆″]
(.391)

289
Female nude standing on pedestal, facing
slightly left, arms raised, ca. 1889
Albumen print, 11.6 × 5.5 cm [4⁹⁄₁₆ × 2¹⁄₁₆″]
(.526)

290
Female nude standing on wooden block,
arms raised, from rear, ca. 1898
Platinum print, 7.0 × 2.9 irr. cm [2¾ ×
1⅛″ irr.] (.524)
Platinum print, 8.1 × 4.8 cm [3³⁄₁₆ × 1⅞″]
(.523)

See fig. 3.

Photographed in Thomas Eakins's Chest-
nut Street studio. The image may be re-
lated to 1908 versions of his William Rush
paintings.

Circle of Eakins

291
Attributed to Elizabeth Macdowell
†Female nude semireclining, on draped
couch, from rear, ca. 1885
Albumen print, 10.8 × 9.4 cm [4¼ ×
3¹¹⁄₁₆″] (.516)

See fig. 36.

Inscribed on the verso in her own hand:
Elizabeth Macdowell. The same model ap-
pears in cat. no. 292.

292
Attributed to Elizabeth Macdowell
†Female nude sitting on draped couch,
hands clasped around knee, ca. 1885
Albumen print, 11.6 × 8.3 cm [4⁹⁄₁₆ × 3¼″]
(.517)

293

†Female nude sitting on draped couch, with palm fronds, ca. 1885
Albumen print, 8.9 × 8.3 cm [3½ × 3¼″] (.519)

The same model appears in cat. no. 294; the same backdrop is used in cat. nos. 294, 311, and 351–53. Elizabeth Macdowell may have been the photographer.

294

†Female nude reclining on draped couch, from rear, with palm fronds, ca. 1885
Albumen print, 5.2 × 11.1 cm [2¹/₁₆ × 4⅜″] (.520)
Albumen print, 6.4 × 11.1 cm [2½ × 4⅜″] (.518)

295

†Female nude on octagonal pedestal in Pennsylvania Academy sculpture studio, ca. 1885
Albumen copy print, 4.9 × 3.8 cm [1¹⁵/₁₆ × 1½″] (.395)

The same model appears in cat. no. 296.

296

†Female nude on octagonal pedestal, facing left in Pennsylvania Academy sculpture studio, ca. 1885
Albumen copy print, 5.1 × 3.8 cm [2 × 1½″] (.396)

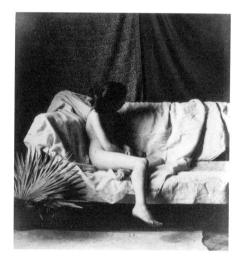

293

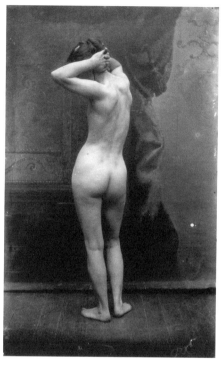

299

297

†Female nude standing on pedestal, arms raised, ca. 1885
Albumen print, 26.5 × 10.3 irr. cm [10⁷/₁₆ × 4¹/₁₆″ irr.] (.525)

See fig. 14.

It is possible that this is a French photograph made in the 1870s (see McCauley essay).

298

†Female nude standing on small round pedestal, from rear, ca. 1885
Dry-plate negative, 12.7 × 20.3 cm [5 × 8″] (.1057)

The same model appears in cat. no. 299.

299

†Female nude, hands on head, from rear, ca. 1885
Dry-plate negative, 12.7 × 20.3 cm [5 × 8″] (.1058)

NUDE WOMEN OUTDOORS

All of the photographs in this group are of Susan Macdowell, before her marriage to Thomas Eakins. They were made as studies for his two Arcadia paintings, which are set in a wooded landscape. Only one other photograph from this session is published (Hendricks 1972, fig. 19). Two images (cat. nos. 301, 302) served as the sources for the clothed figure in *An Arcadian* (ca. 1883, Spanierman Gallery, New York, and Alexander Gallery, New York); and another (cat. no. 306) was used for the female figure in *Arcadia* (1883, Metropolitan Museum of Art, New York). Other photographic studies for the painting *Arcadia* are catalogued under Nude Males Outdoors.

300

Susan Macdowell Eakins nude, from rear, ca. 1883
Cyanotype, 10.0 × 4.4 cm [3¹⁵⁄₁₆ × 1¾″] (.533)
Glass positive, 10.2 × 6.8 cm [4 × 2¹¹⁄₁₆″] (.616)
Glass positive, 11.3 × 8.9 cm [4⁷⁄₁₆ × 3½″] (.617)
Dry-plate negative, 10.2 × 12.7 cm [4 × 5″] (.1048)

301

Susan Macdowell Eakins nude, sitting, looking over right shoulder, ca. 1883
Cyanotype, 8.9 × 11.3 cm [3½ × 4⁷⁄₁₆″] (.544)

302

Susan Macdowell Eakins nude, sitting on blanket, looking over right shoulder, ca. 1883
Cyanotype, 8.3 × 9.5 cm [3¼ × 3¾″] (.545)

See plate 9.

303

Susan Macdowell Eakins nude, sitting, facing right, hands clasping right leg, ca. 1883
Albumen print, 12.9 × 19.8 cm [5¹⁄₁₆ × 7¹³⁄₁₆″] (.537)
Platinum print, 8.3 × 10.3 cm [3¼ × 4¹⁄₁₆″] (.538)
Dry-plate negative, 10.2 × 12.7 cm [4 × 5″] (.1049)

304

Susan Macdowell Eakins nude, sitting, facing right, hands clasping left leg, ca. 1883
Cyanotype, 5.6 × 7.1 cm [2³⁄₁₆ × 2¹³⁄₁₆″] (.539)
Cyanotype, 9.2 × 11.4 cm [3⅝ × 4½″] (.540)
Platinum print, 8.6 × 11.1 cm [3⅜ × 4⅜″] (.541)
Dry-plate negative, 10.2 × 12.7 cm [4 × 5″] (.1050)

305

Susan Macdowell Eakins nude, sitting, facing right, hand on knee, ca. 1883
Platinum print, 7.1 × 8.1 cm [2¹³⁄₁₆ × 3³⁄₁₆″] (.543)
Glass positive, 6.4 × 9.7 cm [2½ × 3¹³⁄₁₆″] (.615)

306

Susan Macdowell Eakins nude, reclining on elbow, from rear, ca. 1883
Albumen print, 8.3 × 10.2 cm [3¼ × 4″] (.542)

307

Susan Macdowell Eakins nude, lying on stomach, ca. 1883
Cyanotype, 9.2 × 11.6 cm [3⅝ × 4⁹⁄₁₆″ irr.] (.535)
Albumen print, 8.7 × 10.8 cm [3⁷⁄₁₆ × 4¼″] (.536)
Platinum print, 14 irr. × 28.4 cm [5⅝ irr. × 11³⁄₁₆″] (.534)

NUDE CHILDREN INDOORS

In this group are several images of children posed in an artistic manner more often associated with adults. They include reclining and contrapposto positions seen in classical and Renaissance painting and sculpture. The younger children and infants are posed less formally. Two of the photographs (cat. nos. 308, 309) were taken at Thomas Eakins's studio on Mount Vernon Street; the locations of the others are not known. The attribution of these photographs is problematic for several reasons. None of the children is identified, and there is great variety in the settings. The poses in several (cat. nos. 308–13) are charged with sexual overtones. Photographs of this kind caused Eakins's sister Fanny to object to his photographing her daughters in the nude (see her letters to him of April 4 and 7, 1890, in the Bregler collection).

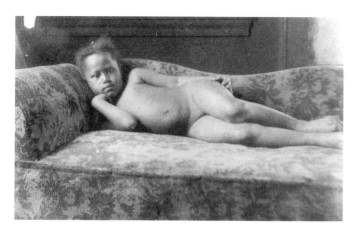

308

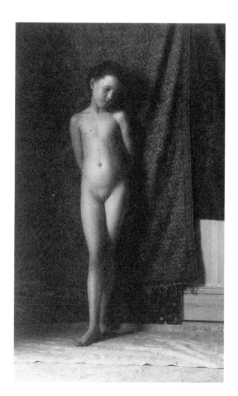

311

308

African-American girl nude, reclining on couch, ca. 1882

Albumen print, 3.7 × 6.2 cm [1⁷⁄₁₆ × 2⁷⁄₁₆″] (.565)

The same model appears in cat. no. 309.

309

African-American girl nude, reclining on couch, from rear, ca. 1882

Albumen print, 6.0 × 7.3 cm [2⅜ × 2⅞″] (.566)

310

Girl nude, sitting on draped box in front of printed-fabric backdrop, ca. 1885

Albumen print, 11.0 × 4.9 cm [4⁵⁄₁₆ × 1¹⁵⁄₁₆″] (.555)

Albumen print, 10.8 × 5.2 cm [4¼ × 2¹⁄₁₆″] (.556)

311

Girl nude in front of printed-fabric backdrop, ca. 1885

Platinum print, 9.2 × 5.6 cm [3⅝ × 2³⁄₁₆″] (.554)

The same backdrop is used in cat. nos. 293, 294, and 351–53.

312

Girl nude, hand on wall, in front of shelf of books and casts, ca. 1885

Platinum print, 9.5 × 5.6 cm [3¾ × 2³⁄₁₆″] (.561)

Platinum print, 9.2 × 6.7 cm [3⅝ × 2⅝″] (.562)

313

Boy and girl nude in front of light backdrop, ca. 1885

Platinum print, 10.0 × 6.5 cm [3¹⁵⁄₁₆ × 2⁹⁄₁₆″] (.567)

Circle of Eakins

314

†Boy nude, standing at sitting woman's knee, ca. 1885

Albumen print, 9.7 × 7.1 cm [3¹³⁄₁₆ × 2¹³⁄₁₆″] (.558)

315

†Boy nude sitting on table in front of light backdrop, ca. 1885

Platinum print, 8.6 × 7.9 cm [3⅜ × 3⅛″] (.568)

316

†Child nude sitting on bed, ca. 1885

Albumen print, 9.5 × 7.1 cm [3¾ × 2¹³⁄₁₆″] (.559)

The same model appears in cat. no. 317. A partial inscription on the print of this image in the Macdowell family collection (Roanoke, Virginia) suggests that the sitter is Carrie Macdowell and the photographer is Elizabeth Macdowell Kenton.

317

†Child nude sitting on bed, facing left, ca. 1885

Albumen print, 8.1 × 7.0 cm [3³⁄₁₆ × 2¾″] (.560)

318

†Child nude sitting on floor with dolls, ca. 1885

Cyanotype, 6.8 × 4.1 cm [2¹¹⁄₁₆ × 1⅝″] (.569)

319

†Infant nude on draped chair, ca. 1885
Gelatin printing-out-paper print, 7.7 × 7.1 cm [3³⁄₁₆ × 2¹³⁄₁₆″] (.705)

NUDE CHILDREN OUTDOORS

These photographs are more playful and more informally posed than the indoor scenes. Included are prints and dry-plate negatives of the Crowell children at Avondale, Pennsylvania, as well as unidentified children at the water's edge. The latter suggest a conscious association between nude children and outdoor bathing.

320

Boy in shorts and boy nude, standing in beach grass, from rear, ca. 1883
Albumen print, 8.9 × 11.1 cm [3½ × 4⅜″] (.580)

321

Three Crowell boys nude, near creek at Gloucester, New Jersey(?), ca. 1883
Dry-plate negative, 10.2 × 12.7 cm [4 × 5″] (.1061)

322

Crowell boy nude, from rear, at Avondale, Pennsylvania, 1883
Dry-plate negative, 10.2 × 12.7 cm [4 × 5″] (.1062)

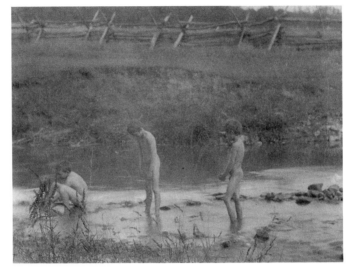

329

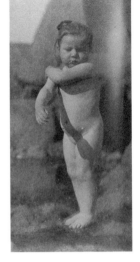

333 (.579)

323

Three Crowell children nude and setter, outdoors at Avondale, Pennsylvania, 1883
Dry-plate negative, 10.2 × 12.7 cm [4 × 5″] (.1059)
Hendricks 1972, fig. 59.

324

Two Crowell children nude, at Avondale, Pennsylvania, 1883
Dry-plate negative, 10.2 × 12.7 cm [4 × 5″] (.1060)
Hendricks 1972, fig. 57.

325

Crowell boy nude, in creek at Avondale, Pennsylvania, ca. 1885
Platinum print, 6.7 × 3.2 cm [2⅝ × 1¼″] (.576)
Hendricks 1972, fig. 143.

326

Crowell boy nude, hand on tree, at Avondale, Pennsylvania, ca. 1885
Platinum print, 6.0 × 3.7 cm [2⅜ × 1⁷⁄₁₆″] (.571)

Cat. nos. 326 and 327 are halves of a single photograph.

327

Two Crowell boys nude, at Avondale, Pennsylvania, ca. 1885
Platinum print, 5.9 × 3.7 cm [2⁵⁄₁₆ × 1⁷⁄₁₆″] (.572)

328

Three Crowell boys nude, at Avondale, Pennsylvania, ca. 1885
Platinum print, 8.9 × 7.8 cm [3½ × 3¹⁄₁₆″] (.573)

See fig. 52.

329

Three Crowell boys nude, in creek at
Avondale, Pennsylvania, ca. 1885
Platinum print, 7.9 × 10.3 cm [3⅛ × 4¹⁄₁₆″]
(.574)

330

Three Crowell boys nude, in creek at
Avondale, Pennsylvania, ca. 1885
Platinum print, 7.1 × 8.6 cm [2¹³⁄₁₆ × 3⅜″]
(.575)

331

Three Crowell children nude, in creek at
Avondale, Pennsylvania, ca. 1885
Platinum print, 8.1 × 8.6 cm [3³⁄₁₆ × 3⅜″]
(.577)

Circle of Eakins

332

†Two boys nude, one playing pipe,
ca. 1882
Albumen copy print, 3.5 × 7.0 cm [1⅜ ×
2¾″] (1971.22.3)
Albumen copy print, 8.3 × 16.5 cm [3¼ ×
6½″] (1971.22.2)

333

Attributed to Elizabeth Macdowell
†Girl nude, ca. 1883
Albumen print, 8.7 × 4.3 cm [3⁷⁄₁₆ × 1¹¹⁄₁₆″]
(.578)
Albumen print, 9.5 × 4.9 cm [3¾ × 1¹⁵⁄₁₆″]
(.579)

.578 is inscribed in her own hand: *Elizabeth
Macdowell, '83.*

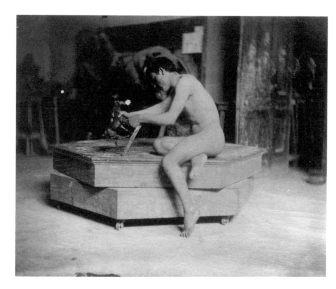

334

NUDE MEN INDOORS

These photographs are similar to the stud-
ies of nude women, except that none of
the men is masked. The group includes
four identified models. Those of Bill Duck-
ett (cat. nos. 336–40), John Wright (cat.
nos. 345, 346), and Tom Eagan (cat. nos.
343–46) were probably taken at the Art Stu-
dents' League. Three remarkable images
of Thomas Eakins nude, holding a nude fe-
male model (cat. nos. 348–50), were made
at the Pennsylvania Academy. The exis-
tence of negatives for the images of Duck-
ett in the Pennsylvania Academy's collec-
tion suggests an attribution to Eakins
himself, but other images may have been
taken by members of Eakins's circle. In ad-
dition to these nude studies, there are
nude men indoors in the "naked series."

334

Male nude sitting on modeling stand, hold-
ing small sculpture of horse, in Pennsylva-
nia Academy studio, ca. 1885
Albumen print, 9.7 × 12.1 cm [3¹³⁄₁₆ × 4¾″]
(.428)

335

Male nude crouching in sunlit rectangle in
Pennsylvania Academy studio, ca. 1885
Albumen print, 9.7 × 4.1 cm [3¹³⁄₁₆ × 1⅝″]
(.429)

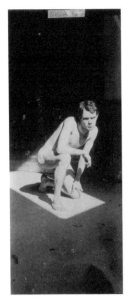 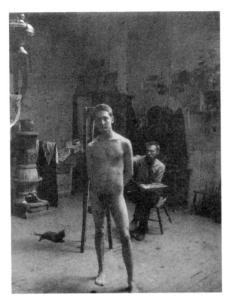

335 345

336

Bill Duckett nude, lying on stomach, hold-
ing vase, ca. 1889
Platinum print, 6.8 irr. × 11.1 cm [2¹¹⁄₁₆ irr.
× 4⅜″] (.412)
Platinum print, 8.4 × 10.8 cm [3⁵⁄₁₆ × 4¼″]
(.411)
Platinum print, 14.4 × 27.9 irr. cm [5¹¹⁄₁₆ ×
11″ irr.] (.410)
Dry-plate negative, 10.2 × 12.7 cm [4 × 5″]
(.1007)

See fig. 38.

For information about the identity of the
model in cat. nos. 336–40 see Johns essay.

337

Bill Duckett nude, reclining on side, hand
on knee, ca. 1889
Platinum print, 7.5 × 10.9 cm [2¹⁵⁄₁₆ ×
4⁵⁄₁₆″] (.416)
Platinum print, 9.0 × 11.3 cm [3⁹⁄₁₆ × 4⁷⁄₁₆″]
(.417)
Platinum print, 12.4 × 23.2 cm [4⅞ × 9⅛″]
(.414)
Platinum print, 11.6 × 18.3 cm [4⁹⁄₁₆ ×
7³⁄₁₆″] (.415)
Platinum print, 17.9 × 29.5 cm [7¹⁄₁₆ ×
11⅝″] (.413)
Hendricks 1972, fig. 198.

 See plate 2.

338

Bill Duckett nude, sitting on chair, ca. 1889
Platinum print, 9.4 × 8.4 cm [3¹¹⁄₁₆ × 3⁵⁄₁₆″]
(.420)
Platinum print, 10.8 × 8.7 cm [4¼ × 3⁷⁄₁₆″]
(.418)
Platinum print, 11.0 × 8.6 cm [4⁵⁄₁₆ × 3⅜″]
(.419)
Hendricks 1972, figs. 193, 194.

See fig. 39.

339

Bill Duckett nude, leaning against chair,
from rear, ca. 1889
Platinum print, 10.5 × 4.6 cm [4⅛ × 1¹³⁄₁₆″]
(.421)

340

Bill Duckett nude, sitting on small
wooden pedestal, ca. 1889
Dry-plate negative, 10.2 × 12.7 cm [4 × 5″]
(.1008)

341

Tom Eagan nude, in front of folding
screen, ca. 1889
Albumen print, 11.7 × 4.3 cm [4⅝ × 1¹¹⁄₁₆″]
(.447)
Albumen print, 12.1 × 7.5 cm [4¾ × 2¹⁵⁄₁₆″]
(.437)
Platinum print, 12.1 × 6.8 cm [4¾ × 2¹¹⁄₁₆″]
(.441)

The model in cat. nos. 341–44 has been
identified by an inscription, in the hand of
Susan Macdowell Eakins, on the verso of
one print in the series: *S. M. E. from T.
Eagan.*

342

Tom Eagan nude, facing left, in front of folding screen, ca. 1889
Albumen print, 11.7 × 4.3 cm [4⅝ × 1¹¹⁄₁₆″] (.448)
Albumen print, 12.4 × 10.2 cm [4⅞ × 4″] (.436)
Platinum print, 12.2 × 8.1 cm [4¹³⁄₁₆ × 3³⁄₁₆″] (.440)

See fig. 28.

343

Tom Eagan nude, facing right, in front of folding screen, ca. 1889
Albumen print, 11.7 × 4.0 cm [4⅝ × 1⁹⁄₁₆″] (.446)
Platinum print, 11.9 × 7.5 cm [4¹¹⁄₁₆ × 2¹⁵⁄₁₆″] (.439)
Platinum print, 11.7 × 7.5 irr. cm [4⅝ × 2¹⁵⁄₁₆″ irr.] (.438)

344

Tom Eagan nude, from rear, in front of folding screen, ca. 1889
Platinum print, 11.7 × 7.1 cm [4⅝ × 2¹³⁄₁₆″] (.442)

See fig. 29.

345

John Wright nude, posing for George Reynolds at easel, ca. 1889
Cyanotype, 11.4 × 9.0 cm [4½ × 3⁹⁄₁₆″] (.427)
Hendricks 1972, fig. 188.

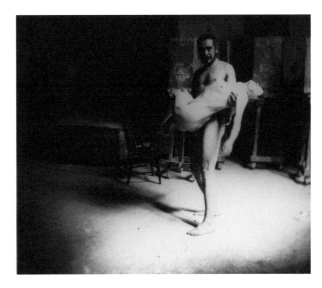

349

346

Male (possibly John Wright) nude, posing for George Reynolds, ca. 1889
Platinum print, 11.3 × 8.9 cm [4⁷⁄₁₆ × 3½″] (.806)
Hendricks 1972, fig. 187.

Circle of Eakins

347

†Thomas Eakins nude, semireclining on couch, from rear, ca. 1883
Platinum print, 13.7 × 18.4 cm [5⅜ × 7¼″] (.425)
Dry-plate negative, 6.0 × 5.7 cm [2⅜ × 2¼″] (.1009)
Hendricks 1972, fig. 258 (printed in reverse).

See plate 7.

348

†Thomas Eakins nude, holding nude female in his arms, looking down, ca. 1885
Dry-plate negative, 10.2 × 12.7 cm [4 × 5″] (.847)

See fig. 33.

349

†Thomas Eakins nude, holding nude female in his arms, looking at camera, ca. 1885
Dry-plate negative, 10.2 × 12.7 cm [4 × 5″] (.848)

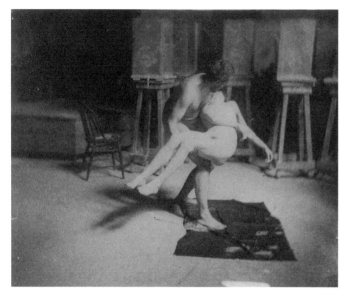

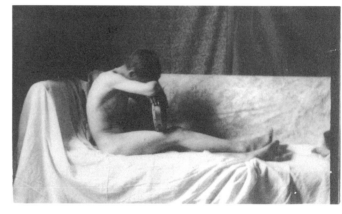

350 (.430)

352 (.424)

350

†Thomas Eakins nude, lowering nude female to the floor, ca. 1885
Platinum print (fragment), 6.4 × 6.5 cm [2½ × 2⁹⁄₁₆″] (.431)
Platinum print, 9.4 × 11.3 cm [3¹¹⁄₁₆ × 4⁷⁄₁₆″] (.430)

351

†Male nude reclining on draped couch, ca. 1885
Albumen print, 7.3 × 11.0 cm [2⅞ × 4⁵⁄₁₆″] (.422)

See fig. 37.

The same backdrop is used in cat. nos. 293, 294, 311, 352, and 353.

352

†Male nude on draped couch, forearm and head resting on tambourine, ca. 1885
Albumen print, 8.3 × 10.2 irr. cm [3¼ × 4″ irr.] (.423)
Platinum print, 6.2 × 10.3 cm [2⁷⁄₁₆ × 4¹⁄₁₆″] (.424)

353

†Boy nude, sitting on draped table in front of printed-fabric backdrop, ca. 1885
Albumen print, 9.4 × 6.7 cm [3¹¹⁄₁₆ × 2⅝″] (.557)

354

†Male nude, sitting on book, head on knees, ca. 1885
Gelatin silver print, 25.2 × 20.2 cm [9¹⁵⁄₁₆ × 7¹⁵⁄₁₆″] (.426)

NUDE MEN OUTDOORS

These studies seem to be the result of several outdoor photographing sessions in which Thomas Eakins and his male students posed singly and in groups for each other. The photographs show, more clearly than any others, the collaborative nature of Eakins's photographic work. Because he appears in many of the images, Eakins seems to have been both in front of and behind the camera in any given session.

Almost all of these sessions are known (from photographs published in Hendricks 1972), but the Pennsylvania Academy's collection adds significant variants to the group. Several models appear to have been posed as classical statues, and there

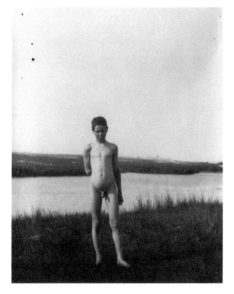

356 (.1063)

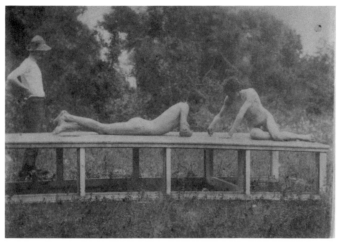

360

are numerous studies of nudes for the Arcadia paintings, in addition to those listed under Nude Women Outdoors. Taken as a whole, this group of photographs is the most consistent in style and choice of subject; it seems likely, therefore, that all of the images were taken by Eakins or were under his close supervision. Other nude men outdoors are included in the sections on Nude Men in Sports, Nudes with Horses, and Motion Studies.

355

Male nude wearing head scarf, from rear, at edge of river, ca. 1882
Albumen print, 7.5 × 8.3 cm [2¹⁵⁄₁₆ × 3¼″] (.457)
Albumen print, 20.5 × 15 irr. cm [8¹⁄₁₆ × 5¾″ irr.] (.456)

The same background appears in cat. nos. 356 and 357.

356

Boy nude at edge of river, ca. 1882
Albumen print, 11.7 × 9.2 cm [4⅝ × 3⅝″] (.460)
Platinum print, 9.5 irr. × 7.9 cm [3¾ irr. × 3⅛″] (.461)
Dry-plate negative, 10.2 × 12.7 cm [4 × 5″] (.1063)

357

Male nude wearing head scarf, and boy nude, at edge of river, ca. 1882
Albumen print, 9.0 × 11.1 cm [3⁹⁄₁₆ × 4⅜″] (.458)
Platinum print, 7.9 × 6.4 cm [3⅛ × 2½″] (.459)

See fig. 43.

358

Male nude and J. Laurie Wallace nude on platform in wooded landscape, ca. 1883
Albumen print, 7.9 × 11.7 cm [3⅛ × 4⅝″] (.474)

The same background appears in cat. nos. 359–61.

359

Male nude and male clothed on platform in wooded landscape (fragment), ca. 1883
Albumen print (fragment), 7.9 × 9.5 irr. cm [3⅛ × 3¾″ irr.] (.475)

360

Male clothed, standing, and male nude and J. Laurie Wallace nude, reclining on platform in wooded landscape, ca. 1883
Albumen print, 7.9 × 10.5 cm [3⅛ × 4⅛″] (.476)

361

J. Laurie Wallace nude, semireclining on platform with water in background, ca. 1883
Dry-plate negative, 10.2 × 12.7 cm [4 × 5″] (.1018)

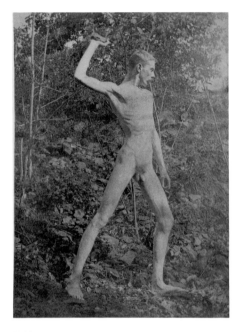

363

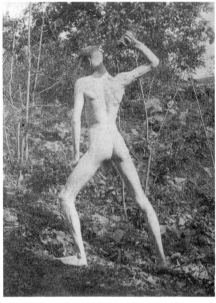

364

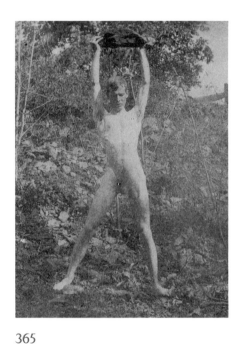

365

362
Male nude and J. Laurie Wallace nude, posing as boxers, and male clothed, water in background, ca. 1883
Albumen print, 8.9 × 11.6 cm [3½ × 4⁹⁄₁₆″] (.477)

363
Male nude, poised to throw rock, facing right, in wooded landscape, ca. 1883
Albumen print, 27.9 × 20.6 cm [11 × 8⅛″] (.449)

The same model appears in cat. nos. 364 and 366 (see discussion in Rosenzweig 1977, pp. 104–5).

364
Male nude, poised to throw rock, facing left, from rear, in wooded landscape, ca. 1883
Albumen print, 9.0 × 6.8 cm [3⁹⁄₁₆ × 2¹¹⁄₁₆″] (.445)

365
Male nude, holding large rock above head, in wooded landscape, ca. 1883
Albumen print, 8.9 × 6.5 cm [3½ × 2⁹⁄₁₆″] (.444)

366
Male nude, standing on one leg, in wooded landscape, ca. 1883
Albumen print, 9.2 × 6.8 cm [3⅝ × 2¹¹⁄₁₆″] (.443)

Circle of Eakins

367
†Thomas Eakins nude, facing right, hands clasped behind head, in tall grass, ca. 1883
Albumen print, 25.2 × 16.7 cm [9¹⁵⁄₁₆ × 6⁹⁄₁₆″] (.462)
Platinum print, 11.0 × 8.6 cm [4⁵⁄₁₆ × 3⅜″] (.464)
Platinum print, 11.3 × 8.9 cm [4⁷⁄₁₆ × 3½″] (.463)

See plate 5.

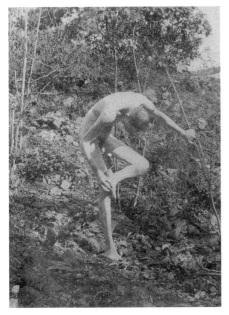

366

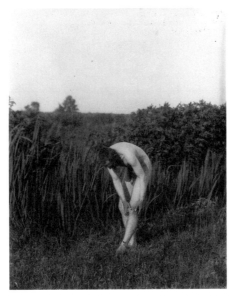

370 (.1012)

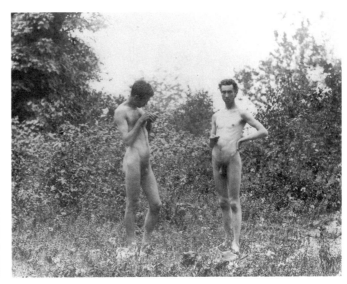

374

368
†Thomas Eakins nude, facing left, from rear, in tall grass, ca. 1883
Platinum print, 11.1 × 7.9 cm [4⅜ × 3⅛″] (.465)
Dry-plate negative, 10.2 × 32.3 cm [4 × 5″] (.1014)

369
†Thomas Eakins nude, bending forward, hands poised above left knee, in tall grass, ca. 1883
Albumen print, 9.4 × 5.1 irr. cm [3¹¹⁄₁₆ × 2″ irr.] (.467)
Albumen print, 13.4 × 13.7 irr. cm [7⅝ × 5⅜″ irr.] (.466)
Platinum print, 10.2 × 8.4 cm [4 × 3⁵⁄₁₆″] (.468)

370
†Thomas Eakins nude, bending forward, hands grasping left knee, in tall grass, ca. 1883
Albumen print, 7.9 × 4.3 irr. cm [3⅛ × 1¹¹⁄₁₆″ irr.] (.469)
Dry-plate negative, 10.2 × 12.7 cm [4 × 5″] (.1012)

371
†Thomas Eakins nude, hands on hips, from rear, in tall grass, ca. 1883
Albumen print, 9.8 × 7.1 irr. cm [3⅞ × 2¹³⁄₁₆″ irr.] (.472)
Albumen print, 9.8 × 9.0 cm [3⅞ × 3⁹⁄₁₆″] (.470)
Albumen print, 10.5 × 6.8 cm [4⅛ × 2¹¹⁄₁₆″] (.471)

372
†Thomas Eakins nude, bending over, from rear, in tall grass, ca. 1883
Platinum print, 10.5 × 8.6 cm [4⅛ × 3⅜″] (.473)

373
†Thomas Eakins nude, bending over, left arm on knee, in tall grass, ca. 1883
Dry-plate negative, 10.2 × 12.7 cm [4 × 5″] (.1013)

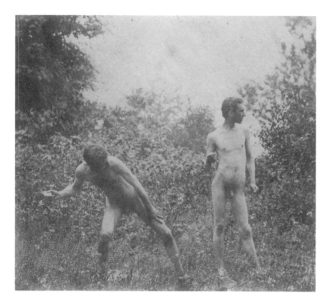

375

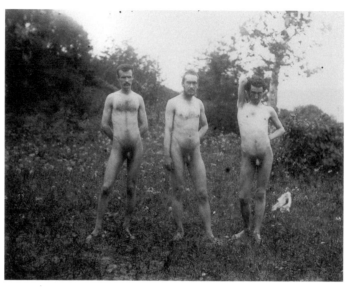

378

374
†Male nude and J. Laurie Wallace nude in wooded landscape, ca. 1883
Dry-plate negative, 10.2 × 12.7 cm [4 × 5″] (.1015)

The same background appears in cat. nos. 375–78.

375
†Male nude, poised to throw rock, and J. Laurie Wallace nude, looking right, in wooded landscape, ca. 1883
Albumen print, 9.5 irr. × 10.8 cm [3¾ irr. × 4¼″] (.451)

376
†Male nude and J. Laurie Wallace nude, from rear, in wooded landscape, ca. 1883
Albumen print, 19.4 × 18.4 cm [7⅝ × 7¼″] (.450)
Dry-plate negative, 10.2 × 12.7 cm [4 × 5″] (.1016)

See fig. 40.

377
†Male nude, from rear, and J. Laurie Wallace nude, facing left, in wooded landscape, ca. 1883
Albumen print (fragment), 9.0 × 6.3 irr. cm [3⁹⁄₁₆ × 2½″ irr.] (.453)
Albumen print, 9.0 × 10.0 cm [3⁹⁄₁₆ × 3¹⁵⁄₁₆″] (.452)

378
†Male nude, Thomas Eakins nude, and J. Laurie Wallace nude in wooded landscape, ca. 1883
Dry-plate negative, 10.2 × 12.7 cm [4 × 5″] (.1017)

379
†Thomas Eakins nude and J. Laurie Wallace nude in front of boat at shoreline, ca. 1883
Albumen print, 16.8 × 14.9 cm [6⅝ × 5⅞″] (.455)

380
†Thomas Eakins nude and J. Laurie Wallace nude, from rear, in front of boat at shoreline, ca. 1883
Albumen print, 8.9 × 10.16 cm [3½ × 4″] (.454)

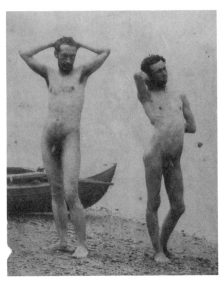

379

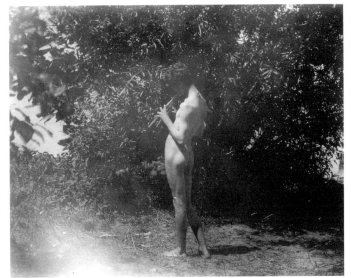

386

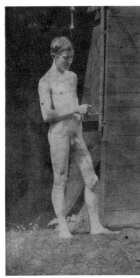

388

Hendricks 1972, fig. 254.

See plate 6.

381

†Male nude and J. Laurie Wallace nude at shoreline, ca. 1883
Dry-plate negative, 10.2 × 12.7 cm [4 × 5″] (.1019)

382

†Thomas Eakins nude, playing pipes, facing right, ca. 1883
Albumen print, 9.2 × 8.3 irr. cm [3⅝ × 3¼″ irr.] (.486)
Platinum print, 8.9 × 11.6 cm [3½ × 4⁹⁄₁₆″] (.485)

Platinum print, 16.4 × 9.4 cm [6⁷⁄₁₆ × 3¹¹⁄₁₆″] (.487)
Dry-plate negative, 10.2 × 12.7 cm [4 × 5″] (.1011)

See plate 4.

383

†Thomas Eakins nude, playing pipes, facing left, ca. 1883
Albumen print, 9.2 × 7.3 cm [3⅝ × 2⅞″] (.488)
Albumen print, 9.2 × 8.6 cm [3⅝ × 3⅜″] (.489)
Albumen print, 9.2 × 8.4 cm [3⅝ × 3⁵⁄₁₆″] (.490)
Platinum print, 9.2 × 8.7 cm [3⅝ × 3⁷⁄₁₆″] (.491)
Hendricks 1972, fig. 253.

384

†J. Laurie Wallace nude, playing pipes, facing left, in front of leafy background, ca. 1883
Platinum print, 8.6 × 6.8 cm [3⅜ × 2¹¹⁄₁₆″] (.492)

385

†J. Laurie Wallace nude, playing pipes, facing left, ca. 1883
Platinum print, 9.2 × 10.8 cm [3⅝ × 4¼″] (.484)
Platinum print, 8.9 × 11.3 irr. cm [3½ × 4⁷⁄₁₆″ irr.] (.483)
Platinum print, 16.2 × 12.2 irr. cm [6⅜ × 4¹³⁄₁₆″ irr.] (.482)
Dry-plate negative, 10.2 × 12.7 cm [4 × 5″] (.1010)
Hendricks 1972, fig. 46.

386

†J. Laurie Wallace nude, playing pipes, facing left, ca. 1883

Glass positive, 7.6 × 11.3 cm [3 × 4⁷⁄₁₆″] (.614)

The pose is almost identical to that of the standing piper in *Arcadia* (1883, Metropolitan Museum of Art, New York).

387

†J. Laurie Wallace nude, sitting, playing pipes, ca. 1883

Platinum print, 8.9 × 11.4 cm [3½ × 4½″] (.493)

Platinum print, 13.5 × 11.9 cm [5⁵⁄₁₆ × 4¹¹⁄₁₆″] (.494)

Hendricks 1972, fig. 47.

NUDES IN UNIVERSITY OF PENNSYLVANIA PHOTOGRAPHY SHED

388

George Frank Stephens (?) nude, in University of Pennsylvania photography shed, 1885

Albumen print, 25.1 × 13.5 cm [9⅞ × 5⁵⁄₁₆″] (.498)

389

Male nude, lying on ground, in University of Pennsylvania photography shed, 1885

Dry-plate negative, 10.2 × 12.7 cm [4 × 5″] (.1005)

Circle of Eakins

390

†Thomas Eakins nude and female nude, in University of Pennsylvania photography shed, 1885

Dry-plate negative, 10.2 × 12.7 cm [4 × 5″] (.1006)

See fig. 30.

Cat. nos. 391 and 392 each constitute half of this image.

391

†Thomas Eakins nude, from rear, in University of Pennsylvania photography shed, 1885

Platinum print, 15.6 × 6.35 cm [6⅛ × 2½″] (.495)

See fig. 31.

392

†Female nude, facing left, right arm raised, in University of Pennsylvania photography shed, 1885

Platinum print, 14.8 × 4.3 cm [5¹³⁄₁₆ × 1¹¹⁄₁₆″] (.532)

See fig. 32.

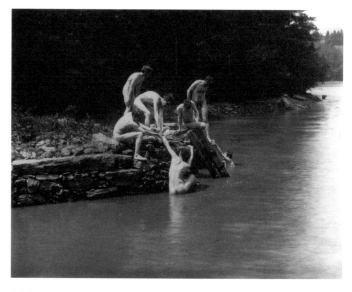

394

NUDE MEN IN SPORTS

Among these photographs of nude men are the swimming pictures related to *The Swimming Hole* (fig. 44). Thomas Eakins's presence in all three confirms the collaborative nature of his work. One of the two negatives (cat. no. 394 previously unknown) shows Eakins at the far right looking down toward the water. The importance of the theme of nude swimming in his oeuvre is reinforced by the size and number of platinum enlargements of one of these images (cat. no. 393), found with the Bregler collection. Also included are six of the original dry-plate negatives for boxing and wrestling pictures taken outdoors (previously known only through copy prints in the Metropolitan Museum of Art, New York). The series of indoor

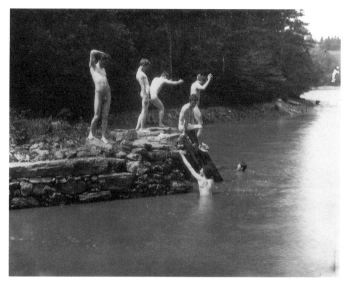

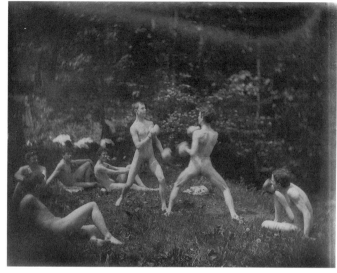

395

399

wrestlers wearing only their trunks was probably taken at the Art Students' League.

SWIMMERS

393
†Thomas Eakins and students, swimming nude, ca. 1883
Albumen print, 8.9 × 11.1 cm [3½ × 4⅜″] (.478)
Platinum print, 22.7 × 28.1 cm [8¹⁵⁄₁₆ × 11¹⁄₁₆″] (.480)
Platinum print, 24.3 × 29.2 cm [9⁹⁄₁₆ × 11½″] (.479)
Hendricks 1972, fig. 44.

See plate 3.

394
†Thomas Eakins and students, swimming nude, ca. 1883
Dry-plate negative, 10.2 × 12.7 cm [4 × 5″] (.1026)

395
†Thomas Eakins and students, swimming nude, ca. 1883
Dry-plate negative, 10.2 × 12.7 cm [4 × 5″] (.1027)
Hendricks 1972, fig. 43.

BOXERS AND WRESTLERS OUTDOORS

396
Six males, nude, two boxing at center, ca. 1883
Albumen print, 7.8 × 10.5 cm [3¹⁄₁₆ × 4⅛″] (.481)
Hendricks 1972, fig. 126.

397
Seven males, nude, two boxing and one standing at center, ca. 1883
Dry-plate negative, 10.2 × 12.7 cm [4 × 5″] (.1023)
Hendricks 1972, fig. 123.

398
Seven males, nude, two boxing and three sitting behind, ca. 1883
Dry-plate negative, 10.2 × 12.7 cm [4 × 5″] (.1024)

399
Seven males, nude, two boxing at center, ca. 1883
Dry-plate negative, 10.2 × 12.7 cm [4 × 5″] (.1025)
Hendricks 1972, fig. 124 (reversed).

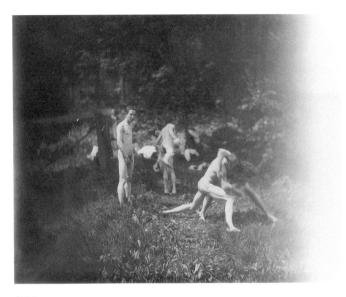

402

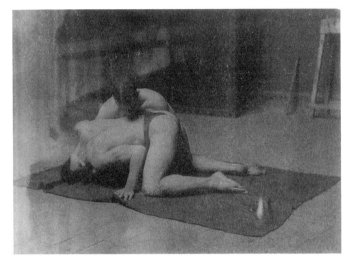

405

400

Six males, nude, wrestling, ca. 1883
Dry-plate negative, 10.2 × 12.7 cm [4 × 5″]
(.1020)
Hendricks 1972, fig. 122.

401

Six males, nude, two wrestling at right,
ca. 1883
Dry-plate negative, 10.2 × 12.7 cm [4 × 5″]
(.1021)
Hendricks 1972, fig. 125.

402

Six males, nude, four wrestling, ca. 1883
Dry-plate negative, 10.2 × 12.7 cm [4 × 5″]
(.1022)

WRESTLERS INDOORS

Circle of Eakins

403

†Two males wrestling, ca. 1892
Platinum print, 9.8 irr. × 8.0 cm [3⅞ irr. ×
3⅛″] (.432)

404

†Two males wrestling, ca. 1892
Platinum print, 8.9 × 7.6 cm [3½ × 3″]
(.435)
Hendricks 1972, fig. 231.

A glass-plate negative for this print is
among the photographs in Edward Boul-
ton's collection (Philadelphia Museum of
Art). The full, uncropped image suggests

that it may have been taken at the Art Stu-
dents' League, where Thomas Eakins
taught until 1893.

405

†Two males wrestling on floor, ca. 1892
Platinum print, 7.0 × 9.8 cm [2¾ × 3⅞″]
(.433)

406

†Two males wrestling on floor, ca. 1892
Platinum print, 7.0 × 10.2 cm [2¾ × 4″]
(.434)
Hendricks 1972, fig. 230.

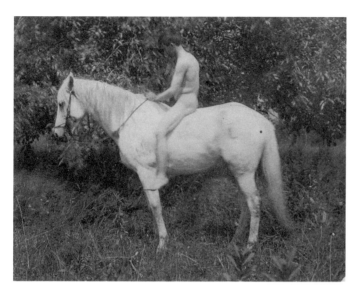

412

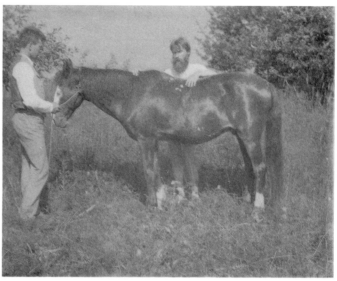

413

NUDES WITH HORSES

Among this group are individual views of Thomas Eakins, Samuel Murray, and Franklin Schenck, all nude, standing next to or mounted on horses. Whereas most of the photographs have been published, the group includes a previously unknown series: images of Susan Macdowell Eakins posed similarly to her husband and Murray with Eakins's horse Billy. In two of the photographs Susan's face has been obscured, presumably by Charles Bregler, in an effort to preserve her anonymity. The images of the female form are decidedly more romantic than Eakins's prosaic studies of horses (cat. nos. 492–95, 506–9), their sensual nature heightened by the atmospheric quality of the platinum prints. All of these images probably date from the early 1890s, when Eakins was involved in equine studies related to the Brooklyn Memorial Arch project.

FEMALE NUDE (SUSAN MACDOWELL EAKINS) WITH A HORSE

407

Susan Macdowell Eakins nude, left arm resting on neck of Thomas Eakins's horse Billy, ca. 1890
Platinum print, 16.2 × 21.9 cm [6⅜ × 8⅝″] (.546)
Platinum print, 16.4 irr. × 19.1 cm [6⁷⁄₁₆ irr. × 7½″] (.547, face obliterated)

See fig. 35.

408

Susan Macdowell Eakins nude, from rear, leaning against Thomas Eakins's horse Billy, ca. 1890
Platinum print, 8.4 × 10.8 cm [3⁵⁄₁₆ × 4¼″] (.548)
Platinum print, 9.0 × 11.0 cm [3⁹⁄₁₆ × 4⁵⁄₁₆″] (.549)
Platinum print, 13.8 × 18.9 cm [5⁷⁄₁₆ × 7⁷⁄₁₆″] (.550)

See plate 8.

409

Susan Macdowell Eakins nude, sitting side-saddle, hands clasped, on Thomas Eakins's horse Billy, ca. 1890
Platinum print, 8.7 irr. × 11.3 cm [3⁷⁄₁₆ irr. × 4⁷⁄₁₆″] (.551)

410

Susan Macdowell Eakins nude, sitting side-saddle on Thomas Eakins's horse Billy, ca. 1890
Platinum print, 8.4 × 9.7 cm [3⅝₆ × 3¹³⁄₁₆″] (.552)
Platinum print, 8.9 × 11.7 cm [3½ × 4⅝″] (.553)
Dry-plate negative, 10.2 × 12.7 cm [4 × 5″] (.1047, face obliterated)

NUDE MALES WITH A HORSE

411

Samuel Murray nude, on Thomas Eakins's horse Billy, ca. 1890
Platinum print, 7.9 × 9.5 cm [3⅛ × 3¾″] (.313)
Platinum print, 9.0 × 11.0 cm [3⁹⁄₁₆ × 4⁵⁄₁₆″] (.497)
Platinum print, 11.1 × 12.2 cm [4⅜ × 4¹³⁄₁₆″] (.314)
Hendricks 1972, fig. 180.

412

Samuel Murray nude, facing left, on Thomas Eakins's horse Billy, ca. 1890
Platinum print, 7.9 × 10.3 cm [3⅛ × 4¹⁄₁₆″] (.496)

413

Samuel Murray clothed and Franklin Schenck nude, with Thomas Eakins's horse Baldy, ca. 1890
Platinum print, 8.9 × 11.1 cm [3½ × 4⅜″] (.682)

414

Samuel Murray clothed and Franklin Schenck nude, with Thomas Eakins's horse Baldy, ca. 1890
Platinum print, 7.6 × 10.0 cm [3 × 3¹⁵⁄₁₆″] (.318)
Platinum print, 8.9 × 10.8 cm [3½ × 4¼″] (.319)

415

Franklin Schenck nude, in front of Thomas Eakins's horse Baldy, ca. 1890
Platinum print, 8.9 × 9.7 cm [3¼ × 3¹³⁄₁₆″] (.829)
Hendricks 1972, fig. 174.

Circle of Eakins

416

†Thomas Eakins nude, facing left, on his horse Billy, ca. 1890
Platinum print, 7.9 × 8.6 irr. cm [3⅛ × 3⅜″ irr.] (.303)

417

†Thomas Eakins nude, facing right, on his horse Billy, both arms raised, ca. 1890
Platinum print, 8.3 × 8.3 irr. cm [3¼ × 3¼″ irr.] (.304)

418

†Thomas Eakins nude, facing right, on his horse Billy, ca. 1890
Platinum print, 6.2 × 8.1 cm [2⁷⁄₁₆ × 3³⁄₁₆″] (.305)
Platinum print, 8.9 × 10.8 irr. cm [3½ × 4¼″ irr.] (.306)
Hendricks 1972, fig. 268.

See fig. 34.

SCIENTIFIC PHOTOGRAPHS

THE "NAKED SERIES"

The series derives its name from an entry in one of Thomas Eakins's 1883 account books: "2 pieces of glass 8 × 10 (.15) for mounting naked series." Eakins photographed nude models, including himself, in seven standing positions. The individual negatives were then printed and mounted in the following sequence of poses:

Profile, heels together, hips straight
Profile, right leg bent
Profile, left leg bent
Front, arms behind head or back, legs straight
Front, with leg bent
Rear, knees together, legs straight
Rear, left leg bent

The Pennsylvania Academy's collection consists of five complete sets mounted on cards and seventy-nine loose prints constituting thirteen partial sets. There are also nineteen negatives of Eakins posing in the standard positions in front of three different backdrops. The latter are previously unknown.

The loose prints and negatives are arranged in groups representing the standardized poses as Eakins used them in class. Variations in the background setting suggest that these photographs were taken on several different occasions and in several different locations. Because of the collaborative nature of the project, all images in the naked series are attributed to the circle of Eakins. The Pennsylvania

Academy's naked-series images do not add much new information to our understanding of the project as a whole, but they do enlarge our sense of its scale and complexity. Several previously unknown models appear among these images. One set (cat. no. 435) includes a small classical bust that is visible also in several of the figure studies (cat. nos. 196, 197). The prints in two other groups of nudes (cat. nos. 269–71, and 280–85) are slightly larger than those in the naked series, and their poses vary.

MALES

Circle of Eakins

419

†Naked series: African-American male, poses 1–7, ca. 1883
Seven albumen prints mounted on blue board, each approx. 7.6 × 3.0 cm [3 × 1³⁄₁₆″] (.347)

See fig. 17.

420

†Naked series: Joseph Smith, poses 1–7, ca. 1883
Seven albumen prints mounted on blue board, each approx. 7.9 × 3.0 cm [3⅛ × 1³⁄₁₆″] (.348)
Olympia Galleries 1981, fig. 36.

421

†Naked series: male, poses 1–3, 5–7, ca. 1883
Six albumen prints mounted on blue board, each approx. 7.8 × 3.0 cm [3¹⁄₁₆ × 1³⁄₁₆″] (.349)

422

†Naked series: twenty photographs of four males, two complete and two partial series of poses, ca. 1883
Composite albumen print, 16.5 × 29.2 cm [6½ × 11⅛″], each photograph approx. 7.8 × 3.0 cm [3¹⁄₁₆ × 1³⁄₁₆″] (.350)
Hendricks 1972, fig. 133 (showing thirty photographs).

423

†Naked series: ten photographs of two males; boy, poses 3, 1, 7; adult, poses 2, 1 (twice), 7, 6, 5, 4, (last pose a fragment), ca. 1883
Composite albumen print, each photograph approx. 2.7 × 7.8 cm [1¹⁄₁₆ × 3¹⁄₁₆″] (.351 and .352, combined by conservator)
Olympia Galleries 1981, figs. 42, 44 (adult male misidentified as George Reynolds).

424

†Naked series: male, poses 1–3, ca. 1883
Composite albumen print, 8.1 × 10.0 cm [3³⁄₁₆ × 3¹⁵⁄₁₆″] (.354)

THOMAS EAKINS IN "NAKED SERIES" POSES

Circle of Eakins

425

†Naked series: four photographs of two models; male, poses 2, 1; Thomas Eakins, poses 7, 6, ca. 1883
Composite albumen print, each photograph approx. 8.1 × 3.2 cm [3³⁄₁₆ × 1¼″] (.353)
Olympia Galleries 1981, fig. 24.

426

†Naked series: Thomas Eakins in front of wallpaper backdrop, poses 1, 3, 6, 7, ca. 1883
Four dry-plate negatives, each approx. 7.9 × 2.7 cm [3⅛ × 1¹⁄₁₆″] (.1030, .1033, .1043, .1036)

427

†Naked series: Thomas Eakins with chair in front of cloth backdrop, poses 1–7, ca. 1883
Seven dry-plate negatives, each 10.2 × 4.3 cm [4 × 1¹¹⁄₁₆″] (.1040, .1041, .1032, .1034, .1035, .1039, .1037)

428

†Naked series: Thomas Eakins in front of cloth backdrop, poses 1–7 (pose 5 twice), ca. 1883
Eight dry-plate negatives, each approx. 10.2 × 4.3 cm [4 × 1¹¹⁄₁₆″] (.1038, .1029, .1031, .1042, .1028, .1044–46)

See fig. 50.

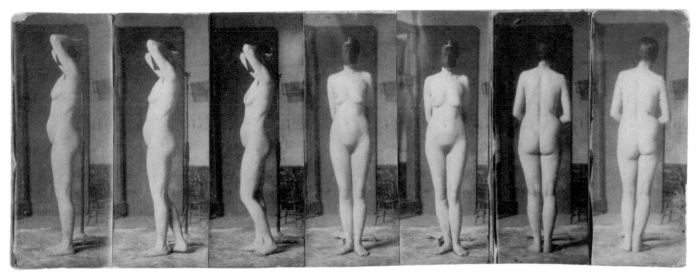

433

FEMALES

Circle of Eakins

429

†Naked series: "Brooklyn No. 1," female with dark mask, poses 1–7, ca. 1883
Seven albumen prints mounted on blue board, each 7.8 × 3.0 cm [3¹⁄₁₆ × 1³⁄₁₆″] (.356)
Olympia Galleries 1981, fig. 30.

The quoted title in nos. 429 and 430 comes from a handwritten inscription on the verso of the image in the source cited above.

430

†Naked series: "Brooklyn No. 1," female with dark mask, poses 1, 2, 4–7, ca. 1883
Six albumen prints, each approx. 7.1 × 2.7 cm [2¹³⁄₁₆ × 1¹⁄₁₆″] (.364–69, .366 cropped at knees)
Olympia Galleries 1981, fig. 30.

431

†Naked series: "Brooklyn No. 2," female with dark mask, pose 1, and poses 7, 4, 5, ca. 1883
Two albumen prints, 7.6 × 3.0 cm [3 × 1³⁄₁₆″] (.370) and 8.7 × 9.5 cm [3⁷⁄₁₆ × 3¾″] (.359)
Olympia Galleries 1981, fig. 35.

The quoted title comes from a handwritten inscription on the verso of the image in the source cited above.

432

†Naked series: "Lillie," female with dark mask, poses 1–3, 5, ca. 1883
Four albumen prints, each approx. 7.9 × 3.2 cm [3⅛ × 1¼″] (.360–63)
Olympia Galleries 1981, fig. 27.

The quoted title comes from a handwritten inscription on the verso of the image in the source cited above.

433

†Naked series: female with dark mask, poses 1–7, ca. 1883
Seven albumen prints mounted on blue board, each 7.8 × 3.0 cm [3¹⁄₁₆ × 1³⁄₁₆″] (.355)
Olympia Galleries 1981, fig. 28.

434

†Naked series: female with dark mask, poses 1 and 3 and poses 7, 6, 2, 7, ca. 1883

Three albumen prints, 7.1 × 2.4 cm [2¹³⁄₁₆ ×¹⁵⁄₁₆″] (.371), 7.9 × 3.0 cm [3⅛ × 1³⁄₁₆″] (.357), and 8.6 × 14.6 cm [3⅜ × 5¾″] (.358)

435

†Naked series: female with dark mask, small classical bust in background, poses 1–4, 6, ca. 1883

Five albumen prints, each approx. 7.6 × 3.2 cm [3 × 1¼″] (.372–76)

MOTION STUDIES

The group consists of twenty-three negatives, six prints, and a fragment of a print from Eakins's 1884–85 attempts to capture human locomotion on film. The setting for these experiments was a shed Eakins had constructed for the purpose at the University of Pennsylvania. Almost all of the images are published in a variety of references, but they were known previously only through Charles Bregler's gifts of second-generation copy prints and a few negatives that he gave to other institutions. Each of Eakins's original negatives in this group, with one exception, carries a date and a number, incised in Eakins's hand, which may enable scholars to reconstruct the daily progress of the sessions. These images are significantly smaller than the 10.2 × 12.7 cm [4 × 5″] plates on which they appear; thus, measurements are given for the image size rather than the negative size.

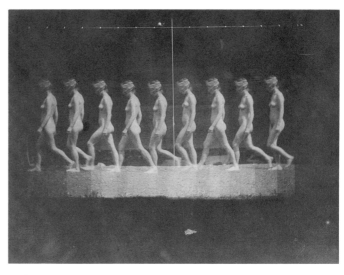

442

WALKING

436

Motion study: George Reynolds nude, walking to right, 1885

Dry-plate negative, 8.9 × 11.4 irr. cm [3½ × 4½″ irr.] (.981)

Hendricks 1972, fig. 96.

437

Motion study: George Reynolds nude, walking to right, 1885

Dry-plate negative, 8.89 × 11.4 irr. cm [3½ × 4½″ irr.] (.982)

Hendricks 1972, fig. 94.

438

Motion study: male nude, walking to left, 1885

Dry-plate negative, 9.5 × 12.4 irr. cm [3¾ × 4⅞″ irr.] (.978)

Hendricks 1972, fig. 106.

439

Motion study: male nude, walking to left, 1885

Dry-plate negative, 9.5 × 12.4 irr. cm [3¾ × 4⅞″ irr.] (.980)

Hendricks 1972, fig. 105 (reversed).

Gordon Hendricks (1972) identified the model in cat. nos. 438, 439, and 444 as Jesse Godley. Godley (1862–89), however, would have been twenty-five years of age in 1885, and this model appears much older.

440

Motion study: male nude, walking to right, 1885
Albumen print, 5.7 × 7.6 cm [2¼ × 3″] (.397)

441

Motion study: male nude, walking to left, 1885
Dry-plate negative, 9.2 × 12.1 irr. cm [3⅝ × 4¾″ irr.] (.979)
Hendricks 1972, fig. 110 (reversed and cropped).

442

Motion study: female nude, blindfolded, walking to left, 1885
Dry-plate negative, 9.2 × 11.7 cm [3⅝ × 4⅝″] (.983)
Hendricks 1972, fig. 90.

443

Motion study: female nude, blindfolded, walking to left, 1885
Dry-plate negative, 8.6 × 11.7 irr. cm [3⅜ × 4⅝″ irr.] (.984)

RUNNING

444

Motion study: male nude (metallic markers attached to his body), running to left, 1885
Dry-plate negative, 9.2 × 11.7 cm [3⅝ × 4⅝″] (.994)
Hendricks 1972, fig. 103.

445

Motion study: male nude, running to right, 1885
Albumen print, 5.7 × 8.4 cm [2¼ × 3⁵⁄₁₆″] (.399)
Cyanotype, 8.6 × 11.1 cm [3⅜ × 4⅜″] (.400)

Circle of Eakins

446

†Motion study: Thomas Eakins nude, running to left, 1885
Dry-plate negative, 9.8 × 11.1 irr. cm [3⅞ × 4⅜″ irr.] (.991)

See fig. 49.

447

†Motion study: Thomas Eakins nude, running to left, 1885
Cyanotype, 6.4 × 6.2 cm [2½ × 2⁷⁄₁₆″] (.401)
Dry-plate negative, 9.2 × 11.7 irr. cm [3⅝ × 4⅝″ irr.] (.992)
Hendricks 1972, fig. 87.

STANDING JUMP

448

Motion study: George Reynolds nude, standing jump to right, 1885
Dry-plate negative, 9.0 × 11.7 cm [3⁹⁄₁₆ × 4⅝″] (.995)
Hendricks 1972, fig. 99.

449

Motion study: male nude, standing jump to right, 1885
Dry-plate negative, 9.2 × 11.4 irr. cm [3⅝ × 4½″ irr.] (.985)
Hendricks 1972, figs. 113, 114.

See fig. 45.

A print from this image was shown as *History of a Jump* in an 1886 exhibition of the Philadelphia Photographic Society at the Pennsylvania Academy.

450

Motion study: male nude, standing jump to left, 1885
Dry-plate negative, 8.9 × 11.4 irr. cm [3½ × 4½″ irr.] (.989)
Hendricks 1972, fig. 115.

451

Motion study: male nude, double standing jump to right, 1885
Dry-plate negative, 9.8 × 11.1 irr. cm [3⅞ × 4⅜″ irr.] (.986)
Hendricks 1972, fig. 116.

RUNNING JUMP

452

Motion study: George Reynolds nude, running jump to right, 1885
Dry-plate negative, 9.2 × 12.1 irr. cm [3⅝ × 4¾″ irr.] (.988)
Hendricks 1972, fig. 98 (reversed).

453

Motion study: male nude, running jump to right, 1885

Dry-plate negative, 8.9 × 11.4 irr. cm [3½ × 4½″ irr.] (.993)

454

Motion study: male nude, running jump to right, 1885

Dry-plate negative, 9.2 × 11.4 irr. cm [3⅝ × 4½″ irr.] (.990)

Hendricks 1972, fig. 117.

455

Motion study: male nude, running jump to left, 1885

Dry-plate negative, 8.3 × 12.1 irr. cm [3¼ × 4¾″ irr.] (.987)

Hendricks 1972, fig. 111.

POLE VAULT

456

Motion study: George Reynolds nude, pole-vaulting to right, 1885

Dry-plate negative, 9.2 × 11.7 irr. cm [3⅝ × 4⅝″ irr.] (.997)

Hendricks 1972, fig. 101.

457

Motion study: George Reynolds nude, pole-vaulting to left, 1885

Dry-plate negative, 9.8 × 11.7 irr. cm [3⅞ × 4⅝″ irr.] (.996)

Hendricks 1972, fig. 100.

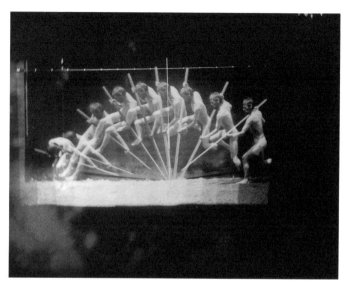

457

THROWING BALL

458

Motion study: male nude, throwing ball to left, 1885

Albumen print, 8.9 × 10.8 irr. cm [3½ × 4¼″ irr.] (.403)

Dry-plate negative, 9.7 × 12.1 cm [3¹³⁄₁₆ × 4¾″] (.999)

459

Motion study: male nude, throwing ball to right, 1885

Dry-plate negative, 6.4 × 10.2 irr. cm [2½ × 4″ irr.] (.998)

Hendricks 1972, fig. 112.

OTHER MOTION STUDIES

460

Motion study: male nude, carrying boy on his shoulders, walking to right, 1885

Albumen print, 5.9 × 10.3 cm [2⁵⁄₁₆ × 4¹⁄₁₆″] (.398)

461

Motion study: male nude on horse, 1885

Dry-plate negative, 8.9 × 9.5 irr. cm [3½ × 3¾″ irr.] (.1000)

Hendricks 1972, fig. 118.

462

Motion study: fragment showing metallic markers, 1885

Platinum print, 5.7 × 8.6 cm [2¼ × 3⅜″] (.402)

Circle of Eakins

463

†Motion study: man in light suit running in front of draped brick wall; man in dark suit standing at right, ca. 1885
Albumen print, 8.4 × 12.1 cm [3⁹⁄₁₆ × 4¾″]
(.404)

DIFFERENTIAL-ACTION STUDIES

These photographs show Thomas Eakins's assistants demonstrating the action of the horse's leg. They were taken at the University of Pennsylvania in 1885 and appear to be related indirectly to Eakins's interest in motion studies. His examination of equine anatomy culminated nine years later, when he delivered a lecture titled "The Differential Action of Certain Muscles Passing More than One Joint" at the Philadelphia Academy of Natural Sciences. The talk demonstrated various points about the tensile strength of the muscles of a horse's leg. Included in the Pennsylvania Academy's collection of images are four negatives (two of which carry incised dates), six prints, and one lantern slide. The latter (.618) was probably used in the 1894 lecture. The Franklin Institute owns several slides of diagrams related to this lecture. These images are significantly smaller than the 10.2 × 12.7 cm [4 × 5″] plates on which they appear; thus, measurements are given for the image size rather than the negative size.

464

Differential-action study: man on ladder, leaning on horse's stripped foreleg, 1885
Platinum print, 4.4 × 4.0 cm [1¾ × 1⁹⁄₁₆″]
(.406)
Platinum print, 7.8 × 7.0 cm [3¹⁄₁₆ × 2¾″]
(.407)
Glass positive, 4.4 × 4.0 cm [1¾ × 1⁹⁄₁₆″]
(.618)
Dry-plate negative, 4.4 × 4.0 cm [1¾ × 1⁹⁄₁₆″] (.1002)
Hendricks 1972, fig. 121 (reversed).

465

Differential-action study: man on ladder, leaning on horse's stripped hind leg, while second man at left looks on, 1885
Albumen print, 4.9 × 4.0 cm [1¹³⁄₁₆ × 1⁹⁄₁₆″]
(.405a)
Dry-plate negative, 4.9 × 4.0 cm [1¹³⁄₁₆ × 1⁹⁄₁₆″] (.1004)
Hendricks 1972, fig. 119 (reversed).

See fig. 48.

466

Differential-action study: man on ladder, moving horse's stripped leg, while second man at left looks on, 1885
Platinum print, 4.4 × 3.3 cm [1¾ × 1⁵⁄₁₆″]
(.408)

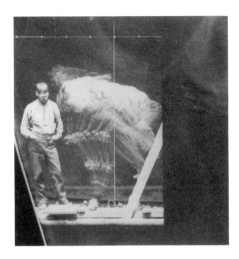

466

467

Differential-action study: man in bowler hat, moving horse's stripped leg, 1885
Albumen print, 4.4 × 4.1 cm [2⁵⁄₁₆ × 1⅝″]
(.405b)
Platinum print, 6.2 × 6.5 cm [2⁷⁄₁₆ × 2⁹⁄₁₆″]
(.409)
Dry-plate negative, 6.5 irr. × 4.0 cm [2⁹⁄₁₆ irr. × 1⁹⁄₁₆″] (.1003)

468

Differential-action study: man in bowler hat, moving horse's stripped leg, 1885
Dry-plate negative, 4.6 × 4.0 cm [1¹³⁄₁₆ × 1⁹⁄₁₆″] (.1001)
Hendricks 1972, fig. 120.

ANIMALS

These photographs fall into two broad categories. The first, possibly taken by a number of different photographers, consists of images of pets of the Eakins and Macdowell families (dogs, cats, and a monkey). The photographs of cats exist in two media: platinum and printing-out-paper prints. Many of them are dark, closely cropped, and include dramatic highlights—stylistic features that relate to Susan Macdowell Eakins's photograph of a child holding a doll (cat. no. 68). The second category is made up of photographs of various farm animals, which Thomas Eakins may have intended as studies for specific paintings and sculptures. Among these are a number of views of horses at the Crowell farm in Avondale, Pennsylvania; three views of a horse with chalk lines on its body; views of Thomas Eakins on horseback; and one photograph of a mounted cavalry officer at the United States Military Academy at West Point. Whereas the photographs of horses may be the products of one or more photographers, numerous studies of geese and sheep—which exist only as dry-plate negatives—are most likely the work of Eakins himself.

472

DOGS

469

Thomas Eakins's setter Harry on carpet, ca. 1885

Platinum print, 6.5 × 16.0 cm [2⁹⁄₁₆ × 6⁵⁄₁₆″] (.271)

Platinum print, 7.5 × 16.5 cm [2¹⁵⁄₁₆ × 6½″] (.810)

Hendricks 1972, fig. 206.

470

Setter with four white legs, facing right, in front of dark backdrop, ca. 1885

Albumen print, 9.2 × 9.8 cm [3⅝ × 3⅞″] (.274)

471

Setter with four white legs, sitting on draped platform, ca. 1885

Platinum print, 20.0 × 13.5 cm [7¾ × 5⁵⁄₁₆″] (.276)

472

Setter with four white legs, sitting in front of dark backdrop, ca. 1885

Dry-plate negative, 10.2 × 12.7 cm [4 × 5″] (.936)

473

Two setters in front of dark backdrop, ca. 1885

Platinum print, 7.8 × 9.4 cm [3¹⁄₁₆ × 3¹¹⁄₁₆″] (.661)

Hendricks 1972, fig. 205.

474
Setter sitting on shed roof, ca. 1885
Albumen print, 5.1 × 7.0 irr. cm [2 × 2¾"
irr.] (1988.10.60)

Circle of Eakins

475
†Black dog sleeping, ca. 1885
Platinum print, 7.1 × 10.2 cm [2¹³⁄₁₆ × 4"]
(.273)

476
†Short-haired hound on upholstered chair,
ca. 1895
Platinum print, 16.2 × 11.7 cm [6⅜ × 4⅝"]
(.275)

CATS

477
Four cats in back yard of the family home
at 1729 Mount Vernon Street, Philadelphia,
ca. 1885
Platinum print, 4.4 × 7.1 cm [1¾ × 2¹³⁄₁₆"]
(.644)

Circle of Eakins

478
Attributed to Susan Macdowell Eakins
†Cat sleeping on caned chair, ca. 1885
Platinum print, 4.6 × 9.4 cm [1¹³⁄₁₆ ×
3¹¹⁄₁₆"] (.643)
Platinum print, 4.6 × 9.7 cm [1¹³⁄₁₆ ×
3¹³⁄₁₆"] (.683)
Gelatin printing-out-paper print, [1¹¹⁄₁₆ ×
3⅞"] (.281)

479
Attributed to Susan Macdowell Eakins
†Cat on carpeted table, ca. 1885
Platinum print, 5.6 × 8.4 cm [2³⁄₁₆ × 3⁵⁄₁₆"]
(.669)

480
Attributed to Susan Macdowell Eakins
†Cat on carpeted table, looking down,
ca. 1885
Platinum print, 5.1 × 8.6 cm [2 × 3⅜"]
(.672)
Gelatin printing-out-paper print, 9.7 × 15.6
cm [3¹³⁄₁₆ × 6⅛"] (.289)

481
Attributed to Susan Macdowell Eakins
†Cat on floor, looking left, ca. 1885
Platinum print, 5.2 × 10.5 cm [2¹⁄₁₆ × 4⅛"]
(.681)

482
Attributed to Susan Macdowell Eakins
†Tiger-striped kitten on newspaper on
round chair, ca. 1885
Platinum print, 5.9 × 8.9 cm [2⁵⁄₁₆ × 3½"]
(.811)

483
Attributed to Susan Macdowell Eakins
†Tiger-striped kitten on carpet, looking
up, ca. 1885
Albumen print, 7.9 × 5.1 cm [3⅛ × 2"]
(.814)

484
Attributed to Susan Macdowell Eakins
†Two tiger-striped kittens sleeping,
ca. 1885
Collodion printing-out-paper print, 6.0 ×
9.4 cm [2⅜ × 3¹¹⁄₁₆"] (.812)

485
Attributed to Susan Macdowell Eakins
†Two cats on table, ca. 1885
Gelatin printing-out-paper print, 9.2 × 10.8
cm [3⅝ × 4¼"] (.279)
Hendricks 1972, fig. 213.

486
Attributed to Susan Macdowell Eakins
†Two cats on table, ca. 1885
Gelatin printing-out-paper print, 4.1 × 14.0
cm [1⅝ × 5½"] (.284)
Hendricks 1972, fig. 212.

487
Attributed to Susan Macdowell Eakins
†Two tiger-striped cats on draped boxes,
ca. 1885
Platinum print, 6.0 × 7.6 cm [2⅜ × 3"]
(.678)
Platinum print, 16.8 × 20.5 cm [6⅝ ×
8¹⁄₁₆"] (.809)
Platinum print, 24.9 × 27.1 cm [9¹³⁄₁₆ ×
10¹¹⁄₁₆"] (.290)
Gelatin printing-out-paper print, 12.2 ×
15.1 cm [4¹³⁄₁₆ × 5¹⁵⁄₁₆"] (.288)

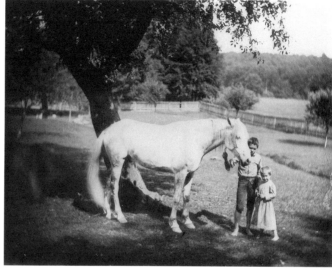

487 (.809)

494 (.937)

488
Attributed to Susan Macdowell Eakins
†Cat and two kittens, ca. 1885
Gelatin printing-out-paper print, 9.5 × 12.9 cm [3¾ × 5⅟₁₆″] (.285)

489
Attributed to Susan Macdowell Eakins
†Two kittens in yard, ca. 1885
Gelatin printing-out-paper print, 8.9 × 8.9 cm [3½ × 3½″] (.286)

490
Attributed to Susan Macdowell Eakins
†Two cats in yard, ca. 1885
Platinum print, 8.4 × 5.1 cm [3⁵⁄₁₆ × 2″] (.680)

491
Attributed to Susan Macdowell Eakins
†Two cats outdoors, ca. 1895
Gelatin silver print, 10.8 × 8.4 cm [4¼ × 3⁵⁄₁₆″] (.287)

THOMAS EAKINS'S HORSE BILLY

492
Thomas Eakins's horse Billy, saddled, facing left; man standing behind, ca. 1892
Platinum print, 8.1 × 10.8 cm [3³⁄₁₆ × 4¼″] (.294)

493
Thomas Eakins's horse Billy, saddled, facing left; man standing behind, ca. 1892
Platinum print, 6.7 × 8.9 cm [2⅝ × 3½″] (.321)

494
Thomas Eakins's horse Billy and two Crowell children at Avondale, Pennsylvania, ca. 1892
Dry-plate negative, 10.2 × 12.7 cm [4 × 5″] (.937)
Platinum print, 9.2 × 9.7 cm [3⅝ × 3¹³⁄₁₆″] (.684)

Circle of Eakins

495
†Thomas Eakins riding his horse Billy, facing right, ca. 1893
Platinum print, 3.7 × 4.9 cm [1⁷⁄₁₆ × 1¹⁵⁄₁₆″] (.296)

496

†Thomas Eakins riding his horse Billy, facing right, ca. 1893

Platinum print, 4.0 irr. × 5.9 cm [1⁹⁄₁₆ irr. × 2⁵⁄₁₆″] (.297)

497

†Thomas Eakins riding his horse Billy, facing right, ca. 1893

Platinum print, 3.3 × 4.4 irr. cm [1⁵⁄₁₆ × 1¾″ irr.] (.298)

498

†Thomas Eakins riding his horse Billy, facing right, ca. 1893

Platinum print, 3.8 × 5.1 cm [1½ × 2″] (.300)

499

†Thomas Eakins riding his horse Billy, facing right, ca. 1893

Platinum print, 3.7 × 5.7 cm [1⁷⁄₁₆ × 2¼″] (.308)

500

†Thomas Eakins riding his horse Billy, facing left, ca. 1893

Platinum print, 3.7 × 4.1 cm [1⁷⁄₁₆ × 1⅝″] (.299)

501

†Thomas Eakins riding his horse Billy, facing left, ca. 1893

Platinum print, 4.0 × 5.1 cm [1⁹⁄₁₆ × 2″] (.301)

502

†Thomas Eakins riding his horse Billy, facing right, ca. 1893

Platinum print, 4.0 × 5.1 cm [1⁹⁄₁₆ × 2″] (.309)

503

†Thomas Eakins riding his horse Billy, halting, ca. 1893

Platinum print, 3.7 × 4.1 cm [1⁷⁄₁₆ × 1⅝″] (.307)

504

†Thomas Eakins with white hat, riding his horse Billy, ca. 1893

Albumen print, 5.1 × 4.8 cm [2 × 1⅞″] (.310)

Platinum print, 6.4 × 6.8 cm [2½ × 2¹¹⁄₁₆″] (.302)

505

†Thomas Eakins crouching in front of his horse Billy, ca. 1893

Platinum print, 7.1 × 8.6 cm [2¹³⁄₁₆ × 3⅜″] (.323)

OTHER HORSES

506

Horse with man and woman, ca. 1881

Platinum print, 8.9 × 10.2 cm [3½ × 4″] (.775)

Dry-plate negative, 10.2 × 12.7 cm [4 × 5″] (.938)

507

Two horses with man and woman, ca. 1881

Platinum print, 18.7 × 20.6 cm [7⅜ × 8⅛″] (1988.10.54)

508

The horse Bess with groom, ca. 1881

Albumen print, 6.0 × 10.8 cm [2⅜ × 4¼″] (1988.10.55)

509

Horse with groom, ca. 1881

Albumen print, 6.5 × 10.8 cm [2⁹⁄₁₆ × 4¼″] (1988.10.56)

510

Man in derby hat on horse, facing left, 1885

Platinum print, 8.9 × 12.1 irr. cm [3½ × 4¾″ irr.] (.322)

The plumb bob and the horizontal line indicate that the photograph was taken in the photography shed at the University of Pennsylvania.

511

Horse outside stable, ca. 1890

Platinum print, 7.1 × 8.6 cm [2¹³⁄₁₆ × 3⅜″] (.320)

512

Horse (chalk grid drawn on body), from rear, ca. 1890

Platinum print, 7.8 × 4.9 cm [3¹⁄₁₆ × 1¹⁵⁄₁₆″] (.315)

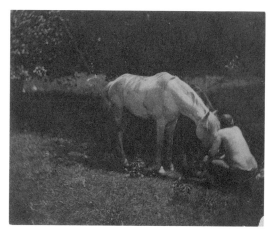

505

507

518 (.941)

513

Horse (chalk grid drawn on body), facing left, ca. 1890
Platinum print, 6.4 × 7.0 cm [2½ × 2¾″]
(.316)

514

Horse (chalk grid drawn on body), facing left diagonally, ca. 1890
Platinum print, 5.1 × 6.2 cm [2 × 2⁷⁄₁₆″]
(.317)

515

Captain Louis A. Craig on horseback, West Point, New York, ca. 1892
Platinum print, 19.1 × 17.1 cm [7½ × 6¾″]
(.324)

Reproduced in Cleveland Moffet, "Grant and Lincoln in Bronze," *McClure's Magazine* (October 1895), p. 427.

SHEEP

516

Sheep with two children at Crowell farm, Avondale, Pennsylvania, ca. 1885
Dry-plate negative, 10.2 × 12.7 cm [4 × 5″]
(.939)

517

Sheep with two children at Crowell farm, Avondale, Pennsylvania, ca. 1885
Dry-plate negative, 10.2 × 12.7 cm [4 × 5″]
(.940)

518

Sheep with girl at Crowell farm, Avondale, Pennsylvania, ca. 1885
Albumen print, 9.0 × 11.4 cm [3⁹⁄₁₆ × 4½″]
(.765)
Dry-plate negative, 10.2 × 12.7 cm [4 × 5″]
(.941)

519

Sheep with girl at Crowell farm, Avondale, Pennsylvania, ca. 1885
Dry-plate negative, 10.2 × 12.7 cm [4 × 5″]
(.942)

520

Sheep in front of fence at Crowell farm, Avondale, Pennsylvania, ca. 1885
Dry-plate negative, 10.2 × 12.7 cm [4 × 5″]
(.943)

521

Sheep in front of fence at Crowell farm, Avondale, Pennsylvania, ca. 1885
Dry-plate negative, 10.2 × 12.7 cm [4 × 5″]
(.944)

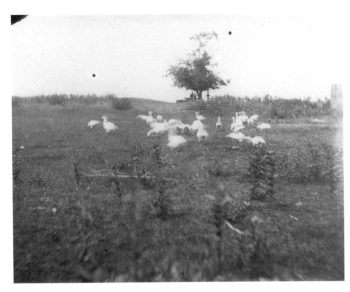

524

544

522

Sheep in front of fence at Crowell farm, Avondale, Pennsylvania, ca. 1885
Dry-plate negative, 10.2 × 12.7 cm [4 × 5″] (.945)

523

Sheep in front of fence at Crowell farm, Avondale, Pennsylvania, ca. 1885
Dry-plate negative, 10.2 × 12.7 cm [4 × 5″] (.946)

GEESE

524

Geese with tree and two men in background at Gloucester, New Jersey, 1881
Dry-plate negative, 10.2 × 12.7 cm [4 × 5″] (.947)

Cat. nos. 524 and 525 are the images most directly related to Thomas Eakins's painting *Mending the Net* (1881, Philadelphia Museum of Art).

525

Geese with tree and two men in background at Gloucester, New Jersey, 1881
Dry-plate negative, 10.2 × 12.7 cm [4 × 5″] (.948)
Hendricks 1972, fig. 29.

526

Geese in field with wooden bridge at Gloucester, New Jersey, 1881
Dry-plate negative, 10.2 × 12.7 cm [4 × 5″] (.949)

527

Geese in field with wooden bridge, 1881
Dry-plate negative, 10.2 × 12.7 cm [4 × 5″] (.950)

528

Geese in field with wooden bridge, 1881
Dry-plate negative, 10.2 × 12.7 cm [4 × 5″] (.951)

529

Geese in field with wooden bridge, 1881
Dry-plate negative, 10.2 × 12.7 cm [4 × 5″] (.952)

530
Geese in field with wooden bridge, 1881
Dry-plate negative, 10.2 × 12.7 cm [4 × 5″]
(.953)

531
Geese in field with wooden bridge, house,
and large building, 1881
Dry-plate negative, 10.2 × 12.7 cm [4 × 5″]
(.954)

532
Geese in field with wooden bridge, house,
and large building, 1881
Dry-plate negative, 10.2 × 12.7 cm [4 × 5″]
(.955)

533
Geese in field with wooden bridge, house,
and large building, 1881
Dry-plate negative, 10.2 × 12.7 cm [4 × 5″]
(.956)

534
Geese in field with wooden bridge, house,
and large building, 1881
Dry-plate negative, 10.2 × 12.7 cm [4 × 5″]
(.957)

535
Geese in field with fence, 1881
Dry-plate negative, 10.2 × 12.7 cm [4 × 5″]
(.958)

536
Geese in field with fence and large build-
ing, 1881
Dry-plate negative, 10.2 × 12.7 cm [4 × 5″]
(.959)

537
Geese at water's edge, 1881
Dry-plate negative, 10.2 × 12.7 cm [4 × 5″]
(.960)

538
Geese and cows at edge of river, 1881
Dry-plate negative, 10.2 × 12.7 cm [4 × 5″]
(.961)

539
Geese swimming in river, 1881
Dry-plate negative, 10.2 × 12.7 cm [4 × 5″]
(.962)

540
Geese in field with shuffleboard sign, 1881
Dry-plate negative, 10.2 × 12.7 cm [4 × 5″]
(.963)

541
Geese in field with row of trees at left,
1881
Dry-plate negative, 10.2 × 12.7 cm [4 × 5″]
(.964)

OTHER ANIMALS

542
Thomas Eakins's monkey Bobby, ca. 1885
Platinum print, 16.4 × 10.8 cm [6⁷⁄₁₆ ×
4¼″] (.291)

543
Thomas Eakins's monkey Bobby, sitting
on porch, ca. 1885
Platinum print, 4.4 × 6.35 cm [1¾ × 2½″]
(.784)

544
Thomas Eakins's monkey Bobby on cloth-
covered bench, ca. 1885
Albumen print, 5.9 × 6.0 cm [2⁵⁄₁₆ × 2⅜″]
(.813)

Circle of Eakins

545
†Cow in Pennsylvania Academy studio,
ca. 1882
Albumen print, 9.4 × 11.7 cm [3¹¹⁄₁₆ × 4⅝″]
(.807)

546
†Three turkeys, ca. 1885
Albumen print, 5.9 × 7.9 cm [2⁵⁄₁₆ × 3⅛″]
(1988.10.61)

547
†Farmyard with chickens, ca. 1890
Gelatin printing-out-paper print, 9.5 × 11.6
cm [3¾ × 4⁹⁄₁₆″] (.773)

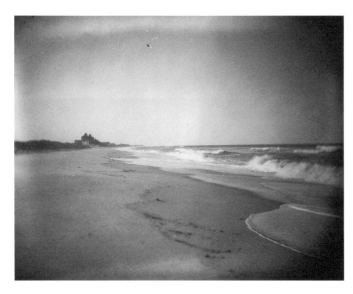

550

557 (.334)

LANDSCAPES AND MARINE VIEWS

Landscape photography, a relatively minor aspect of Thomas Eakins's work, occurred early in his career. Most of the scenes are related to the New Jersey shore or the Delaware River, where Eakins, his family, and students often went on summer excursions. (There are few surviving prints; most images exist in the form of dry-plate negatives.) Other landscapes were made in Gloucester, New Jersey, and the Dakota Territory.

548

Beach with sailboat on sand and Beach House Hotel in distance, at Manasquan, New Jersey, ca. 1881
Dry-plate negative, 10.2 × 12.7 cm [4 × 5″]
(.969)

549

Beach with Beach House Hotel in distance, at Manasquan, New Jersey, ca. 1881
Dry-plate negative, 10.2 × 12.7 cm [4 × 5″]
(.971)

550

Beach with Beach House Hotel in distance, at Manasquan, New Jersey, ca. 1881
Dry-plate negative, 10.2 × 12.7 cm [4 × 5″]
(.973)

551

Beach with Beach House Hotel in distance, at Manasquan, New Jersey, ca. 1881
Dry-plate negative, 10.2 × 12.7 cm [4 × 5″]
(.974)

552

Beach in fog, with figures in distance, at Manasquan, New Jersey, ca. 1881
Dry-plate negative, 10.2 × 12.7 cm [4 × 5″]
(.977)

553

Beach with two swimmers at Manasquan, New Jersey, ca. 1881
Dry-plate negative, 10.2 × 12.7 cm [4 × 5″]
(.972)

554

Beach at Manasquan, New Jersey, ca. 1881
Dry-plate negative, 10.2 × 12.7 cm [4 × 5″]
(.970)

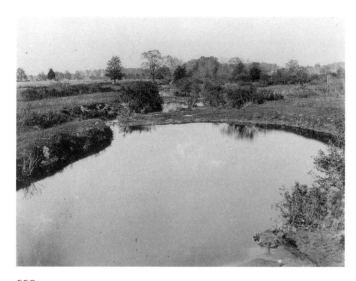

558

560

555

William J. Crowell's home with Benjamin Eakins in foreground, at Avondale, Pennsylvania, ca. 1882
Platinum print, 17.5 × 20.0 cm [6⅞ × 7¾″] (.331)

The subject is identified through an inscription on a print in the Metropolitan Museum of Art, New York.

556

Back yard of Thomas Eakins's home at 1729 Mount Vernon Street, Philadelphia, ca. 1882
Platinum print, 11.6 × 16.7 cm [4⁹⁄₁₆ × 6⁹⁄₁₆″] (.788)

557

Marshy landscape with row of trees on horizon, ca. 1882
Albumen print, 9.0 × 10.6 cm [3⁹⁄₁₆ × 4³⁄₁₆″] (.766)
Gelatin printing-out-paper print, [3⅞ × 4⁷⁄₁₆″] (.334)

558

Landscape with river, ca. 1882
Albumen print, 7.1 × 9.7 cm [2¹³⁄₁₆ × 3¹³⁄₁₆″] (.778)

559

Landscape with river and overhanging trees, Avondale, Pennsylvania (?), ca. 1882
Cyanotype, 9.5 × 12.1 cm [3¾ × 4¾″] (.335)

560

Landscape at Gloucester, New Jersey, ca. 1882
Dry-plate negative, 10.2 × 12.7 cm [4 × 5″] (.965)

Study for the painting *The Meadows, Gloucester* (ca. 1882, Philadelphia Museum of Art).

561

Delaware River with small sailboat on port tack, ca. 1882
Dry-plate negative, 10.2 × 12.7 cm [4 × 5″] (.967)

562

Delaware River with small sailboat on starboard tack, ca. 1882

Dry-plate negative, 10.2 × 12.7 cm [4 × 5″]
(.968)

563

Delaware River with beached dory,
ca. 1882

Dry-plate negative, 10.2 × 12.7 cm [4 × 5″]
(.976)

564

Sailboats on Delaware Bay, ca. 1882

Gelatin printing-out-paper print, 11.4 × 8.7
cm [4½ × 3⁷⁄₁₆″] (.333)

Circle of Eakins

565

†Landscape with river in foreground,
ca. 1882

Gelatin printing-out-paper print, 9.5 × 11.7
cm [3¾ × 4⅝″] (.768)

GLOUCESTER (NEW JERSEY) STUDIES

The forty-six negatives and one print in this series—most of them previously unknown—are related to Eakins's oil paintings and watercolors of shad fishing in Gloucester, New Jersey (1881–82). Validating earlier speculation by Theodor Siegl and other scholars that many elements were based directly on photographs, the Gloucester pictures represent the largest group of photographic studies for one project. Never again would Thomas Eakins rely so heavily on photography for composition. Inscriptions in his hand on the original boxes for the negatives in the Bregler collection provide dates for his Gloucester photographs: April 21 and 23 and May 14 and 15, 1881, and May 24 and June 7, 1882. It is impossible, however, to ascertain which negatives were originally in each box. Therefore, this entire group is dated about 1881.

These photographs are important also as visual documentation of a popular and profitable seasonal activity on the Delaware River.

566

Shad fishing: net folded on shad flat,
ca. 1881

Dry-plate negative, 10.2 × 12.7 cm [4 × 5″]
(.885)

567

Shad fishing: setting the net, ca. 1881

Dry-plate negative, 10.2 × 12.7 cm [4 × 5″]
(.886)

Study for *Shad Fishing at Gloucester on the Delaware River* (1881, Philadelphia Museum of Art).

568

Shad fishing: setting the net, ca. 1881

Dry-plate negative, 10.2 × 12.7 cm [4 × 5″]
(.887)

Study for *Shad Fishing at Gloucester on the Delaware River* (1881, private collection);
ill. in Goodrich 1982, vol. 1, fig. 94.

569

Shad fishing: setting the net, ca. 1881

Dry-plate negative, 10.2 × 12.7 cm [4 × 5″]
(.888)

Study for *Taking Up the Net* (1881, Metropolitan Museum of Art, New York).

570

Shad fishing: setting the net, ca. 1881

Dry-plate negative, 10.2 × 12.7 cm [4 × 5″]
(.889)

571

Shad fishing: setting the net, ca. 1881

Dry-plate negative, 10.2 × 12.7 cm [4 × 5″]
(.890)

572

Shad fishing: setting the net, ca. 1881

Dry-plate negative, 10.2 × 12.7 cm [4 × 5″]
(.891)

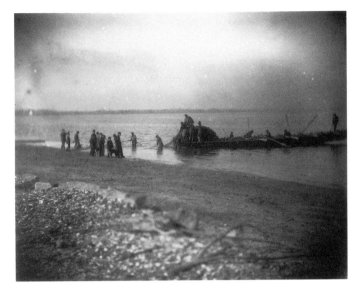

567

579

573
Shad fishing: setting the net, ca. 1881
Dry-plate negative, 10.2 × 12.7 cm [4 × 5″]
(.892)

574
Shad fishing: setting the net, ca. 1881
Dry-plate negative, 10.2 × 12.7 cm [4 × 5″]
(.893)

575
Shad fishing: setting the net, ca. 1881
Dry-plate negative, 10.2 × 12.7 cm [4 × 5″]
(.894)

576
Shad fishing: hauling the net with the capstan, ca. 1881
Dry-plate negative, 10.2 × 12.7 cm [4 × 5″]
(.895)
Hendricks 1972, fig. 31.

Study for *Drawing the Seine* (1882, Philadelphia Museum of Art).

577
Shad fishing: hauling the net with the capstan, ca. 1881
Dry-plate negative, 10.2 × 12.7 cm [4 × 5″]
(.896)

578
Shad fishing: hauling the net with the capstan, ca. 1881
Dry-plate negative, 10.2 × 12.7 cm [4 × 5″]
(.897)

579
Shad fishing: hauling the net, ca. 1881
Dry-plate negative, 10.2 × 12.7 cm [4 × 5″]
(.898)

580
Shad fishing: hauling the net, ca. 1881
Dry-plate negative, 10.2 × 12.7 cm [4 × 5″]
(.899)

581
Shad fishing: hauling the net, ca. 1881
Dry-plate negative, 10.2 × 12.7 cm [4 × 5″]
(.900)

582
Shad fishing: hauling the net, ca. 1881
Dry-plate negative, 10.2 × 12.7 cm [4 × 5″]
(.901)

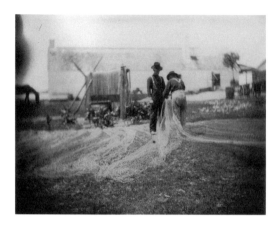

598

604

605

583
Shad fishing: hauling the net, ca. 1881
Dry-plate negative, 10.2 × 12.7 cm [4 × 5″]
(.902)

584
Shad fishing: hauling the net, ca. 1881
Dry-plate negative, 10.2 × 12.7 cm [4 × 5″]
(.903)

585
Shad fishing: hauling the net, ca. 1881
Dry-plate negative, 10.2 × 12.7 cm [4 × 5″]
(.904)

586
Shad fishing: hauling the net, ca. 1881
Dry-plate negative, 10.2 × 12.7 cm [4 × 5″]
(.905)

587
Shad fishing: hauling the net, ca. 1881
Albumen print, 8.7 × 10.5 cm [3⁷⁄₁₆ × 4⅛″]
(.764)
Dry-plate negative, 10.2 × 12.7 cm [4 × 5″]
(.906)

588
Shad fishing: hauling the net, ca. 1881
Dry-plate negative, 10.2 × 12.7 cm [4 × 5″]
(.907)

589
Shad fishing: hauling the net, ca. 1881
Dry-plate negative, 10.2 × 12.7 cm [4 × 5″]
(.908)

590
Shad fishing: hauling the net, ca. 1881
Dry-plate negative, 10.2 × 12.7 cm [4 × 5″]
(.909)

591
Fisherman mending a net, ca. 1881
Dry-plate negative, 10.2 × 12.7 cm [4 × 5″]
(.913)

592
Fisherman mending a net, ca. 1881
Dry-plate negative, 10.2 × 12.7 cm [4 × 5″]
(.914)

593
Fisherman mending a net, ca. 1881
Dry-plate negative, 10.2 × 12.7 cm [4 × 5″]
(.916)

594
Two fishermen mending nets, ca. 1881
Dry-plate negative, 10.2 × 12.7 cm [4 × 5″]
(.915)

595
Two fishermen mending nets, ca. 1881
Dry-plate negative, 10.2 × 12.7 cm [4 × 5"]
(.911)

596
Two fishermen mending nets, ca. 1881
Dry-plate negative, 10.2 × 12.7 cm [4 × 5"]
(.912)

597
Two fishermen mending nets, ca. 1881
Dry-plate negative, 10.2 × 12.7 cm [4 × 5"]
(.917)

598
Two fishermen mending nets, ca. 1881
Dry-plate negative, 10.2 × 12.7 cm [4 × 5"]
(.918)

Study for *Mending the Net* (1881, Philadelphia Museum of Art).

599
Three fishermen mending nets, ca. 1881
Dry-plate negative, 10.2 × 12.7 cm [4 × 5"]
(.910)

Study for *Mending the Net* (1881, Philadelphia Museum of Art).

600
Three fishermen standing at edge of Delaware River, ca. 1881
Dry-plate negative, 10.2 × 12.7 cm [4 × 5"]
(.919)

601
Three fishermen standing at edge of Delaware River, ca. 1881
Dry-plate negative, 10.2 × 12.7 cm [4 × 5"]
(.920)

602
Woman in plaid dress with parasol at edge of Delaware River, ca. 1881
Dry-plate negative, 10.2 × 12.7 cm [4 × 5"]
(.921)

603
Three women, man, and dog near Delaware River, ca. 1881
Dry-plate negative, 10.2 × 12.7 cm [4 × 5"]
(.922)

Cat. nos. 603 and 604 are studies for *Shad Fishing at Gloucester on the Delaware River* (1881, Philadelphia Museum of Art).

604
Three women, man, and dog near Delaware River, ca. 1881
Dry-plate negative, 10.2 × 12.7 cm [4 × 5"]
(.923)

605
Benjamin Eakins standing and man sitting, under tree near Delaware River, ca. 1881
Dry-plate negative, 10.2 × 12.7 cm [4 × 5"]
(.924)

Study for *Mending the Net* (1881, Philadelphia Museum of Art).

606
Shoreline of Delaware River, ca. 1881
Dry-plate negative, 10.2 × 12.7 cm [4 × 5"]
(.925)

607
Shoreline of Delaware River with boats, ca. 1881
Dry-plate negative, 10.2 × 12.7 cm [4 × 5"]
(.926)

608
Shoreline of Delaware River with fishing nets, ca. 1881
Dry-plate negative, 10.2 × 12.7 cm [4 × 5"]
(.927)

609
Shoreline of Delaware River with fishing nets, ca. 1881
Dry-plate negative, 10.2 × 12.7 cm [4 × 5"]
(.928)

610
Clapboard house with ropes on porch and sail on ground, ca. 1881
Dry-plate negative, 10.2 × 12.7 cm [4 × 5"]
(.929)

611
Tree near Delaware River, ca. 1881
Dry-plate negative, 10.2 × 12.7 cm [4 × 5"]
(.966)

Study for *Mending the Net* (1881, Philadelphia Museum of Art).

DAKOTA TERRITORY STUDIES

In 1887 Thomas Eakins traveled to the BT Ranch in the Badlands of the Dakota Territory, where he photographed cowboys, landscapes, and ranch buildings. He also made portrait photographs of people at the ranch. Before the emergence of the Bregler collection, only four images from the trip were known. The thirty-six glass-plate negatives and one platinum print now in the Pennsylvania Academy reveal the extent of Eakins's camera work in the Badlands. He incorporated elements of several photographs into his painting *Cowboys in the Badlands* (1888, private collection). All of the negatives are incised with three digits that may be evidence of a lost numbering system.

612

Badlands, panoramic view, 1887

Dry-plate negative, 10.2 × 12.7 cm [4 × 5″]

(.1064)

613

Badlands landscape, 1887

Dry-plate negative, 10.2 × 12.7 cm [4 × 5″]

(.1065)

614

BT Ranch building, full view, 1887

Dry-plate negative, 10.2 × 12.7 cm [4 × 5″]

(.1069)

615

Two BT Ranch buildings, 1887

Dry-plate negative, 10.2 × 12.7 cm [4 × 5″]

(.1066)

616

BT Ranch building, partial view, 1887

Dry-plate negative, 10.2 × 12.7 cm [4 × 5″]

(.1067)

617

BT Ranch building, partial view, 1887

Dry-plate negative, 10.2 × 12.7 cm [4 × 5″]

(.1068)

618

Hogs and chickens at BT Ranch, 1887

Dry-plate negative, 10.2 × 12.7 cm [4 × 5″]

(.1070)

619

Hogs and chickens at BT Ranch, 1887

Dry-plate negative, 10.2 × 12.7 cm [4 × 5″]

(.1071)

620

Man sitting in front of draped background, 1887

Dry-plate negative, 10.2 × 12.7 cm [4 × 5″]

(.1073)

621

Woman sitting at BT Ranch, 1887

Dry-plate negative, 10.2 × 12.7 cm [4 × 5″]

(.1072)

The same model appears in cat. no. 622.

622

Woman on horse at BT Ranch, 1887

Dry-plate negative, 10.2 × 12.7 cm [4 × 5″]

(.1075)

Hendricks 1972, fig. 136.

623

Cowboy sitting in front of BT Ranch building, 1887

Dry-plate negative, 10.2 × 12.7 cm [4 × 5″]

(.1074)

Hendricks 1972, fig. 134.

The same model appears in cat. no. 624.

624

Cowboy aiming revolver, 1887

Dry-plate negative, 10.2 × 12.7 cm [4 × 5″]

(.1076)

625

Cowboy aiming rifle, 1887

Dry-plate negative, 10.2 × 12.7 cm [4 × 5″]

(.1077)

626

Cowboy in dark shirt, on dappled horse, shielding eyes from sun, 1887

Dry-plate negative, 10.2 × 12.7 cm [4 × 5″]

(.1078)

The same model appears in cat. nos. 627 and 628.

627

Cowboy in dark shirt, on dappled horse, 1887

Dry-plate negative, 10.2 × 12.7 cm [4 × 5″]

(.1079)

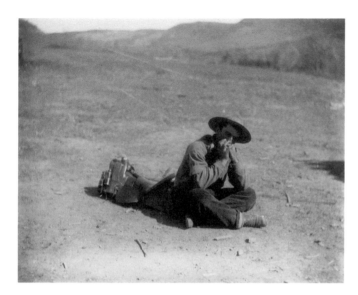

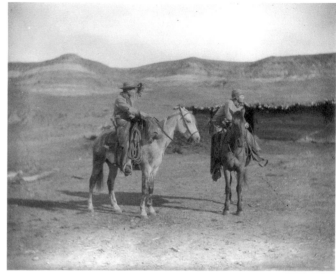

633

638

628

Cowboy in dark shirt, standing next to dappled horse, 1887
Dry-plate negative, 10.2 × 12.7 cm [4 × 5″]
(.1080)

629

Cowboy with dark neckerchief, on dappled horse, 1887
Dry-plate negative, 10.2 × 12.7 cm [4 × 5″]
(.1081)

The same model appears in cat. no. 630.

630

Cowboy with dark neckerchief, on dappled horse, 1887
Dry-plate negative, 10.2 × 12.7 cm [4 × 5″]
(.1082)

631

Cowboy in buckskin shirt, on dappled horse, right leg over pommel, 1887
Dry-plate negative, 10.2 × 12.7 cm [4 × 5″]
(.1083)

The same model appears in cat. no. 632.

632

Cowboy in buckskin shirt, on dappled horse, lariat in hand, 1887
Dry-plate negative, 10.2 × 12.7 cm [4 × 5″]
(.1084)

633

Cowboy sitting on ground playing harmonica, 1887
Dry-plate negative, 10.2 × 12.7 cm [4 × 5″]
(.1085)

634

Cowboy in checked pants, on dark horse, 1887
Dry-plate negative, 10.2 × 12.7 cm [4 × 5″]
(.1086)

635

Cowboy in dark vest, on dark horse, 1887
Dry-plate negative, 10.2 × 12.7 cm [4 × 5″]
(.1089)

636

Two cowboys with horses in BT Ranch yard, dog in foreground, 1887
Dry-plate negative, 10.2 × 12.7 cm [4 × 5″]
(.1090)

637

Two cowboys on horses in BT Ranch
yard, 1887
Dry-plate negative, 10.2 × 12.7 cm [4 × 5″]
(.1091)

638

Two cowboys on horses in BT Ranch
yard, cowboy at left shielding eyes, 1887
Dry-plate negative, 10.2 × 12.7 cm [4 × 5″]
(.1092)

639

Two cowboys on dark horses at BT
Ranch, 1887
Dry-plate negative, 10.2 × 12.7 cm [4 × 5″]
(.1093)

640

Two cowboys on horses in front of corral
at BT Ranch, 1887
Dry-plate negative, 10.2 × 12.7 cm [4 × 5″]
(.1094)

641

Three cowboys on horses, 1887
Dry-plate negative, 10.2 × 12.7 cm [4 × 5″]
(.1098)

642

Two men standing with horses in BT
Ranch yard, 1887
Dry-plate negative, 10.2 × 12.7 cm [4 × 5″]
(.1097)

The identical costumes of these models
may indicate that they are soldiers.

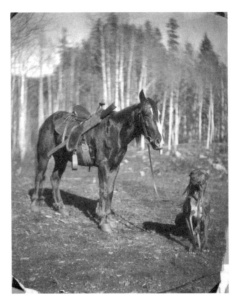

648

643

Cowboy in dark shirt, standing next to
dappled horse, on grassland, 1887
Dry-plate negative, 10.2 × 12.7 cm [4 × 5″]
(.1087)

The grassland setting in cat. nos. 643–46
indicates a location some distance from
the BT Ranch.

644

Cowboy in buckskin shirt, standing next
to dark horse on grassland, 1887
Dry-plate negative, 10.2 × 12.7 cm [4 × 5″]
(.1088)

645

Two cowboys on dark horses on grass-
land, 1887
Dry-plate negative, 10.2 × 12.7 cm [4 × 5″]
(.1095)

646

Two cowboys on horses on grassland,
1887
Dry-plate negative, 10.2 × 12.7 cm [4 × 5″]
(.1096)

647

Cattle in corral at BT Ranch, 1887
Dry-plate negative, 10.2 × 12.7 cm [4 × 5″]
(.1099)

648

Dog and pony in Dakota Territory, 1887
Platinum print, 23.7 × 18.9 cm [9⁵⁄₁₆ ×
7⁷⁄₁₆″] (.277)
Hendricks 1972, fig. 138.

APPENDIX A: PHOTOGRAPHS FROM OUTSIDE THE CIRCLE OF EAKINS

About 275 photographs that were part of either the Bregler or Hendricks purchases have been omitted from the catalogue because their date, medium, subject, or maker suggest a photographer other than Thomas Eakins and his circle. Some 240 of these are professional studio portraits of Eakins, his family, and his friends. In addition to tintypes, cartes de visite, cabinet cards, and platinum and silver prints, there are a number of candid portraits, figure studies, animals, and landscapes.

Several of the portraits are significant for Eakins scholarship. A carte de visite of Rosa Bonheur by Disdéri et Cie was probably acquired by Eakins during the time he studied in France, for his letters of 1868 and 1869 mention his friendship with the Bonheurs. A photograph of Frank Hamilton Cushing in Zuni dress by John K. Hillers may have been acquired by Eakins when he painted Cushing's portrait (Gilcrease Institute, Tulsa). Copies of this photograph exist in several collections. There are also many portrait photographs of currently unidentified persons, some of which may depict Susan Eakins's and Charles Bregler's friends or relatives.

The carte de visite of a Spanish acrobat by J. Laurent and one-half of a stereo card showing four North African children may have been acquired by Eakins in Spain. A large hand-colored platinum print, *Returning from a Walk* by Wallace Nutting, suggests the eighteenth-century interests of both Thomas and Susan Eakins. Five photographs of animals by the well-known specialist firm of Schreiber and Sons underscore Eakins's own interest in this subject.

Listed below are photographers, represented in the Pennsylvania Academy's Bregler or Hendricks collections, whose work falls outside the circle of Eakins. The majority of the images are portraits of Thomas Eakins's family and friends.

Thomas Anshutz, 1851–1912
J. R. Applegate, active 1867–1901
A. P. Beecher, active 1860s
Broadbent and Phillips, active 1870s
Chappel Studios, active 1890s–1930s
City Gallery of the Union Photograph Company
Disdéri et Cie, active in Paris, 1854–89
Frederick Gutekunst, 1831–1917
Conrad Haesseler, active 1899–1910

John K. Hillers, 1843–1925
L. Horning, active 1863–92
H. S. Keller, active ca. 1890
L. F. C.
J. Laurent, active in Paris, 1860s and 1870s
Ch. Leymarie
Henri Marceau, 1896–1969
Edward R. Morgan, active 1859–70
Wallace Nutting, 1861–1941
H. C. Phillips, active 1890s

Pirrong and Sons, active 1871–1900
Potter and Company (G. C. Potter and J. P. Silver), active 1871–1905
Schreiber and Sons, active 1870s–1900
A. K. P. Trask, 1830–1900
Eva Watson, 1867–1935
O. H. Willard, active 1854–76
Amelia Van Buren, 1856–1942
Carl Van Vechten, 1880–1904
Frederick Von Rapp, active 1890–1915

APPENDIX B: DISSEMINATION OF MAJOR GROUPS OF EAKINS PHOTOGRAPHS

This chart indicates only the major holdings of Eakins photographs and the dates of acquisition when known. There are smaller concentrations of images in the Franklin Institute (Philadelphia), the Detroit Institute of Arts, the Archives of American Art, and various private collections. The largest collection by far is that of the Pennsylvania Academy of the Fine Arts, almost all of which was acquired by Charles Bregler in 1939, when Susan Macdowell Eakins's estate was dispersed. The provenance of several other collections can also be traced to the breakup of Mrs. Eakins's home: the group of prints purchased from Bregler in the 1940s by the Metropolitan Museum of Art, the Joseph Katz portion of the Hirshhorn collection, and Seymour Adelman's holdings now scattered between the Dietrich, Getty, and Bryn Mawr College collections. It should be noted that the Samuel Murray portion of the Hirshhorn collection and the Crowell and Macdowell family collections were initially assembled much closer in time to the actual making of the photographs, probably by persons intimately associated with the photographers. The collections of the Philadelphia Museum of Art and the J. Paul Getty Museum have been assembled from a variety of sources.

One important group of photographs, not represented on the chart, is now dispersed. This group, published by Olympia Galleries in 1976, 1977, and 1981, descended from the estate of Edward Hornor Coates. Coates, as the chairman of the Committee on Instruction, requested Thomas Eakins's resignation from the Pennsylvania Academy in 1886. It was probably at that time that Coates acquired the photographs, which were found by his descendants in the 1970s and then acquired by Olympia Galleries. Of this group, some images are closely associated with Eakins (the "naked series"), while others are now considered to be less closely connected to him (especially the nude women, the men in classical costume, and Academy students in street clothes). Most of the naked-series images are in the Getty collection; the majority of the other Olympia Galleries photographs are unlocated.

DISSEMINATION OF MAJOR GROUPS OF EAKINS PHOTOGRAPHS

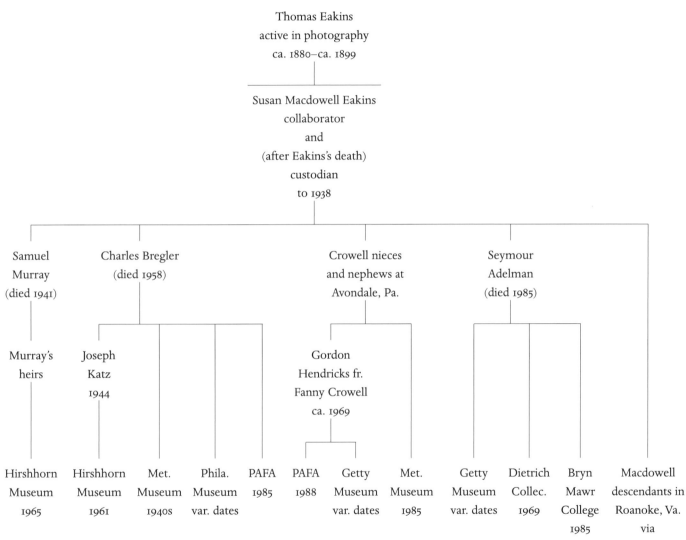

Thomas Eakins
active in photography
ca. 1880–ca. 1899

Susan Macdowell Eakins
collaborator
and
(after Eakins's death)
custodian
to 1938

Samuel
Murray
(died 1941)

Charles Bregler
(died 1958)

Crowell nieces
and nephews at
Avondale, Pa.

Seymour
Adelman
(died 1985)

Murray's
heirs

Joseph
Katz
1944

Gordon
Hendricks fr.
Fanny Crowell
ca. 1969

Hirshhorn
Museum
1965

Hirshhorn
Museum
1961

Met.
Museum
1940s

Phila.
Museum
var. dates

PAFA
1985

PAFA
1988

Getty
Museum
var. dates

Met.
Museum
1985

Getty
Museum
var. dates

Dietrich
Collec.
1969

Bryn
Mawr
College
1985

Macdowell
descendants in
Roanoke, Va.
via
Eliz. Macdowell

APPENDIX C: PHOTOGRAPHIC LECTURES AND EXHIBITIONS HELD AT THE PENNSYLVANIA ACADEMY OF THE FINE ARTS, 1883–1906

In most cases a ticket, an exhibitor's prospectus, and/or an exhibition catalogue survive in the Academy archives to document these events.

February 12, 1883	Lecture by Eadweard Muybridge, "The Romance and Realities of Animal Locomotion," illustrated with the Zoopraxiscope
April 12, 1883	Lantern-slide evening sponsored by the Philadelphia Society of Photographers
December 5, 1884	Exhibition of photographs by George Bacon Wood sponsored by the Academy Art Club
May 22, 1885	Lecture by Thomas Eakins, "The Zoetrope"
January 11–16, 1886	Exhibition of photographs by the Philadelphia Society of Photographers; lantern-slide evening, January 14
April 8–20, 1889	Third Annual Joint Exhibition of the Society of Amateur Photographers of New York, the Philadelphia Society of Photographers, and the Boston Camera Club; four lantern-slide evenings, April 9, 11, 16, and 18
April 17–29, 1893	Sixth Annual Joint Exhibition of [three societies above]; lantern-slide evening, April 18
April 11–26, 1894	Sella Collection of Alpine Photographs
October 24–November 12, 1898	First Philadelphia Photographic Salon
October 22–November 19, 1899	Second Philadelphia Photographic Salon
October 21–November 18, 1900	Third Philadelphia Photographic Salon
November 18–December 14, 1901	Fourth Philadelphia Photographic Salon
April 30–May 27, 1906	Exhibition of Photographs by the Photo Secession

GLOSSARY OF PHOTOGRAPHIC TERMS

Adapted with permission from Gordon Baldwin, *Looking at Photographs* (Malibu, Calif.: J. Paul Getty Museum in association with British Museum Press, 1991).

ALBUMEN PRINT

The albumen print was invented in 1850, and until about 1890 it was the most prevalent type of photographic print. It was made by floating a sheet of thin paper on a bath of egg white containing salt, which had been whisked, allowed to subside, and filtered. This produced a smooth surface, the pores of the paper having been filled by the albumen. After drying, the albumenized paper was sensitized by floating it on a bath of silver-nitrate solution or by brushing on the same solution. The paper was again dried, but this time in the dark. (The salt and silver nitrate combined to form light-sensitive silver salts.) This doubly coated paper was put into a wooden, hinged-back frame in contact with a negative, usually made of glass but occasionally of paper; it was then placed in the sun to print. After printing, which sometimes required only a few minutes but could take an hour or more, the resultant proof, still unstable, was fixed by immersing it in a solution of hyposulfite of soda ("hypo") and water and then thoroughly washed to prevent further chemical reactions. Variations in tone and hue were achieved by stopping the processes described above at different stages and times or, more often, by additional toning. The finished print ranges in color from reddish to purplish brown and is usually glossy.

CARTE DE VISITE

A carte de visite is a stiff piece of card measuring about 11.4 × 6.4 cm (4½ by 2½ inches), the size of a formal visiting card of the 1850s (hence the name), with an attached photograph of nearly the same size. Cartes normally bore full-length studio portraits that were most often albumen prints from collodion wet-plate negatives.

COLLODION WET-PLATE NEGATIVE

In the nineteenth century the collodion used to coat glass plates was made from gun cotton, a commercially available product, which was ordinary cotton that had been soaked in nitric and sulfuric acid and then dried. The photographer dissolved gun cotton in a mixture of alcohol and ether to which potassium iodide had been added. The resultant collodion was a syrupy mixture that could be poured

227

onto clean glass plates. Wet-collodion-on-glass negatives were valued because the transparency of the glass produced a high resolution of detail in both the highlights and the shadows of the resultant prints. Finished negatives were usually used to produce albumen prints of the same size. This process of making negatives was most common from the early 1850s to about 1881.

CYANOTYPE

The cyanotype process for making prints, invented in 1842, involves the light sensitivity of iron salts. A sheet of paper was brushed with solutions of ferric ammonium citrate and potassium ferricyanide and dried in the dark. The object to be reproduced, be it a drawing, a plant specimen, or a negative, was then placed on the sensitized sheet in direct sunlight. After about a fifteen-minute exposure, an impression was formed, resulting in a white image on a blue ground.

DAGUERREOTYPE

A daguerreotype is a detailed image formed on a sheet of copper very thinly plated with silver. A highly polished plate was suspended over iodine in a closed container. Rising vapors from the iodine united with the silver to produce a light-sensitive surface coating of silver iodide. The sensitized plate, inside a lightproof holder, was then transferred to a camera and exposed to light for several minutes. The plate was then developed by being placed in a container suspended over a heated dish of mercury, the vapor from which reacted with the exposed silver iodide to produce an image in an amalgam of silver mercury. The image was fixed by immersion in a salt solution or with hyposulfite of soda and toned. Because there is no negative involved in this process, each daguerreotype is a unique image. The daguerreotype process was invented in 1839 and remained popular until the middle of the 1850s.

DEVELOPING-OUT PAPER

These are papers designed for the production of photographic prints from negatives by chemical development rather than by the action of light alone. Developing-out papers were available from 1873 onward; having been substantially improved by 1880, they became popular, and after 1900 they were preeminent. They were the ancestors of modern gelatin silver photographic papers.

DRY-PLATE NEGATIVE

In general, a dry plate is a glass or metal plate coated with a dried light-sensitive emulsion. The term usually refers to thin glass plates coated with gelatin containing light-sensitive silver salts. Invented in 1871, they were in general use by the mid-1880s. Dry plates wholly supplanted wet collodion, as they did not require messy last-minute chemical preparations and were more sensitive.

ENLARGEMENT

An enlargement is a photographic print of dimensions greater than the negative from which it was made. (A print of the same size as the negative is a contact print.) The process for making an enlargement is to concentrate a source of light by the use of a lens through a negative and then through a magnifying lens onto light-sensitive paper of the desired size. In the nineteenth century, exposures were long, as the usual source of light was the sun.

GELATIN SILVER PRINT

Soon after the invention of the gelatin dry plate in 1871, papers coated with gelatin containing silver salts for making black-and-white prints from negatives were introduced, and they are still in general use. By about 1895 gelatin silver prints had replaced albumen prints as the most common type of photograph.

GLASS-PLATE NEGATIVE

In the nineteenth century, glass plates were the most common support for light-sensitive materials used in producing a negative. Glass-plate negatives were used to produce albumen, platinum, and gelatin silver prints.

INTERPOSITIVE (DIAPOSITIVE)

An interpositive is a photographic image produced from an original negative and is meant to be viewed by transmitted light. In the nineteenth century these were known as diapositives and were produced on glass plates. Some, usually made for display in windows, are also referred to as glass positives. Other interpositives were used to make enlargements.

LANTERN SLIDE

During the mid-nineteenth century, slide projectors were called magic lanterns, and glass lantern slides were the source of the projected image. Lantern slides were used both for home entertainment and for the illustration of public lectures.

PLATINUM PRINT (PLATINOTYPE)

The process for making platinum prints was introduced in 1873, and commercially prepared platinum papers became widely available by 1878. The process depends on the light sensitivity of iron salts. A dried sheet of paper, sensitized with a solution of potassium tetra-chloro-platinate and ferric oxalate, an iron salt, was contact printed under a negative in daylight until a faint image was produced by the reaction of the light with the iron salt. The paper was further developed by immersion in a solution of potassium oxalate that dissolved out the iron salts and reduced the chloro-platinate salt to platinum in those areas where the exposed iron salts had been. After the paper was washed in a series of weak acid baths, it was rinsed in water and sometimes toned. Platinum prints are predominantly silvery gray in color, but hues such as olive green, red, and blue are also possible. The finished print often has a soft matte finish because the platinum is embedded in the paper fibers. Sometimes referred to as platinotypes, platinum prints remained popular until the 1920s, when the price of platinum rose so steeply as to make them prohibitively expensive.

PRINTING-OUT PAPER

Printing-out paper was designed for the production of a photographic print from a negative by the action of light alone on light-sensitive material, rather than by development using chemicals (see developing-out paper). Although albumen prints were printed out, the term printing-out paper is reserved for those commercially manufactured papers coated with silver-chloride emulsions (made usually of gelatin but sometimes of collodion), that were in general use, especially for portraiture, from the 1880s until the late 1920s. Photographs made on printing-out paper exhibit warm image tones and can have a wide variety of surfaces from glossy to matte.

TINTYPE

The ferrotype, better known as the tintype in the United States, where it reached its greatest popularity, depended on the fact that a collodion negative appeared to be a positive image when viewed against a dark background. A tintype was made on a thin sheet of iron, not tin, coated with an opaque black or chocolate-brown lacquer or enamel. The lacquered sheet was coated with wet collodion containing silver salts just before exposure in the camera. Development immediately followed exposure. Like a daguerreotype, the tintype is a unique image and is often housed in a small folding case. From their origin in the 1850s until the end of the century, tintypes remained popular for portrait photography because they were very inexpensive.

BIBLIOGRAPHY

This bibliography lists only major sources of information and commentary on Thomas Eakins and Susan Macdowell Eakins and titles frequently cited in the present text. A more comprehensive listing of references can be found in Goodrich 1982. Works appearing since that volume was published have been added to this list.

Bregler, Charles. "Thomas Eakins as a Teacher." *Arts* 17 (March 1931), pp. 376–86.

———. "Thomas Eakins as a Teacher." *Arts* 18 (October 1931), pp. 27–42.

Carr, Carolyn Kinder. "A Friendship and a Photograph: Sophia Williams, Talcott Williams, and Walt Whitman." *American Art Journal* 21, no. 1 (1989), pp. 2–12.

Casteras, Susan M. *Susan Macdowell Eakins, 1851–1938*. Philadelphia: Pennsylvania Academy of the Fine Arts, 1973.

Foster, Kathleen A. "An Important Eakins Collection." *Antiques* 130, no. 6 (December 1986), pp. 1228–37.

———. "Realism or Impressionism? The Landscapes of Thomas Eakins." In *Studies in the History of Art*. Vol. 37. Washington, D.C.: National Gallery of Art, 1990. Pp. 69–91.

——— and Cheryl Leibold. *Writing about Eakins: The Manuscripts in Charles Bregler's Thomas Eakins Collection*. Philadelphia: University of Pennsylvania Press for Pennsylvania Academy of the Fine Arts, 1989.

Fried, Michael. *Realism, Writing, Disfiguration: Thomas Eakins and Stephen Crane*. Chicago: University of Chicago Press, 1988.

Goodrich, Lloyd. *Thomas Eakins*. 2 vols. Cambridge, Mass.: Harvard University Press for National Gallery of Art, 1982.

Hendricks, Gordon. *The Life and Work of Thomas Eakins*. New York: Grossman Publishers, 1974.

———. *The Photographs of Thomas Eakins*. New York: Grossman Publishers, 1972.

———. *Thomas Eakins: His Photographic Works*. Exhib. cat. Philadelphia: Pennsylvania Academy of the Fine Arts, 1969.

Homer, William Innes, ed. *"Eakins at Avondale" and "Thomas Eakins: A Personal Collection."* Exhib. cat. Chadds Ford, Pa.: Brandywine River Museum, 1980.

———. "A Group of Photographs by Thomas Eakins." *J. Paul Getty Museum Journal* 13 (1985), pp. 151–56.

———. *Thomas Eakins, His Life and Art*. New York: Abbeville Press, 1992.

———. "Who Took Eakins' Photographs?" *Artnews* 82, no. 5 (May 1983), pp. 112–19.

Johns, Elizabeth. *Thomas Eakins: The Heroism of Modern Life*. Princeton: Princeton University Press, 1983.

———. "Thomas Eakins and 'Pure Art' Education." *Archives of American Art Journal* 23, no. 3 (1983), pp. 2–5.

Leibold, Cheryl. "The Many Faces of Thomas Eakins." *Pennsylvania Heritage* 17, no. 2 (Spring 1991), pp. 4–9.

———. "Photographic High Jinks at the Pennsylvania Academy of the Fine Arts." *Nineteenth Century* 12, no. 2 (1993), pp. 2–7.

———. "Thomas Eakins in the Badlands." *Archives of American Art Journal* 28, no. 2 (1988), pp. 2–15.

Lubin, David. *Act of Portrayal: Eakins, Sargent, James.* New Haven, Conn.: Yale University Press, 1985.

Milroy, Elizabeth C. "'Consummatum est . . .': A Reassessment of Thomas Eakins's *Crucifixion* of 1880." *Art Bulletin* 71, no. 2 (June 1989), pp. 269–84.

———. "Thomas Eakins' Artistic Training, 1860–1870." Ph.D. diss., University of Pennsylvania, 1986.

Moffett, Cleveland. "Grant and Lincoln in Bronze." *McClure's Magazine* 5 (October 1895), pp. 419–32.

Onorato, Ronald J. "Photography and Teaching: Eakins at the Academy." *American Art Review* 3 (July–August 1976), pp. 127–40.

Parry, Ellwood C., III. "Thomas Eakins's 'Naked Series' Reconsidered: Another Look at the Standing Nude Photographs Made for the Use of Eakins's Students." *American Art Journal* 20, no. 2 (1988), pp. 53–77.

Peck, Robert McCracken. "Thomas Eakins and Photography: The Means to an End." *Arts Magazine* 53, no. 9 (May 1979), pp. 113–17.

Photographer Thomas Eakins. Exhib. cat. Essay by Ellwood C. Parry III. Philadelphia: Olympia Galleries, 1981.

Rosenzweig, Phyllis D. *The Thomas Eakins Collection of the Hirshhorn Museum and Sculpture Garden.* Washington, D.C.: Smithsonian Institution Press, 1977.

Sellin, David. *Thomas Eakins, Susan Macdowell Eakins, Elizabeth Macdowell Kenton.* Exhib. cat. Roanoke, Va.: North Cross School, 1977.

Sewell, Darrel. *Thomas Eakins: Artist of Philadelphia.* Exhib. cat. Philadelphia: Philadelphia Museum of Art, 1982.

Siegl, Theodor. *The Thomas Eakins Collection.* Philadelphia: Philadelphia Museum of Art, 1978.

Simpson, Marc. "Thomas Eakins and His Arcadian Works." *Smithsonian Studies in American Art* 1, no. 2 (Fall 1987), pp. 70–96.

Wilmerding, John, ed. *Thomas Eakins.* Exhib. cat. London: National Portrait Gallery, 1993.

NAME INDEX

Life dates (when known) are provided in parentheses. Page numbers in italics refer to illustrations.

Adam-Salomon, Antoine Samuel (1811–81), 25–26

Adelman, Seymour (1906–85), 2, 224–25

Alma-Tadema, Sir Lawrence (1836–1912), 56

Anshutz, Thomas (1851–1912), 100, 175

Baldwin, Elizabeth, 143

Barber, Alice (1858–1932), 71, 74, 75

Bargue, Charles (d. 1883), 31

Barnes, Alfred, 53

Bartholdi, Frédéric-Auguste (1834–1904), 31

Baucher, François, 37

Bell, William (1830–1910), 10, 96, 97

Bennett, D. M., 55

Bernard, Claude (1811–90), 95, 99, 103

Bertillon, Alphonse, 40

Bertrand, Alexis, 25

Blanc, Charles (1813–82), 30

Bolton, Rev. J. Gray, 54

Bonheur, Rosa (1822–99), 25

Bonnard, Pierre (1867–1947), 49

Bonnat, Léon (1833–1922), 25

Borelli, Giovanni Alfonso (1608–79), 42

Bouguereau, Adolphe-William (1825–1905), 66

Boulton, Edward, 10, 11, 198

Bregler, Charles (1864–1958), 1, 2, 12, 77, 135, 143, 145, 154, 155, 158, 224

Browne, John C. (1838–1918), 7–10, 8

Brownell, William C. (1851–1928), 106, 109

Cabanel, Alexandre (1824–89), 66

Caillebotte, Gustave (1848–94), 111

Cameron, Julia Margaret (1815–79), 9

Cazin, Jean-Charles (1841–1901), 50

Charcôt, Jean Martin (1825–93), 98

Chesneau, Ernest, 31

Claflin, Tennessee C. (1845–1923), 55, 57

Clark, William, 108

Coates, Edward H. (1846–1921), 23, 56, 75, 88, 101–3, 224

Colgate, Samuel, 53

Comstock, Anthony (1844–1915), 23, 53, 55, 57

Cook, Katherine, 4, 169

Cook, Weda (1867–1937), 4, 169

Corlies, S. Fisher (1830–88), 7, 9

Cornelius, Robert (1809–93), 14

Couture, Thomas (1815–79), 25, 34

Cowperthwait, Eliza (1806–99), 138

Cox, Kenyon (1856–1919), 109–10

Craig, Captain Louis A. (1851–1904), 211

Crepon, Louis, 26

Crowell, Artie (1881–1969), 163

Crowell, Ella (1873–97), 138

Crowell, Frances (1890–1971), 165

Crowell, Frances Eakins (1848–1940), 2, 25, 111, 138, 163, 165

Crowell, James (1888–?), 165

Crowell, Kathryn (1851–79), 77

Crowell, Katie (1886–99), 165

Crowell, Maggie (1876–1920?), 150

Crowell, Tom (1883–1964), 164

Crowell, William J. (1844–1929), 52, 55, 111, 154, 215

Cure, Louis, 25

Cushing, Frank Hamilton (1857–1900), 6

Dagnan-Bouveret, Pascal Adolphe Jean (1852–1929), 95

Dalou, Jules (1838–1902), 50

Both of the typefaces used in *Eakins and the Photograph* were originally cut for metal composition by the Monotype Corporation.

Castellar, the display face, is based on the simple design of a white engraved line on the main stroke of a character. This idea was first introduced by the Parisian type founder Pierre-Simon Fournier about 1749. The Monotype Castellar, with its long and thin serifs, was designed by John Peters in 1957. It was converted from metal to phototypesetting in the late 1970s, then into digitized PostScript by the Monotype Type Drawing Office in 1989.

Dante, the text face, was designed by Giovanni Mardersteig and cut for hand composition by Charles Malin. It was completed in 1954 and first used as a private press typeface for the Officina Bodoni at Verona. It is striking for its wide capitals and the incline of its italics. In 1992 Ron Carpenter and Robin Nicolaus converted Dante to PostScript, working with Mardersteig's son, Martino, and with John Dreyfus, who had been involved in the original cutting. Additional weights were created at that time.

Dwight Agner at Graphic Composition, Inc., in Athens, Georgia, set the final inter-character pairings as displayed in this book. It was typeset on a Miles 33 system and output to film on an Agfa Accuset Imagesetter.

Eakins and the Photograph has been printed on 100 lb. Mohawk Superfine Text white smooth paper by a Heidelberg Speedmaster press at the Stinehour Press in Lunenburg, Vermont.